# *The* SPIRIT *of the* MOUNTAINS

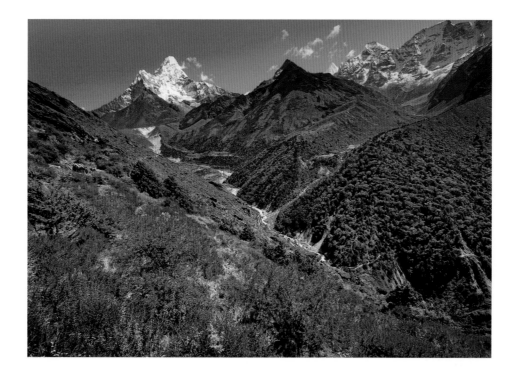

"Photography helped me learn to see.
At the top, there was not just the summit,
but I saw that an infinite number of tracks
lead back down into the valley."

REINHARD KARL (1946–1982),
GERMAN MOUNTAINEER, PHOTOGRAPHER AND WRITER

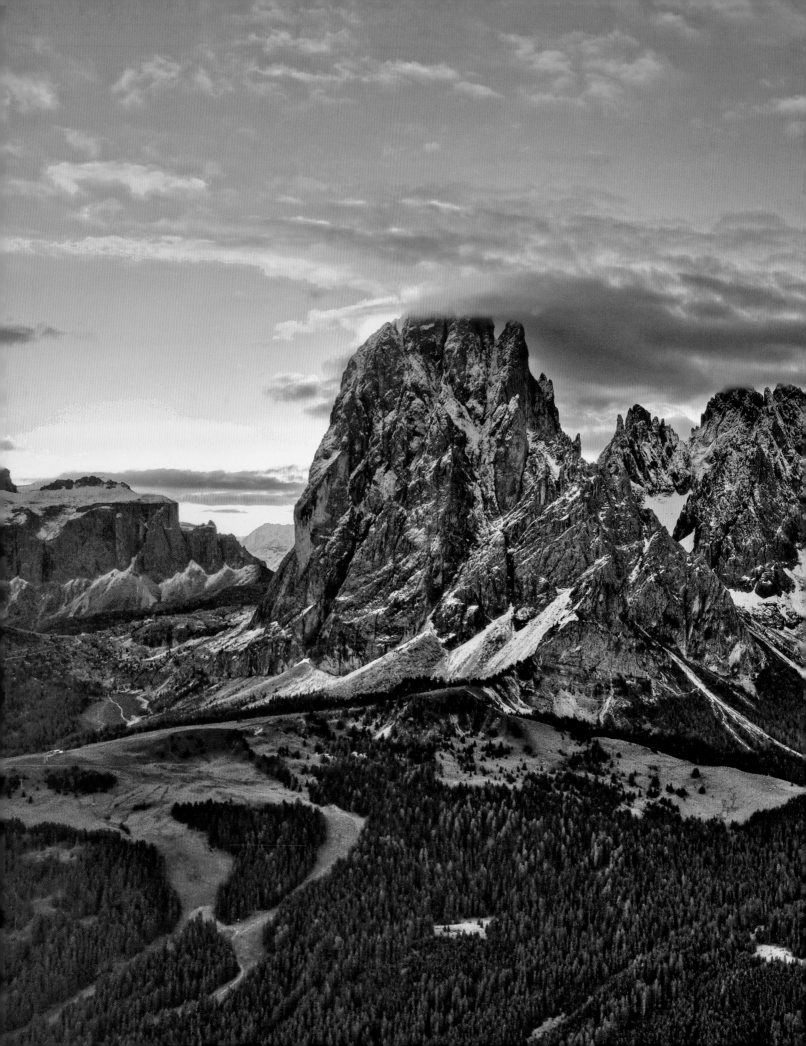

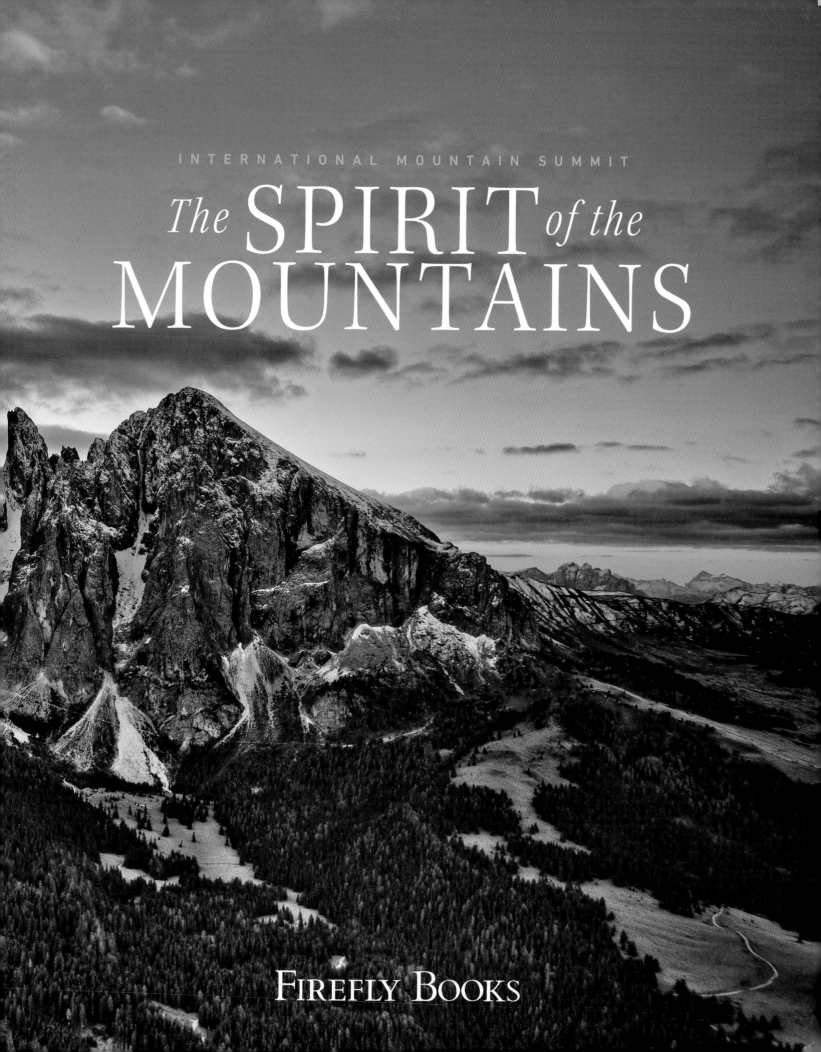

INTERNATIONAL MOUNTAIN SUMMIT

# The SPIRIT of the MOUNTAINS

FIREFLY BOOKS

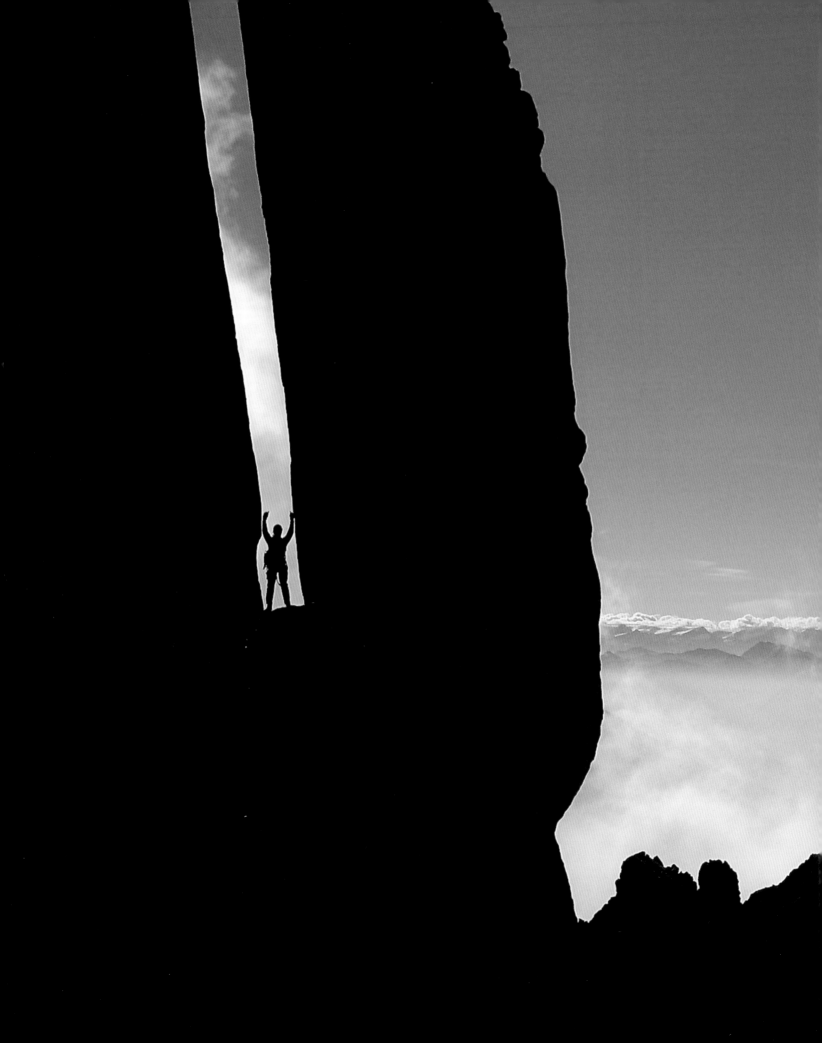

# CONTENTS

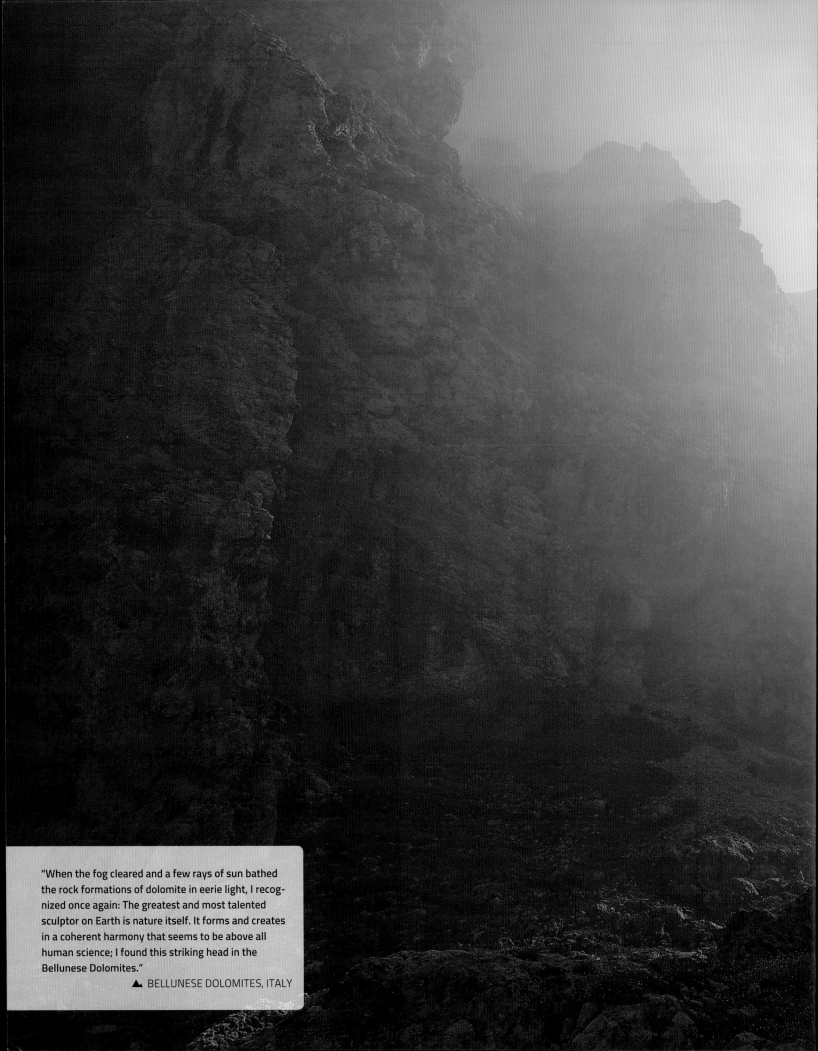

"When the fog cleared and a few rays of sun bathed the rock formations of dolomite in eerie light, I recognized once again: The greatest and most talented sculptor on Earth is nature itself. It forms and creates in a coherent harmony that seems to be above all human science; I found this striking head in the Bellunese Dolomites."

▲ BELLUNESE DOLOMITES, ITALY

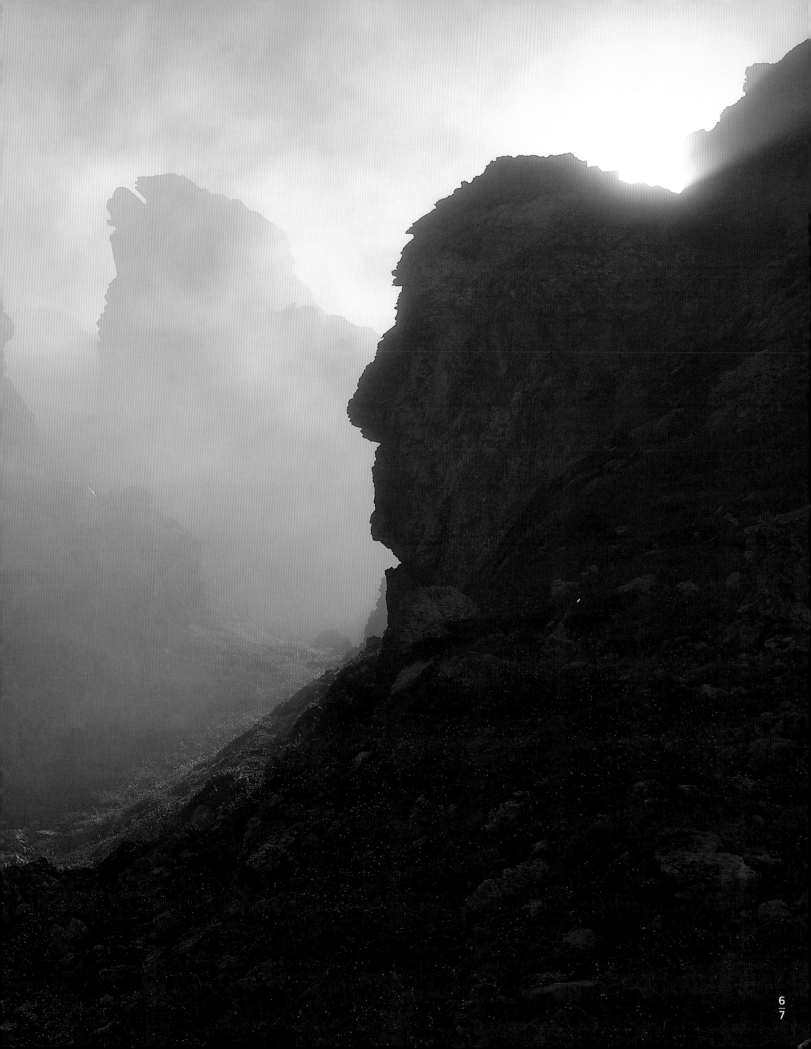

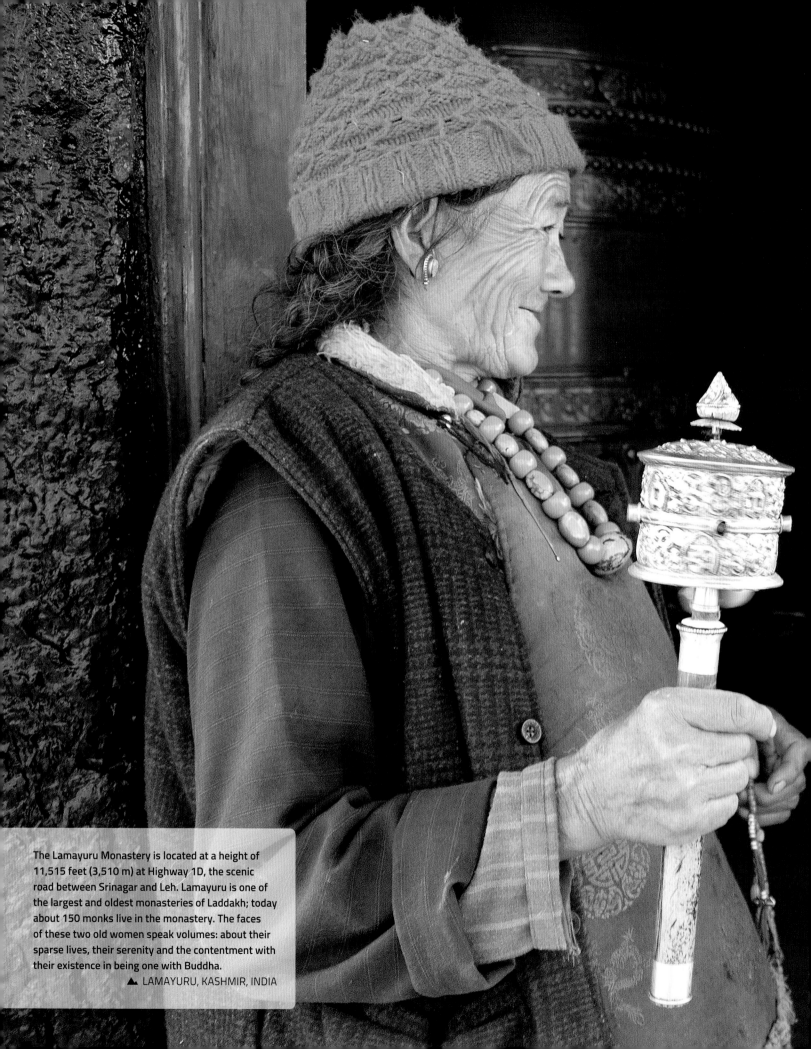

The Lamayuru Monastery is located at a height of
11,515 feet (3,510 m) at Highway 1D, the scenic
road between Srinagar and Leh. Lamayuru is one of
the largest and oldest monasteries of Laddakh; today
about 150 monks live in the monastery. The faces
of these two old women speak volumes: about their
sparse lives, their serenity and the contentment with
their existence in being one with Buddha.

▲ LAMAYURU, KASHMIR, INDIA

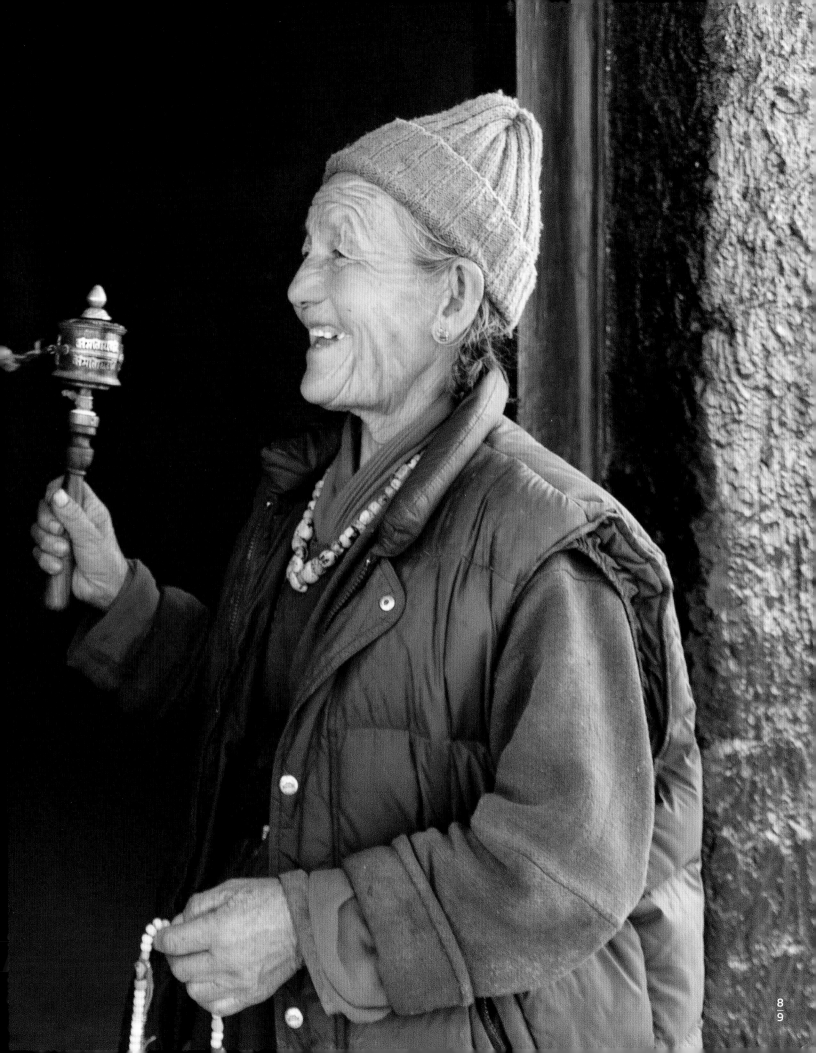

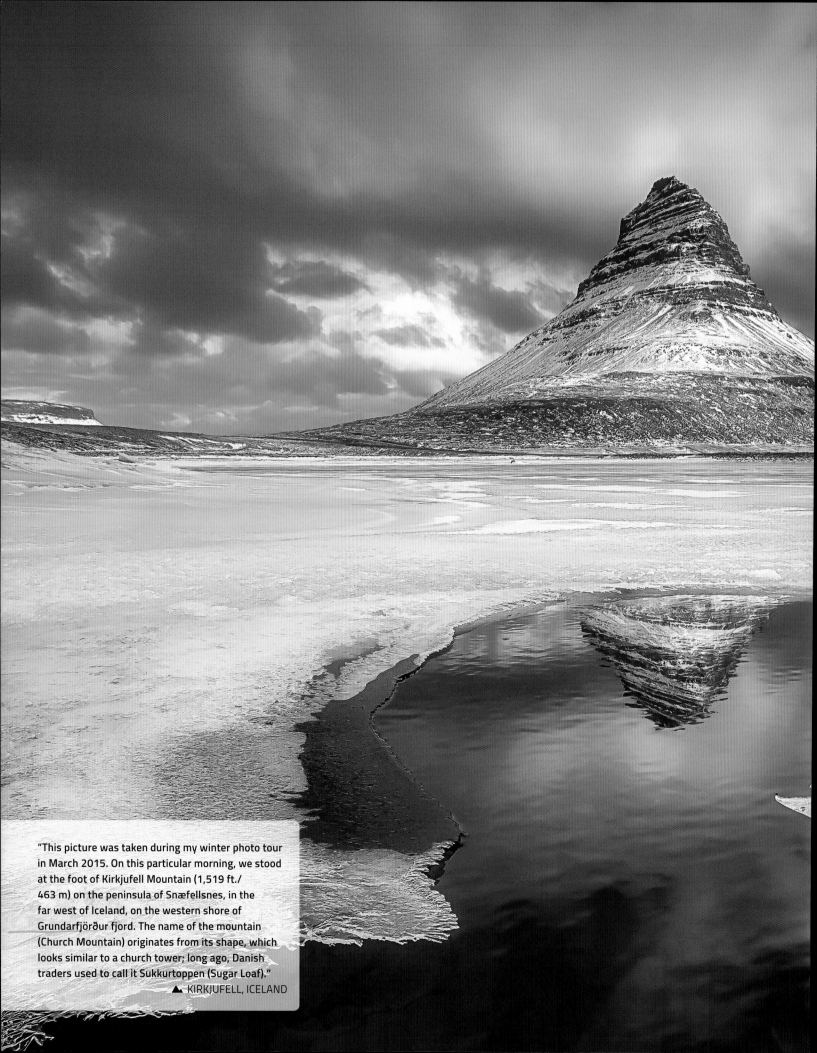

"This picture was taken during my winter photo tour in March 2015. On this particular morning, we stood at the foot of Kirkjufell Mountain (1,519 ft./ 463 m) on the peninsula of Snæfellsnes, in the far west of Iceland, on the western shore of Grundarfjörður fjord. The name of the mountain (Church Mountain) originates from its shape, which looks similar to a church tower; long ago, Danish traders used to call it Sukkurtoppen (Sugar Loaf)."

▲ KIRKJUFELL, ICELAND

# Challenge: Photo Contest

Like most mountain climbers, the founders of the International Mountain Summit (IMS) were united by chance and, ultimately, they formed a rope team that climbed Mount Everest. One word led to another and an idea was born. This vaguely articulated idea then turned into a concrete, well-thought-out and planned project. And a passion was then woken.

For us — Markus Gaiser and Alex Ploner — this passion developed into the International Mountain Summit (IMS). The IMS started as what was supposed to be our mountain tour: a tour with the heights and depth, sunshine and clouds, amazing rope partners and sometimes also free solos.

We can thank the photographer Manuel Ferrigato and graphic designer Arno Dejaco for making the topic of photography a vital component of the festival from the very beginning. The Festival Photo Studio, where the impressive portraits of all mountain climbers and mountain enthusiasts appearing on the stage of the IMS over the past few years have been shown, was their idea; this was in 2009.

Two years later, the decision was reached to include the topic of photography in the program to a greater extent. The IMS Photo Contest was born. The brothers Jürgen and Thomas Braun (KIKU) and Bernhard Fuchs (Salen Frucht), who not only included the KIKU Photo Award in the contest, but also supported the international contest as co-organizers, were some of the founding fathers. It does not happen often that an apple producer participates in launching a mountain photo contest – but in 2011, the time had come!

An impressive total of 926 photographers from 90 countries participated in the first event. Today, there are almost 12,000 photographers from over 100 countries who have sent their most beautiful mountain photographs to the International Mountain Summit. These one-of-a-kind pictures were taken for topics such as "The Four Elements," "Faces of Mountains," "Mountain Traces,"

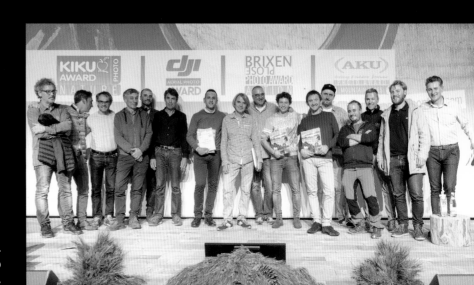

Markus Gaiser and Alex Ploner (above). Prize-giving ceremony at the IMS Photo Contest 2016 (right).

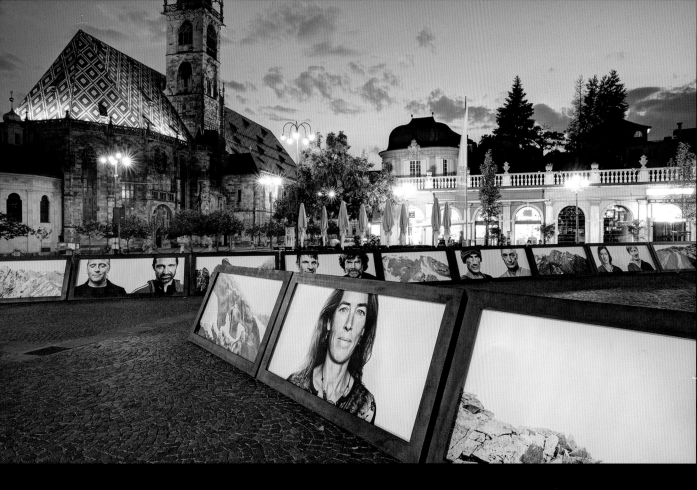

and "Light and Shadow." In 2015, the new topic "Aerial Photos" and the new DJI Aerial Photo Award were included in the contest. As of 2016, there are four main categories in the contest: Nature, Aerial, Faces and Action.

The publishing house Bruckmann Verlag was fascinated by the fact that the IMS attracts not only alpinists and mountain lovers, but also photographers from all over the world. And now we bring you the collective mountain tour, *Spirit of the Mountains* (original German title *Atem der Berge*). It is a book project that intends to offer an understanding of the beauty and fascination, as well as the dangers, of the alpine world to the general public. However, the real protagonists are (and will continue to be) the photographers from all the continents in the world. These photographers have managed to cap-

ture breathtaking moments with their cameras from every imaginable angle, and they have entrusted us with their emotions, memories and experiences. Naturally, they enter the contest in the hope of winning an award, and face the decision of the jury, but they also know that with their contribution, they are participating in something big. More than 12,000 photographers have turned this IMS Photo Contest into an impressive testimony of the passion for photography: an important contribution to mountain culture and to the protection of this unique nature and adventure space. We would like to express our sincerest thanks to all participants! We would like to wish everybody moments full of surprises and fascination with *Spirit of the Mountains*.

*Markus Gaiser and Alex Ploner*

The Mountaineers exhibition at Walther square, Bolzano, Italy

# A Passion for Photos

Prologue by Robert Bösch

**"Photography is a fantastic medium that brings the mountain world close to us — and mountains are an infinite source for impressive photos."**

The IMS Photo Contest has been held since 2011, and as a jury member I am surprised every year, again and again, by the multitude of really impressive pictures. It is not the actual mountains and different light and weather conditions that impress me, but rather the photos taken of these mountains and conditions.

Mountains and photos — these are two completely different things. Those who have been around on the mountains of the world for about 40 years, like me, know these landscapes and different conditions and atmospheres. And still, pictures of mountains astonish and fascinate me time after time because the reality and a picture are not the same thing. When I am in the mountains, I experience nature directly and comprehensively. Everything is present: the sun, the wind, the play of light from a few minutes ago and the cold rain in the present moment.

However, a picture is something completely different; it can only represent

fraction of all of the aforementioned, and is a reduction of time and space into this photographic square. But this exclusion of everything that has happened before and after, and capturing what is still occurring at this particular moment, will create something new: the picture.

We have seen and experienced many of the landscapes that are depicted in the fascinating pictures in this book before; however, we have never seen them this way before. A photo forces us to see the world through the eye of the photographer, and although we think we have seen it all before, we are astonished that the world can still surprise us. Photography is the art of seeing as much as the art of exclusion, as well as the art of reducing this moment of release to a section and point in time.

During the last decade of the 19th century, the Italian mountaineer and photographer Vittorio Sella traveled through the Alps, and later also other mountain areas of the world, to take pictures of the mountain world. Sella was one of the greatest pioneers of mountain photography. You have to take your hat off to his achievements when you look at his photographs, which were often of places that are difficult to access, such as the peak of Dent Blanche, and are even more impressive considering that he had to carry his bulky camera equipment with him wherever he went. Sella was a good mountaineer, but at the same time, he must have had an incredible motivation as a photographer to take on this enormous effort. However, at many locations he was the first photographer ever and he knew

that every new picture he brought back home from his expeditions would show something new that had never been seen before. Such knowledge may have been the reason for his extremely high level of motivation.

Vittorio Sella's photos are primarily characterized by a documentary style. The pictures are very calm, carefully arranged and of surprising quality. As a logical consequence resulting from the heavy and difficult-to-operate camera equipment, you will rarely find spectacular angles or special light and weather conditions. However, Sella did not need to be spectacular, since every single one of his photos of the mostly — at that time — unknown mountain world was in itself a sensation. His pictures showed what had not been seen before. Sella's time has long since passed; today, the white spots on the maps have disappeared. We know Earth from any perspective, even from space.

As such, mountain photography takes on a completely different role. Although in alpinism, pictures still fluctuate between the documentation of a climb and the spectacular world of images, the documentary element has lost its significance in the field of landscape photography. Today's landscape photographers are hardly able to present anything that hasn't been shown before, and therefore strive to present familiar subjects in a new light.

Ever since the first photographers pioneered into the mountain world, impressive mountain pictures have been taken. However, the number of remarkable pictures has multiplied

"Photography is the art of seeing pictures."

Robert Bösch, geographer, mountain guide and member of the jury for the IMS Photo Contest, has been active as a freelance professional photographer for over 30 years. He works for Stern, GEO, Spiegel and Schweizer Illustrierte and has published numerous illustrated books. In 2009, he was awarded the Eiger Special Award for his many years of activity in the field of alpine photography. As a mountain guide his travels and expeditions have led him to all seven continents, where he has climbed many well- and little-known mountains. He climbed Mount Everest for an assignment as a photographer and cameraman. During the past few years, he has been intensively active in the field of landscape photography. His photos have been exhibited in different galleries and museums in Germany and abroad.

Because of its steep granite walls, Cerro Torre in Patagonia is considered one of the most difficult mountains to summit (left).

during the past few years. Imagine an IMS Photo Contest 50 years ago: It would never have been possible to amass such a large quantity of outstanding-quality pictures.

There are various reasons: The number of people who are traveling around in the mountain world has dramatically increased over the past few years. However, the rapid development in photo technology is probably a more decisive reason. Over the past few decades, cameras have become more and more handy, and digital technology has made photography so much easier. In addition, the option of post-processing the photos on the computer has opened a door to a new world of almost unlimited possibilities.

It is a fascinating world that at the same time brings risk to an essential area of photography, since the credibility of the photo is now challenged. I do not refer to the areas in photography where image editing is common practice or where it is used very deliberately, such as in advertising, portrait or studio photography, as well as certain areas of artistic photography. No, I am referring to snapshot photography or photography

"Everybody who is dedicated to photography knows about the small difference between a good and an exceptional photo."

quickly becomes mundane. If the viewer gets the impression that every exceptional photo has more than likely been altered on the computer, admiration for the pictures, such as those in this book, will quickly disappear to be replaced by the sober realization that all of it is constructed and artificial.

There are parallels to alpinism, where the development of technology has to some extent greatly changed climbing and mountaineering. By introducing the bolt, it became possible to climb almost any wall on any line. However, when defeat is virtually excluded from the outset, the challenge becomes uninteresting. In the age of *direttisma* (Italian for "shortest link," meaning a direct climb to the summit of a mountain up the fall line from the valley base to the top), alpinism maneuvered itself into a dead end from which only self-imposed restrictions offered a way out. A reduction of the means used, new rules, and discussions about the style of the ascent "by fair means" and "redpoint," offered exits from the dead end because with these requirements, defeat was a real possibility again.

As with ascent style and means being discussed in mountaineering, image

This book includes an impressive number of exceptional photos. At the same time, it offers the secret to achieving such a number of successful images. Thousands of mountain photographers took thousands of pictures, and this book is the result of tens of thousands of days that photographers spent with their cameras in the mountains around the world. These figures hold the secret for exceptional mountain photos: Besides the art of seeing a picture, you also need to increase the probability of that crucial moment or lucky coincidence, which is also sometimes needed. And for that there is only one recipe: being present in the mountains as often as possible and searching for pictures with open eyes, searching for these rare and exceptional moments — captured in the magical square.

*Robert Bösch*

Nuptse is located in the Khumbu region of the Himalayas, 1.2 miles (2 km) southwest of Mount Everest. Its name originates from Tibetan and means "west peak."

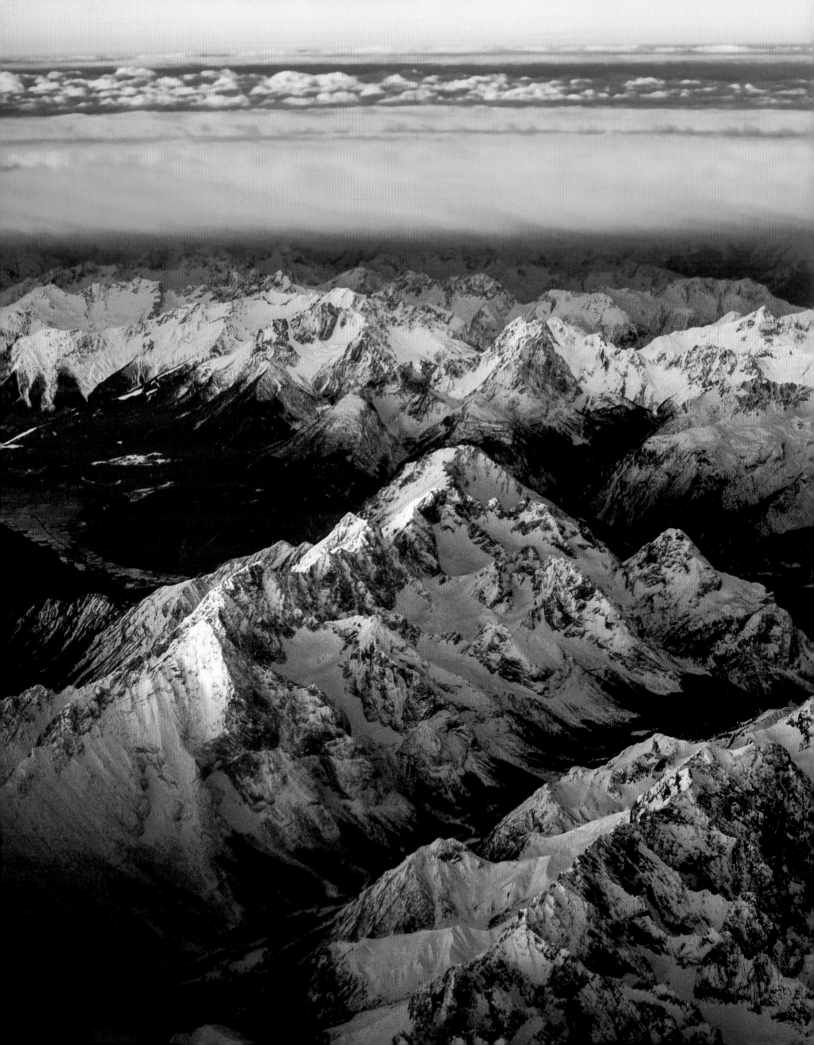

# Under the Spell of the Mountains

On a flight over the main ridge of the Alps en route to Munich, the sunrise presents an incredible spectacle. Oceans of clouds in the west, penetrated by the rays of sun of a new day. This spectacle of light over the peaks of the mountains of Tyrol and Bavaria only lasted a few minutes.

▲ MAIN RIDGE OF THE ALPS

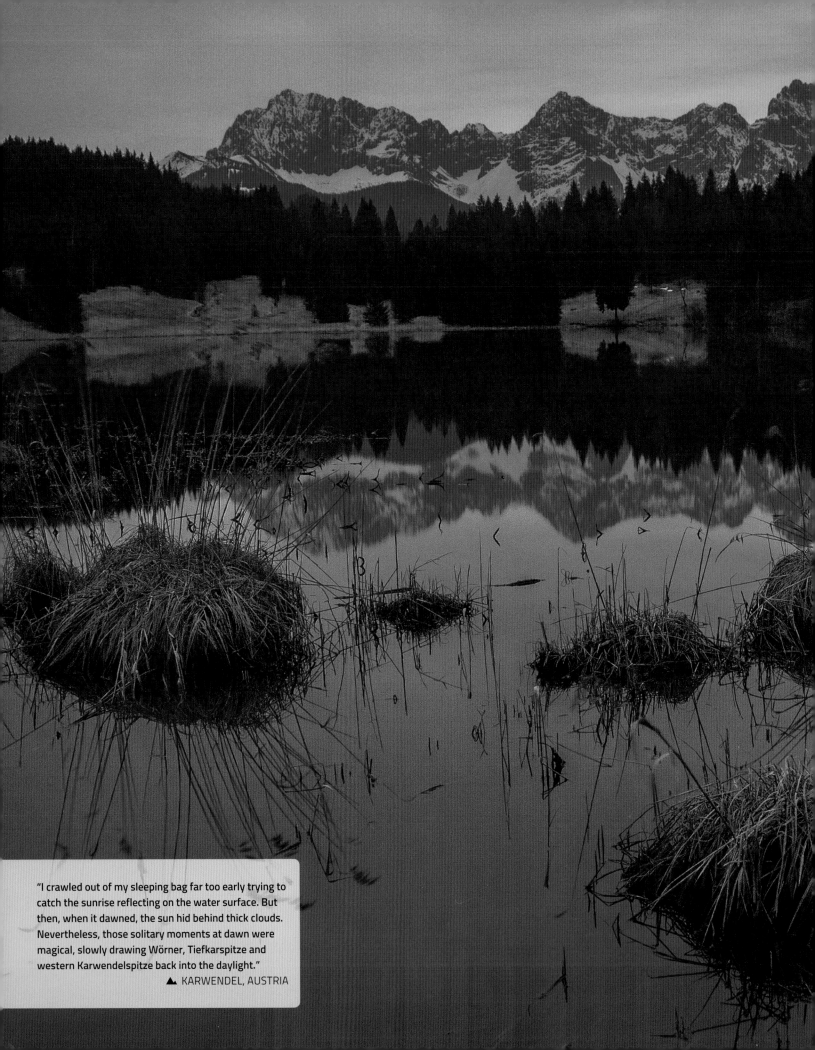

"I crawled out of my sleeping bag far too early trying to catch the sunrise reflecting on the water surface. But then, when it dawned, the sun hid behind thick clouds. Nevertheless, those solitary moments at dawn were magical, slowly drawing Wörner, Tiefkarspitze and western Karwendelspitze back into the daylight."

▲ KARWENDEL, AUSTRIA

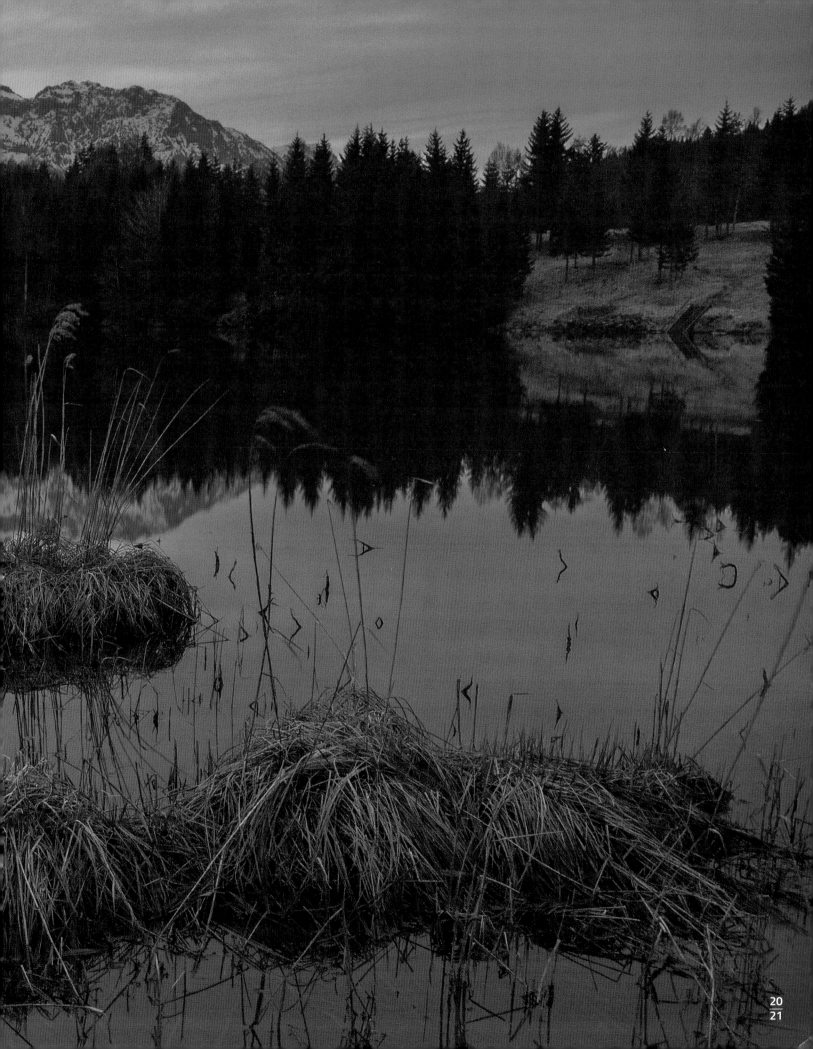

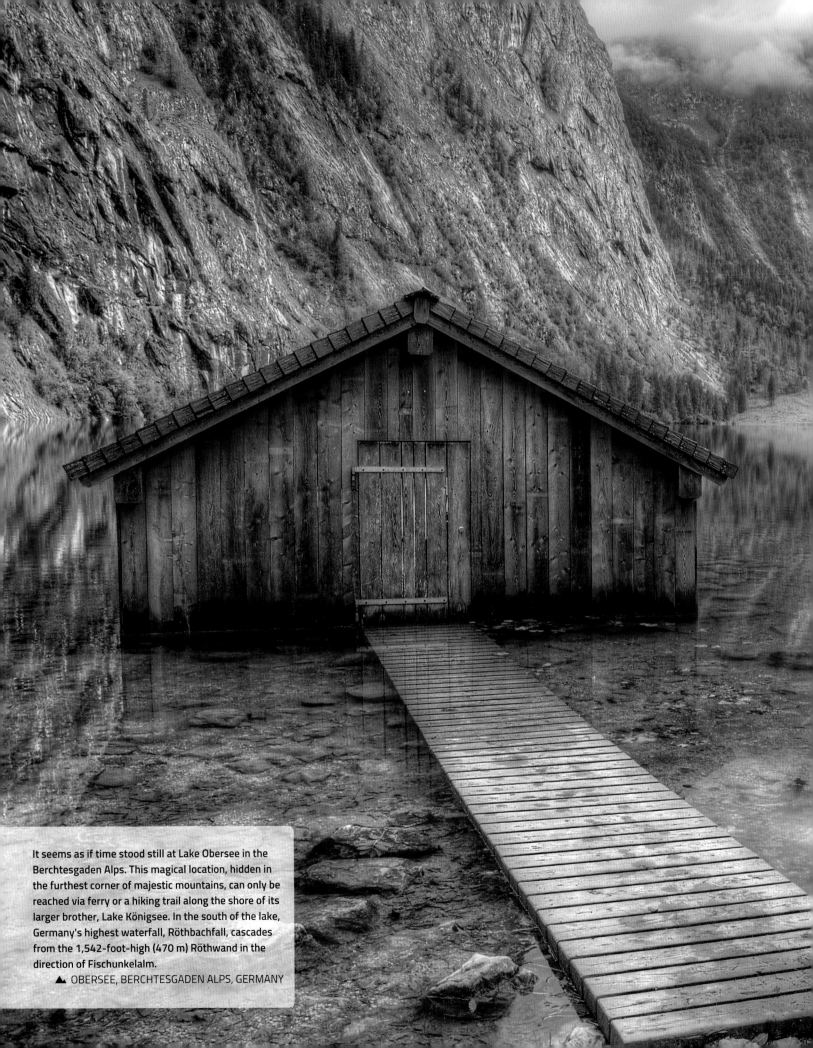

It seems as if time stood still at Lake Obersee in the Berchtesgaden Alps. This magical location, hidden in the furthest corner of majestic mountains, can only be reached via ferry or a hiking trail along the shore of its larger brother, Lake Königsee. In the south of the lake, Germany's highest waterfall, Röthbachfall, cascades from the 1,542-foot-high (470 m) Röthwand in the direction of Fischunkelalm.

▲ OBERSEE, BERCHTESGADEN ALPS, GERMANY

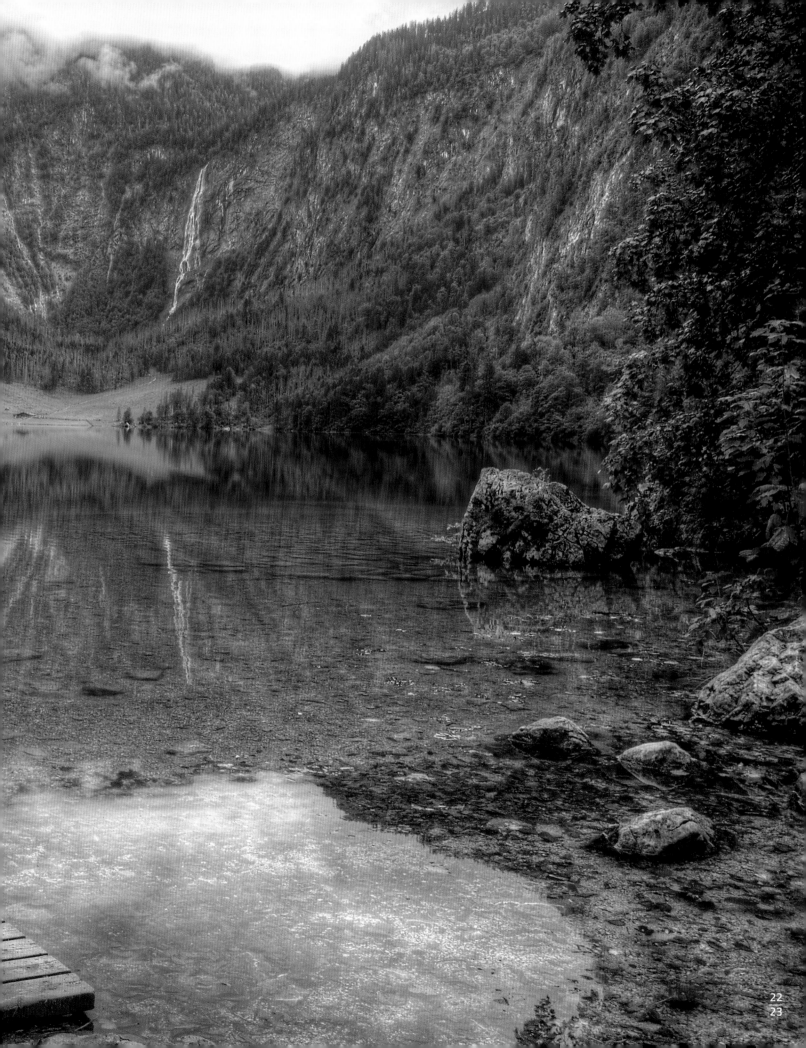

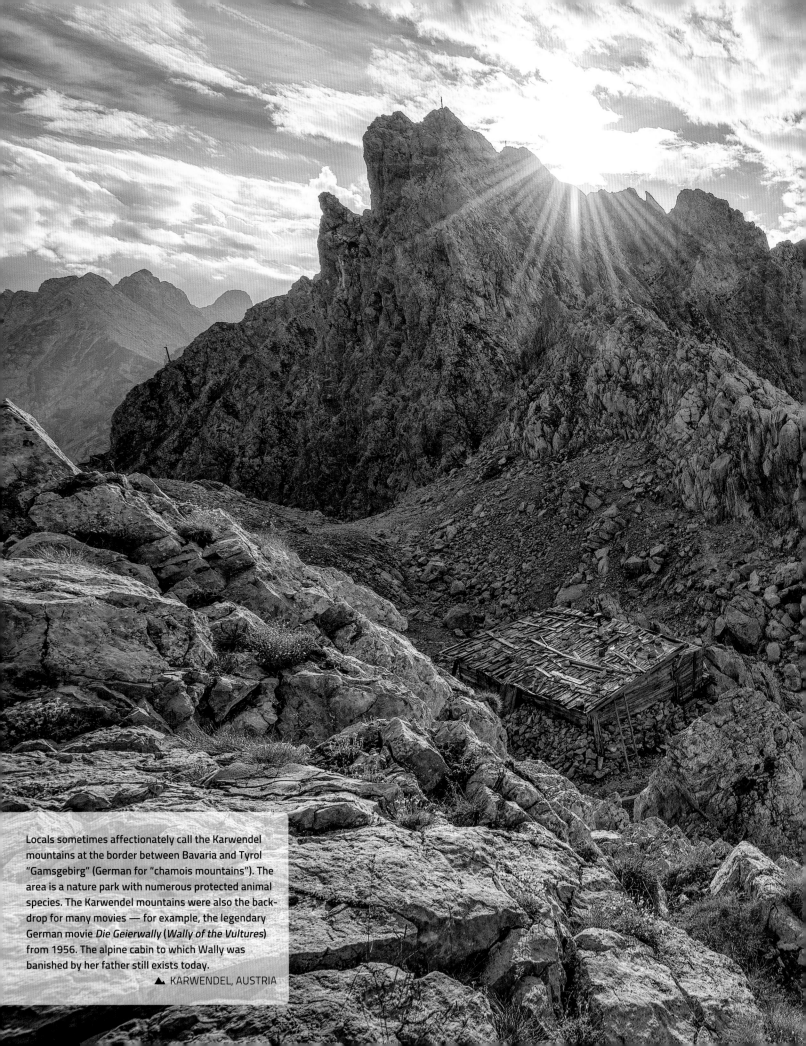

Locals sometimes affectionately call the Karwendel mountains at the border between Bavaria and Tyrol "Gamsgebirg" (German for "chamois mountains"). The area is a nature park with numerous protected animal species. The Karwendel mountains were also the backdrop for many movies — for example, the legendary German movie *Die Geierwally* (*Wally of the Vultures*) from 1956. The alpine cabin to which Wally was banished by her father still exists today.

▲ KARWENDEL, AUSTRIA

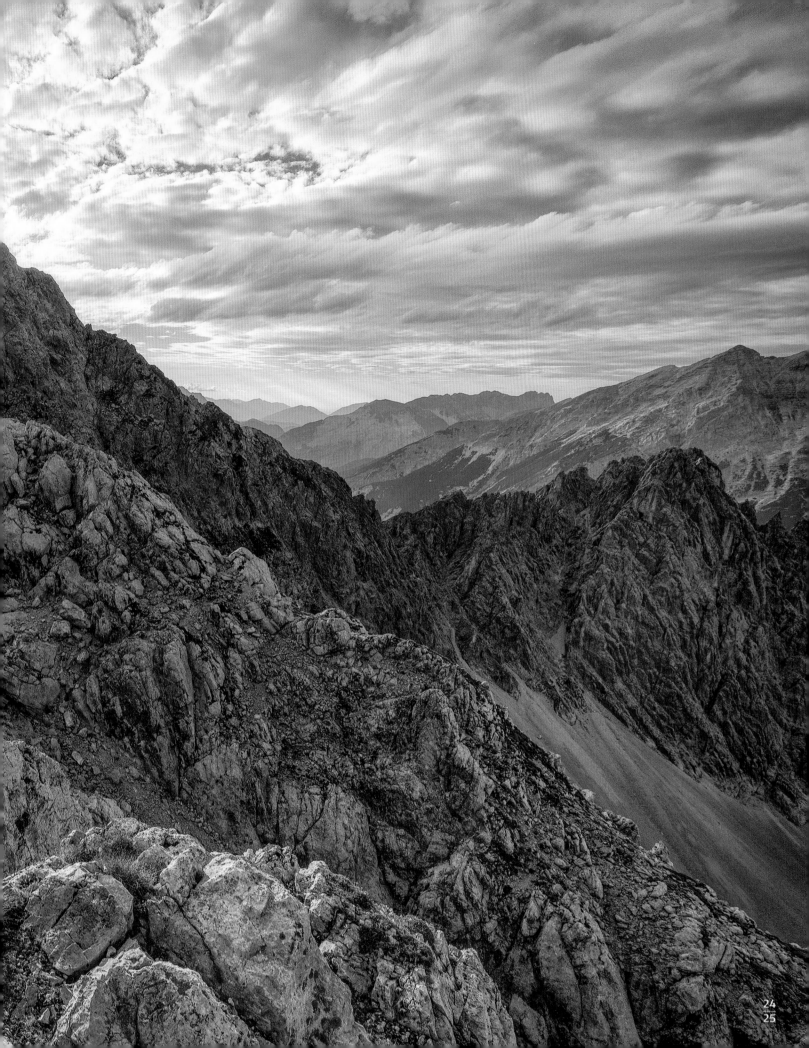

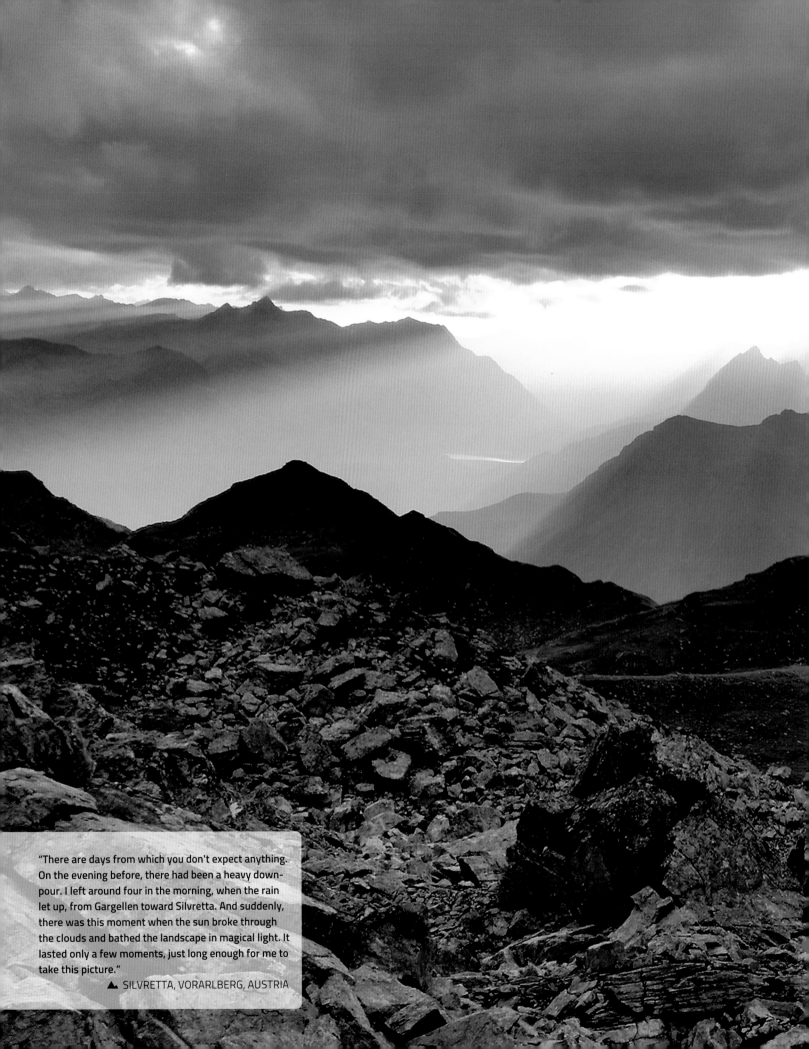

"There are days from which you don't expect anything. On the evening before, there had been a heavy downpour. I left around four in the morning, when the rain let up, from Gargellen toward Silvretta. And suddenly, there was this moment when the sun broke through the clouds and bathed the landscape in magical light. It lasted only a few moments, just long enough for me to take this picture."

▲ SILVRETTA, VORARLBERG, AUSTRIA

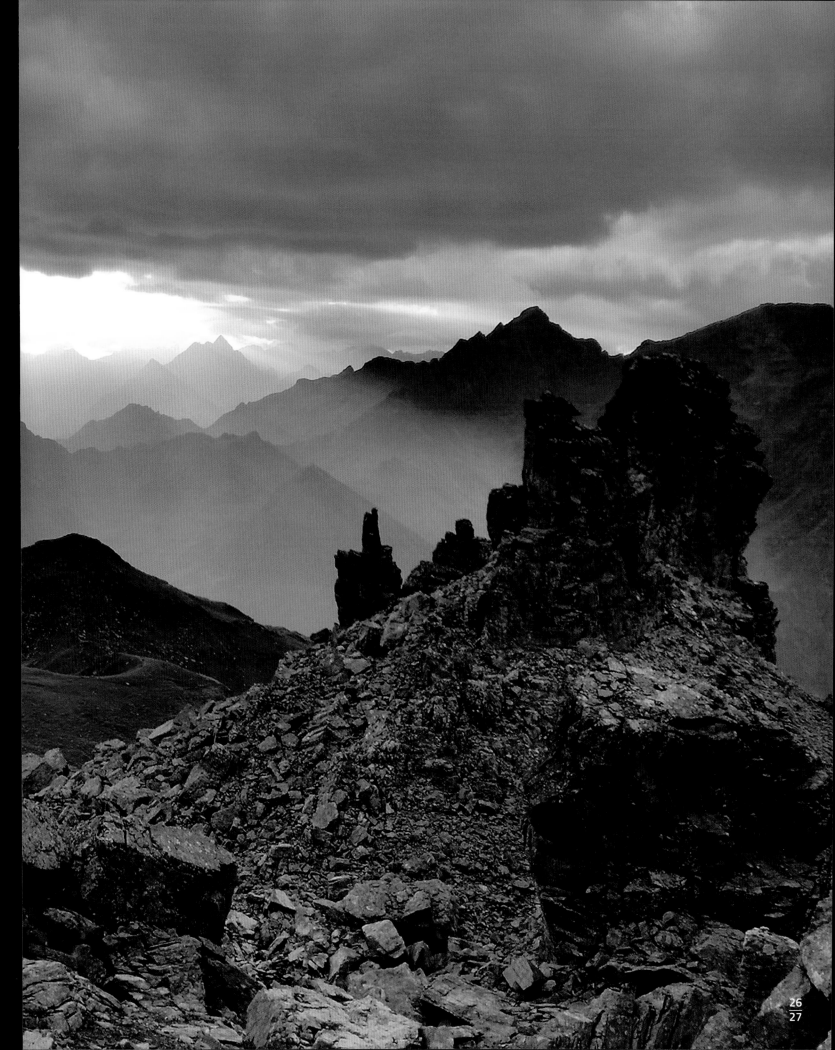

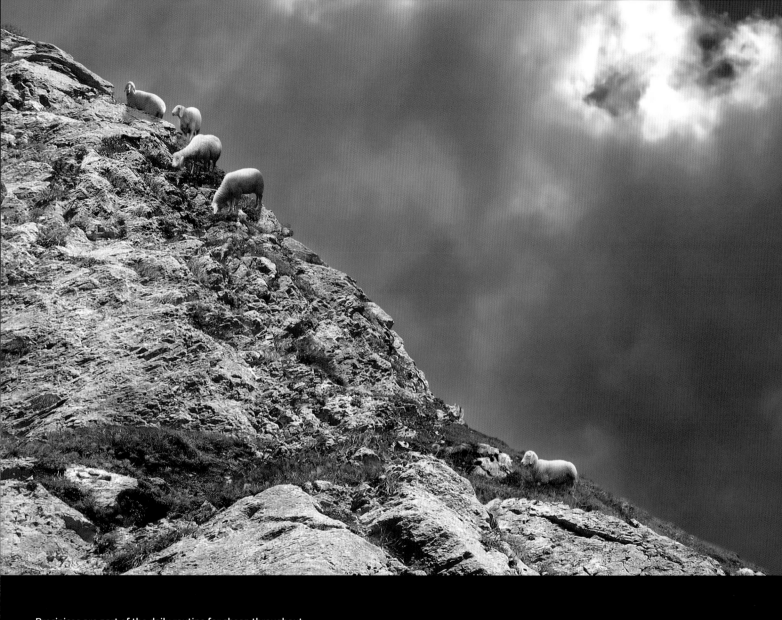

Precipices are part of the daily routine for sheep throughout
an entire summer in the mountains. They feed on mountain
grasses of the high mountain pastures and only return to
their stable in the valley when the first snow falls. These

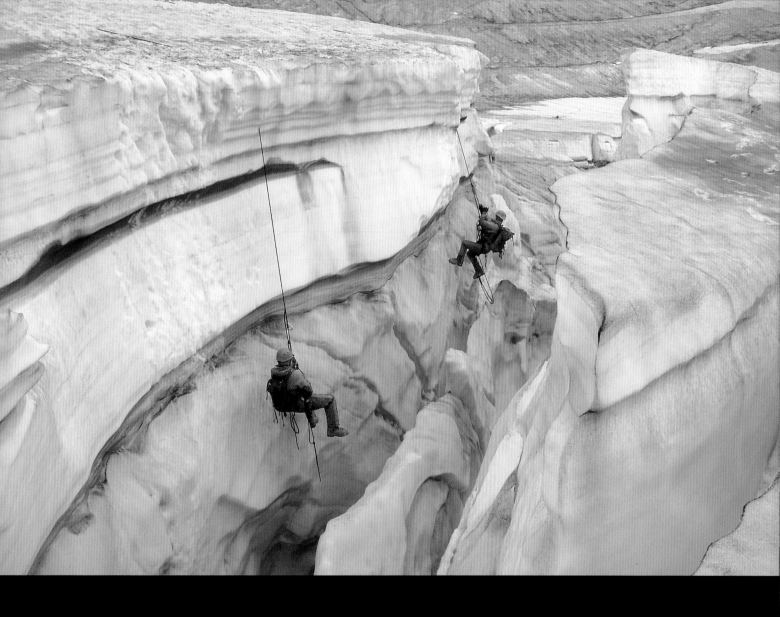

Krimmler Kees is located at the end of the valley of the Krimmler Ache Valley, which separates the Zillertal Alps from the High Tauern. This uneven glacier at the foot of Dreiherrnspitze (Italian: *Picco dei Tre Signori*) (11,480 ft./3,499 m) is characterized by numerous rugged crevasse zones. The soldiers of the Austrian Armed Forces are training in self-rescue from crevasses as part of the Armed Forces Alpine Guide training.

▲ DREIHERRENSPITZE, HIGH TAUERN, AUSTRIA

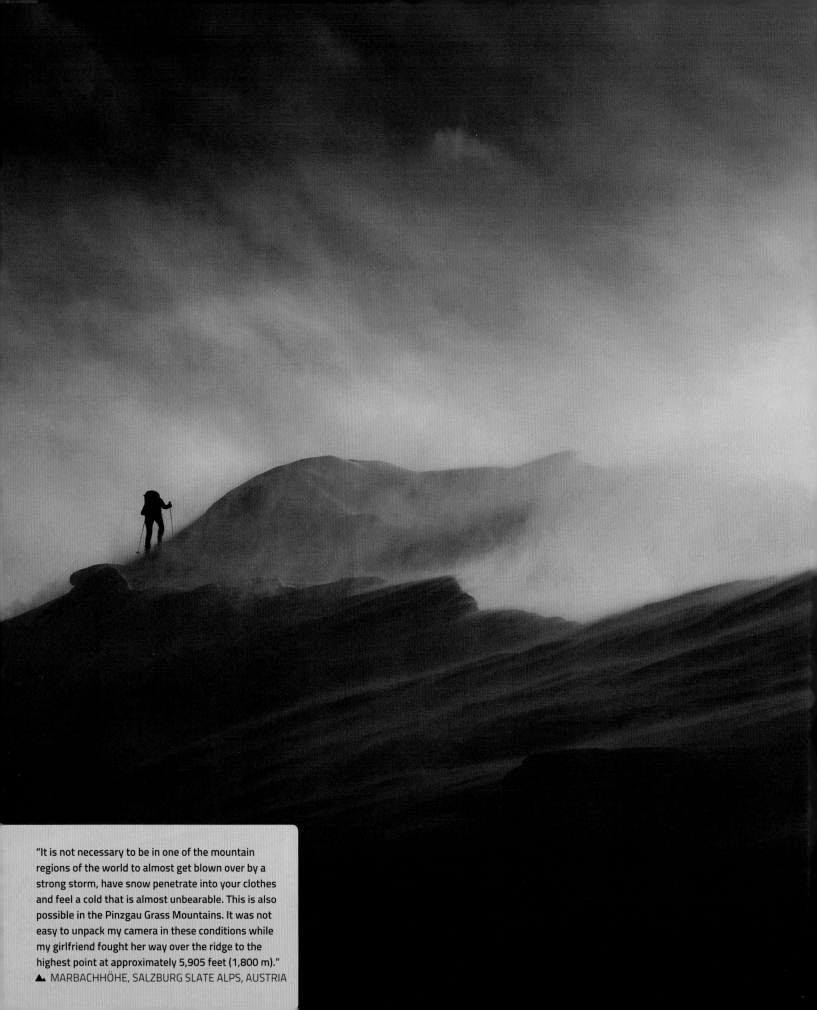

"It is not necessary to be in one of the mountain regions of the world to almost get blown over by a strong storm, have snow penetrate into your clothes and feel a cold that is almost unbearable. This is also possible in the Pinzgau Grass Mountains. It was not easy to unpack my camera in these conditions while my girlfriend fought her way over the ridge to the highest point at approximately 5,905 feet (1,800 m)."

▲ MARBACHHÖHE, SALZBURG SLATE ALPS, AUSTRIA

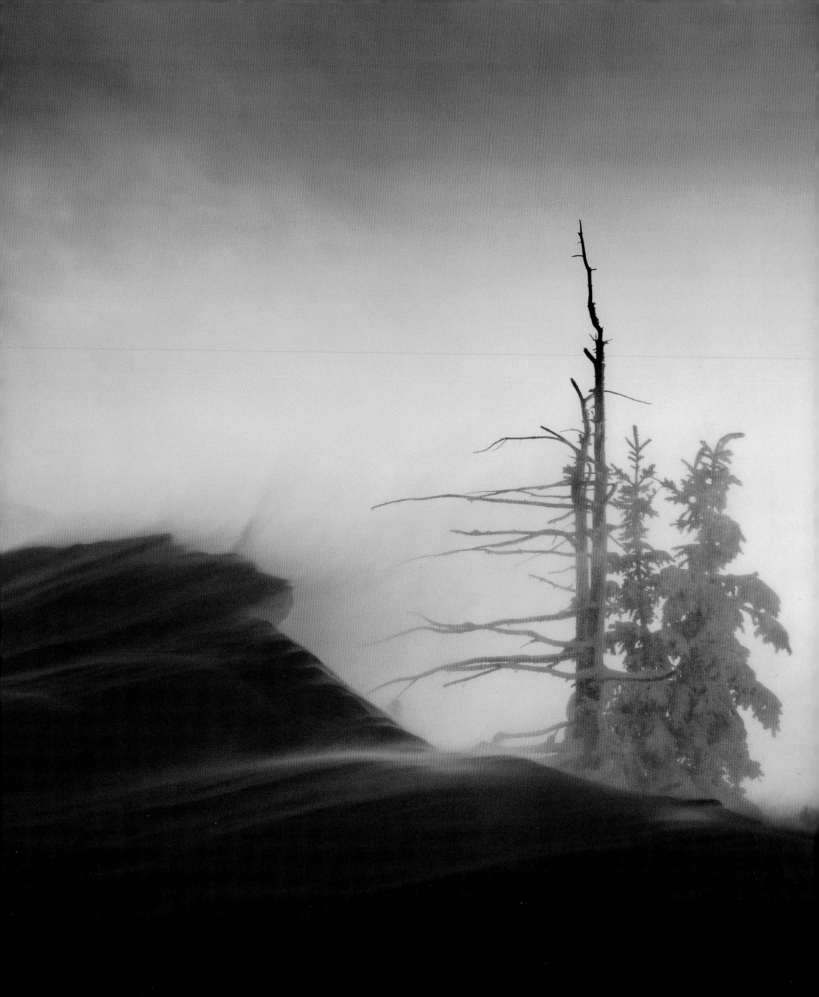

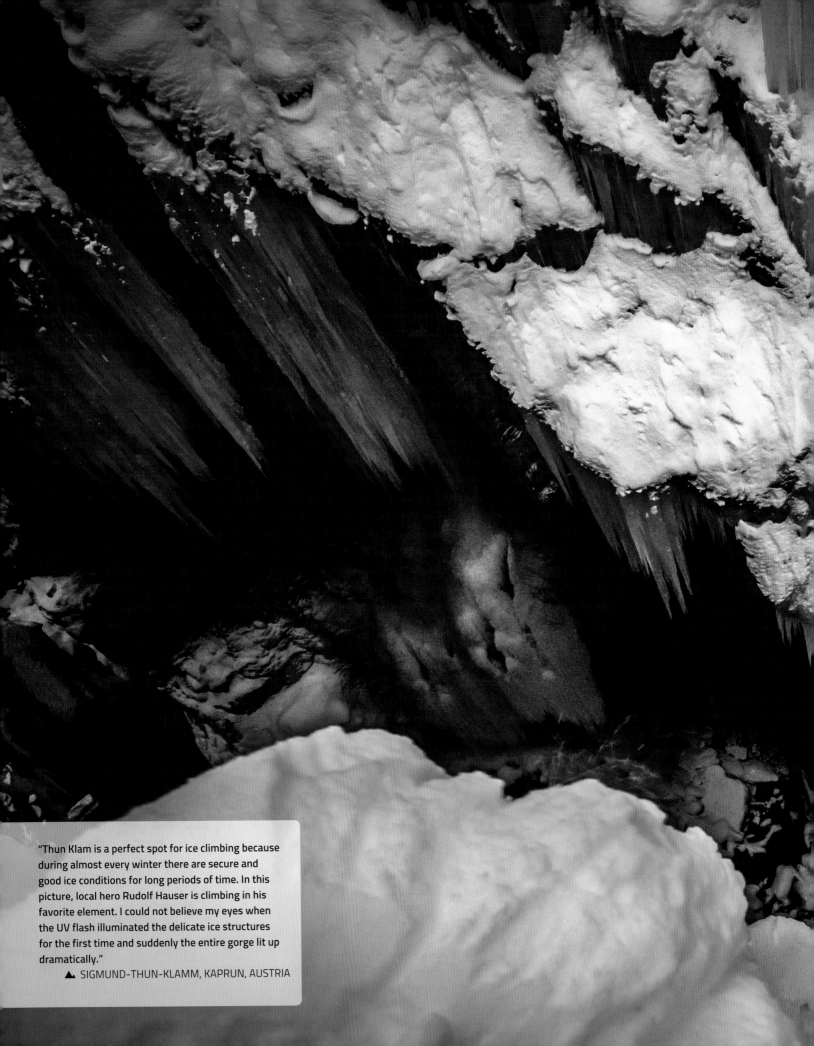

"Thun Klam is a perfect spot for ice climbing because during almost every winter there are secure and good ice conditions for long periods of time. In this picture, local hero Rudolf Hauser is climbing in his favorite element. I could not believe my eyes when the UV flash illuminated the delicate ice structures for the first time and suddenly the entire gorge lit up dramatically."

▲ SIGMUND-THUN-KLAMM, KAPRUN, AUSTRIA

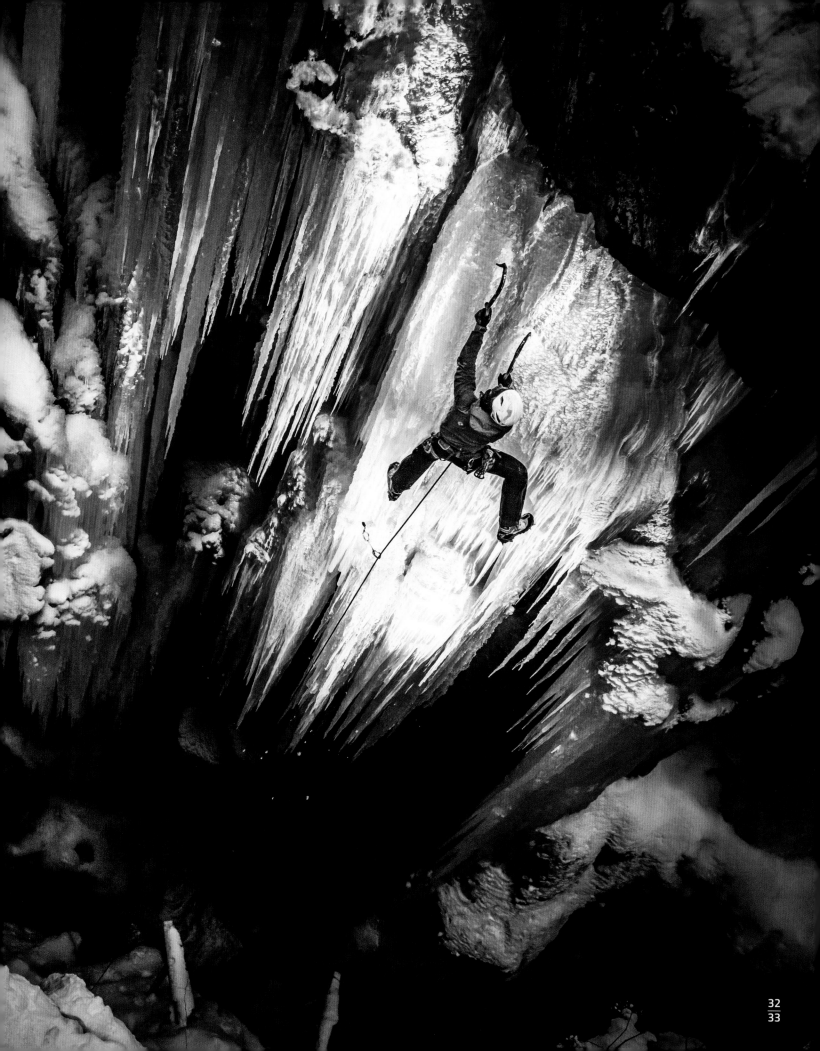

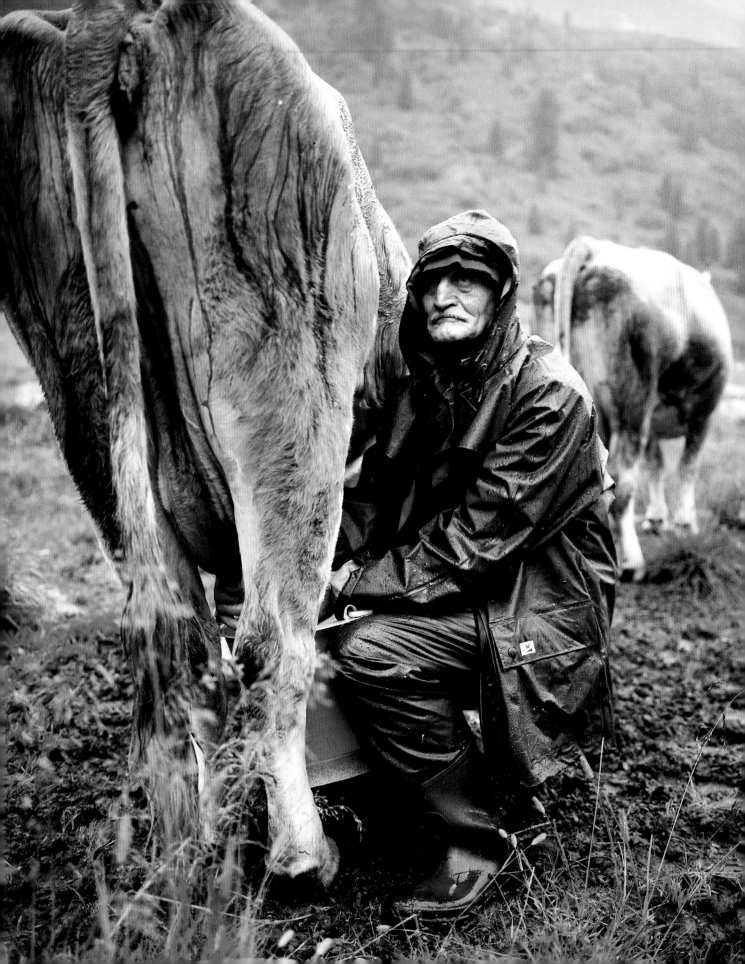

"On a rainy afternoon, I met herdsmen on Bodenalm in the rear Zillertal who were herding their cows from the surrounding hills. There are no milking machines available up here, making milking manual labor, every morning and every evening and in any type of weather. Work on pastures in the mountains has little in common with mountain romance imagined by city dwellers."

▲ ZILLERTAL, TYROL, AUSTRIA

"In March of 2016, I went on a seven-day trip with my friend through the Swiss Alps. Among other things, we were supposed to help director Dinno Kasolo to film material for his film documentary called *Happiness*. This picture shows my friend Ivan Andric near the Matterhorn, during a storm, snowfall and the cold, which was exactly what we had been looking for."

▲ MATTERHORN, SWITZERLAND

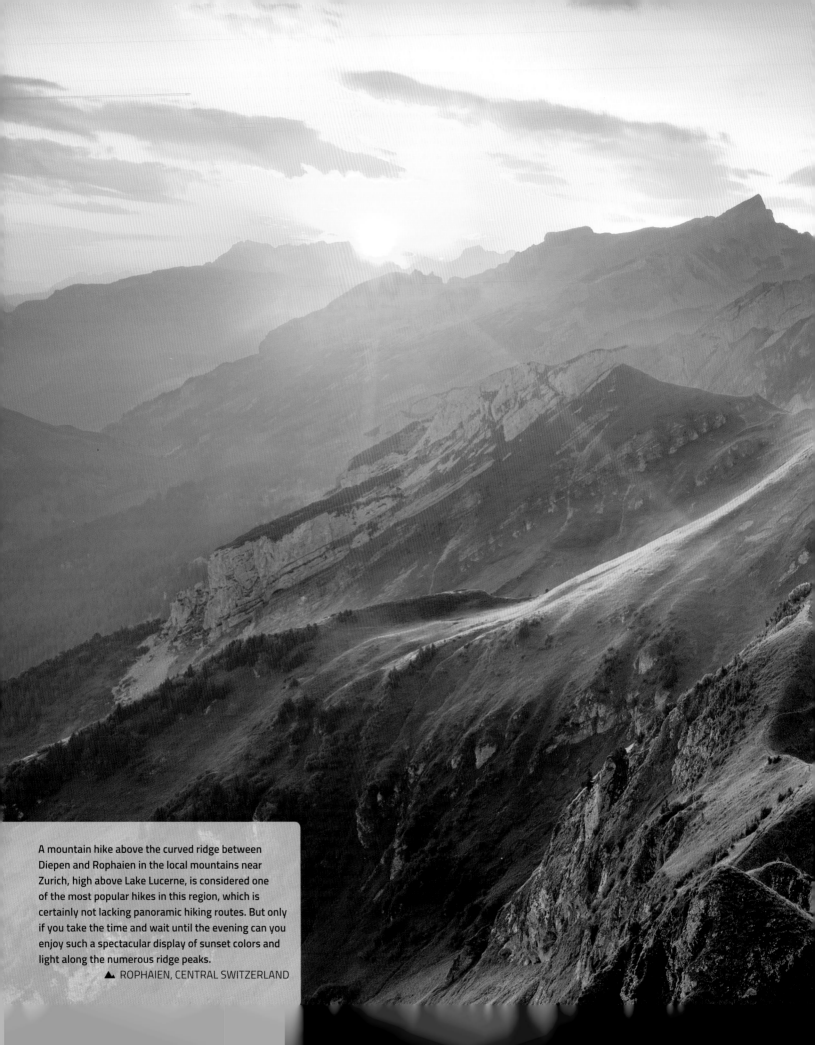

A mountain hike above the curved ridge between Diepen and Rophaien in the local mountains near Zurich, high above Lake Lucerne, is considered one of the most popular hikes in this region, which is certainly not lacking panoramic hiking routes. But only if you take the time and wait until the evening can you enjoy such a spectacular display of sunset colors and light along the numerous ridge peaks.

▲ ROPHAIEN, CENTRAL SWITZERLAND

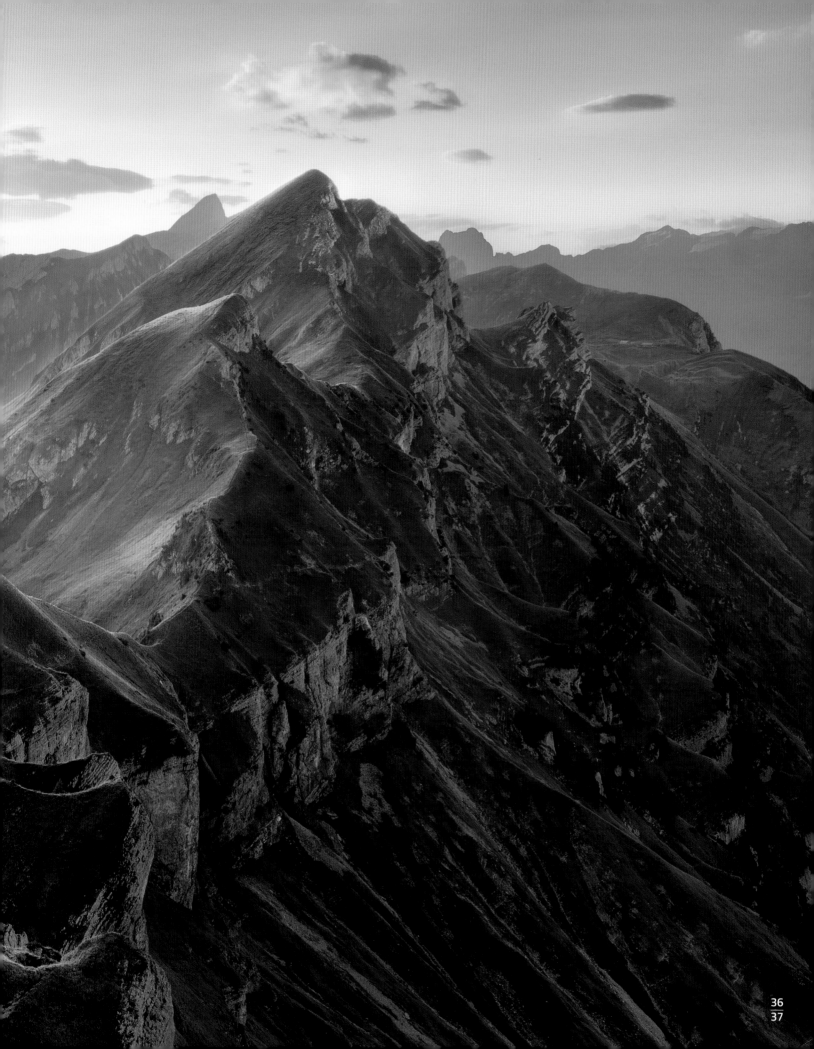

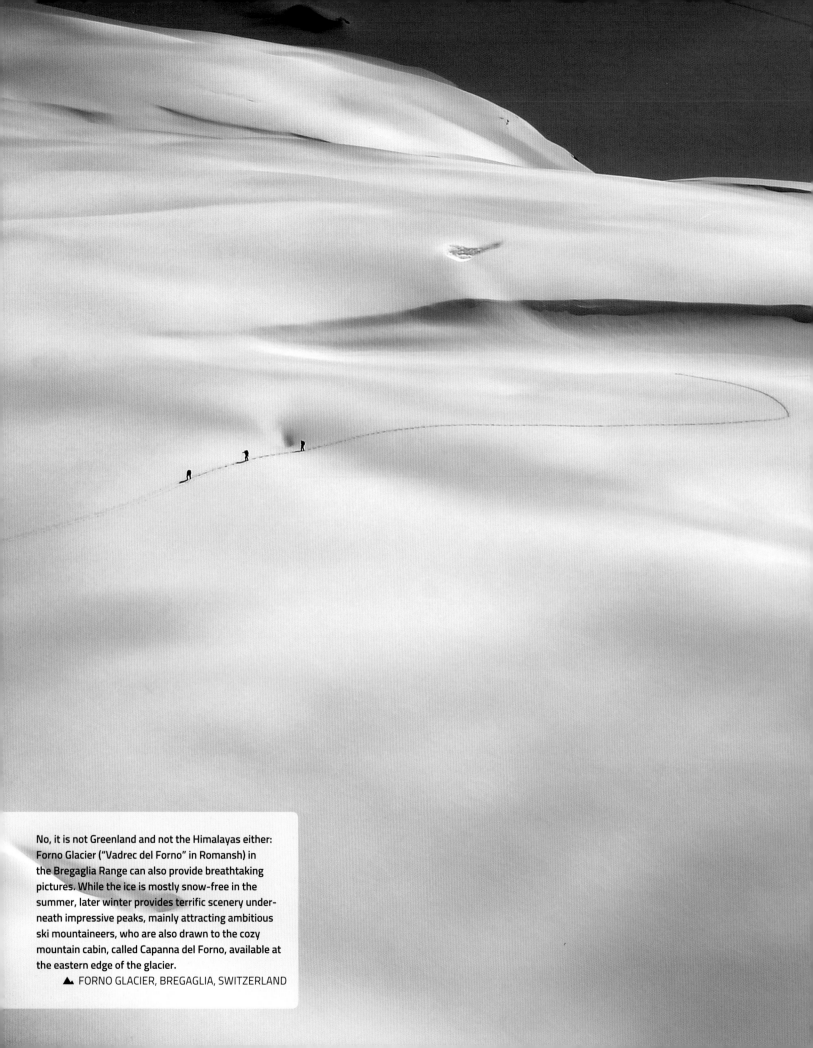

No, it is not Greenland and not the Himalayas either:
Forno Glacier ("Vadrec del Forno" in Romansh) in
the Bregaglia Range can also provide breathtaking
pictures. While the ice is mostly snow-free in the
summer, later winter provides terrific scenery under-
neath impressive peaks, mainly attracting ambitious
ski mountaineers, who are also drawn to the cozy
mountain cabin, called Capanna del Forno, available at
the eastern edge of the glacier.

▲ FORNO GLACIER, BREGAGLIA, SWITZERLAND

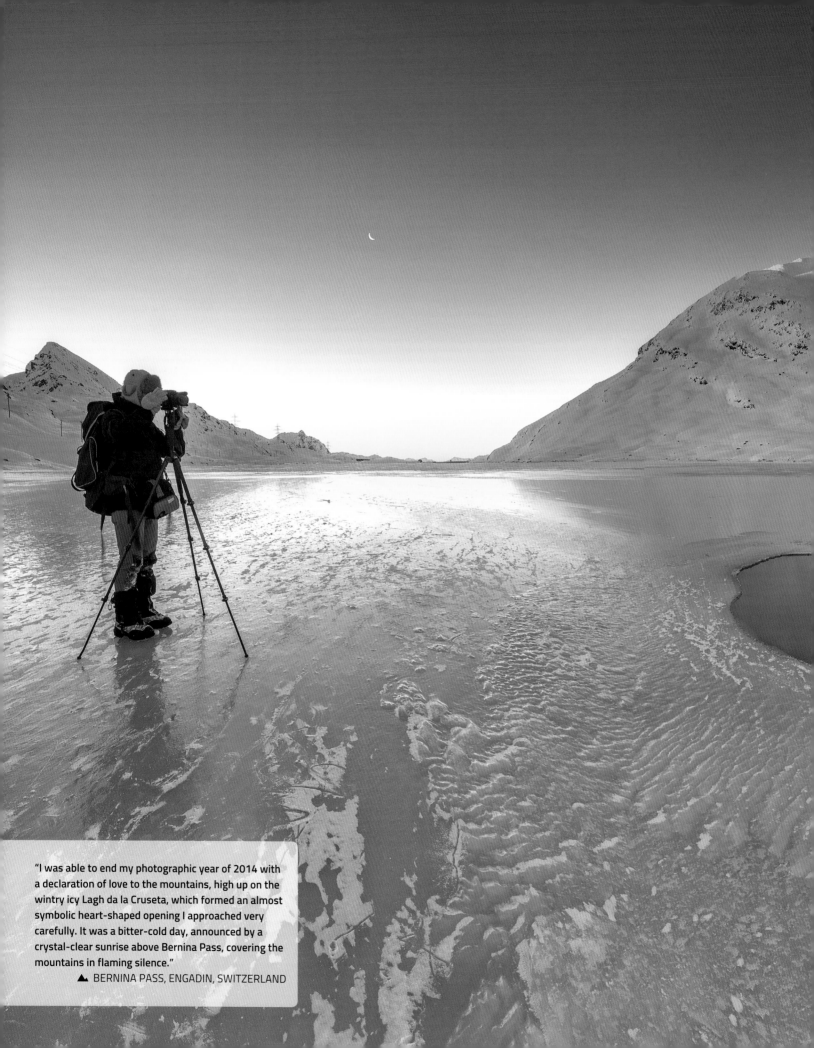

"I was able to end my photographic year of 2014 with a declaration of love to the mountains, high up on the wintry icy Lagh da la Cruseta, which formed an almost symbolic heart-shaped opening I approached very carefully. It was a bitter-cold day, announced by a crystal-clear sunrise above Bernina Pass, covering the mountains in flaming silence."

▲ BERNINA PASS, ENGADIN, SWITZERLAND

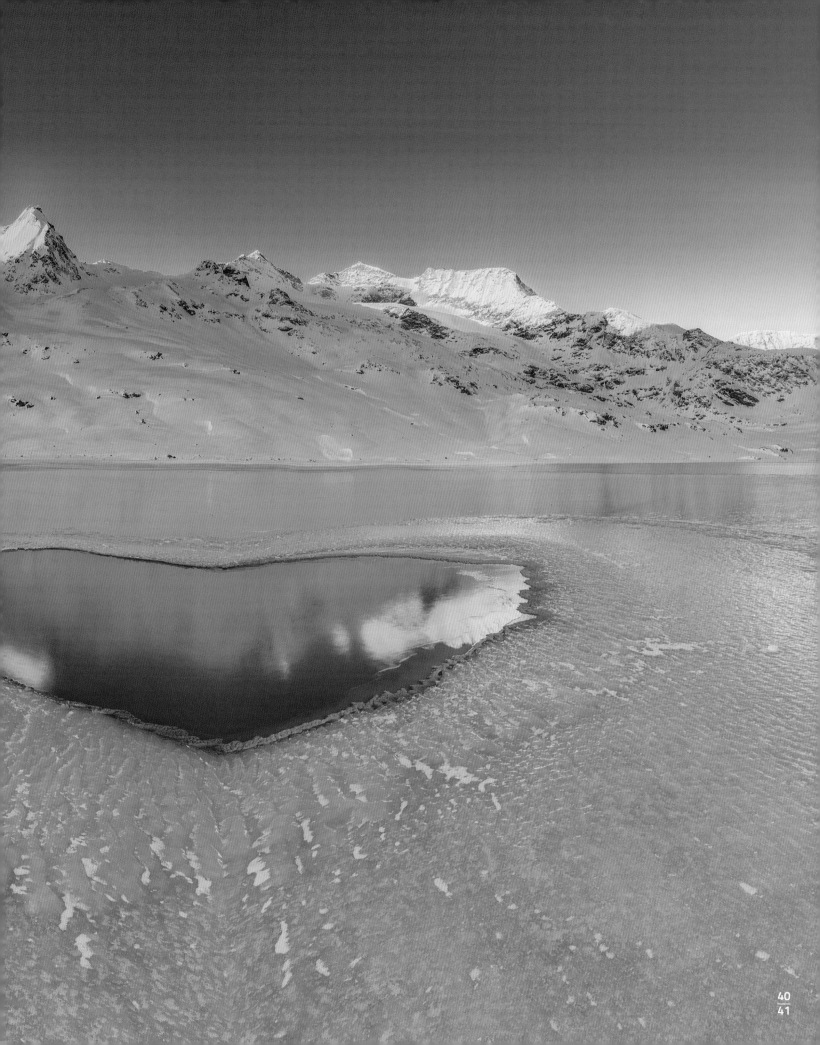

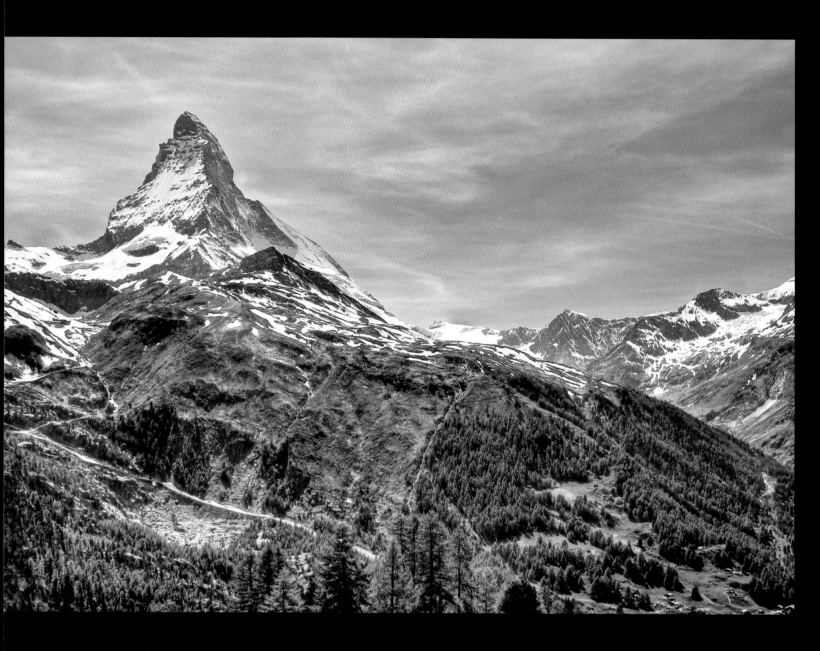

It is the mountain of all mountains: unique in the world due
to its symmetry (four ridges and four faces)! This is where
alpine history has been written, the Matterhorn itself being
alpine history. What presented itself as a perfect pyramid
and mountain when we descended from Gorner Ridge to
Zermatt turned out to be a loose pile of debris poorly held
together by permafrost when taking a closer look and
touching it.

▲ MATTERHORN, VALAIS, SWITZERLAND

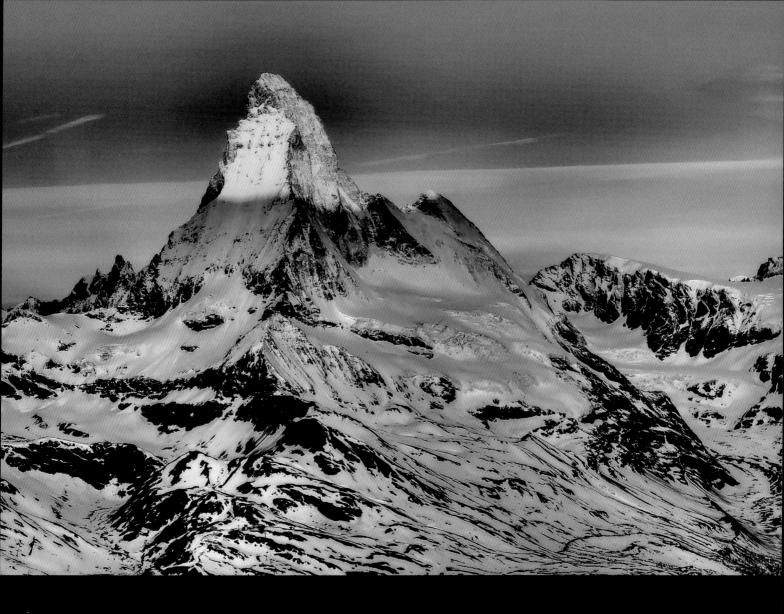

"There is no question: It is the most beautiful mountain of all! Even 150 years after the first ascent, the fascination that the Matterhorn visits on every mountaineer is unbroken. I was able to take this breathtaking picture of a sunset from Rothorn, on the opposite side, which can be reached via cable car from Zermatt. It seems as if a heavenly director went all out to create this sight."

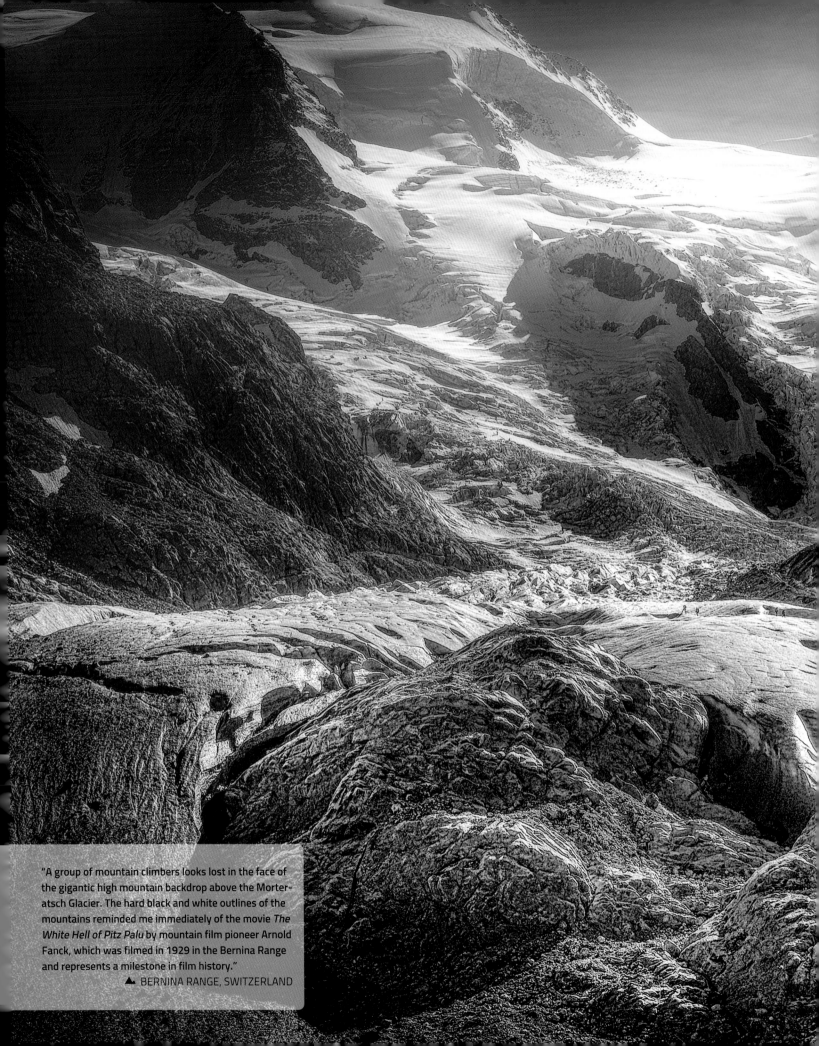

"A group of mountain climbers looks lost in the face of the gigantic high mountain backdrop above the Morteratsch Glacier. The hard black and white outlines of the mountains reminded me immediately of the movie *The White Hell of Pitz Palu* by mountain film pioneer Arnold Fanck, which was filmed in 1929 in the Bernina Range and represents a milestone in film history."

▲ BERNINA RANGE, SWITZERLAND

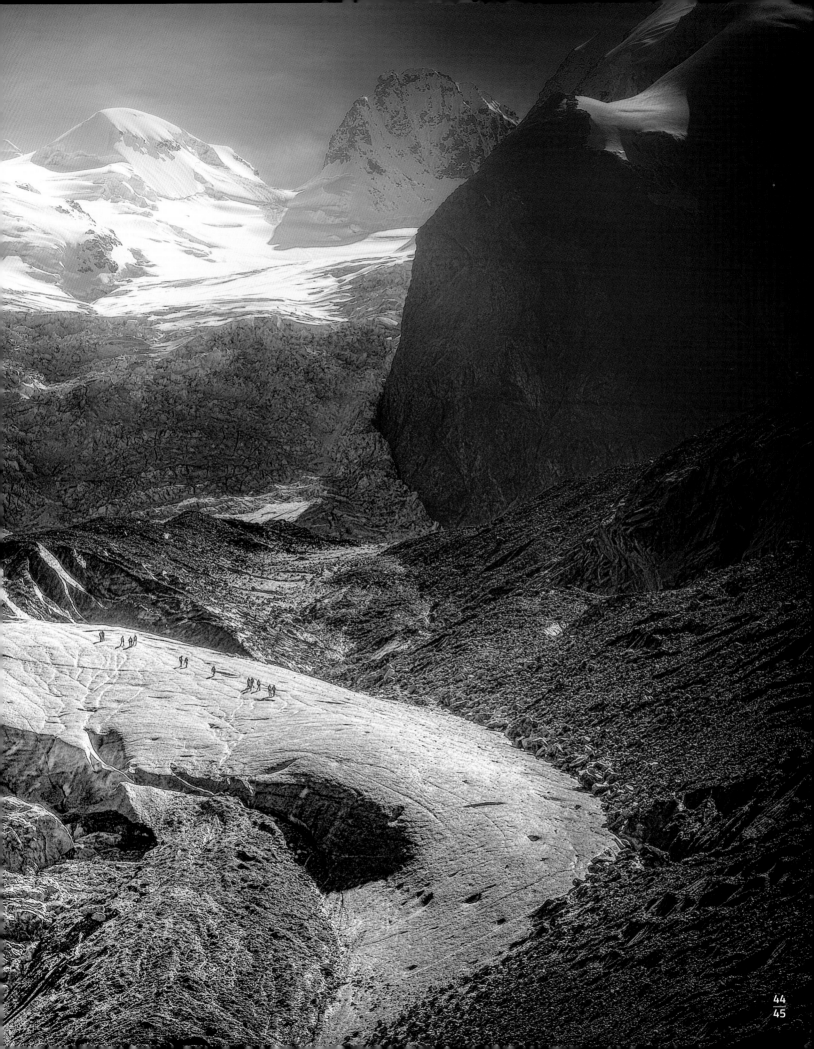

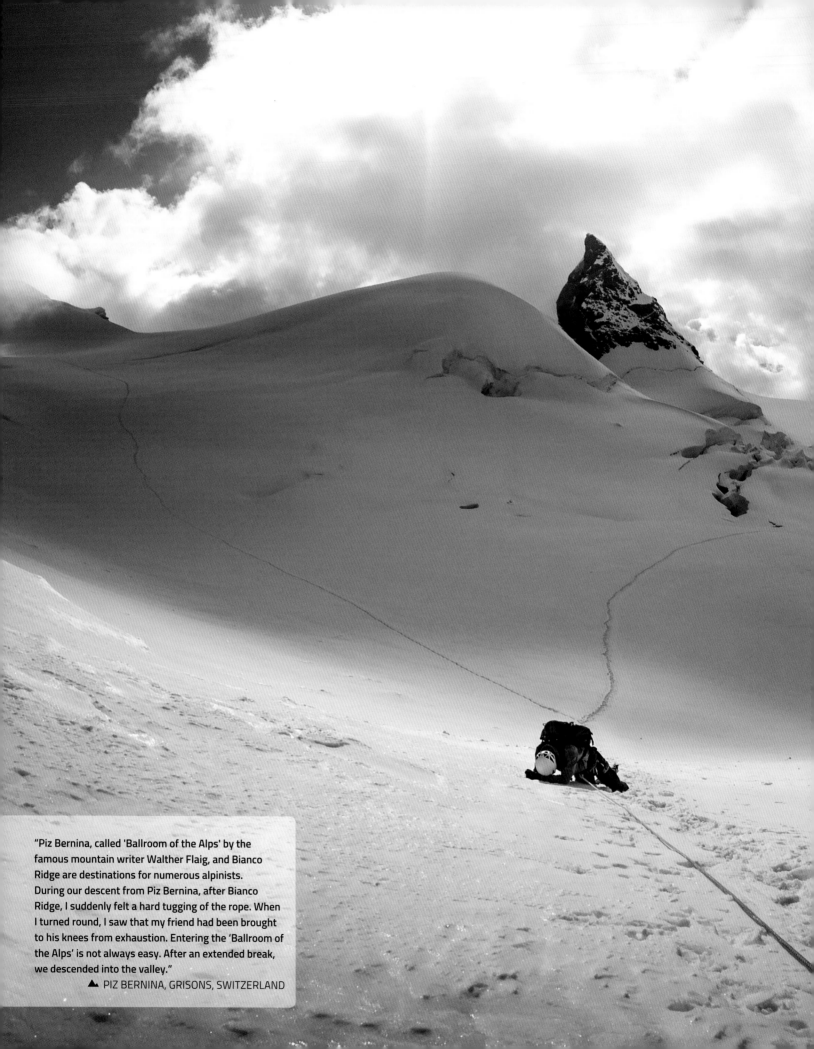

"Piz Bernina, called 'Ballroom of the Alps' by the famous mountain writer Walther Flaig, and Bianco Ridge are destinations for numerous alpinists. During our descent from Piz Bernina, after Bianco Ridge, I suddenly felt a hard tugging of the rope. When I turned round, I saw that my friend had been brought to his knees from exhaustion. Entering the 'Ballroom of the Alps' is not always easy. After an extended break, we descended into the valley."

▲ PIZ BERNINA, GRISONS, SWITZERLAND

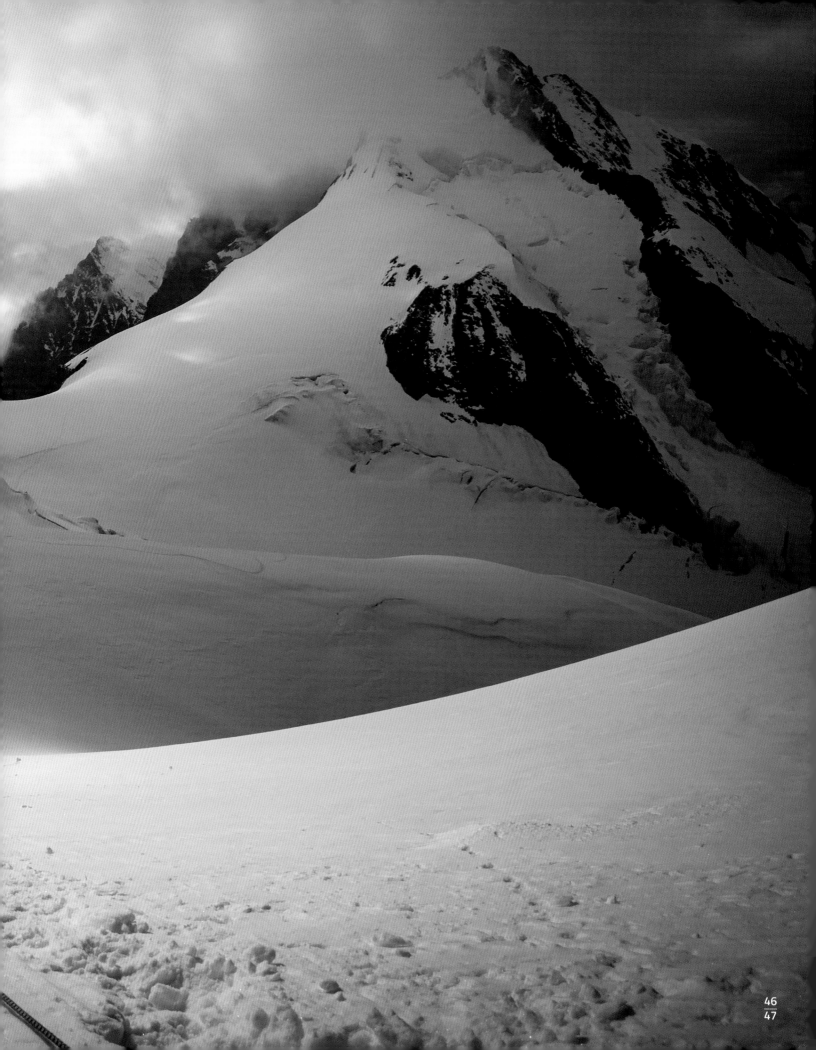

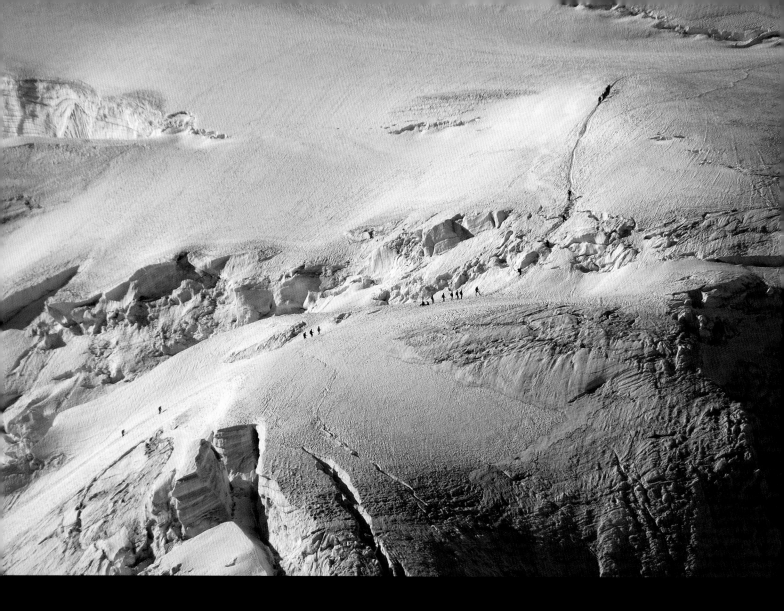

"Small humans on huge mountains!" Alpinists crawl like ants on the icy track toward the peak of Weissmies (13,179 ft./4,017 m), above the valley of Saas Fee. This mountain, which is considered one of the easier mountains in the range of 13,000 feet (4,000 m) in the Valais Alps, is often ascended via its regular routes, the most popular of which is the route via the Weiss-mieshütten (Weismies cabins).

▲ WEISSMIES, VALAIS, SWITZERLAND

"Thirteen mountains in the range of 13,000 feet (4,000 m) in just three-and-a-half days — really, this is only possible in the Monte Rosa Massif. On the last day, having already climbed another two mountains in the range of 13,000 feet (4,000 m), our last two peaks were on the agenda: the highest peak in Switzerland, Dufourspitze, and 'on the side,' the Nordend. I was very impressed with this southern view. When I leaned forward and shot the picture, the mountains gave us a gift: their spirit."

▲ DUFOURSPITZE, VALAIS, SWITZERLAND

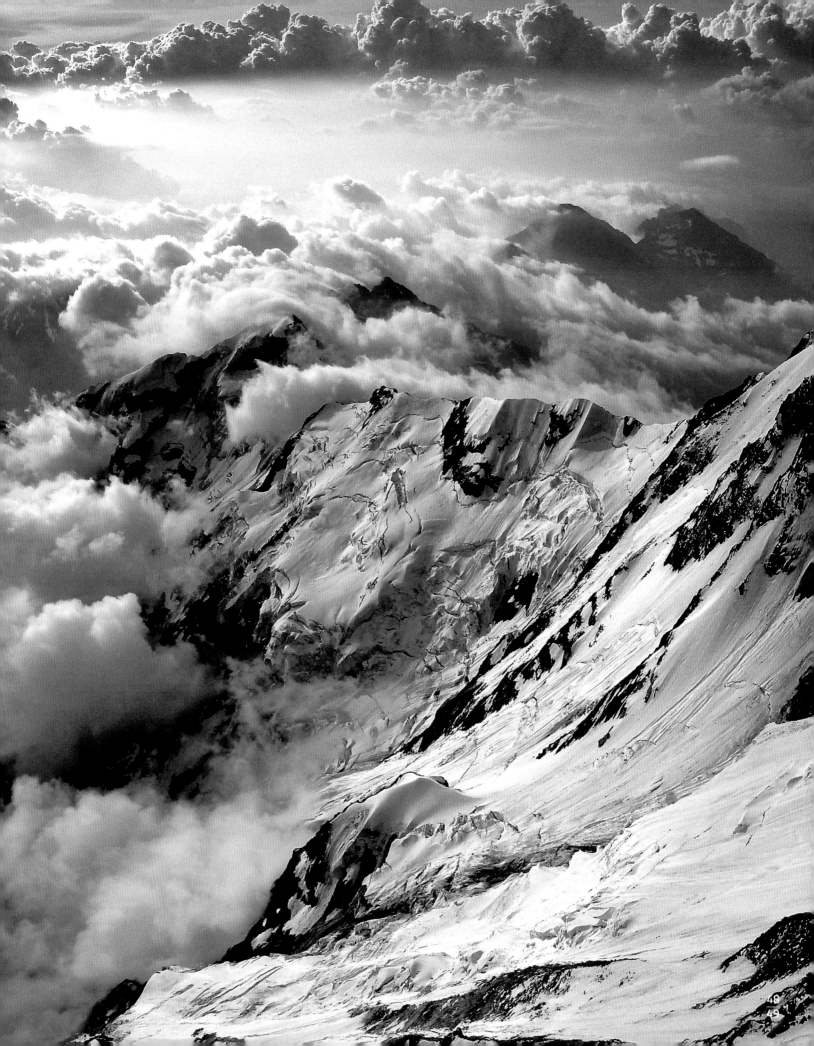

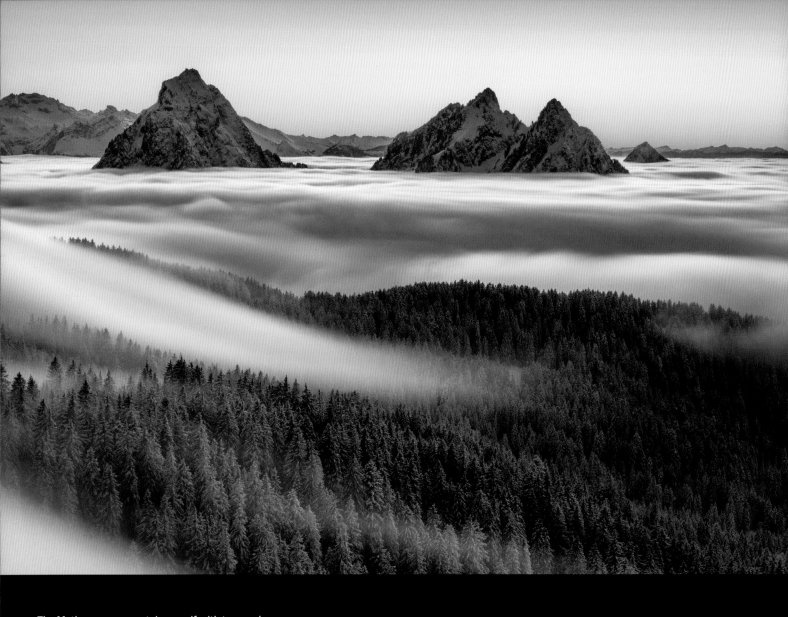

The Mythen are a mountain massif with two peaks
(Grosser Mythen, 6,227 ft./1,898 m, and Kleiner Mythen,
5,942 ft./1,811 m) in the Schwyz Mountains and are

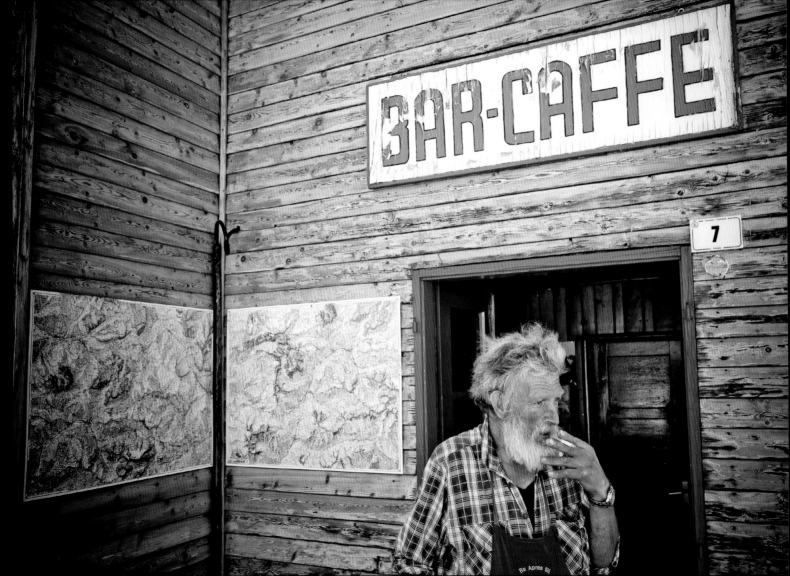

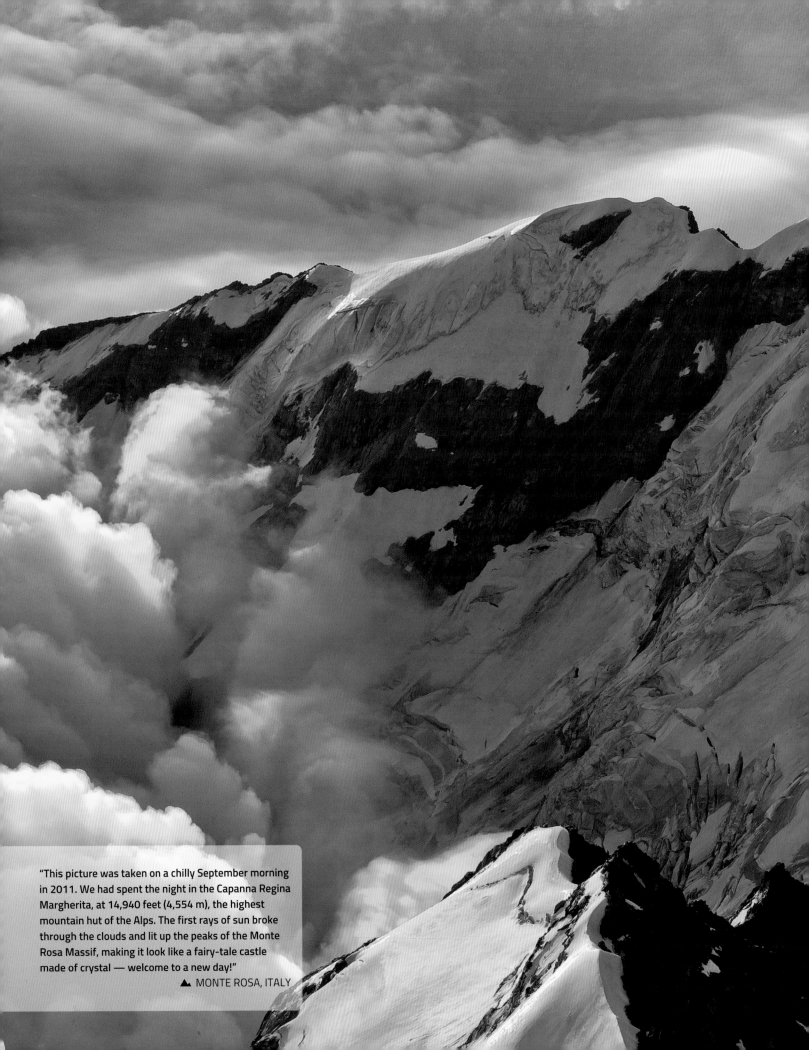

"This picture was taken on a chilly September morning in 2011. We had spent the night in the Capanna Regina Margherita, at 14,940 feet (4,554 m), the highest mountain hut of the Alps. The first rays of sun broke through the clouds and lit up the peaks of the Monte Rosa Massif, making it look like a fairy-tale castle made of crystal — welcome to a new day!"

▲ MONTE ROSA, ITALY

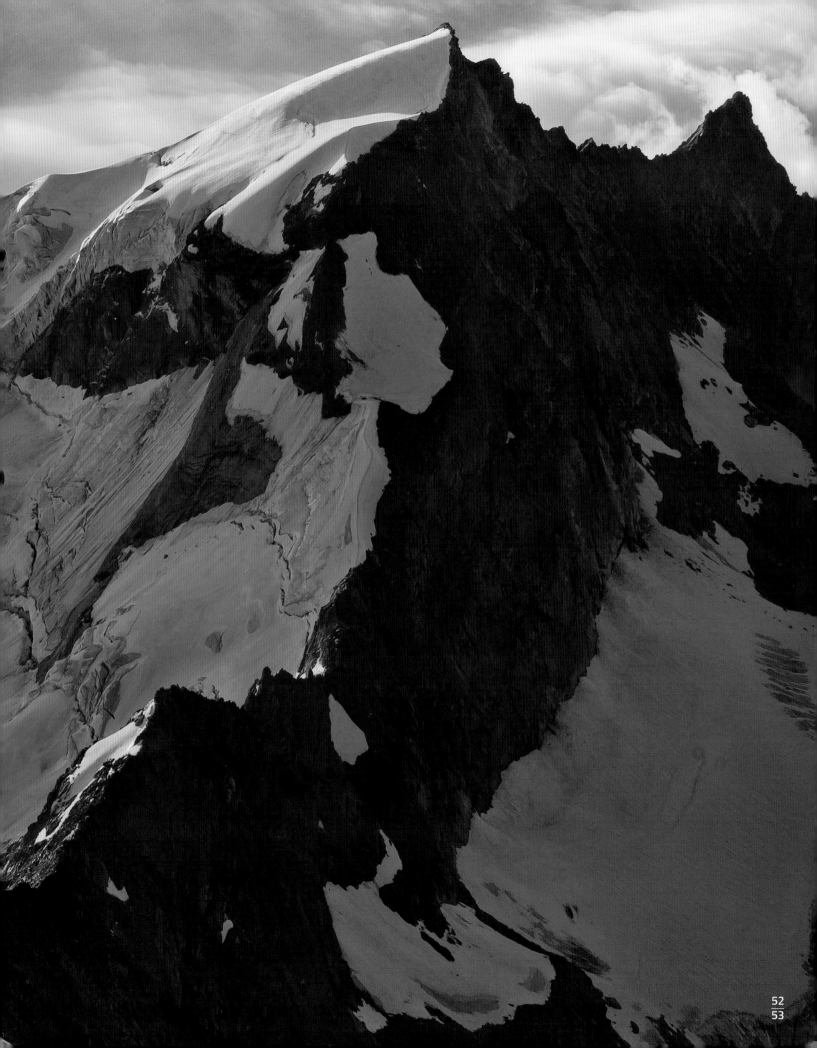

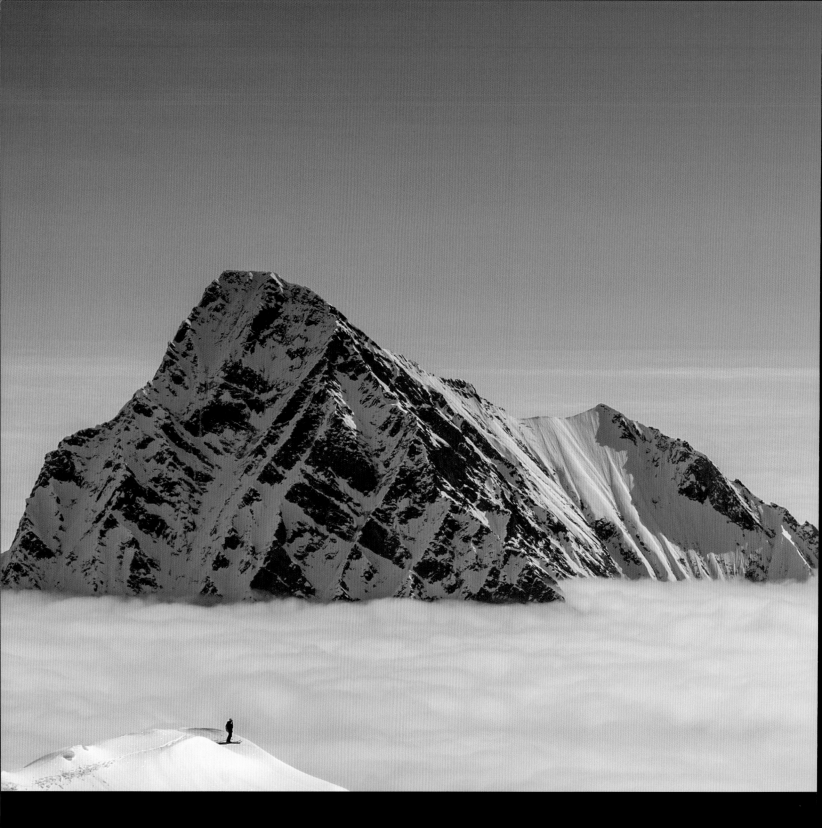

*Ski Mountaineer Above the Clouds* — this image automatically brings to mind the famous painting by the German Romantic Caspar David Friedrich. In that painting *Wanderer Above the Sea of Fog*, also known as *Wanderer above the Mist*, the hiker is facing the rough peaks of the mountains in Saxony. In this photo, we see the secondary summits of the Monte Rosa Massif, where the clouds of the Po Valley accumulate and provide for long-lasting snowfalls — to the advantage of the skiing region of Passo Salati.

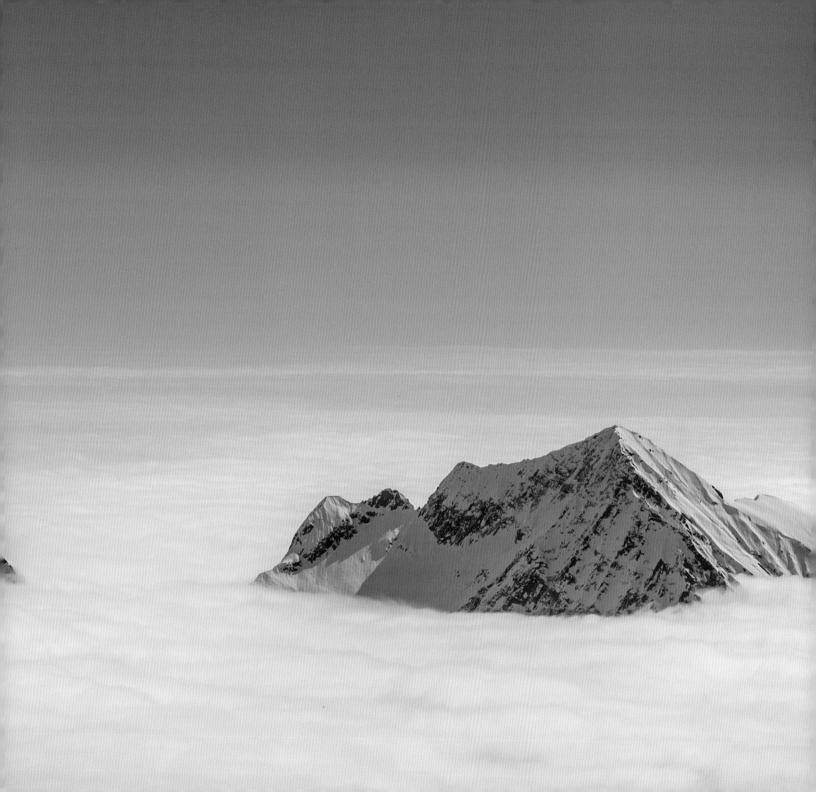

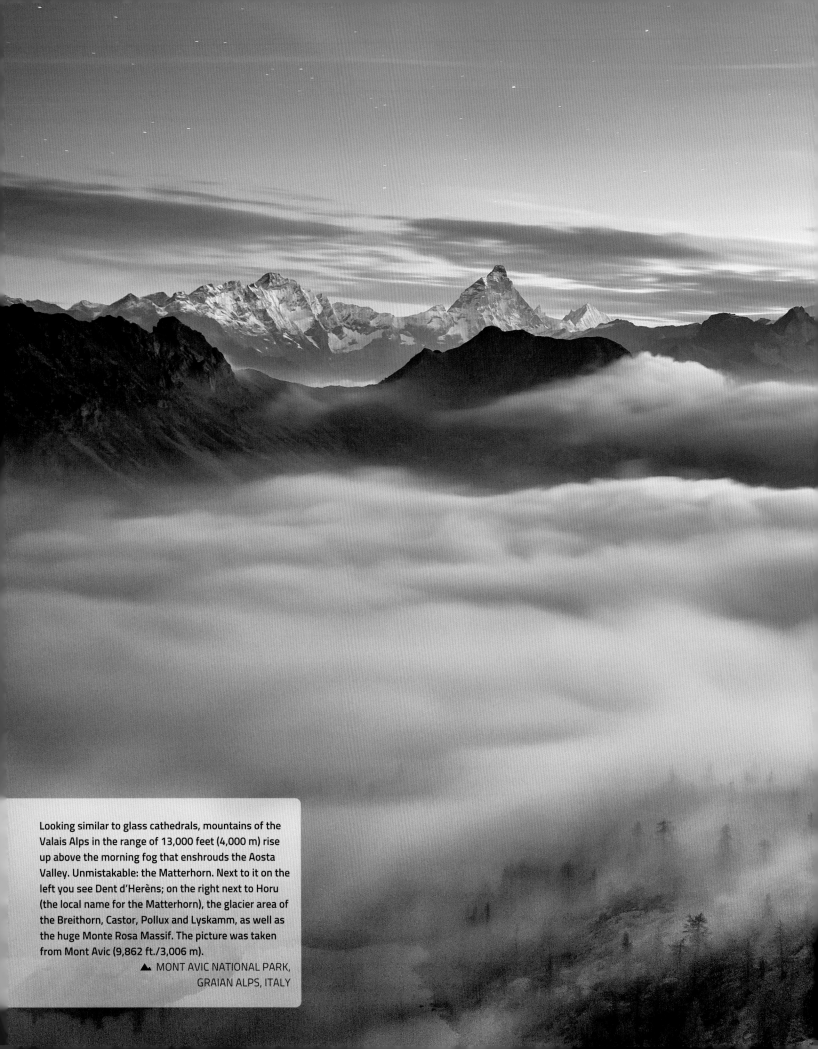

Looking similar to glass cathedrals, mountains of the Valais Alps in the range of 13,000 feet (4,000 m) rise up above the morning fog that enshrouds the Aosta Valley. Unmistakable: the Matterhorn. Next to it on the left you see Dent d'Herèns; on the right next to Horu (the local name for the Matterhorn), the glacier area of the Breithorn, Castor, Pollux and Lyskamm, as well as the huge Monte Rosa Massif. The picture was taken from Mont Avic (9,862 ft./3,006 m).

▲ MONT AVIC NATIONAL PARK,
GRAIAN ALPS, ITALY

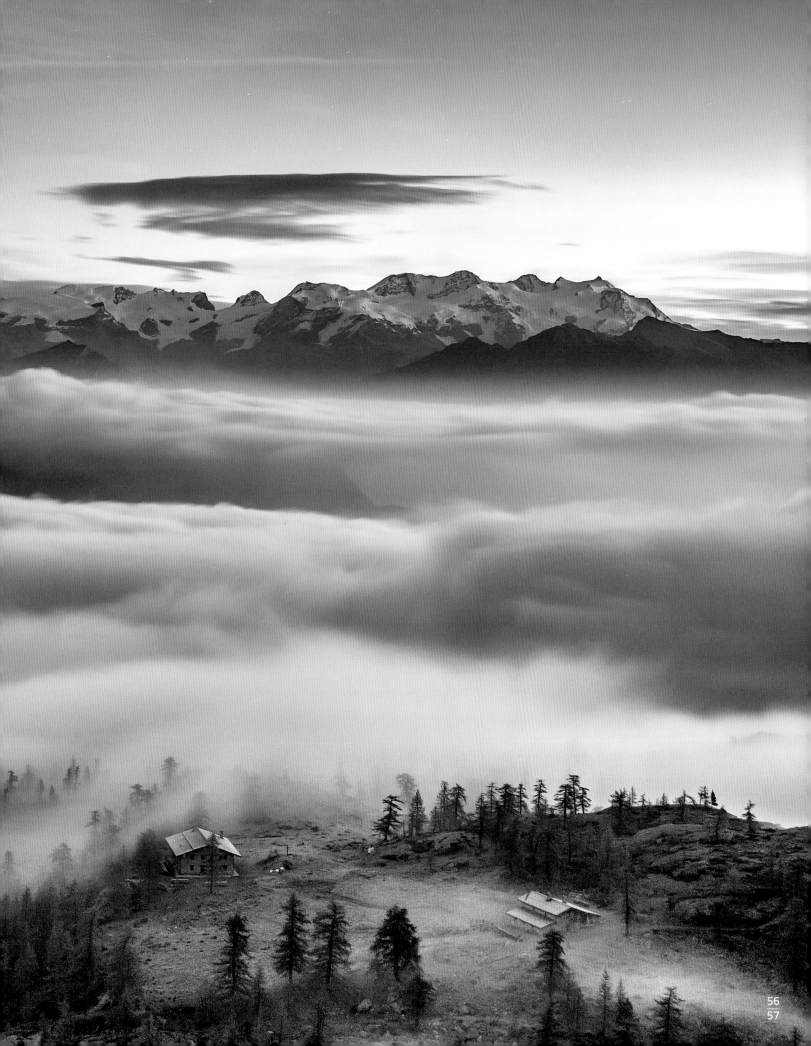

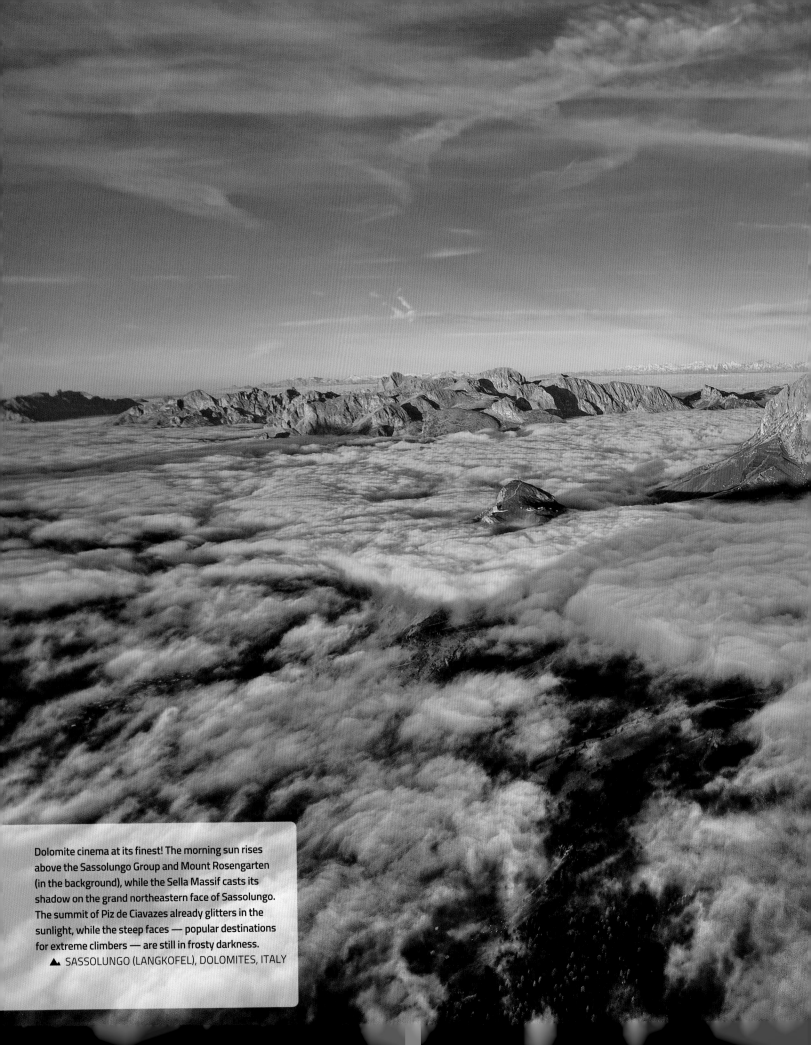

Dolomite cinema at its finest! The morning sun rises above the Sassolungo Group and Mount Rosengarten (in the background), while the Sella Massif casts its shadow on the grand northeastern face of Sassolungo. The summit of Piz de Ciavazes already glitters in the sunlight, while the steep faces — popular destinations for extreme climbers — are still in frosty darkness.

▲ SASSOLUNGO (LANGKOFEL), DOLOMITES, ITALY

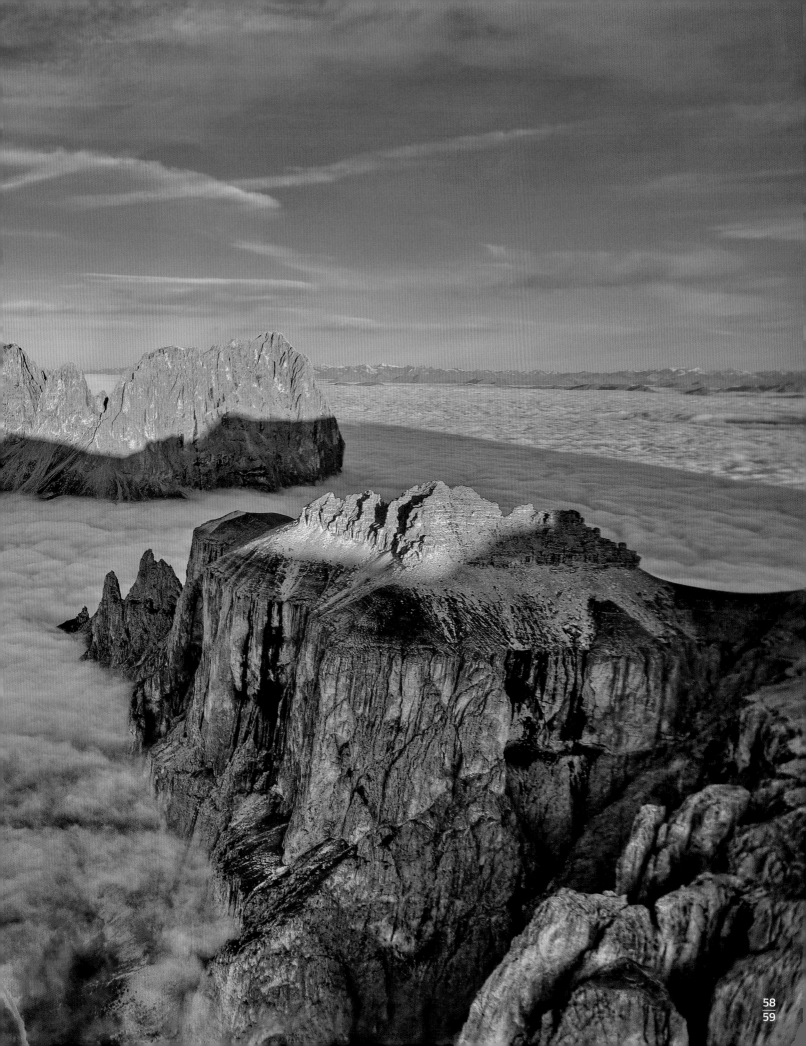

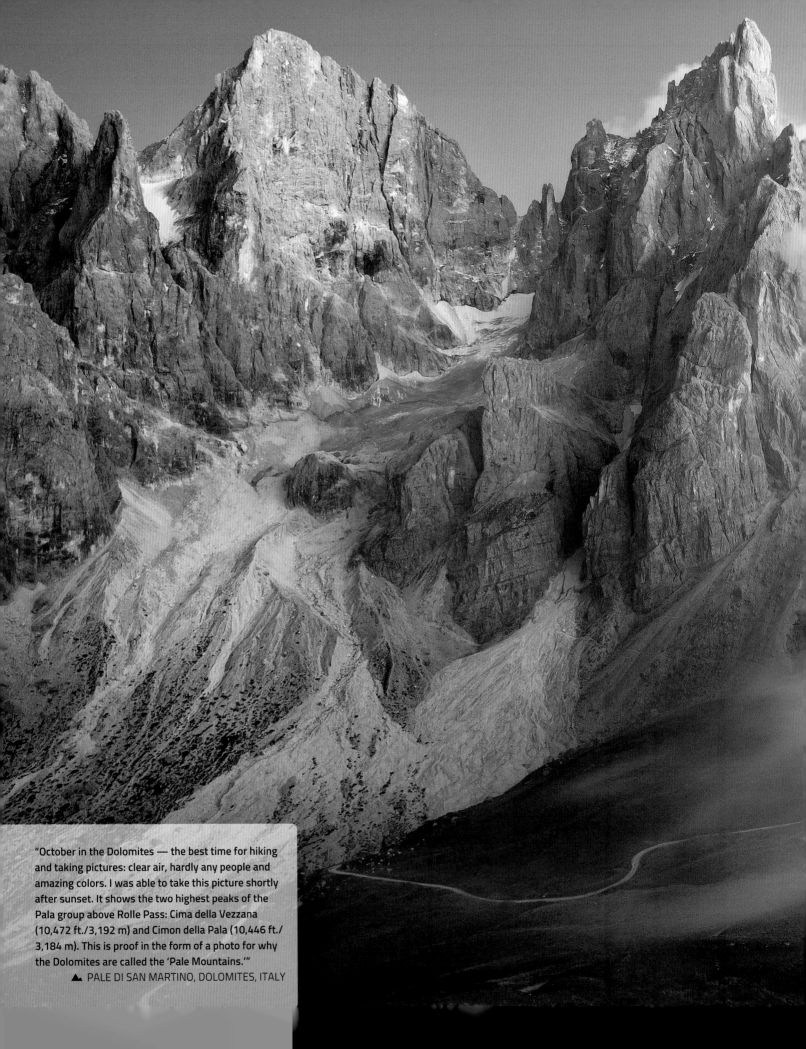

"October in the Dolomites — the best time for hiking and taking pictures: clear air, hardly any people and amazing colors. I was able to take this picture shortly after sunset. It shows the two highest peaks of the Pala group above Rolle Pass: Cima della Vezzana (10,472 ft./3,192 m) and Cimon della Pala (10,446 ft./ 3,184 m). This is proof in the form of a photo for why the Dolomites are called the 'Pale Mountains.'"

▲ PALE DI SAN MARTINO, DOLOMITES, ITALY

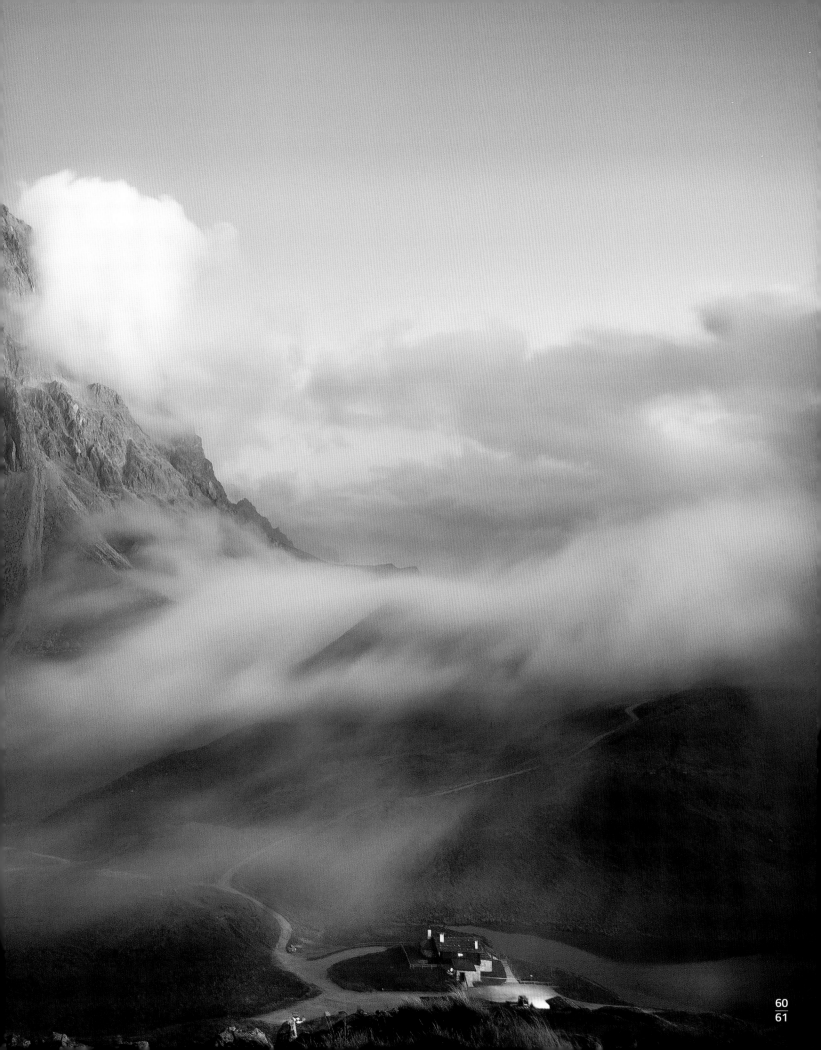

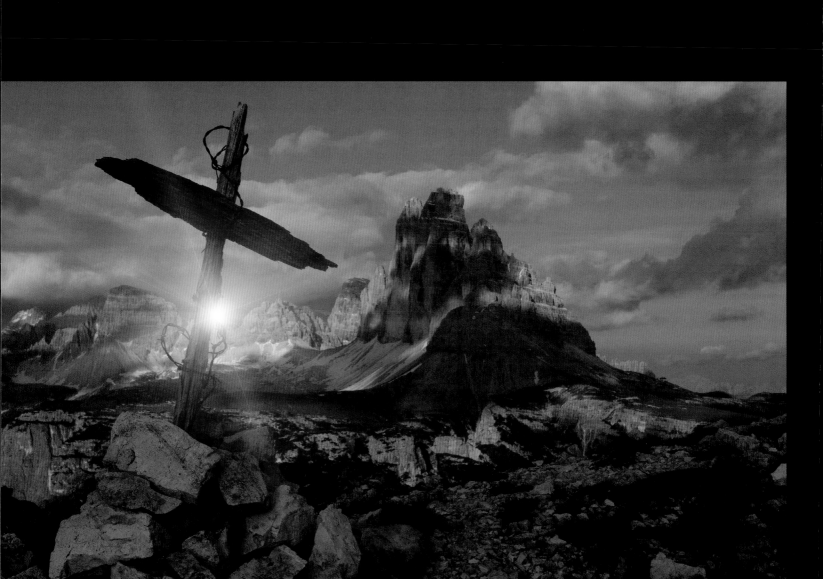

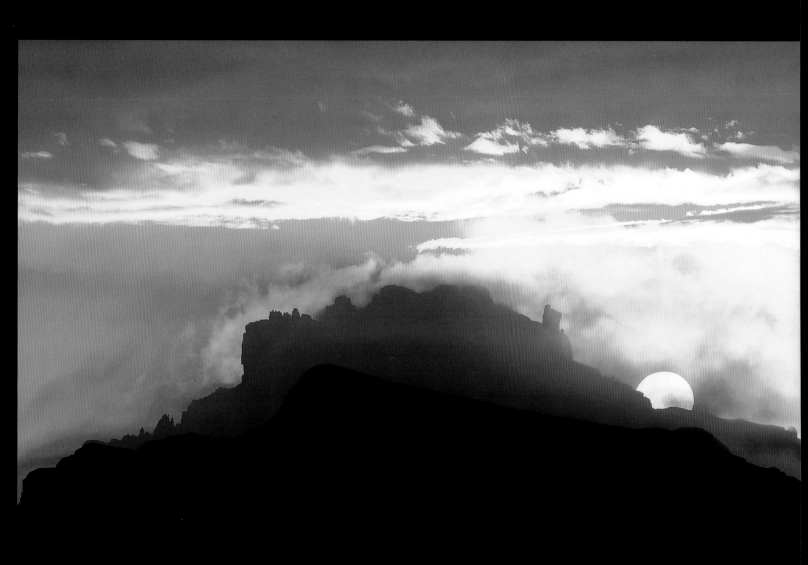

Was it a sunset like this one that inspired the legendary band Grateful Dead to write their song, "Fire on the Mountains"? The sun moves above the rugged peaks of the Bullunese Dolomites and a new day full of adventures awaits you on the summits. As the lyrics say: "Long distance runner, what you standin' there for? Get up, get out, get out of the door…"

▲ BELLUNESE DOLOMITES, ITALY

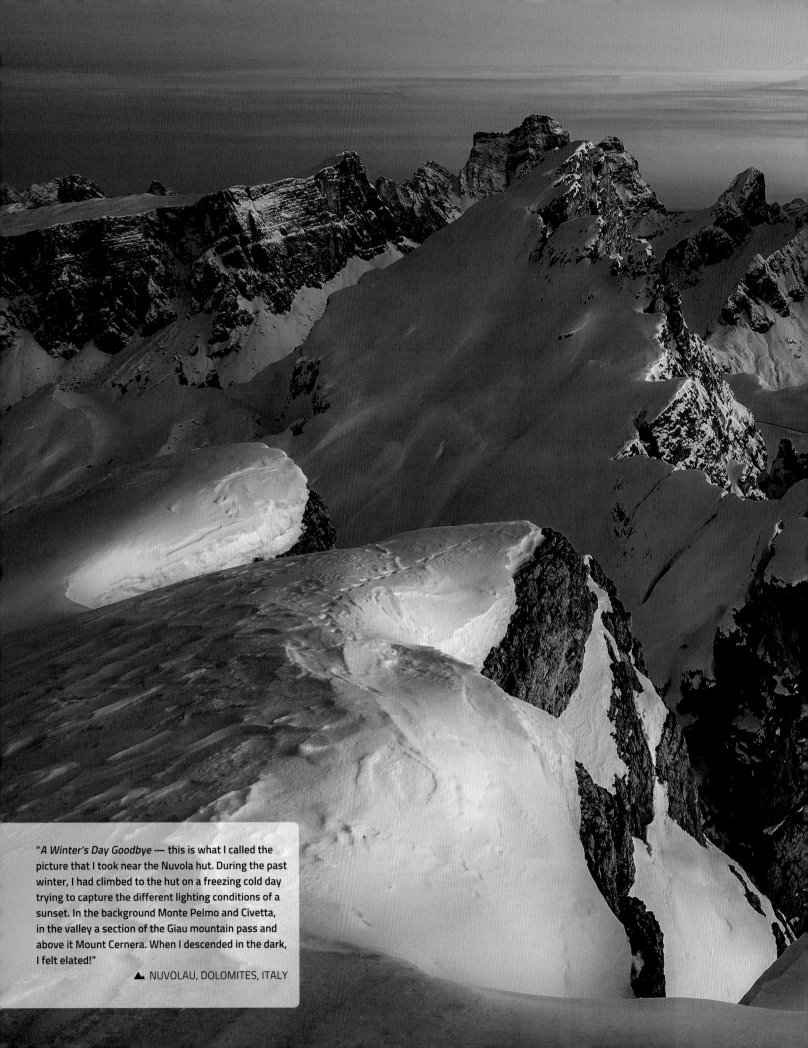

"*A Winter's Day Goodbye* — this is what I called the picture that I took near the Nuvola hut. During the past winter, I had climbed to the hut on a freezing cold day trying to capture the different lighting conditions of a sunset. In the background Monte Pelmo and Civetta, in the valley a section of the Giau mountain pass and above it Mount Cernera. When I descended in the dark, I felt elated!"

▲ NUVOLAU, DOLOMITES, ITALY

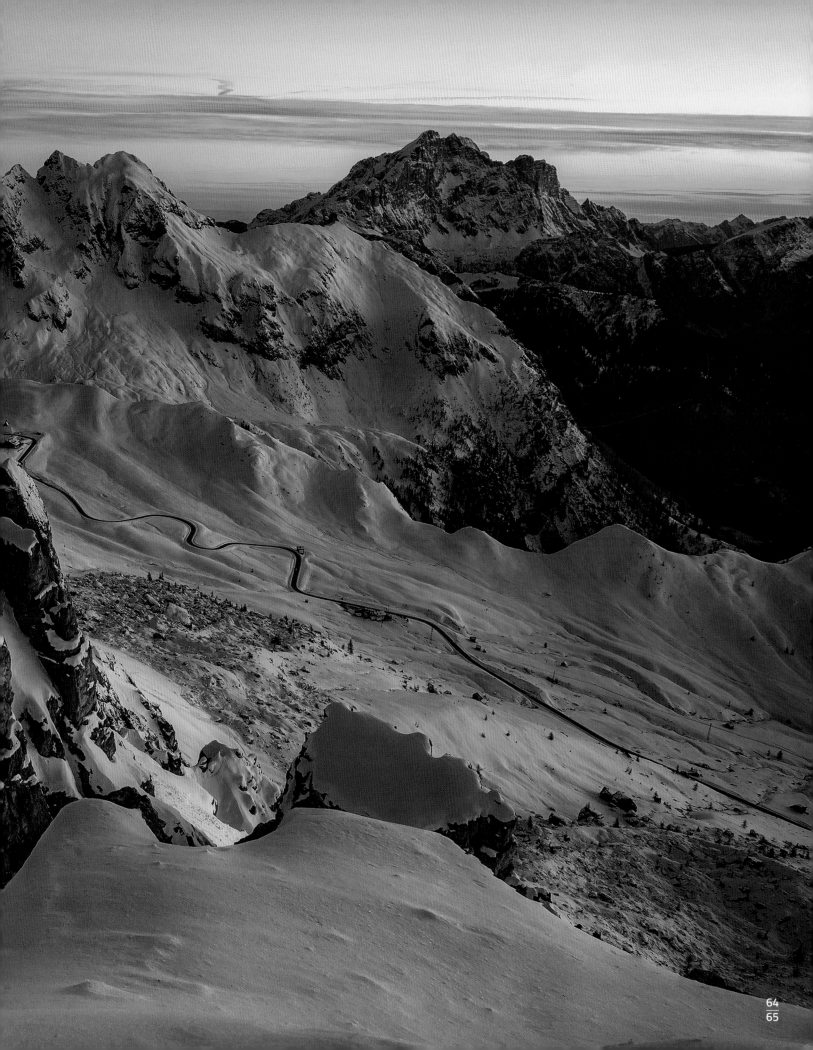

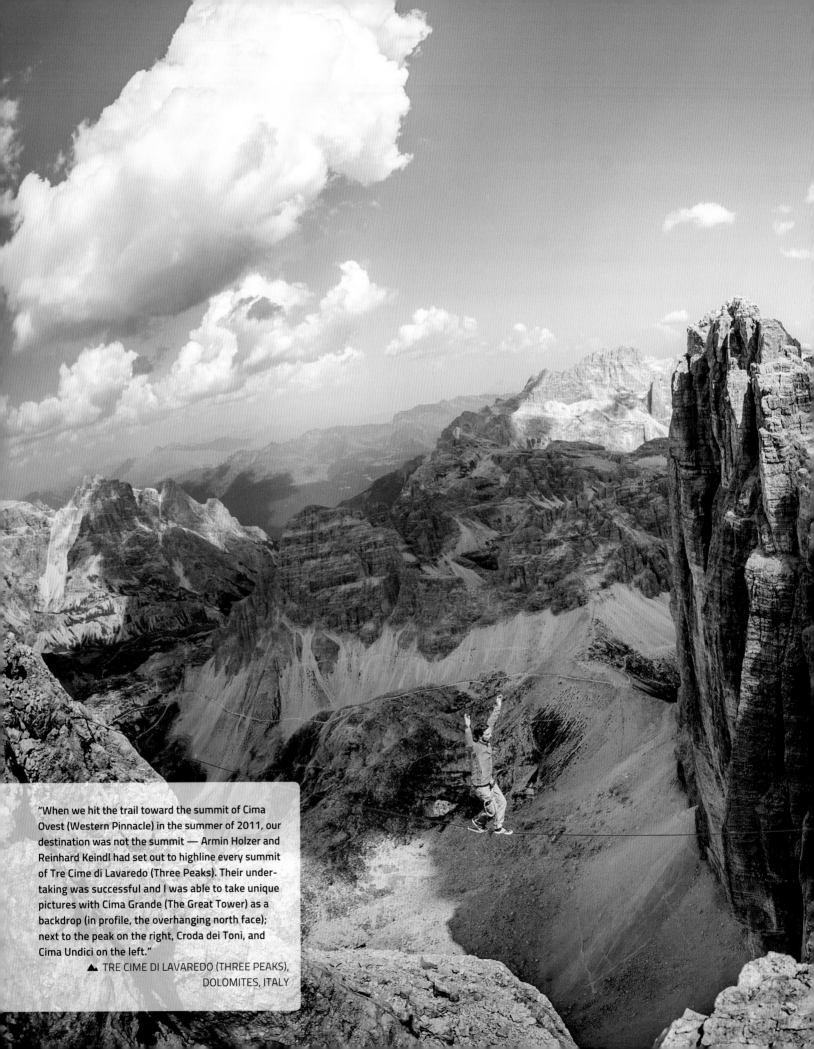

"When we hit the trail toward the summit of Cima Ovest (Western Pinnacle) in the summer of 2011, our destination was not the summit — Armin Holzer and Reinhard Keindl had set out to highline every summit of Tre Cime di Lavaredo (Three Peaks). Their under-taking was successful and I was able to take unique pictures with Cima Grande (The Great Tower) as a backdrop (in profile, the overhanging north face); next to the peak on the right, Croda dei Toni, and Cima Undici on the left."

▲ TRE CIME DI LAVAREDO (THREE PEAKS), DOLOMITES, ITALY

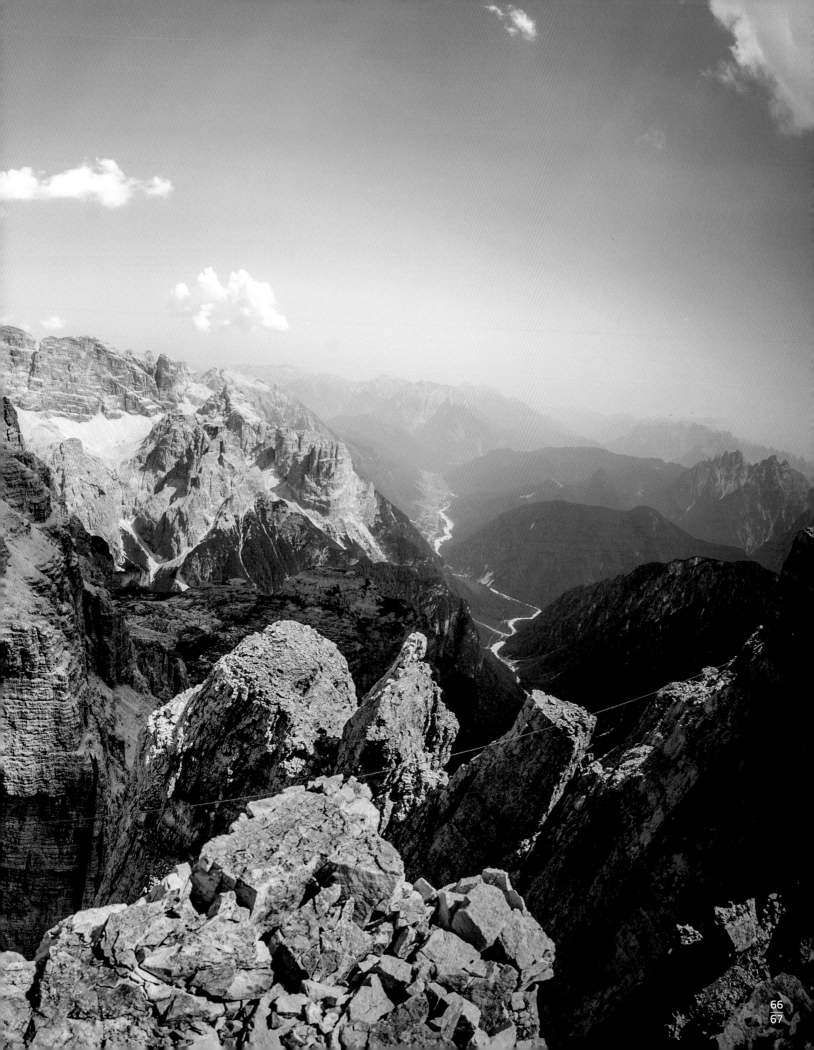

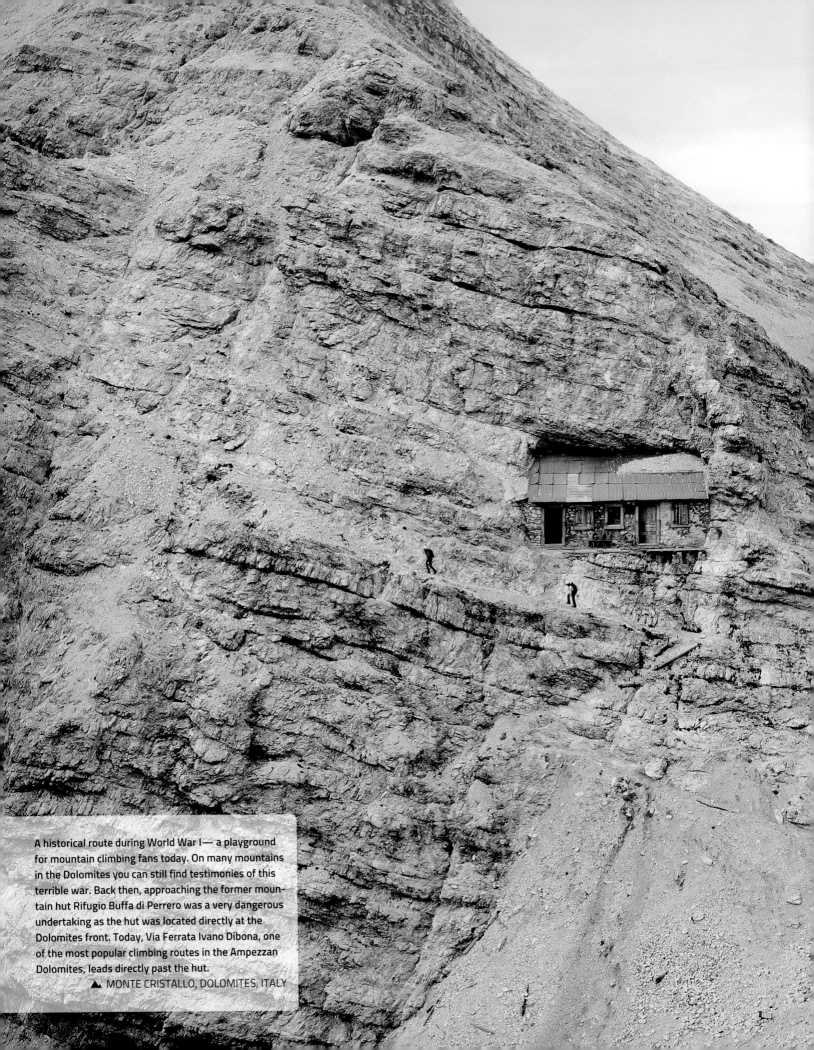

A historical route during World War I— a playground for mountain climbing fans today. On many mountains in the Dolomites you can still find testimonies of this terrible war. Back then, approaching the former mountain hut Rifugio Buffa di Perrero was a very dangerous undertaking as the hut was located directly at the Dolomites front. Today, Via Ferrata Ivano Dibona, one of the most popular climbing routes in the Ampezzan Dolomites, leads directly past the hut.

▲ MONTE CRISTALLO, DOLOMITES, ITALY

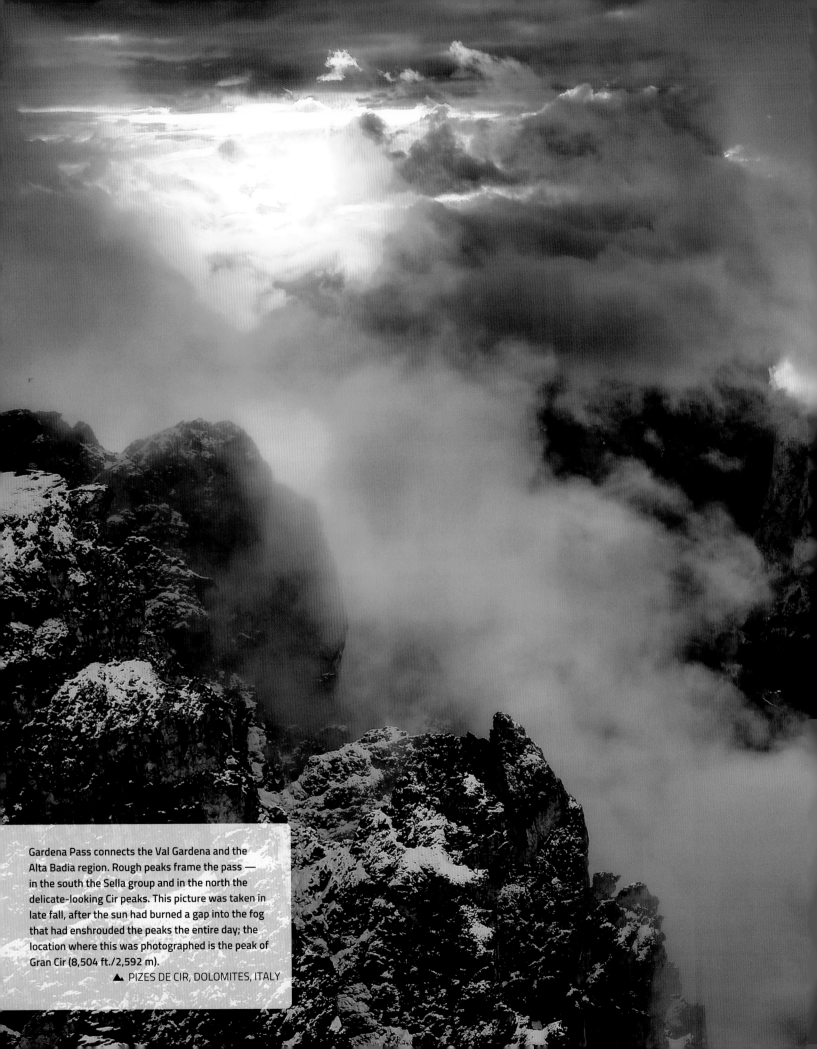

Gardena Pass connects the Val Gardena and the Alta Badia region. Rough peaks frame the pass — in the south the Sella group and in the north the delicate-looking Cir peaks. This picture was taken in late fall, after the sun had burned a gap into the fog that had enshrouded the peaks the entire day; the location where this was photographed is the peak of Gran Cir (8,504 ft./2,592 m).

▲ PIZES DE CIR, DOLOMITES, ITALY

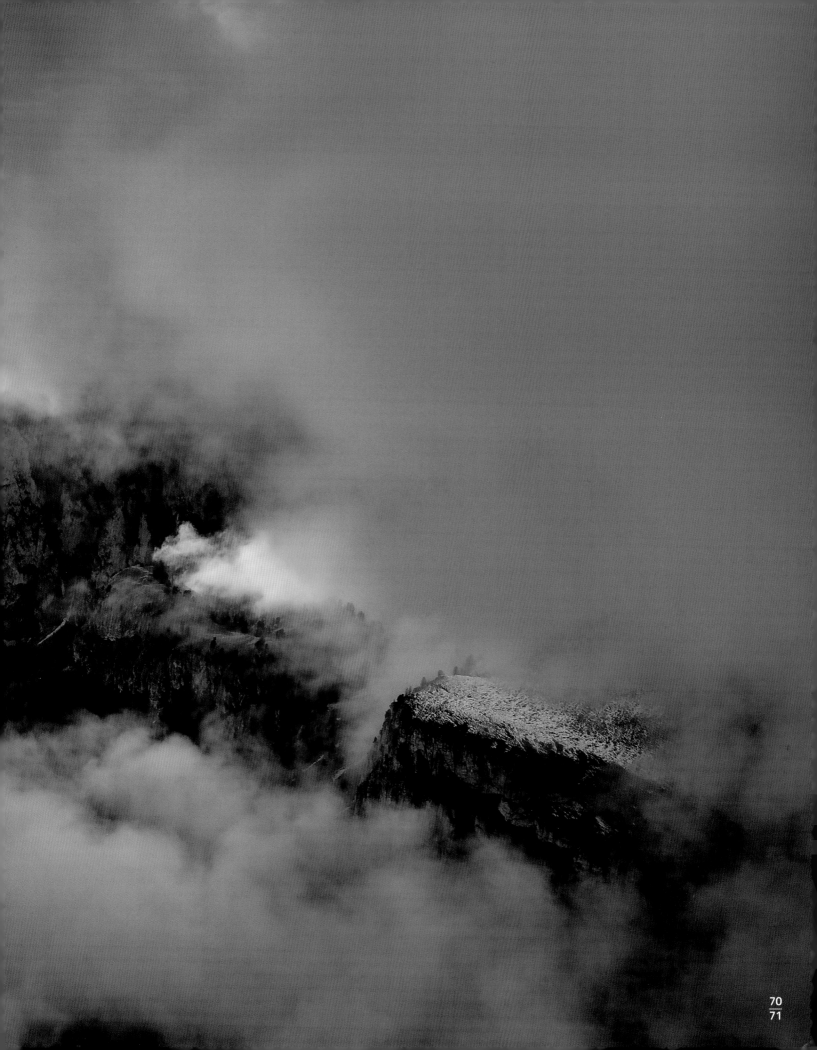

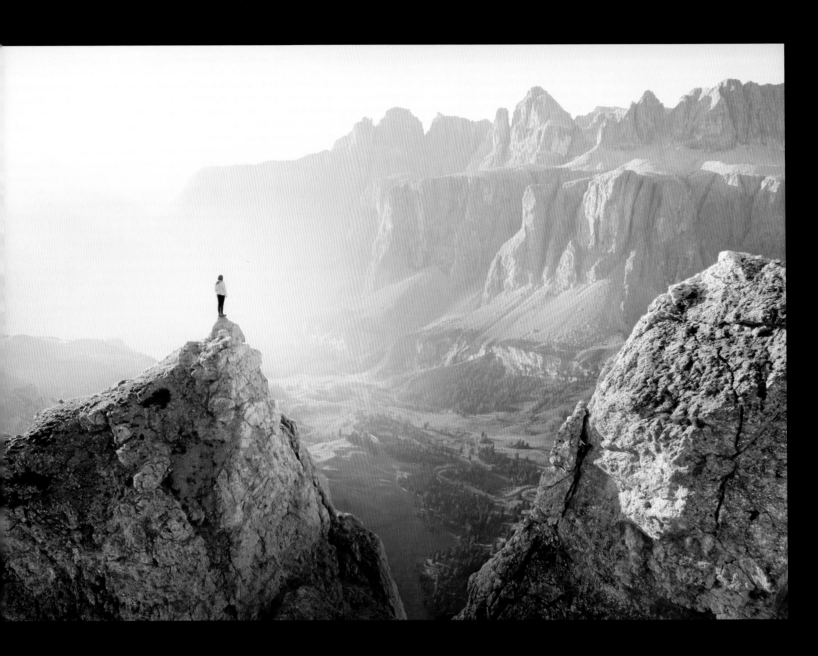

The morning sun bathes the northern precipices of
the Sella group in almost mystical light, while the
Gardena Pass slowly awakens from the shadows of
the night; the lone mountain climber stands on
the top of a ridge, just below the peak of Gran Cir
(8,504 ft./2,592 m), which can be reached by using a
steep path (secured with climbing aids) from Gardena
Pass in approximately one and a half hours.

▲ GRAN CIR, DOLOMITES, ITALY

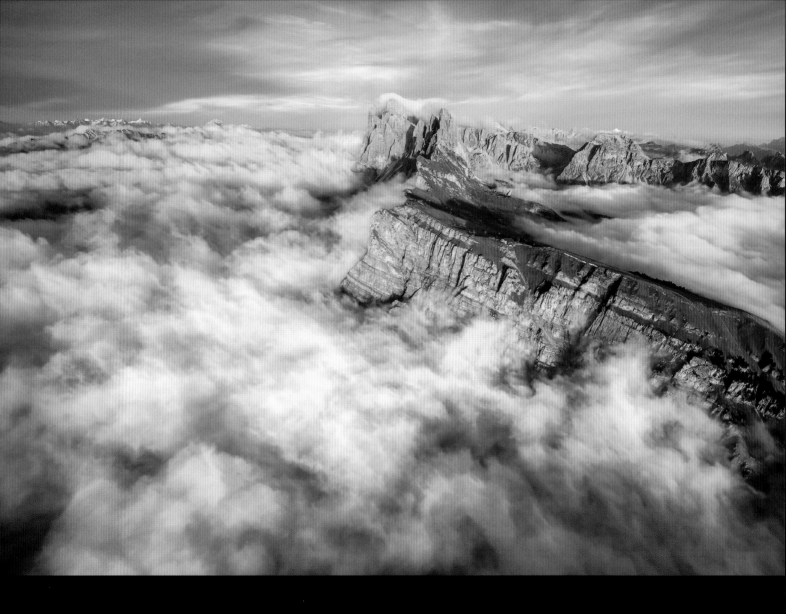

The setting sun was not able to dissolve the fall fog above the Villnöss Valley and Val Gardena, and consequently the Geislerspitze mountain range with the striking Sas Rigais (9,924 ft./3,025 m) and the Furchetta

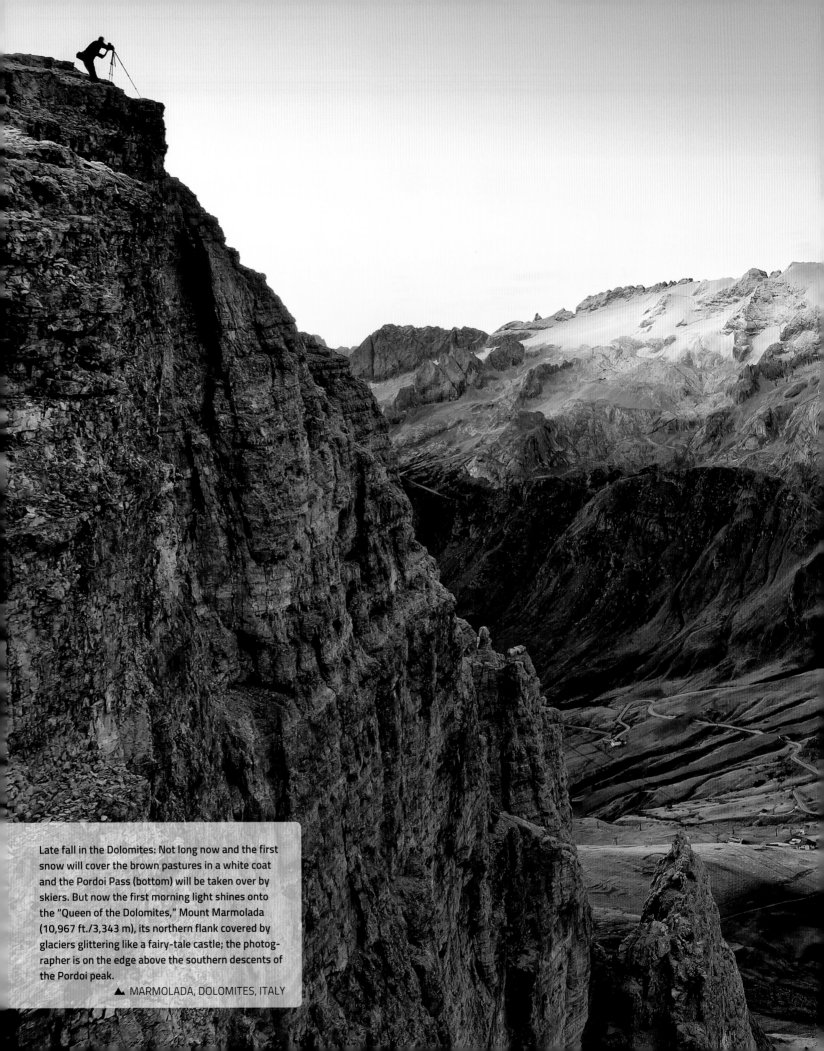

Late fall in the Dolomites: Not long now and the first snow will cover the brown pastures in a white coat and the Pordoi Pass (bottom) will be taken over by skiers. But now the first morning light shines onto the "Queen of the Dolomites," Mount Marmolada (10,967 ft./3,343 m), its northern flank covered by glaciers glittering like a fairy-tale castle; the photographer is on the edge above the southern descents of the Pordoi peak.

▲ MARMOLADA, DOLOMITES, ITALY

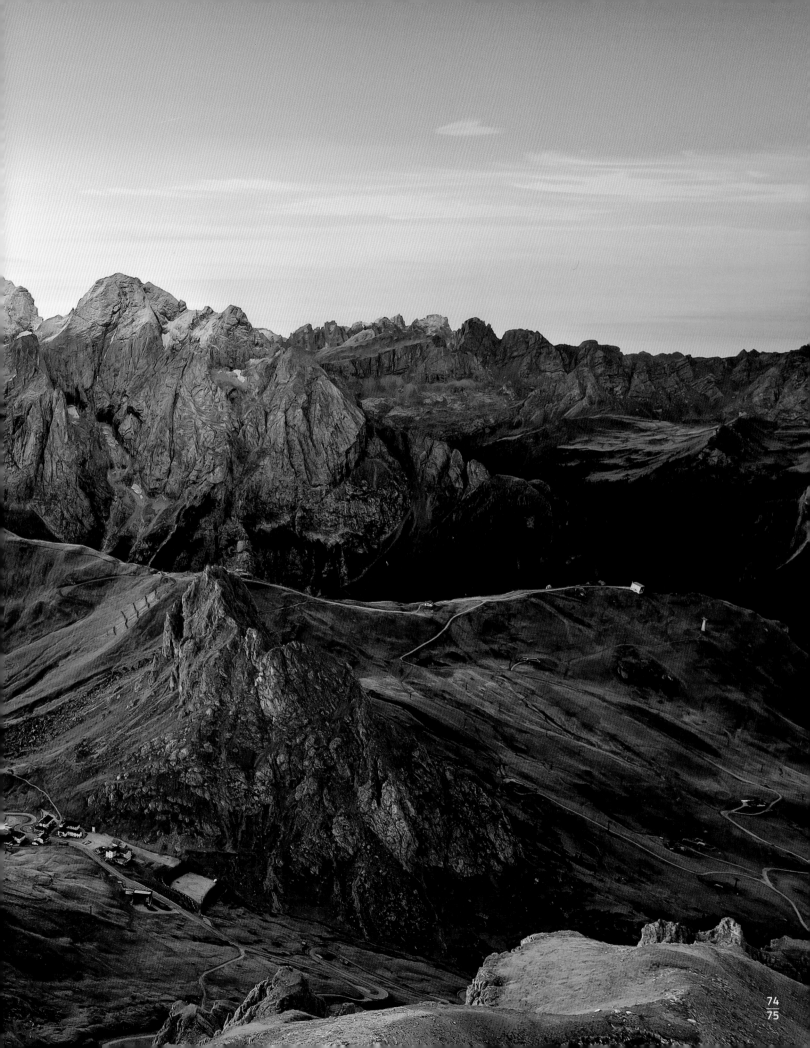

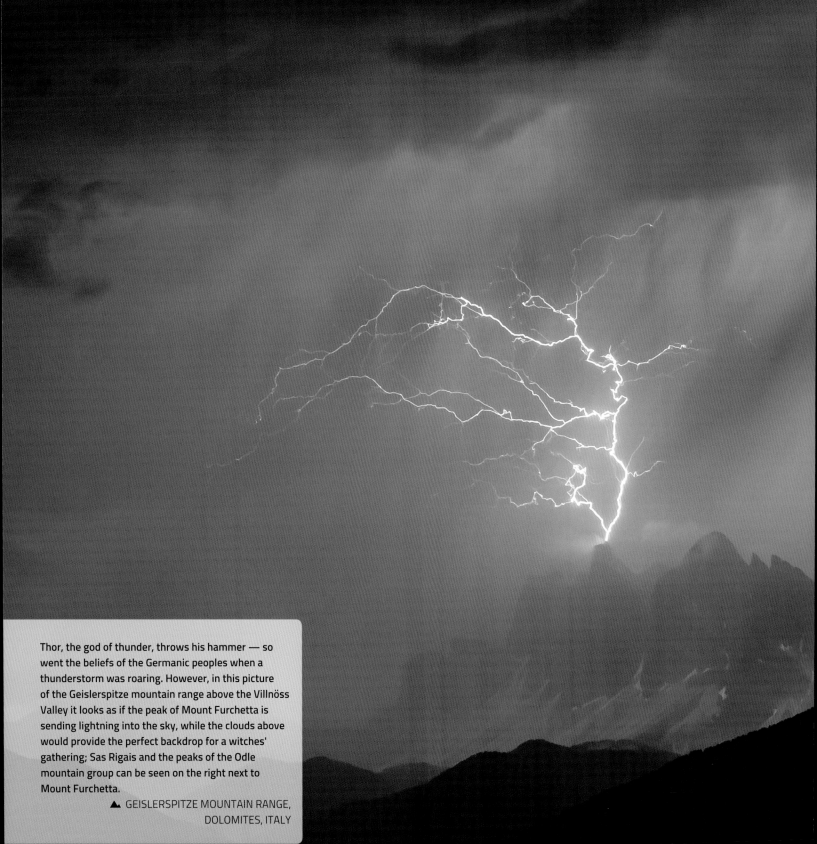

Thor, the god of thunder, throws his hammer — so went the beliefs of the Germanic peoples when a thunderstorm was roaring. However, in this picture of the Geislerspitze mountain range above the Villnöss Valley it looks as if the peak of Mount Furchetta is sending lightning into the sky, while the clouds above would provide the perfect backdrop for a witches' gathering; Sas Rigais and the peaks of the Odle mountain group can be seen on the right next to Mount Furchetta.

▲ GEISLERSPITZE MOUNTAIN RANGE, DOLOMITES, ITALY

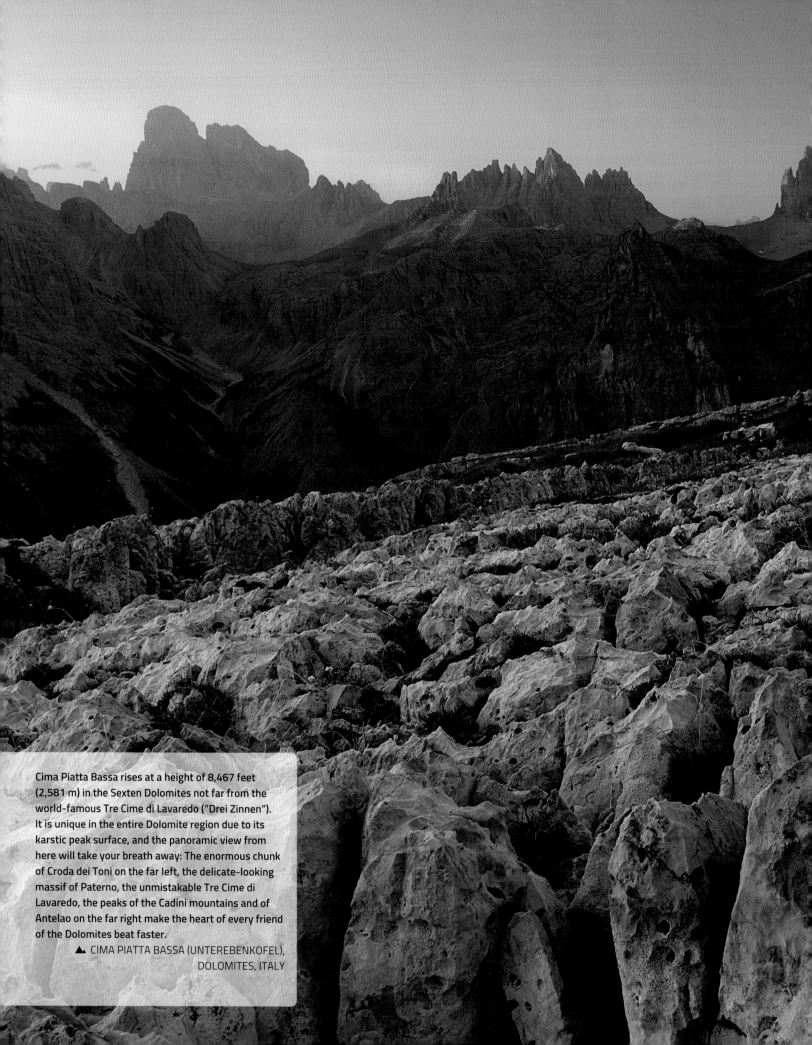

Cima Piatta Bassa rises at a height of 8,467 feet (2,581 m) in the Sexten Dolomites not far from the world-famous Tre Cime di Lavaredo ("Drei Zinnen"). It is unique in the entire Dolomite region due to its karstic peak surface, and the panoramic view from here will take your breath away: The enormous chunk of Croda dei Toni on the far left, the delicate-looking massif of Paterno, the unmistakable Tre Cime di Lavaredo, the peaks of the Cadini mountains and of Antelao on the far right make the heart of every friend of the Dolomites beat faster.

▲ CIMA PIATTA BASSA (UNTEREBENKOFEL), DOLOMITES, ITALY

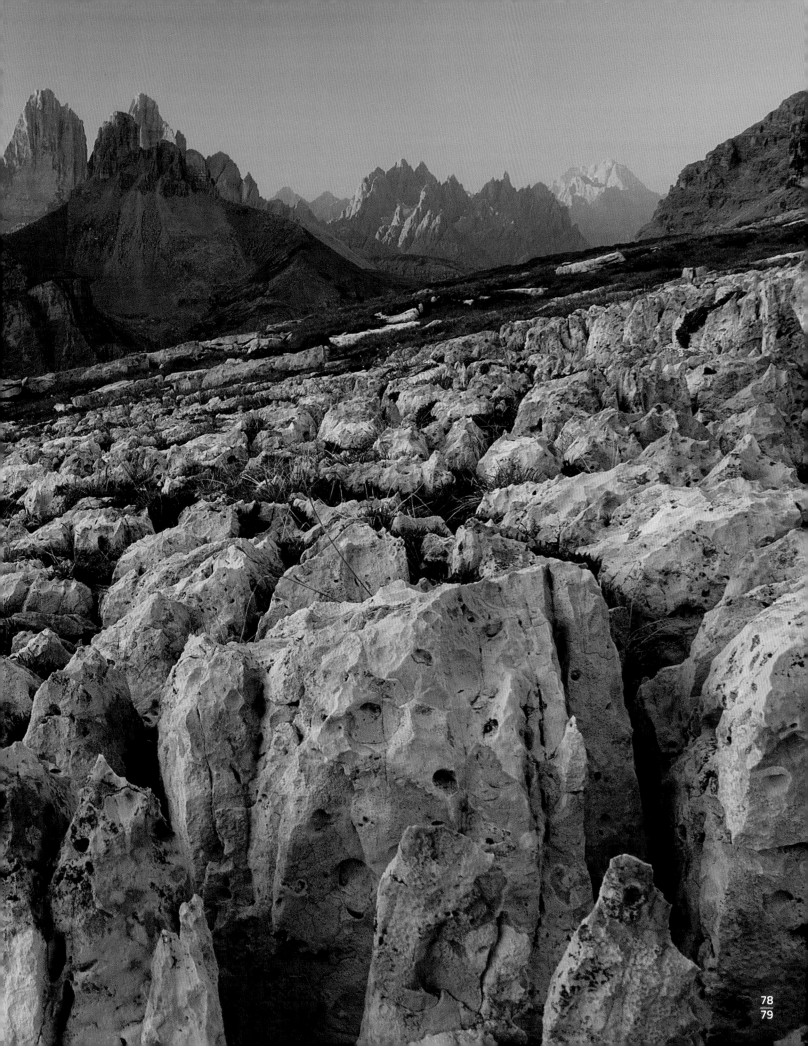

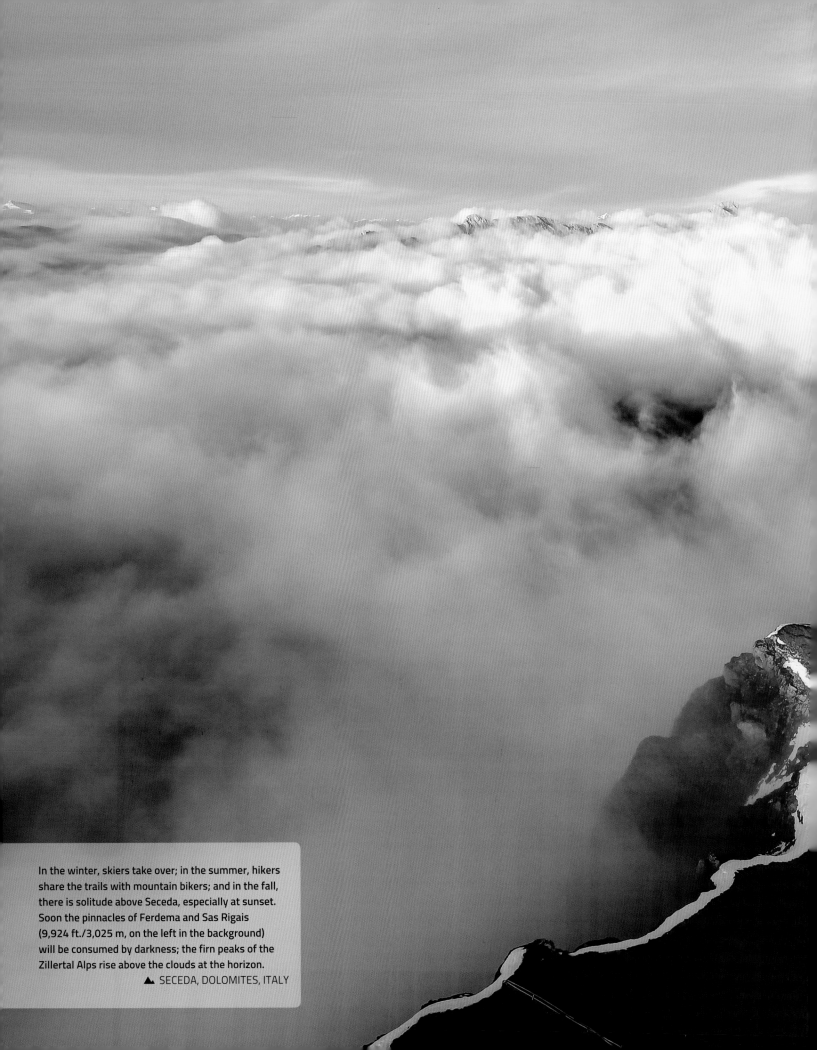

In the winter, skiers take over; in the summer, hikers share the trails with mountain bikers; and in the fall, there is solitude above Seceda, especially at sunset. Soon the pinnacles of Ferdema and Sas Rigais (9,924 ft./3,025 m, on the left in the background) will be consumed by darkness; the firn peaks of the Zillertal Alps rise above the clouds at the horizon.

▲ SECEDA, DOLOMITES, ITALY

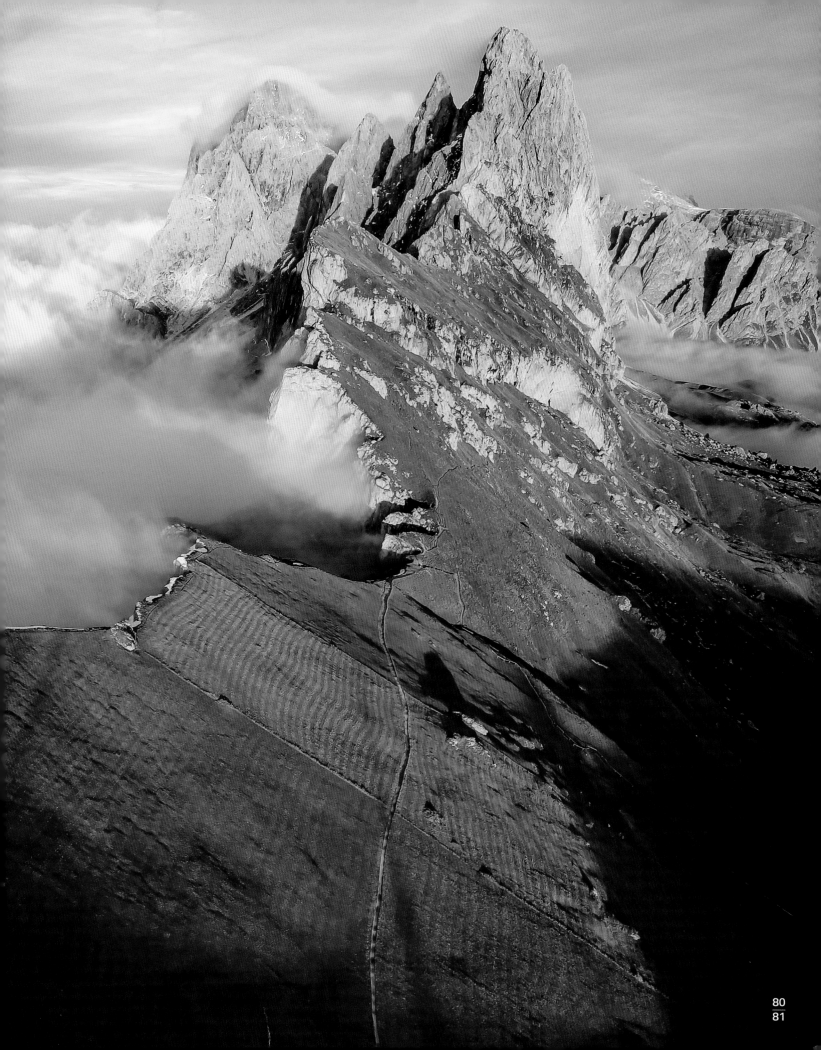

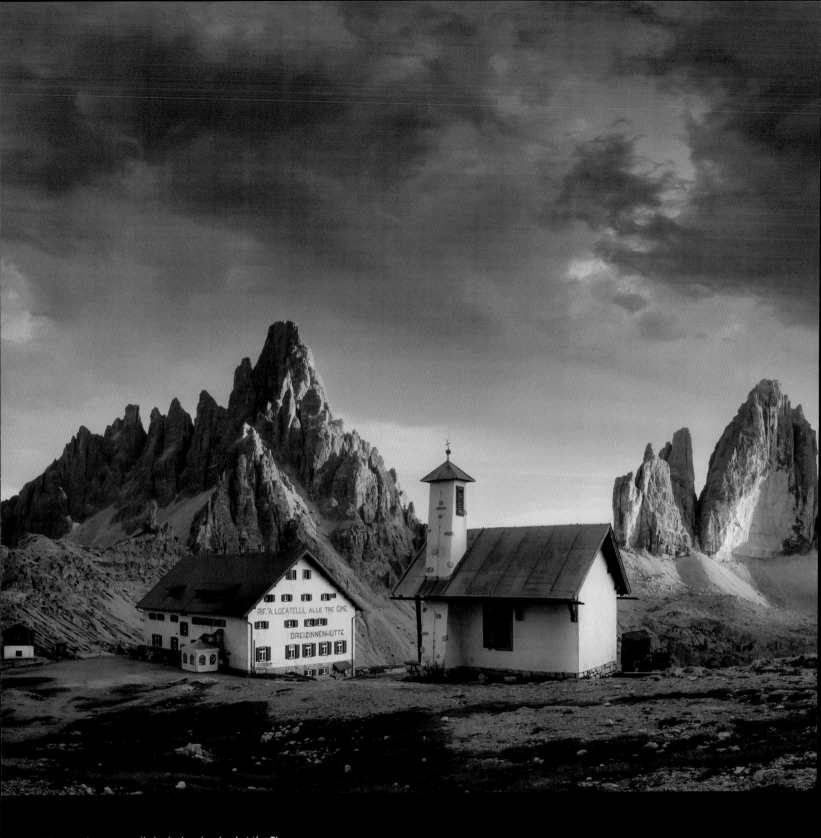

"The weather was really bad when I arrived at the Cime di Lavaredo hut — not exactly the best conditions for a photographer. I was just about to pack my camera away with resignation when suddenly the clouds ripped open! The Cime di Lavaredo and Paterno were bathed in flames for only a few seconds and I was able to capture a moment I will never forget."

▲ CIME DI LAVAREDO HUT,

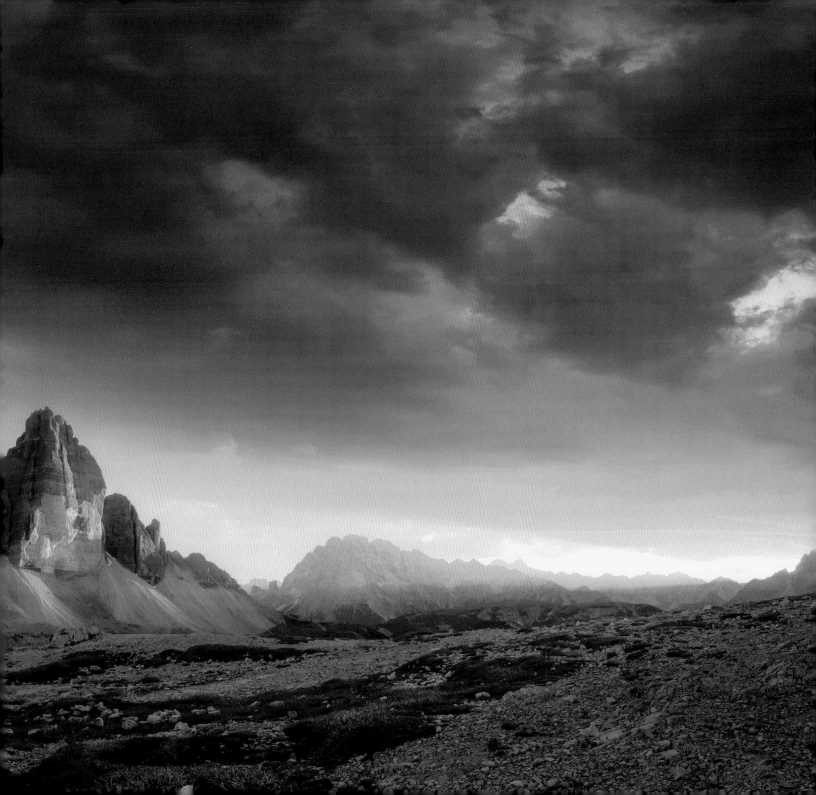

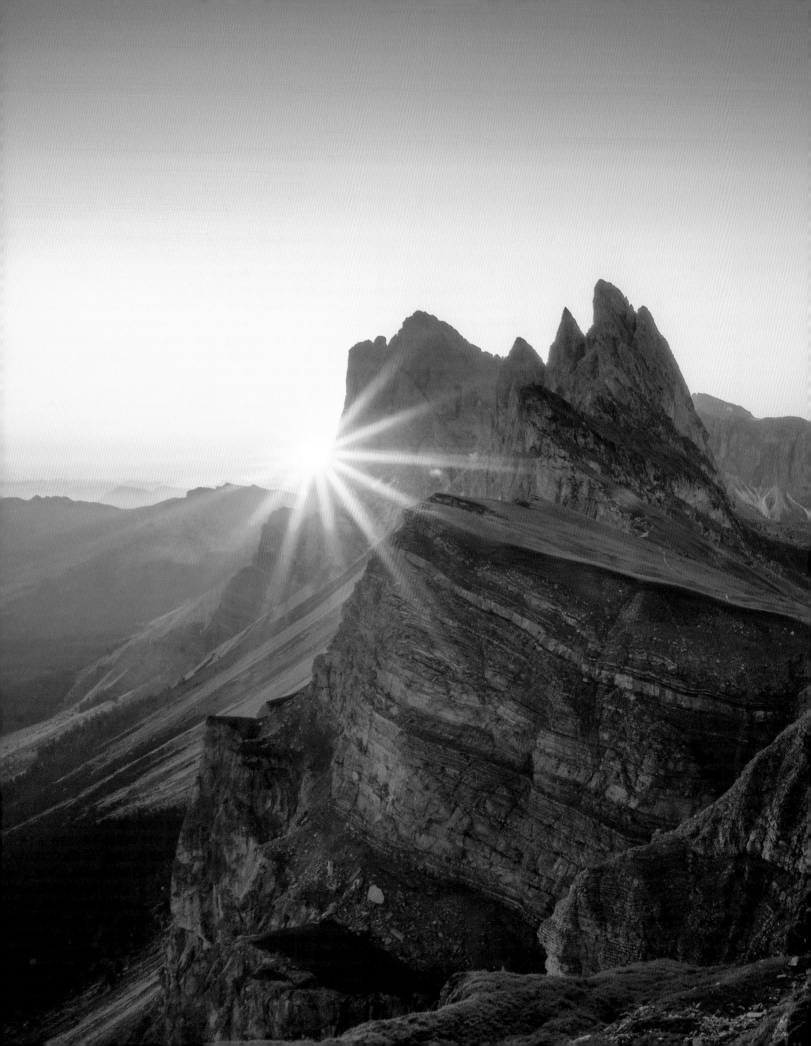

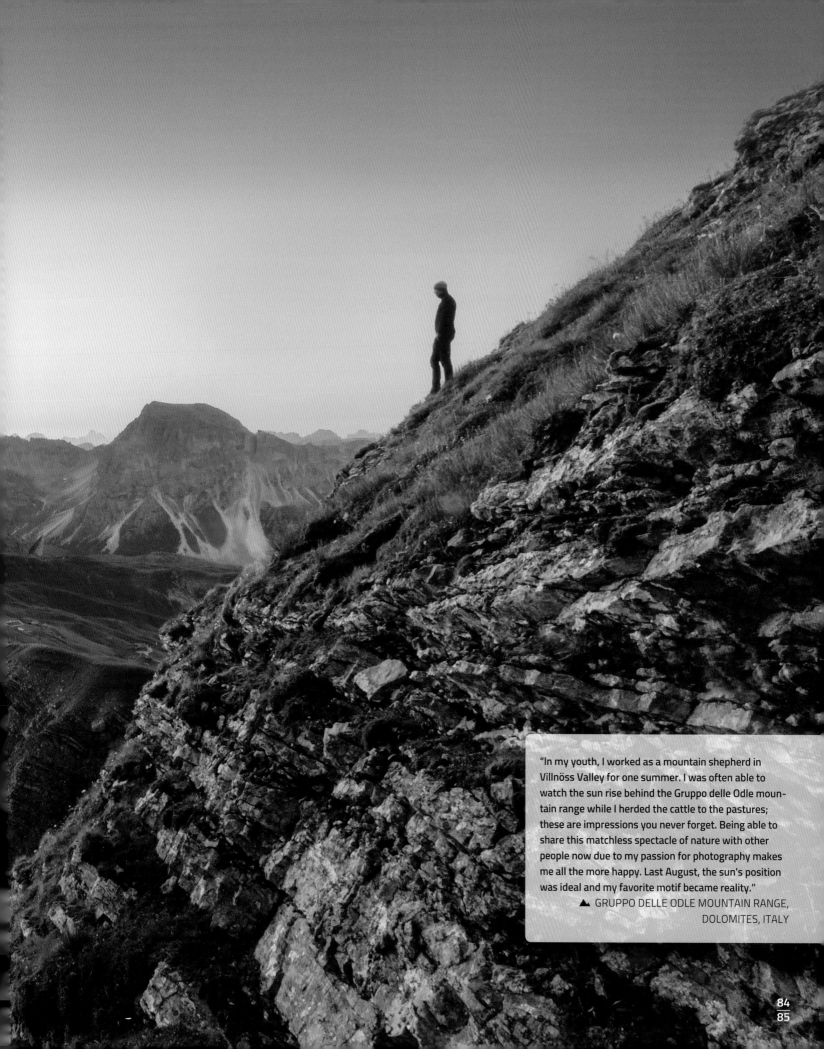

"In my youth, I worked as a mountain shepherd in Villnöss Valley for one summer. I was often able to watch the sun rise behind the Gruppo delle Odle mountain range while I herded the cattle to the pastures; these are impressions you never forget. Being able to share this matchless spectacle of nature with other people now due to my passion for photography makes me all the more happy. Last August, the sun's position was ideal and my favorite motif became reality."

▲ GRUPPO DELLE ODLE MOUNTAIN RANGE,
DOLOMITES, ITALY

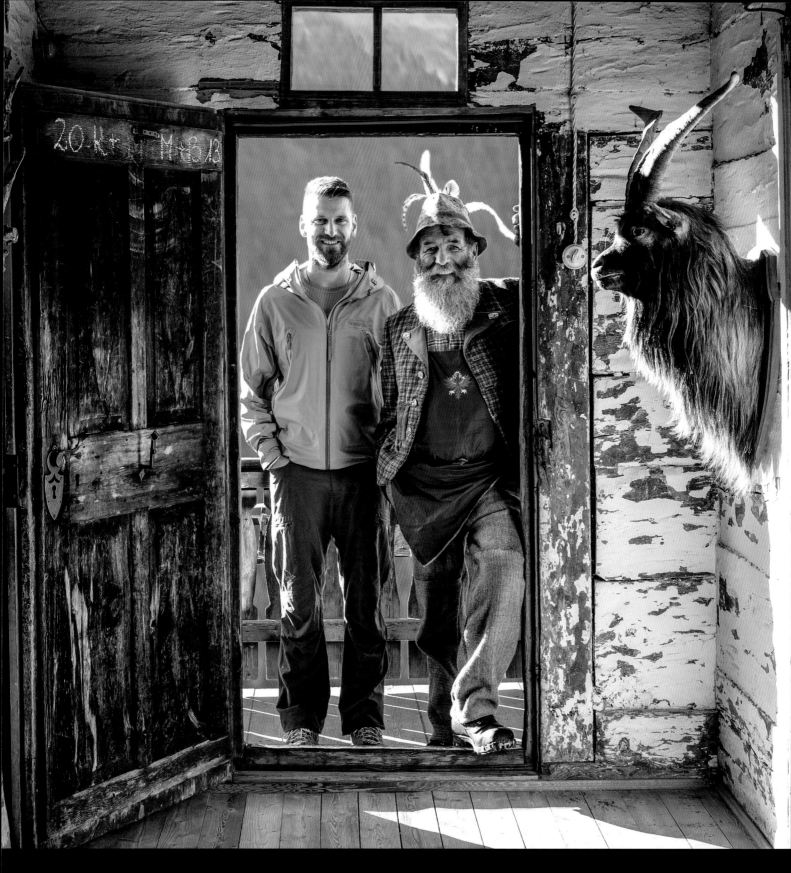

"This photo was taken during a shoot for the catalog of a South Tyrol alpine sports company; you could also call it *Young Meets Old*, or just simply *Mirko Faoro, Huber Sepp and the Mountain Goat*.'"

▲ FINAILHOF SCHNALSTAL, SOUTH TYROL, ITALY

Another classic Dolomite peak: Cima della Madonna (9,000 ft./2,752 m) with the legendary Spigolo del Velo (Edge of the Veil, difficulty level IV+) descending to the left, one of the most beautiful edge-climbing locations in the entire Dolomite region. Behind Cima della Madonna rises its neighboring peak, Sas Maor (9,225 ft./2,812 m) from the very bottom of Rifugio Velo della Madonna.

▲ PALE DI SAN MARTINO, DOLOMITES, ITALY

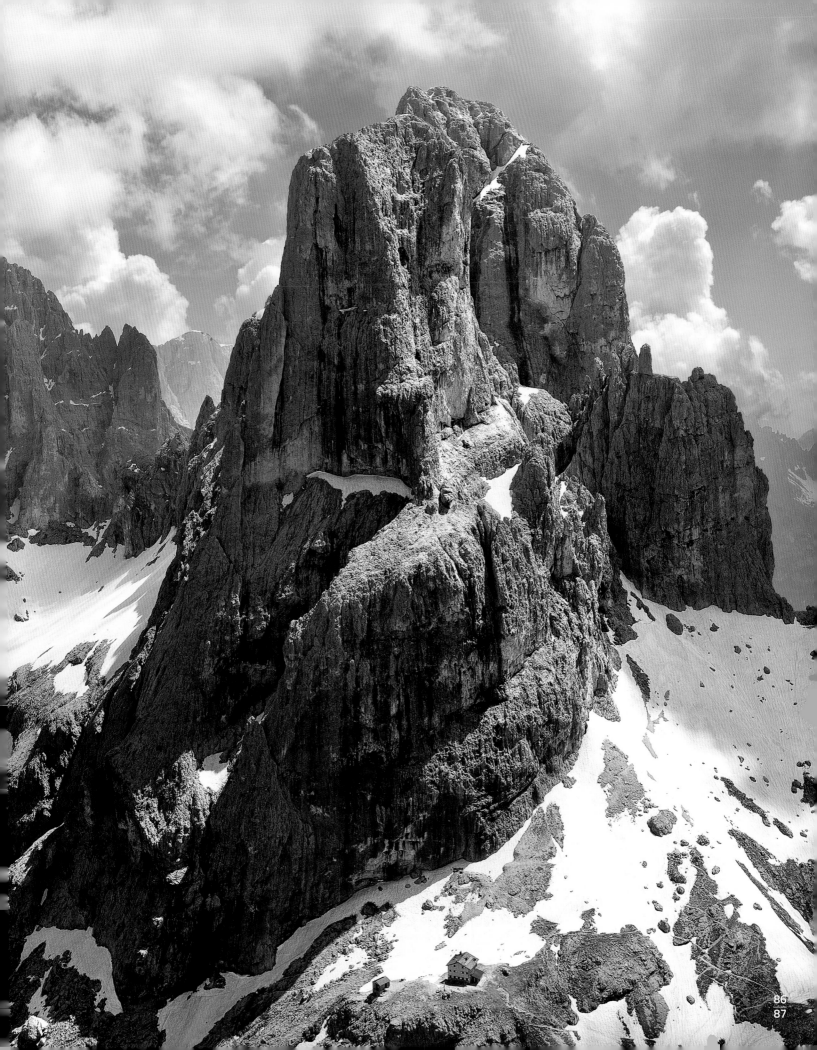

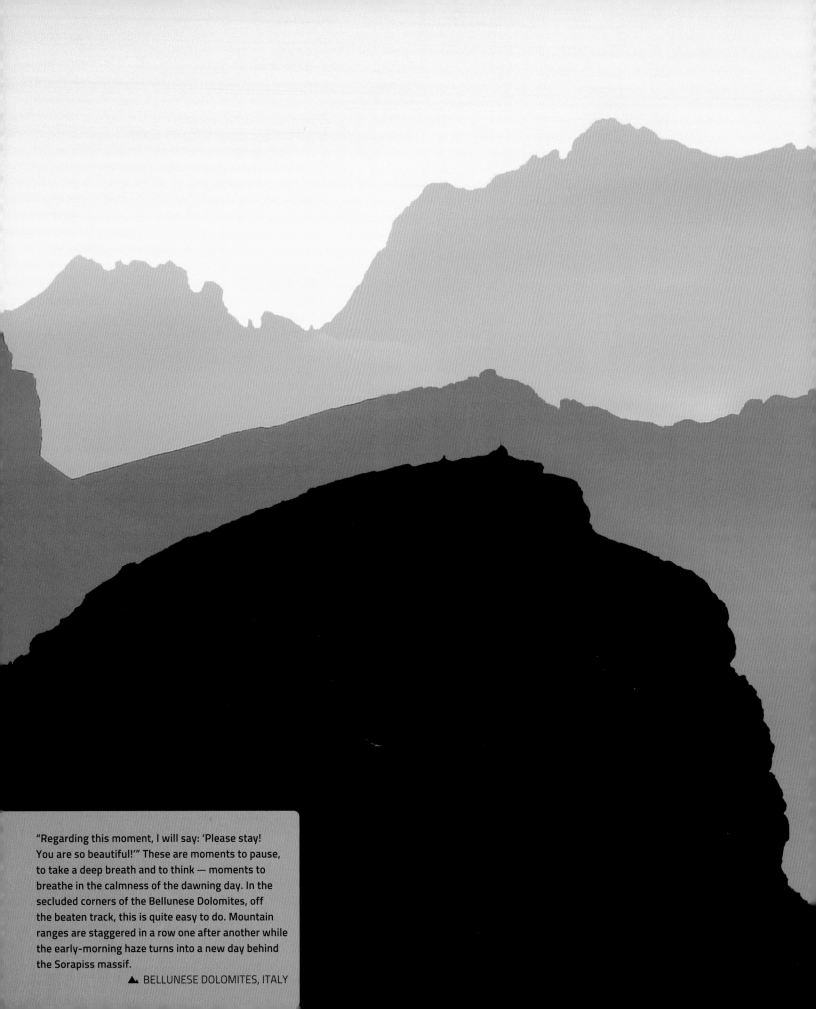

"Regarding this moment, I will say: 'Please stay! You are so beautiful!'" These are moments to pause, to take a deep breath and to think — moments to breathe in the calmness of the dawning day. In the secluded corners of the Bellunese Dolomites, off the beaten track, this is quite easy to do. Mountain ranges are staggered in a row one after another while the early-morning haze turns into a new day behind the Sorapiss massif.

▲ BELLUNESE DOLOMITES, ITALY

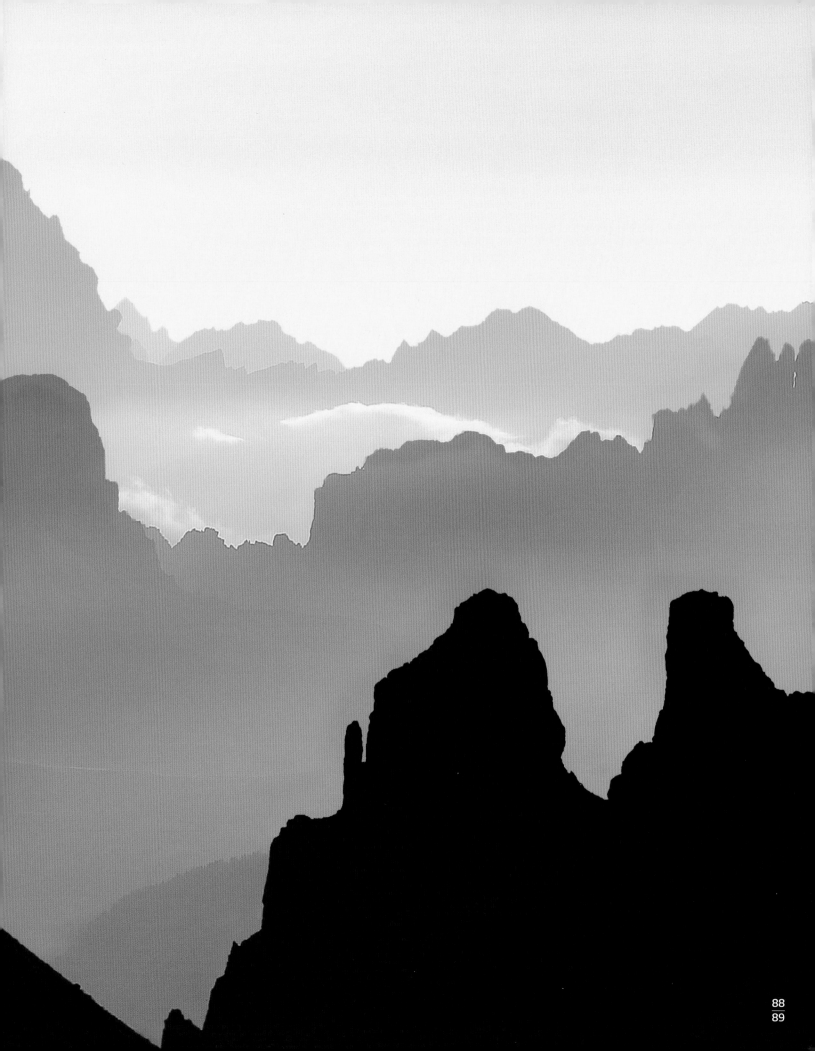

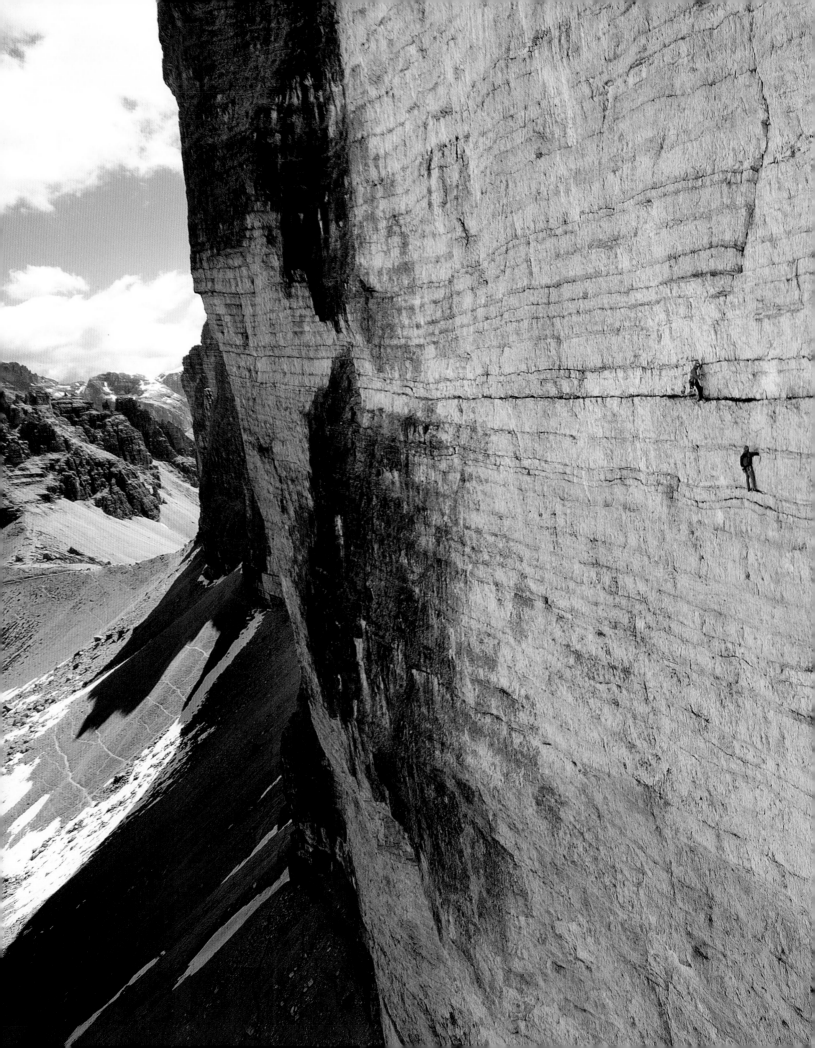

Extreme rock climbing! This picture includes every-
thing that sums up this obsession: feeling exposed,
brittle rock, adrenaline, overcoming fear. The two
rope teams are taking the Cassin route (difficulty
level VIII–) on the north face of Cima Ovest and have
already overcome the main difficulty of this route;
however, the extremely exposed 260-foot (80 m)
traverse (VII) to the left to the black water streak is
still ahead.

▲ CIMA OVEST, DOLOMITES, ITALY

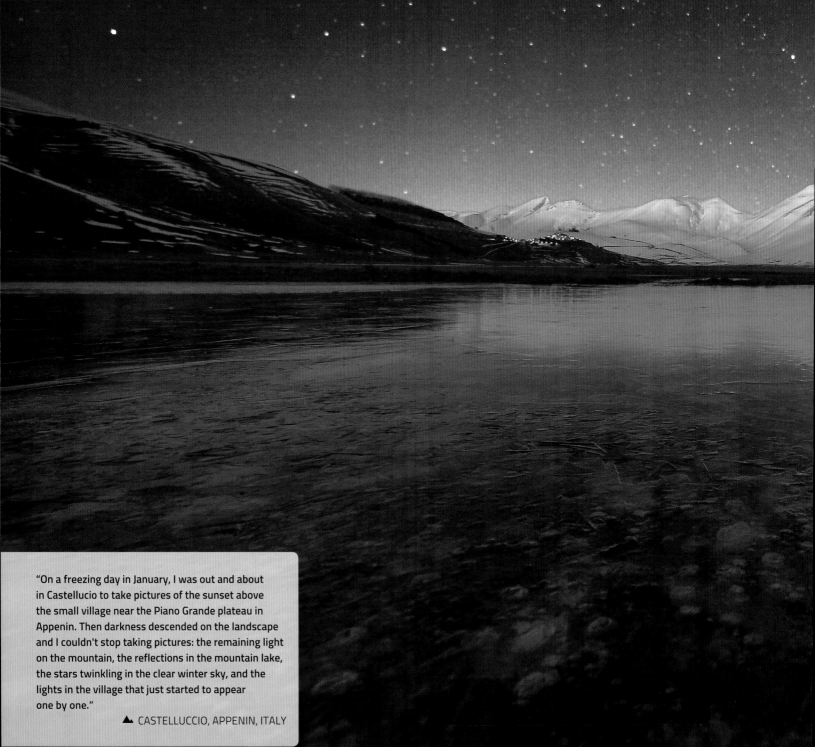

"On a freezing day in January, I was out and about in Castellucio to take pictures of the sunset above the small village near the Piano Grande plateau in Appenin. Then darkness descended on the landscape and I couldn't stop taking pictures: the remaining light on the mountain, the reflections in the mountain lake, the stars twinkling in the clear winter sky, and the lights in the village that just started to appear one by one."

▲ CASTELLUCCIO, APPENIN, ITALY

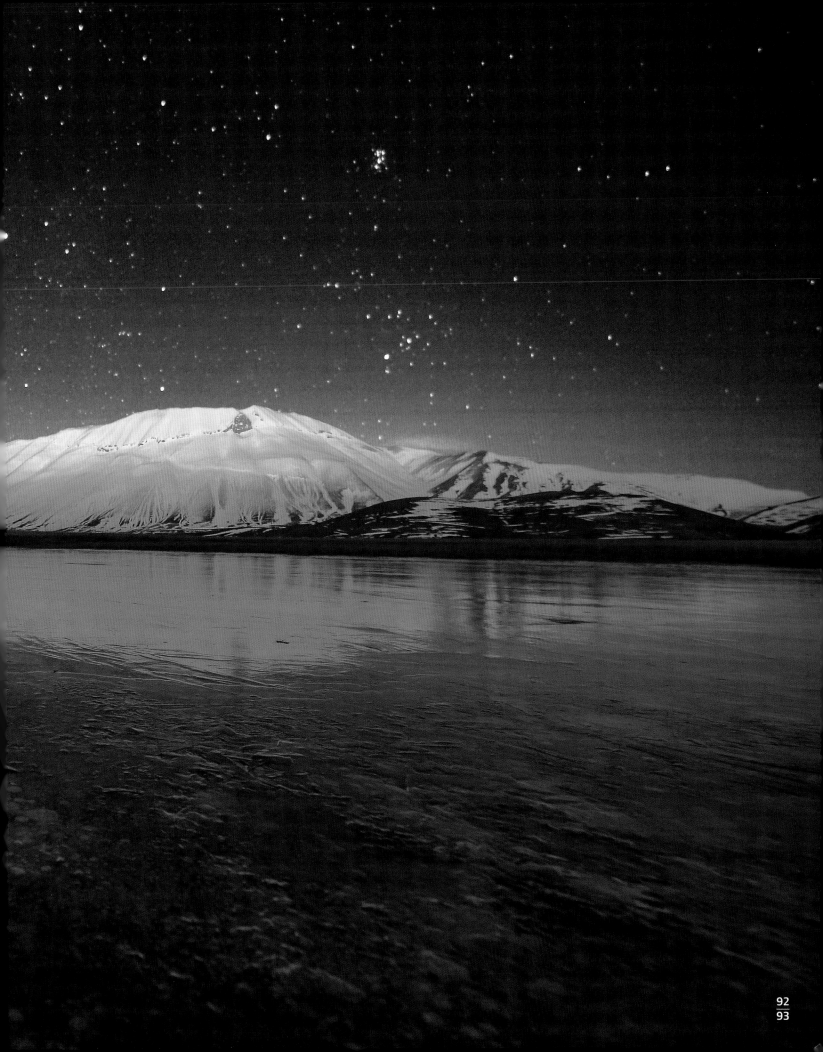

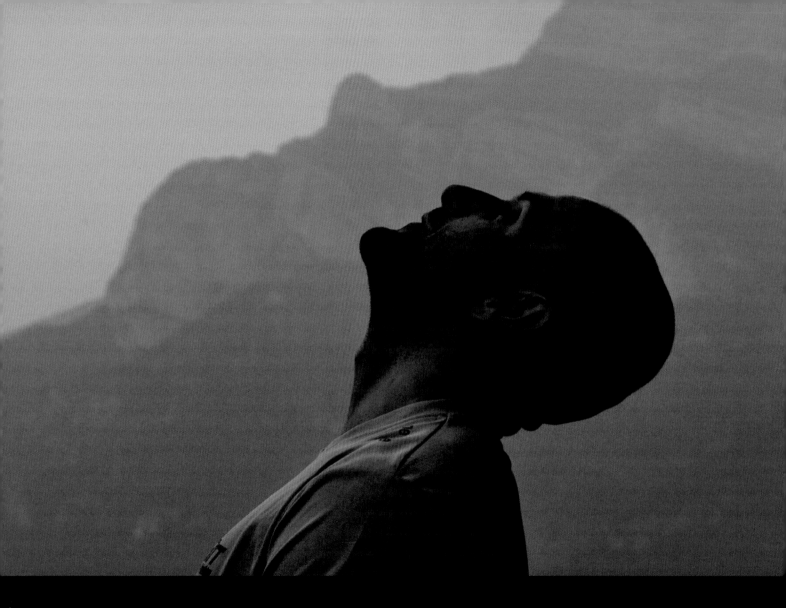

"L'uomo Che Dorme (The Sleeping Man) is the name of the ridge formation in the background at Lavaccio in the Monte Baldo mountain range high above Lake Garda. As a photographer it was obvious that I would ask a friend to pose directly underneath this formation to emphasize the profile of the human-looking face."

This is probably what it looked like at Monte Bondone millions of years ago — with the exception that back then, i was ice and not clouds that covered the valleys. View from Cornetto (7,152 ft./2,180 m), one of the three peaks of Monte Bondone, looking south toward Sarca Valley and Lake Garda.

▲ MONTE BONDONE, TRENTINO, ITALY

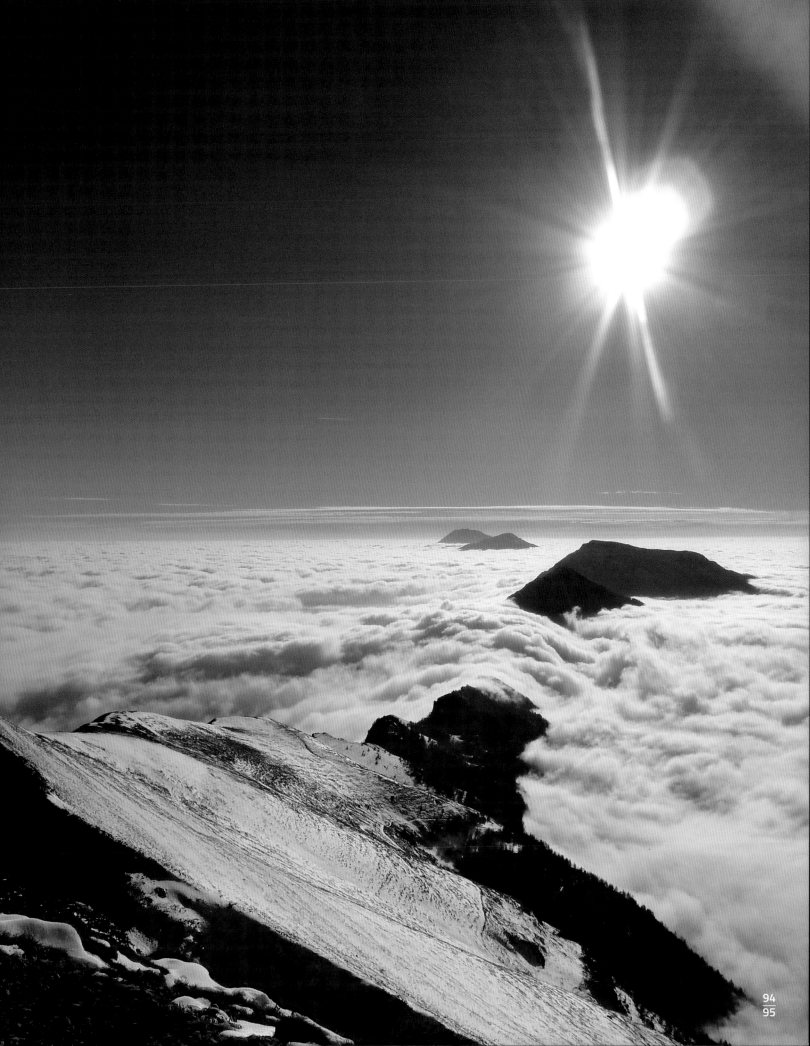

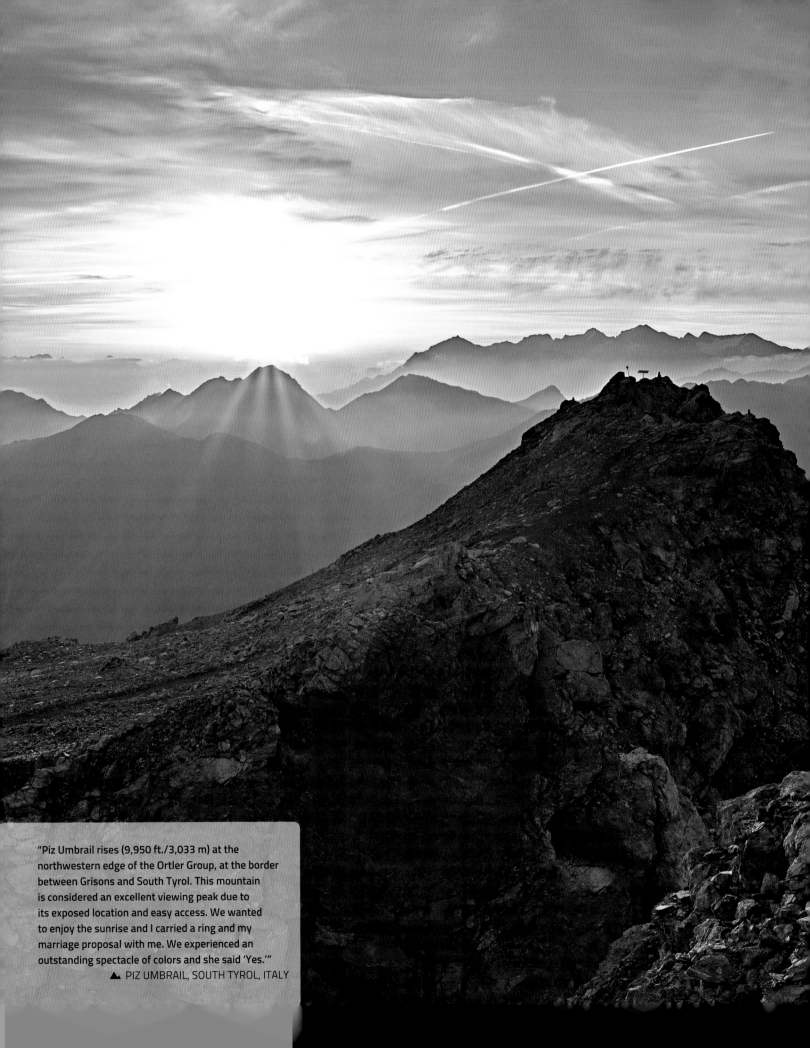

"Piz Umbrail rises (9,950 ft./3,033 m) at the northwestern edge of the Ortler Group, at the border between Grisons and South Tyrol. This mountain is considered an excellent viewing peak due to its exposed location and easy access. We wanted to enjoy the sunrise and I carried a ring and my marriage proposal with me. We experienced an outstanding spectacle of colors and she said 'Yes.'"

▲ PIZ UMBRAIL, SOUTH TYROL, ITALY

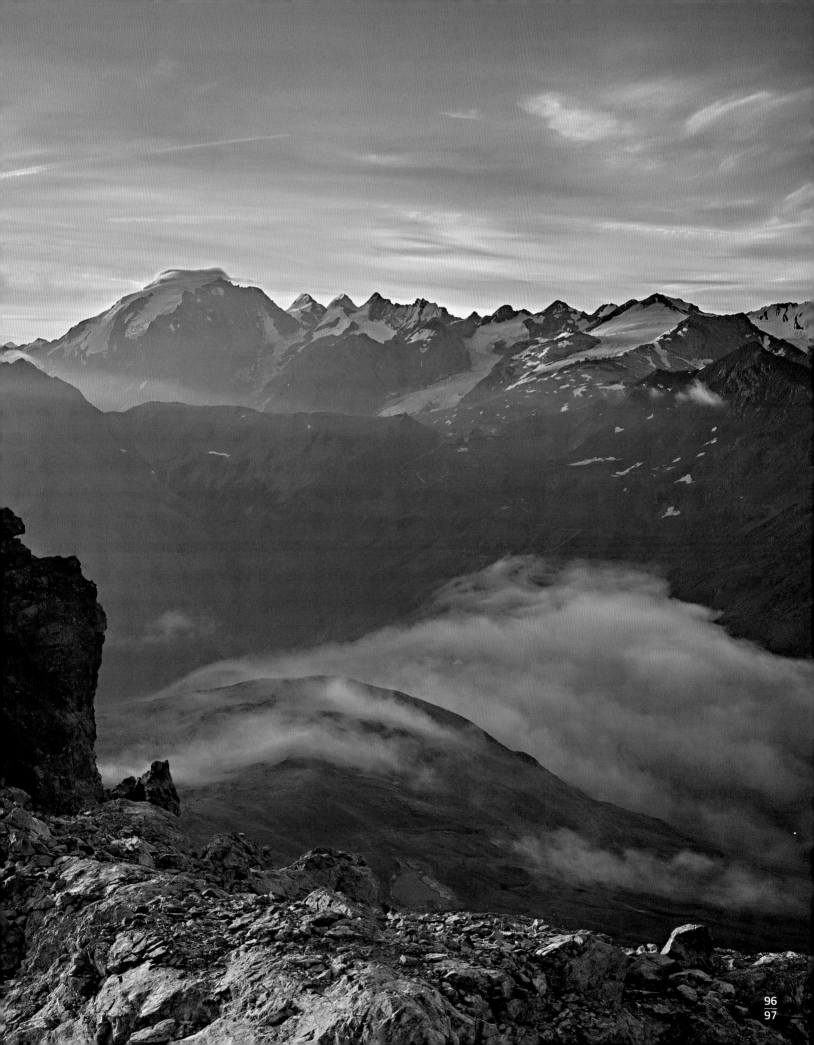

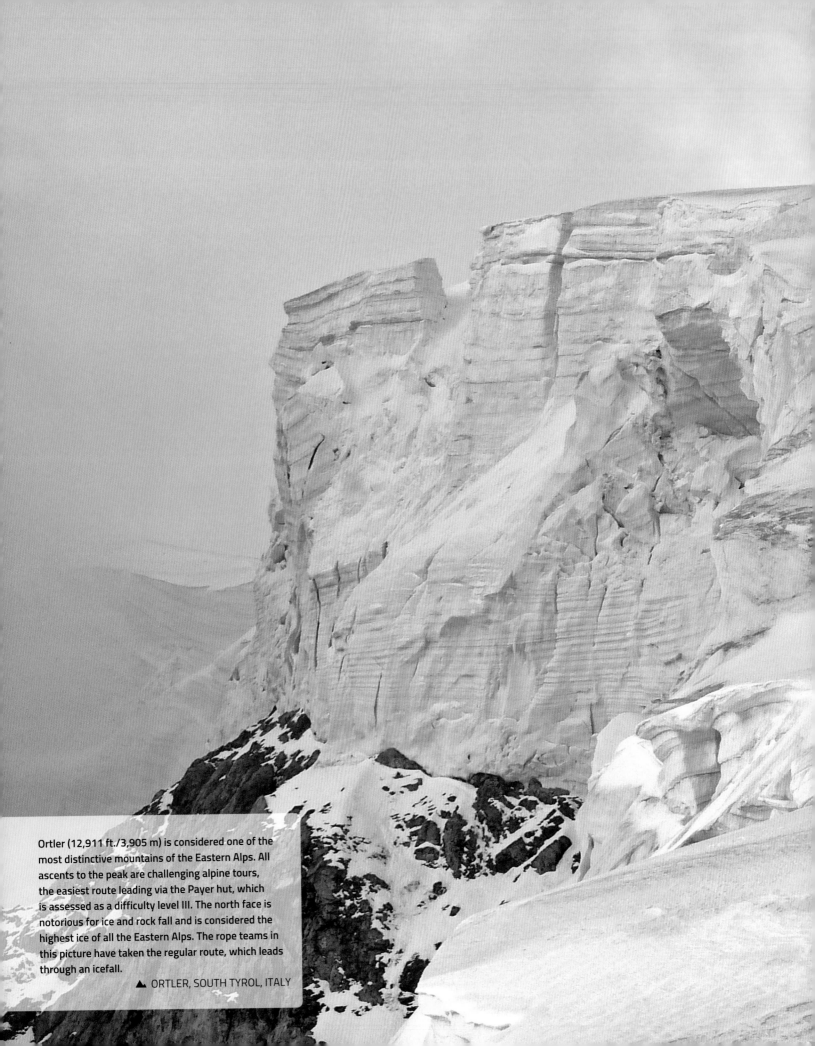

Ortler (12,911 ft./3,905 m) is considered one of the most distinctive mountains of the Eastern Alps. All ascents to the peak are challenging alpine tours, the easiest route leading via the Payer hut, which is assessed as a difficulty level III. The north face is notorious for ice and rock fall and is considered the highest ice of all the Eastern Alps. The rope teams in this picture have taken the regular route, which leads through an icefall.

▲ ORTLER, SOUTH TYROL, ITALY

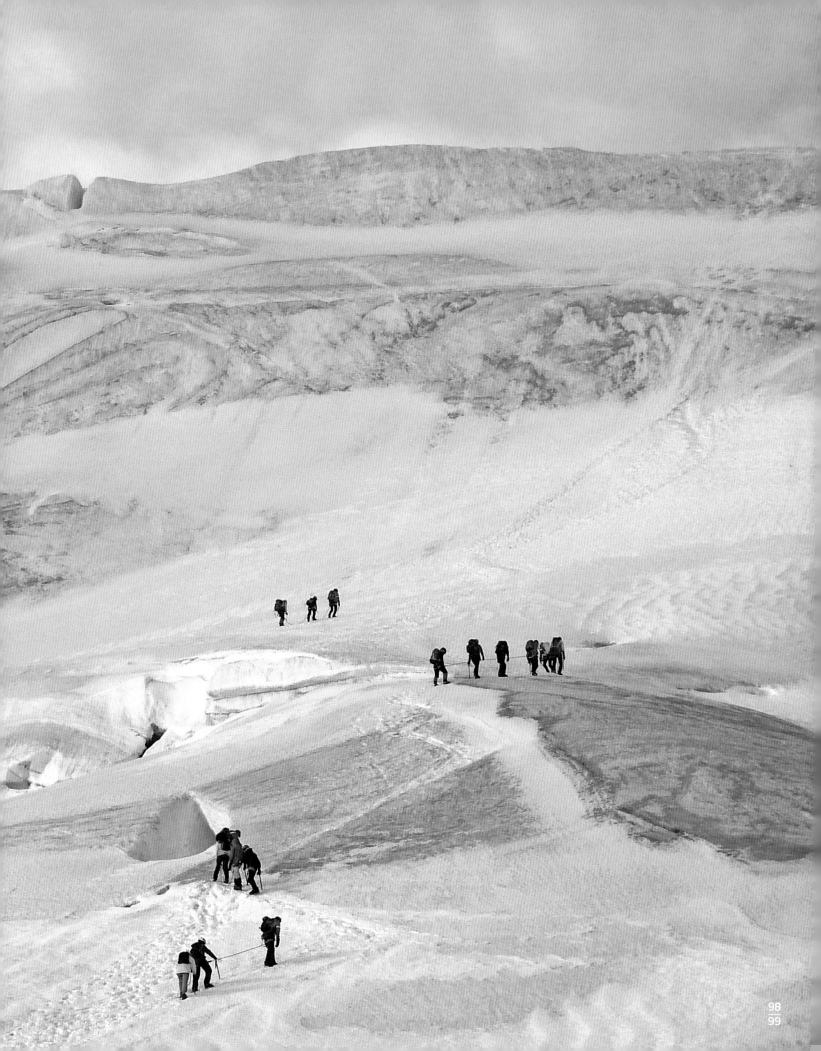

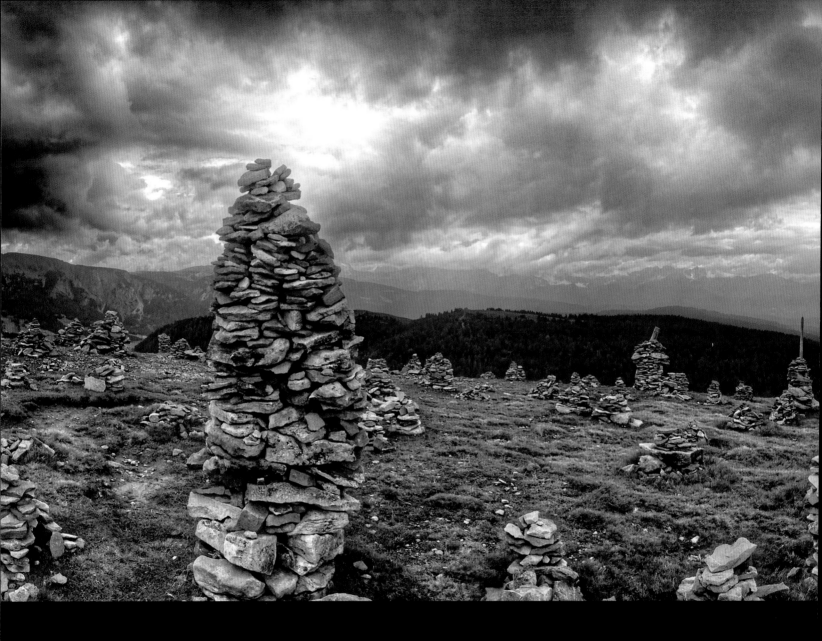

A forest of "stone men" marks the summit plateau of Salten in the Sarntal Alps — a myth-enshrouded location where you almost get the feeling that there are still witches and goblins around.

▲ SALTEN, SOUTH TYROL, ITALY

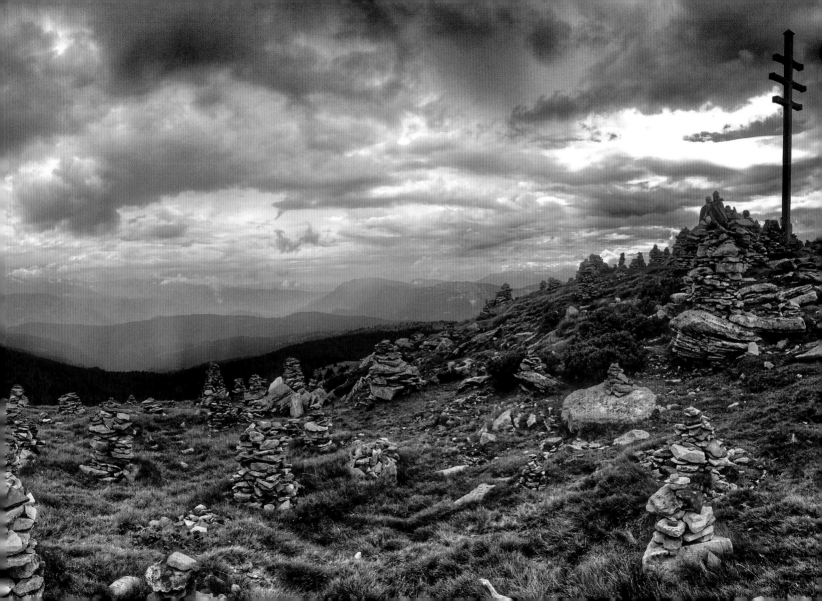

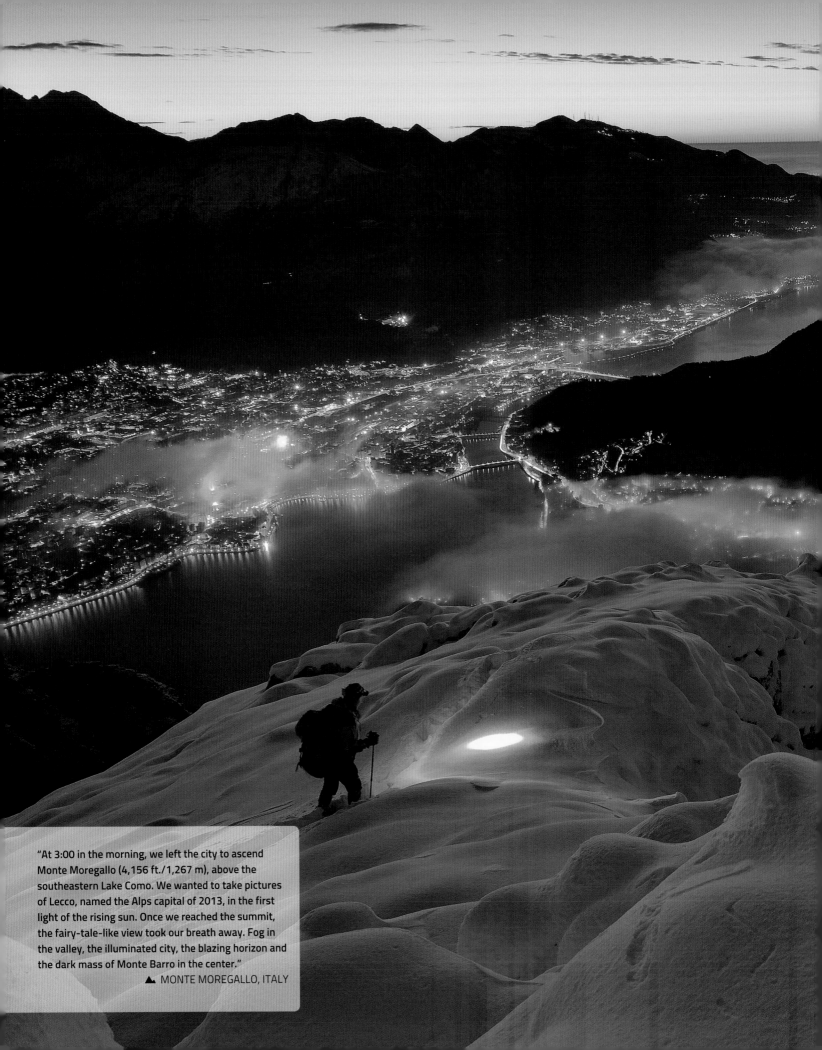

"At 3:00 in the morning, we left the city to ascend Monte Moregallo (4,156 ft./1,267 m), above the southeastern Lake Como. We wanted to take pictures of Lecco, named the Alps capital of 2013, in the first light of the rising sun. Once we reached the summit, the fairy-tale-like view took our breath away. Fog in the valley, the illuminated city, the blazing horizon and the dark mass of Monte Barro in the center."

▲ MONTE MOREGALLO, ITALY

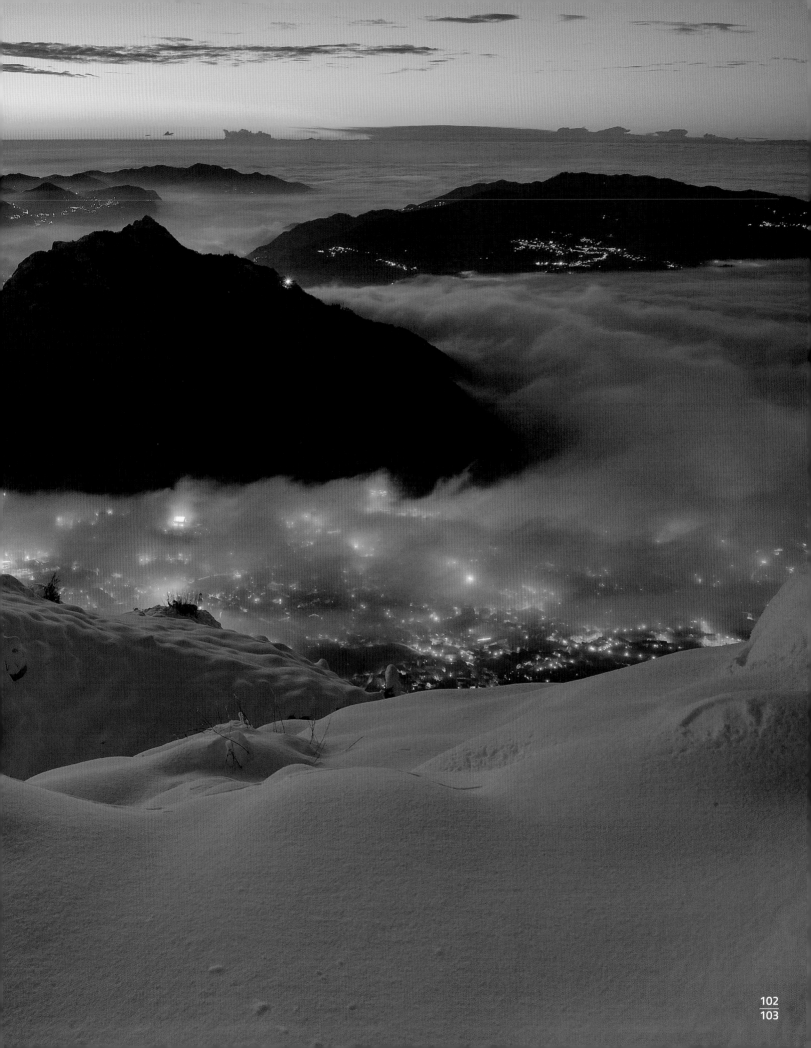

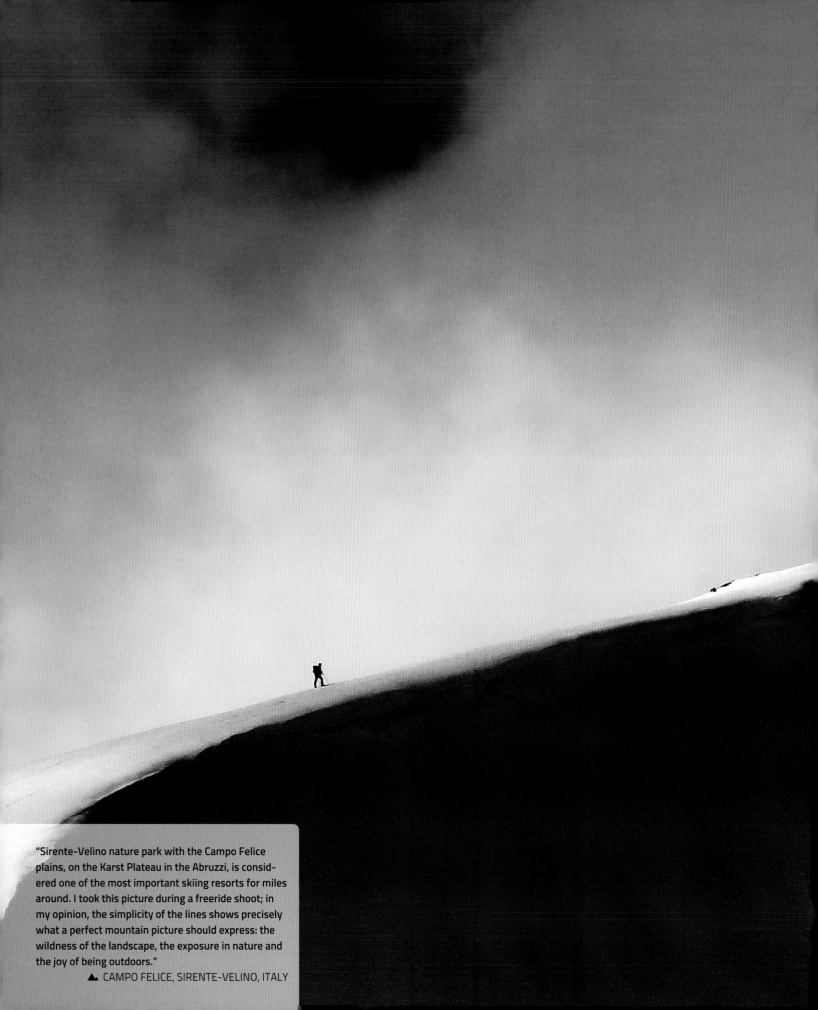

"Sirente-Velino nature park with the Campo Felice plains, on the Karst Plateau in the Abruzzi, is considered one of the most important skiing resorts for miles around. I took this picture during a freeride shoot; in my opinion, the simplicity of the lines shows precisely what a perfect mountain picture should express: the wildness of the landscape, the exposure in nature and the joy of being outdoors."

▲ CAMPO FELICE, SIRENTE-VELINO, ITALY

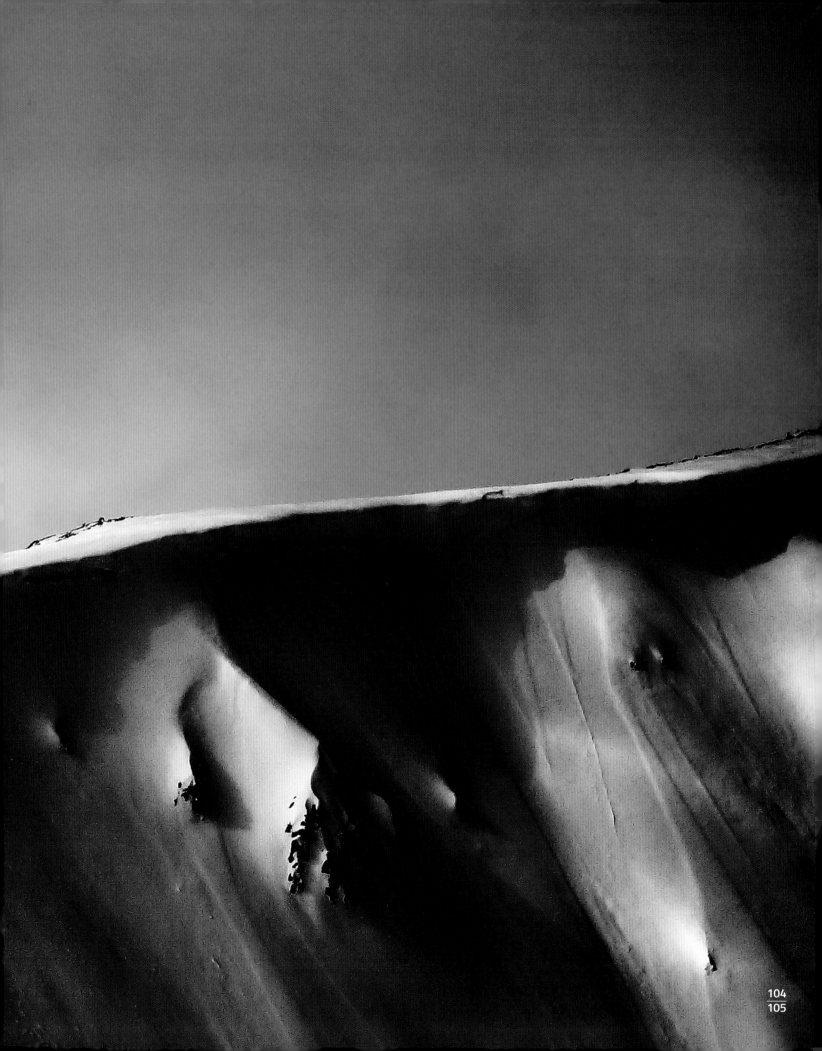

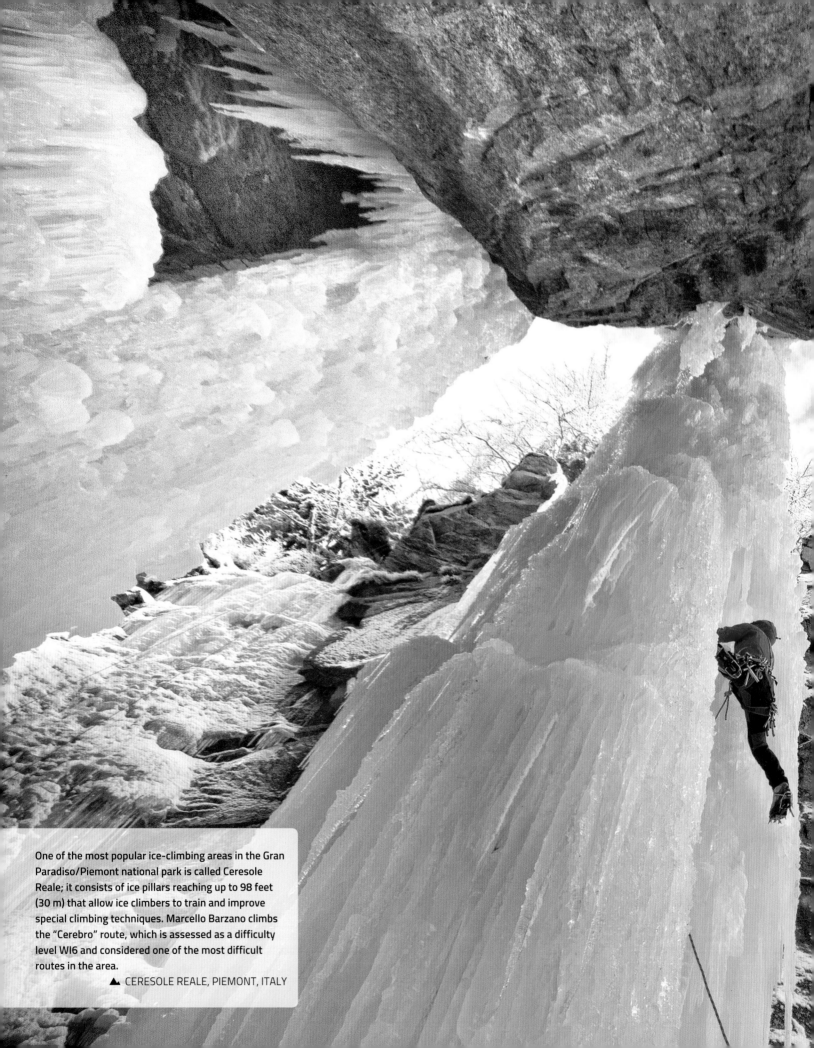

One of the most popular ice-climbing areas in the Gran Paradiso/Piemont national park is called Ceresole Reale; it consists of ice pillars reaching up to 98 feet (30 m) that allow ice climbers to train and improve special climbing techniques. Marcello Barzano climbs the "Cerebro" route, which is assessed as a difficulty level WI6 and considered one of the most difficult routes in the area.

▲ CERESOLE REALE, PIEMONT, ITALY

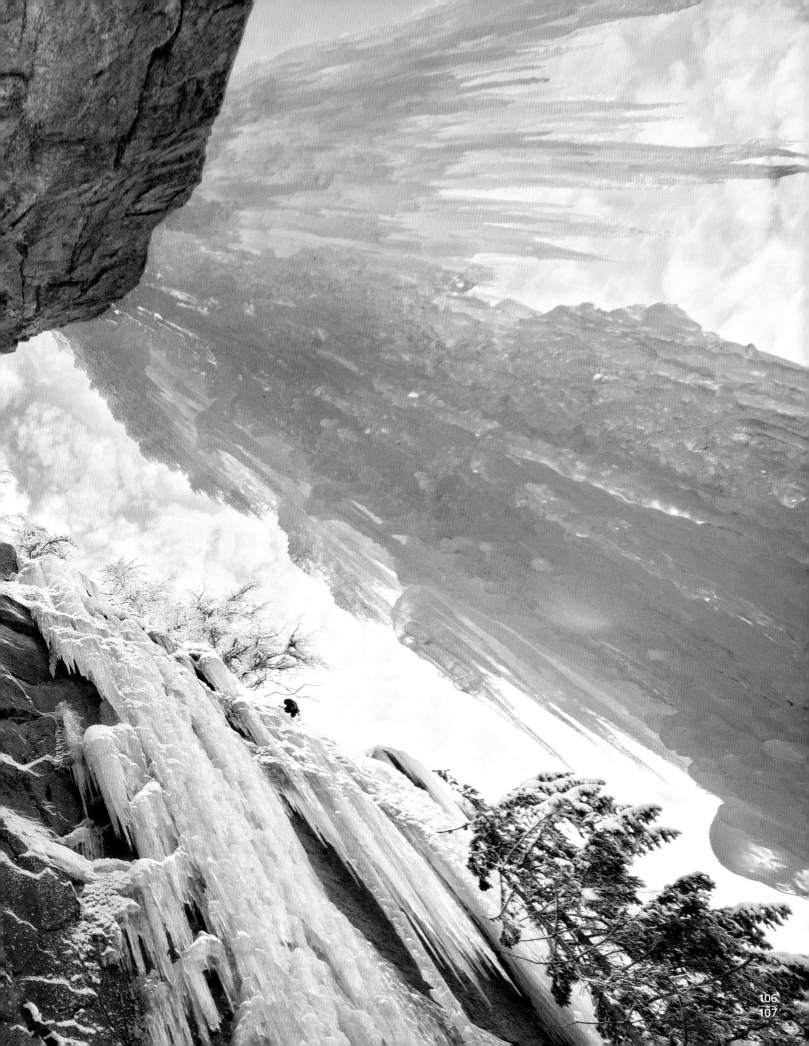

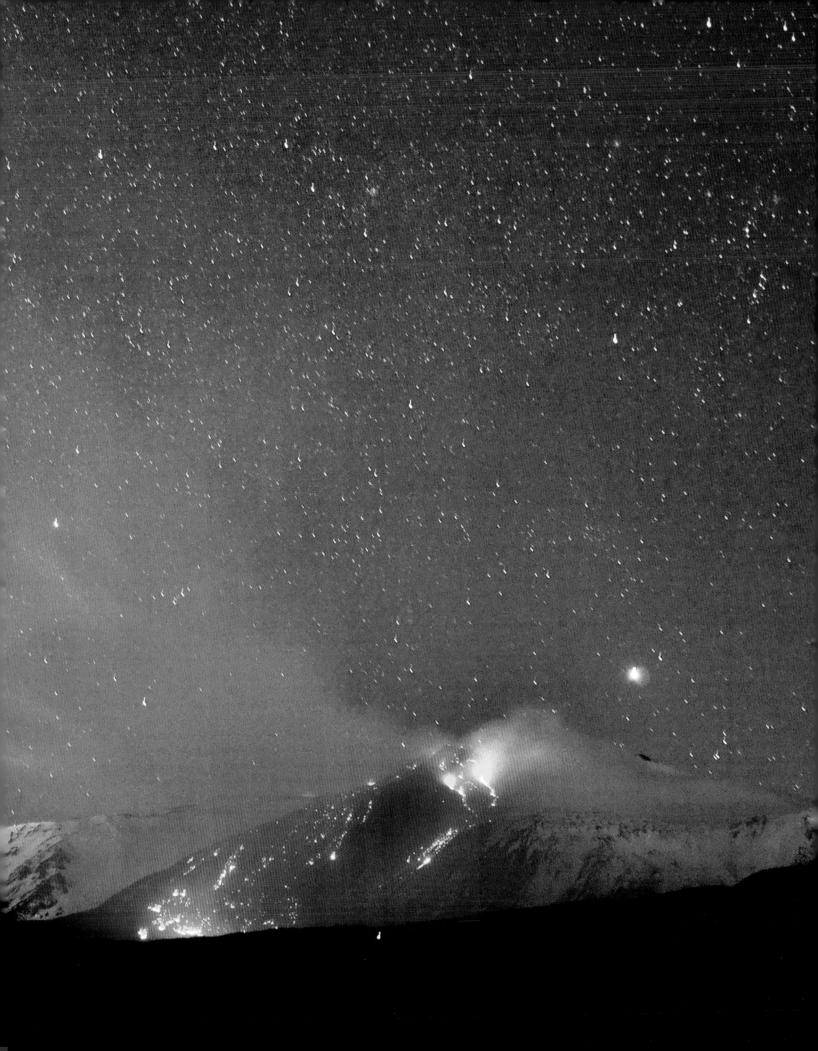

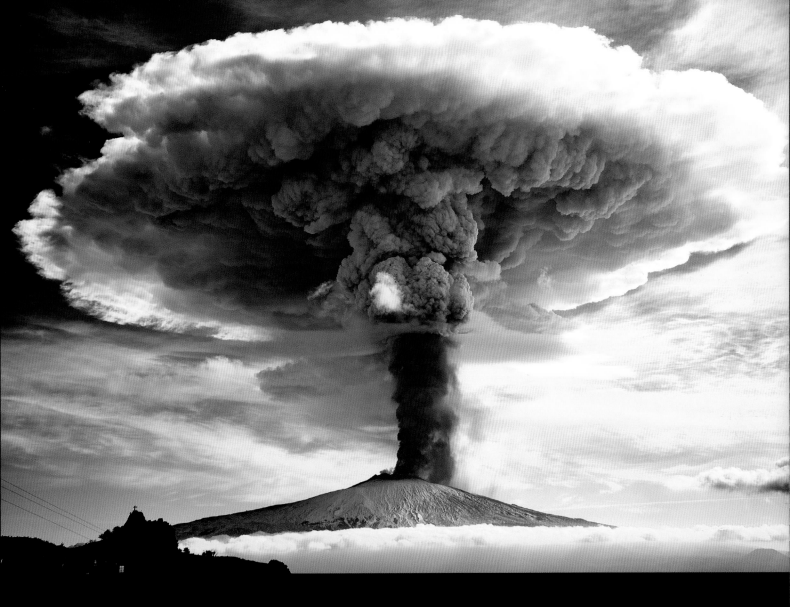

"Mount Etna is the highest and most active volcano in Europe; at almost 11,000 feet (3,350 m) it is the highest peak on the island of Sicily. On April 3, 2013, I was able to take this picture of the last phase of this paroxysm (an increasing sequence of volcanic eruptions). As I see it, this picture combines the grandeur and beauty of the four primal elements: earth, fire, ice and wind."

▲ MOUNT ETNA, SICILY, ITALY

Looking like a huge mushroom cloud, an enormous ash cloud rises into the sky. In the fall and winter of 2015, Mount Etna was extremely active; according to experts, the eruption on December 4 (as seen in the image from Cesarò in Messina) is considered one of the most severe of the past decades. A huge cloud of ash moved northeast in the direction of the large cities of Messina and Reggio Calabria.

▲ MOUNT ETNA, SICILY, ITALY

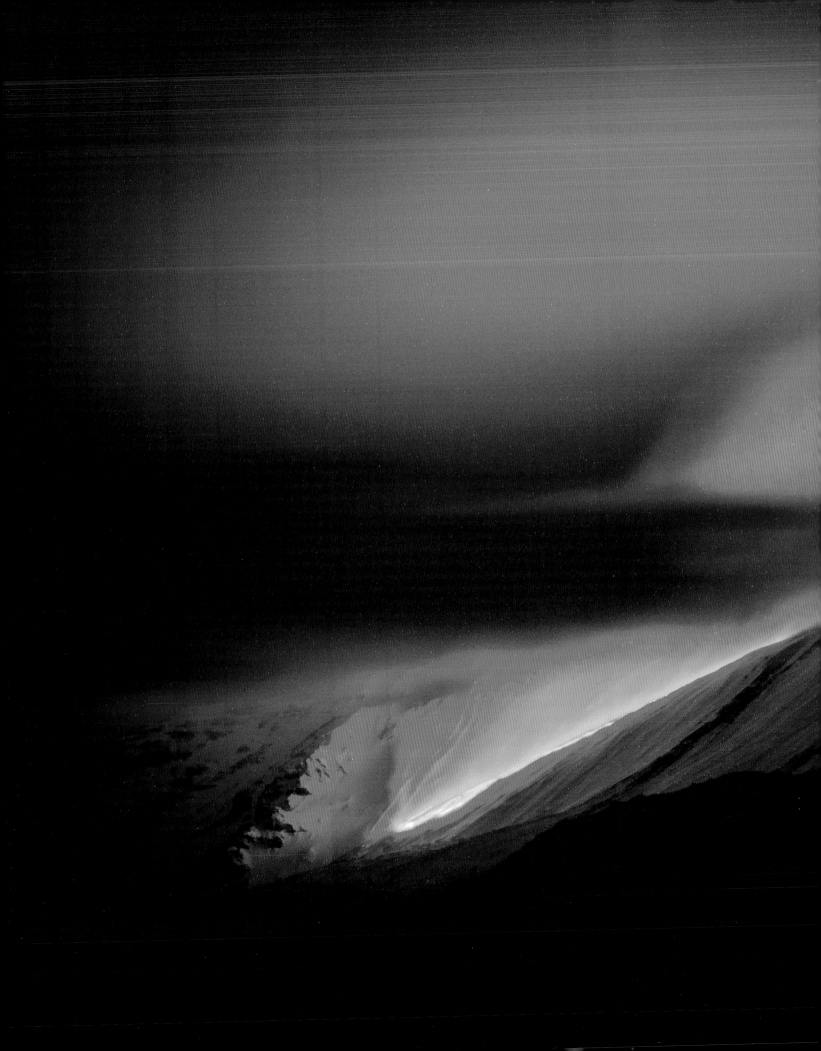

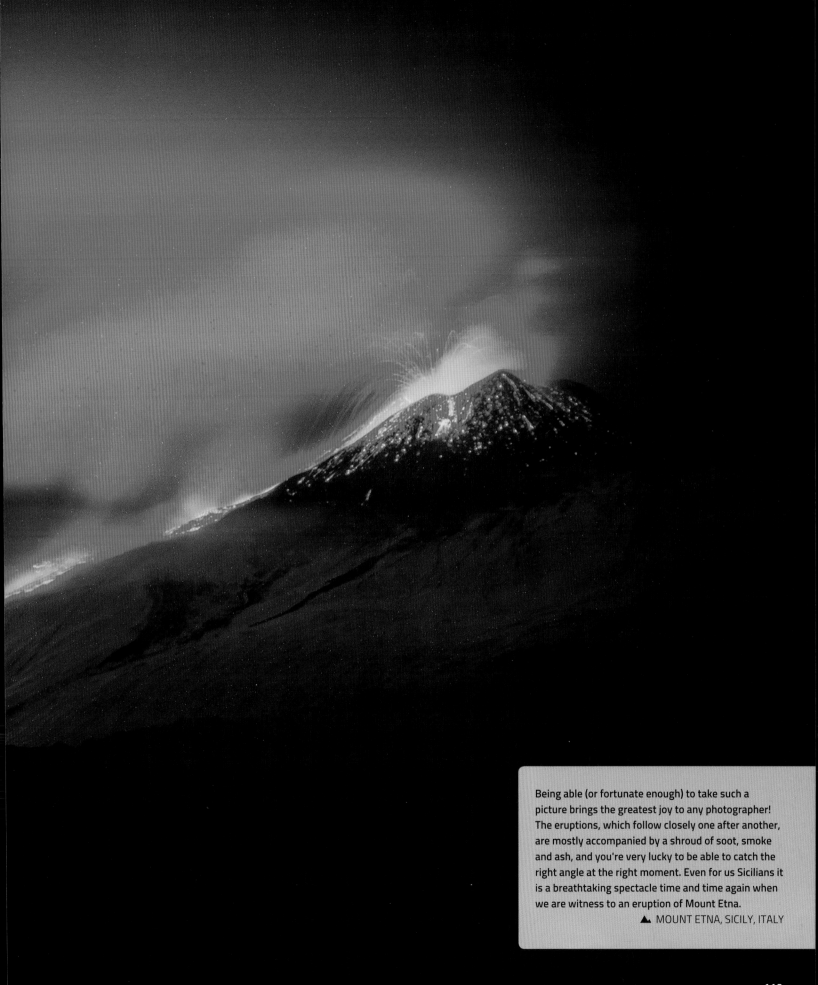

Being able (or fortunate enough) to take such a picture brings the greatest joy to any photographer! The eruptions, which follow closely one after another, are mostly accompanied by a shroud of soot, smoke and ash, and you're very lucky to be able to catch the right angle at the right moment. Even for us Sicilians it is a breathtaking spectacle time and time again when we are witness to an eruption of Mount Etna.

▲ MOUNT ETNA, SICILY, ITALY

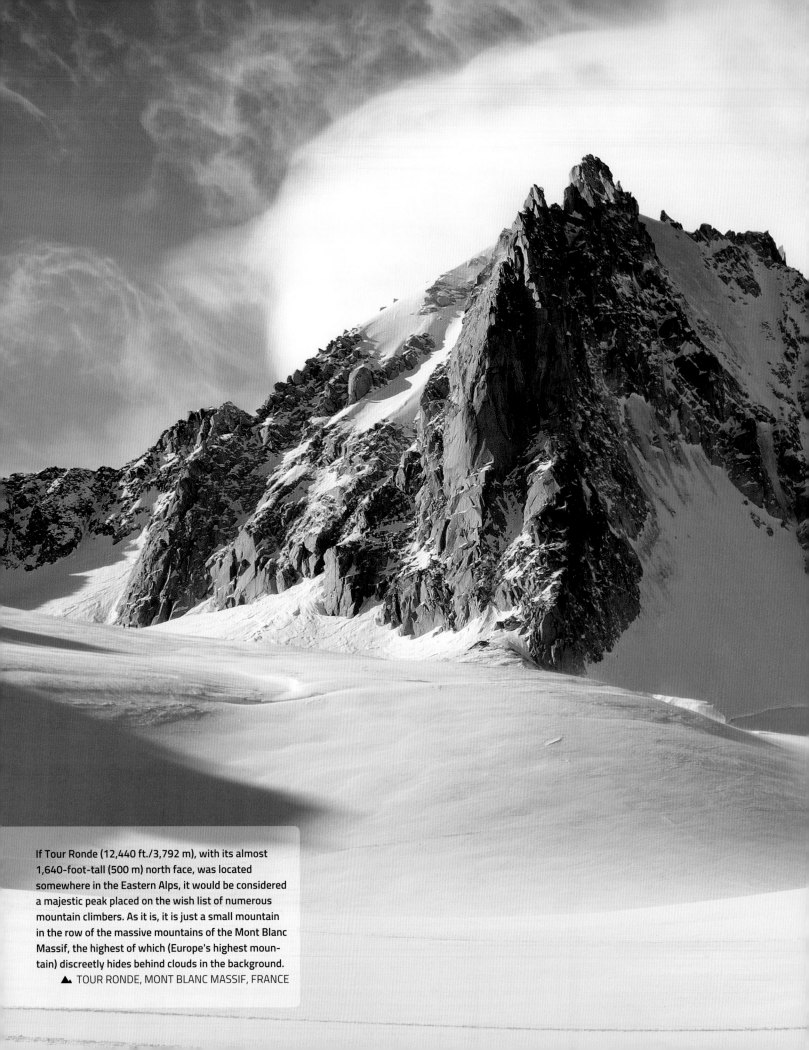

If Tour Ronde (12,440 ft./3,792 m), with its almost 1,640-foot-tall (500 m) north face, was located somewhere in the Eastern Alps, it would be considered a majestic peak placed on the wish list of numerous mountain climbers. As it is, it is just a small mountain in the row of the massive mountains of the Mont Blanc Massif, the highest of which (Europe's highest mountain) discreetly hides behind clouds in the background.

▲ TOUR RONDE, MONT BLANC MASSIF, FRANCE

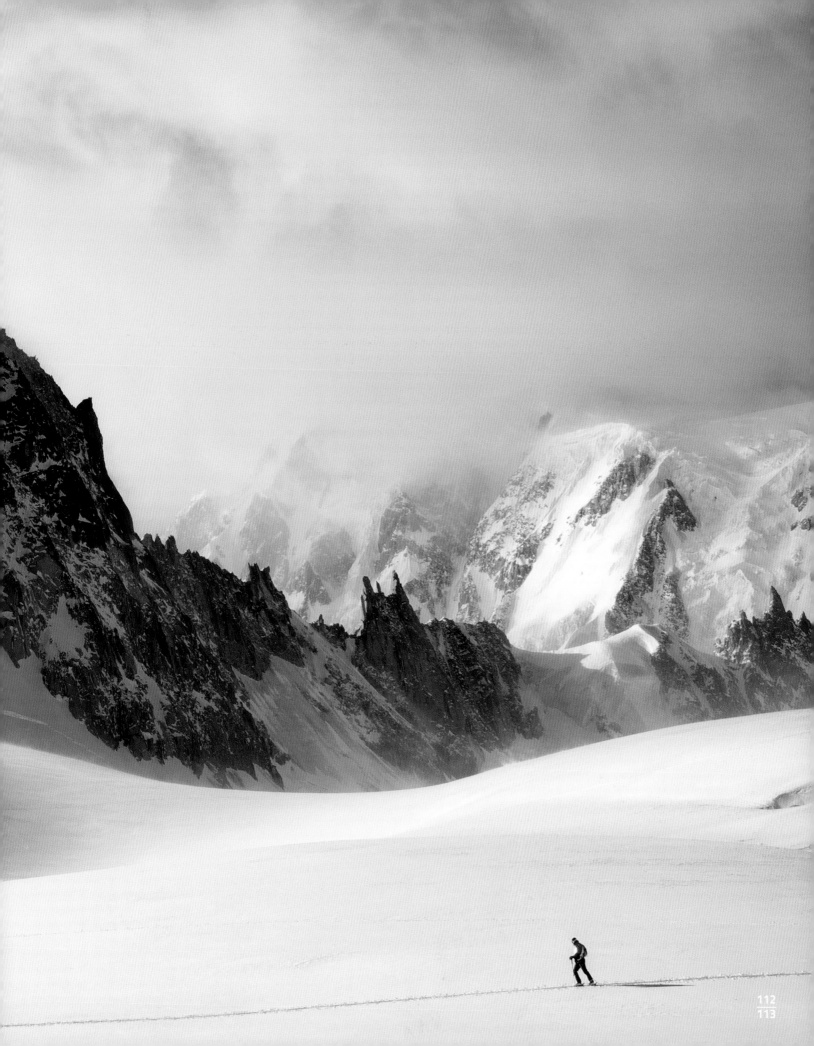

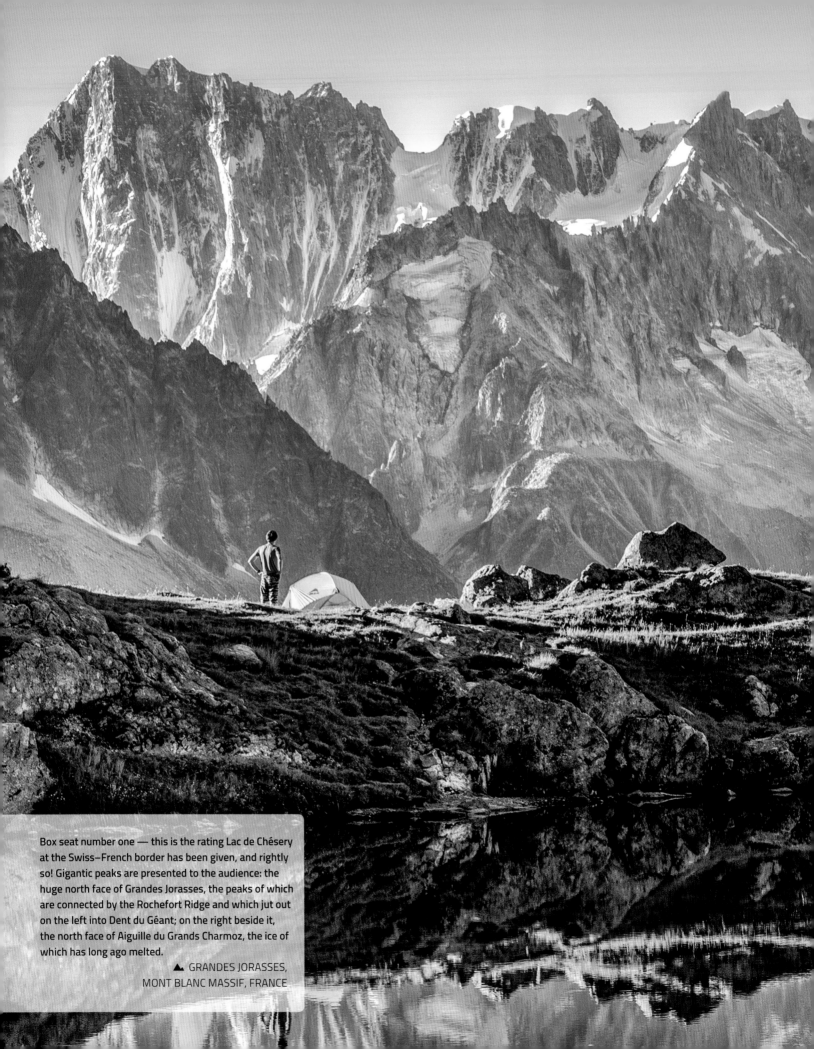

Box seat number one — this is the rating Lac de Chêsery at the Swiss–French border has been given, and rightly so! Gigantic peaks are presented to the audience: the huge north face of Grandes Jorasses, the peaks of which are connected by the Rochefort Ridge and which jut out on the left into Dent du Géant; on the right beside it, the north face of Aiguille du Grands Charmoz, the ice of which has long ago melted.

▲ GRANDES JORASSES,
MONT BLANC MASSIF, FRANCE

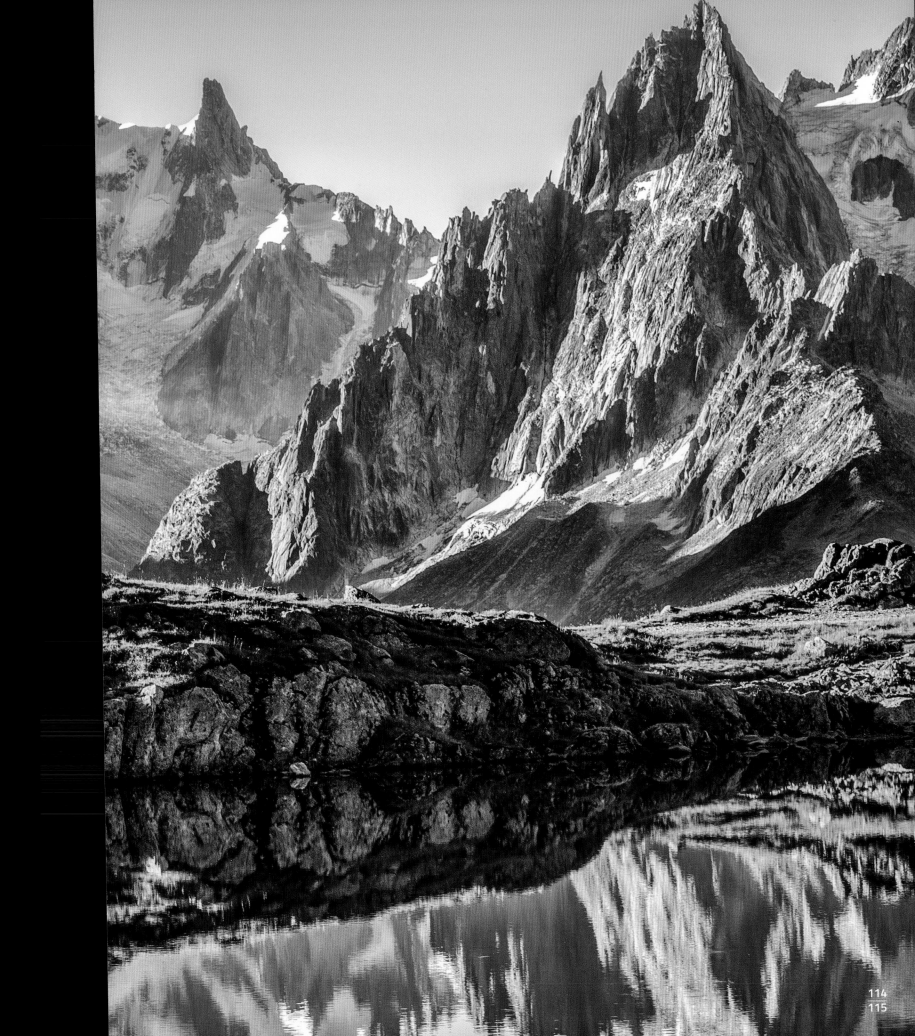

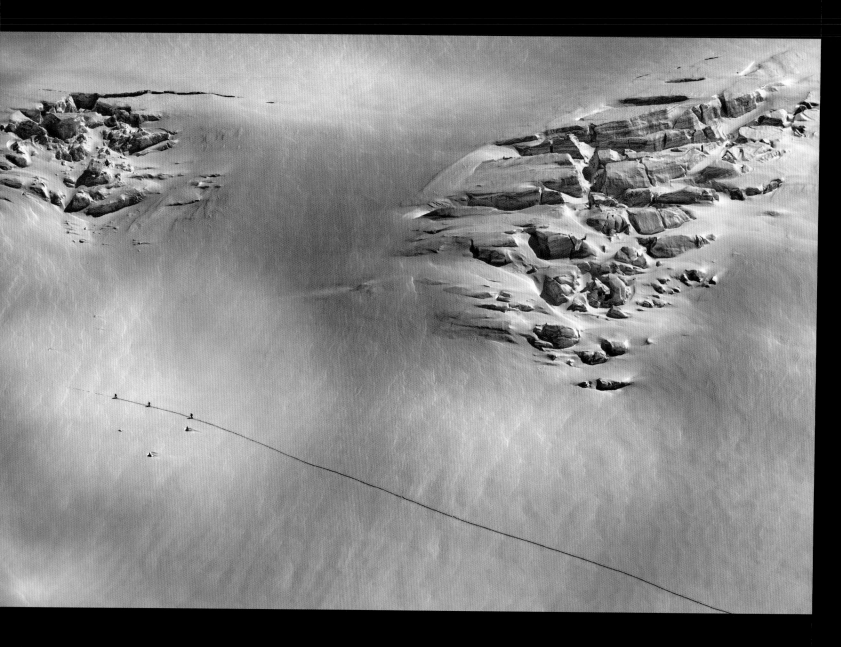

Light and shade play in the Vallée Blanche, the largest glacial valley of the Mont Blanc Massif; rays of sunlight, filtered by fog, trace the structures of the ice impressively, and the three mountain climbers look like small ants compared to the immenseness of the mountains.

▲ MONT BLANC, FRANCE

"*To Draw the Line* — Being the first to leave a trace in the untouched snow that leads to the summit. This is one of the fascinations of mountain climbing. This picture is part of a series of photos that I called *About a Little Man*, that started in the Mont Blanc Massif; the 'little man' is en route on the summit ridge toward the Mont Blanc."

▲ MONT BLANC, FRANCE

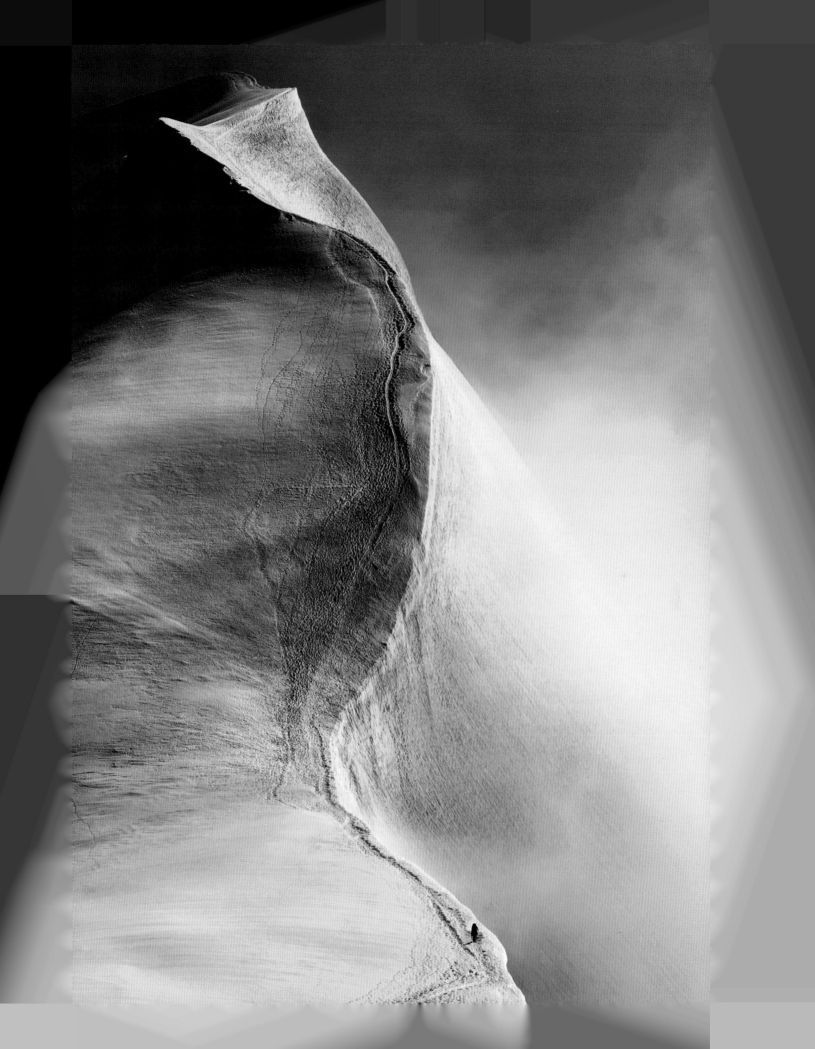

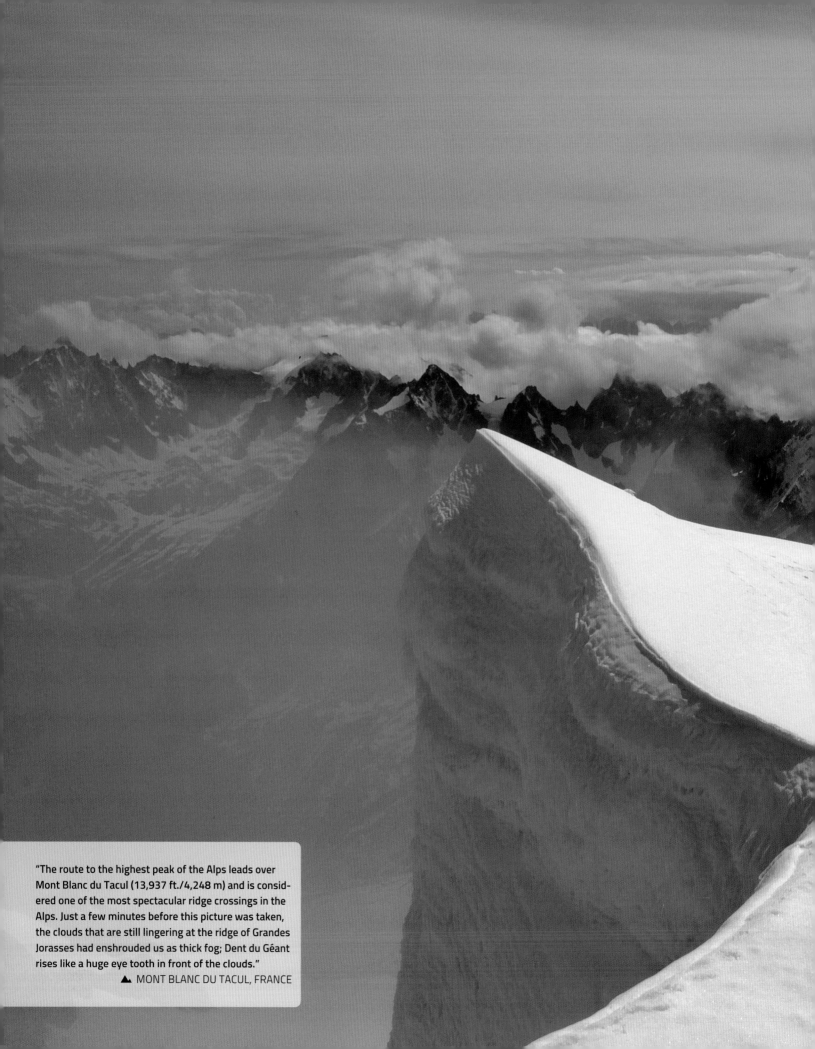

"The route to the highest peak of the Alps leads over Mont Blanc du Tacul (13,937 ft./4,248 m) and is considered one of the most spectacular ridge crossings in the Alps. Just a few minutes before this picture was taken, the clouds that are still lingering at the ridge of Grandes Jorasses had enshrouded us as thick fog; Dent du Géant rises like a huge eye tooth in front of the clouds."

▲ MONT BLANC DU TACUL, FRANCE

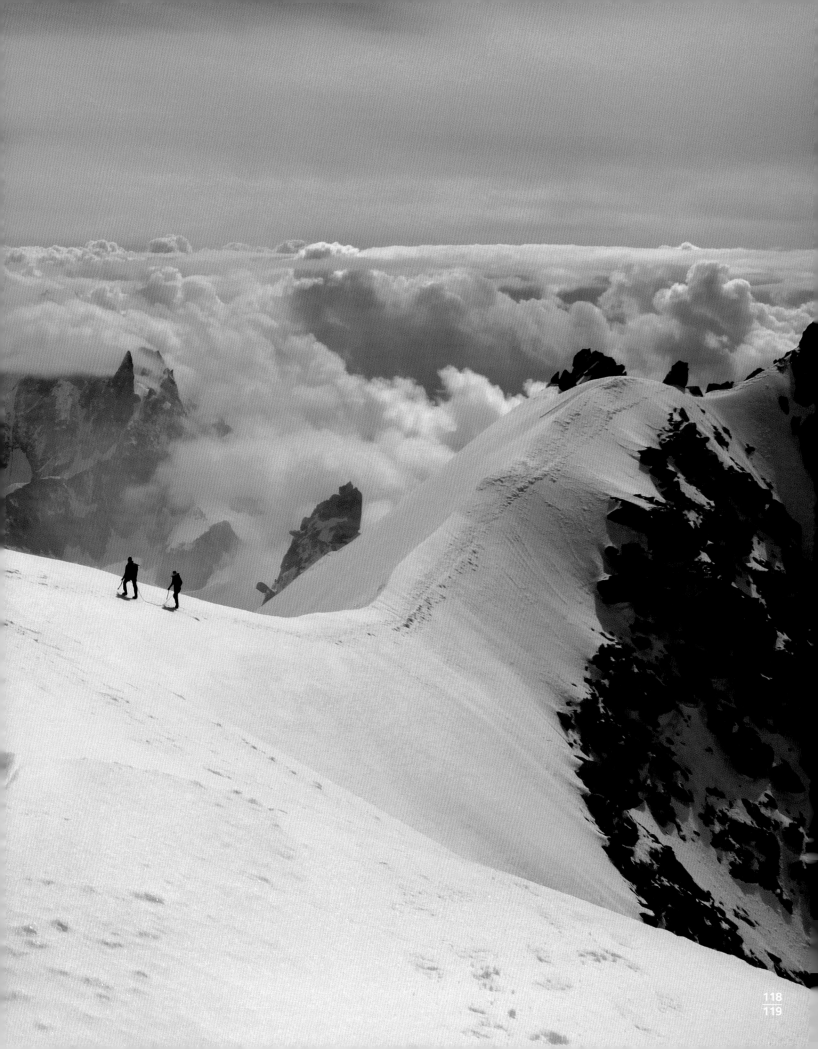

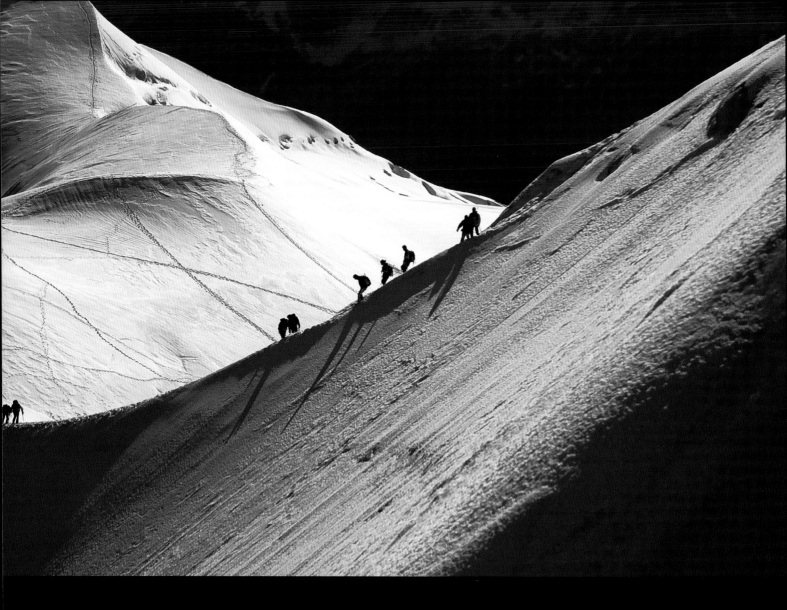

On route with the gondola from Chamonix to Aiguille du Midi, shortly before the mountain station, you get this amazing view of the firn ridge Arête de l'Aiguille du Midi and the Vallée Blanche. There is lots of activity here even early in the morning, and especially when the weather is nice.

▲ AIGUILLE DU MIDI, CHAMONIX, FRANCE

"You could call this picture *Flying Through the Air*; an unknown climber falls during the attempt to climb 'No Future' (8c+) in the 'Biography' section (a short climbing route) in the Southern French climbing region of Céüse. He had flown through the air before and I was pretty sure that he would make a second attempt at it. So I patiently waited with my camera."

▲ CÉÜSE, FRANCE

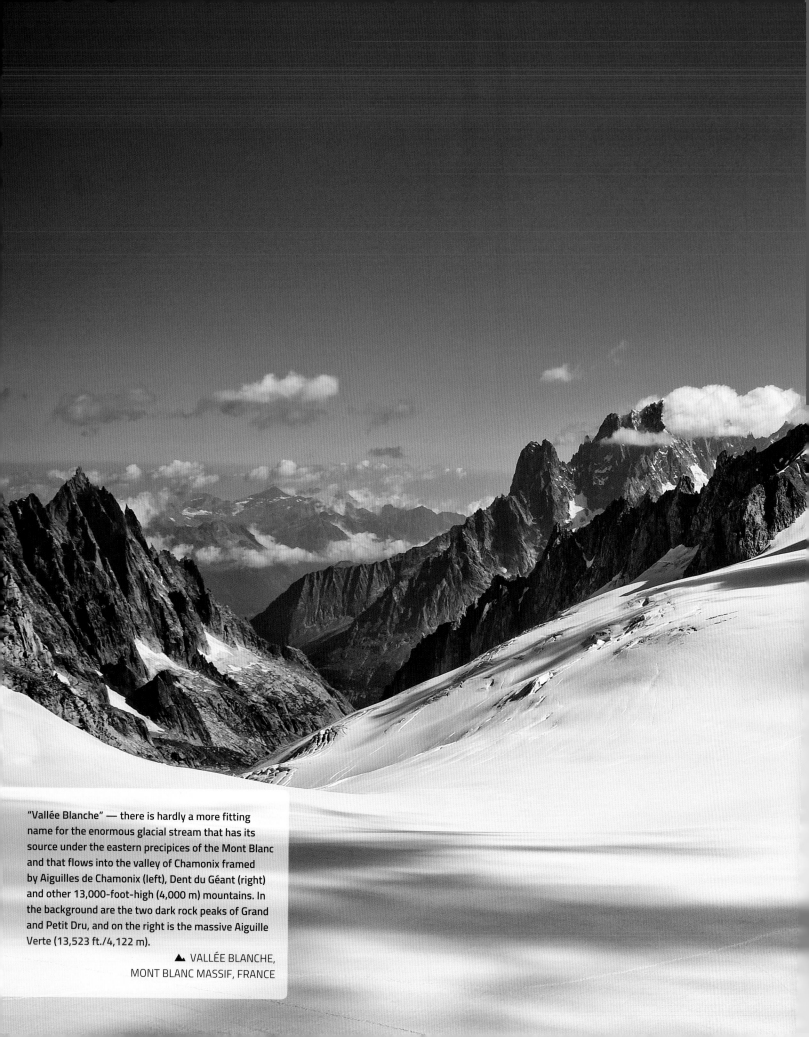

"Vallée Blanche" — there is hardly a more fitting name for the enormous glacial stream that has its source under the eastern precipices of the Mont Blanc and that flows into the valley of Chamonix framed by Aiguilles de Chamonix (left), Dent du Géant (right) and other 13,000-foot-high (4,000 m) mountains. In the background are the two dark rock peaks of Grand and Petit Dru, and on the right is the massive Aiguille Verte (13,523 ft./4,122 m).

▲ VALLÉE BLANCHE,
MONT BLANC MASSIF, FRANCE

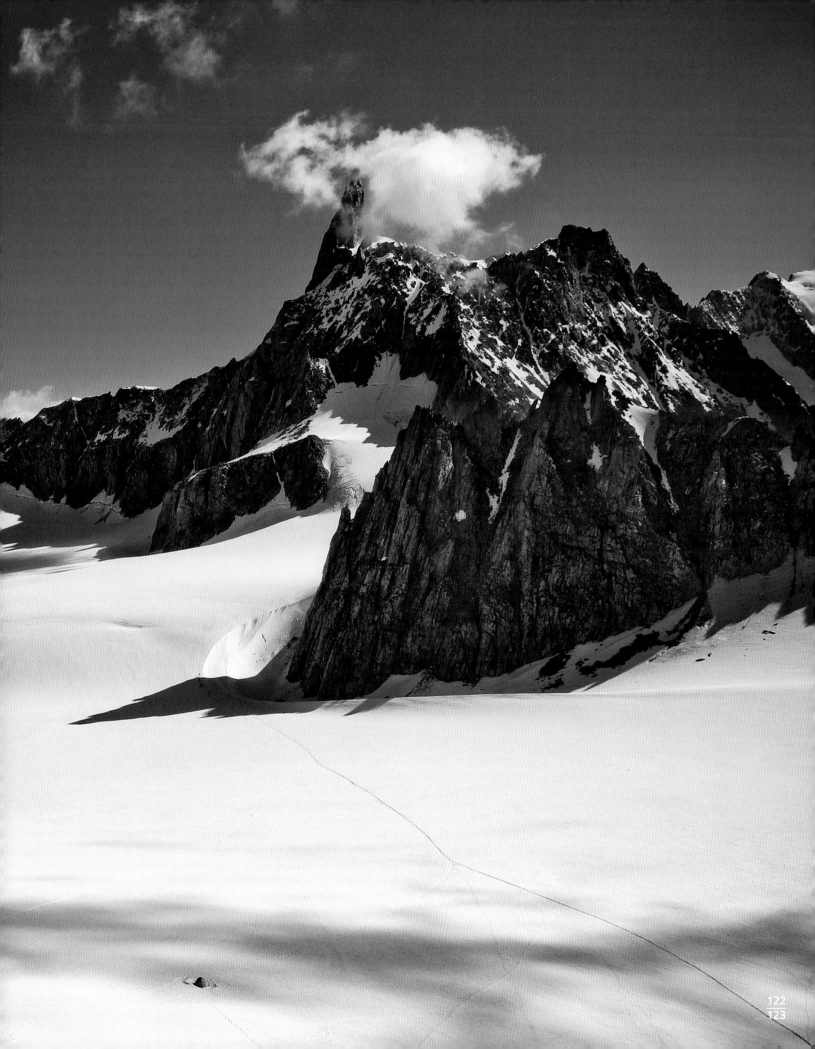

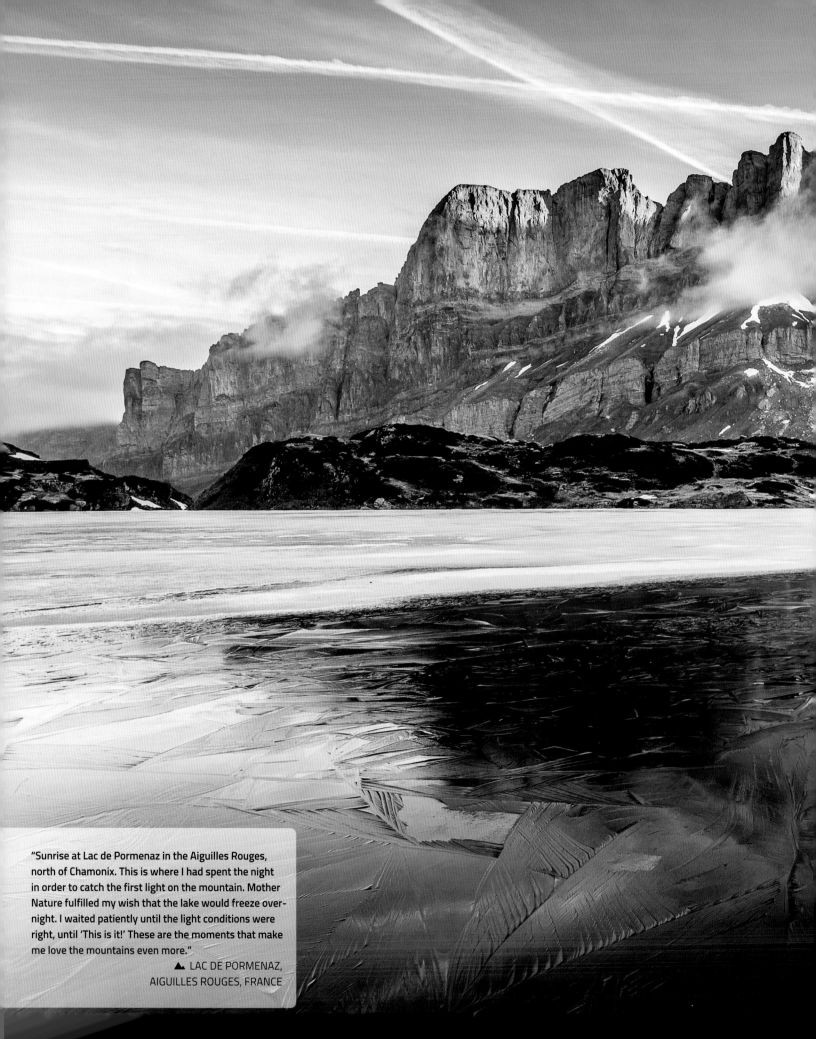

"Sunrise at Lac de Pormenaz in the Aiguilles Rouges, north of Chamonix. This is where I had spent the night in order to catch the first light on the mountain. Mother Nature fulfilled my wish that the lake would freeze overnight. I waited patiently until the light conditions were right, until 'This is it!' These are the moments that make me love the mountains even more."

▲ LAC DE PORMENAZ,
AIGUILLES ROUGES, FRANCE

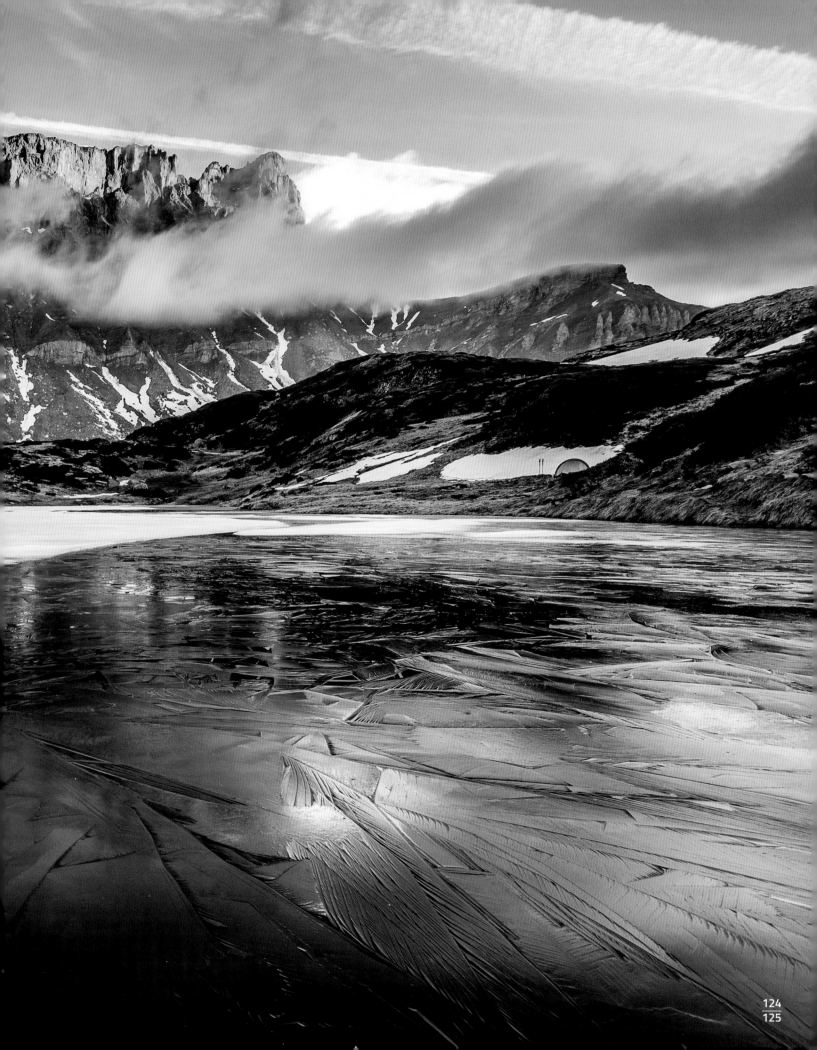

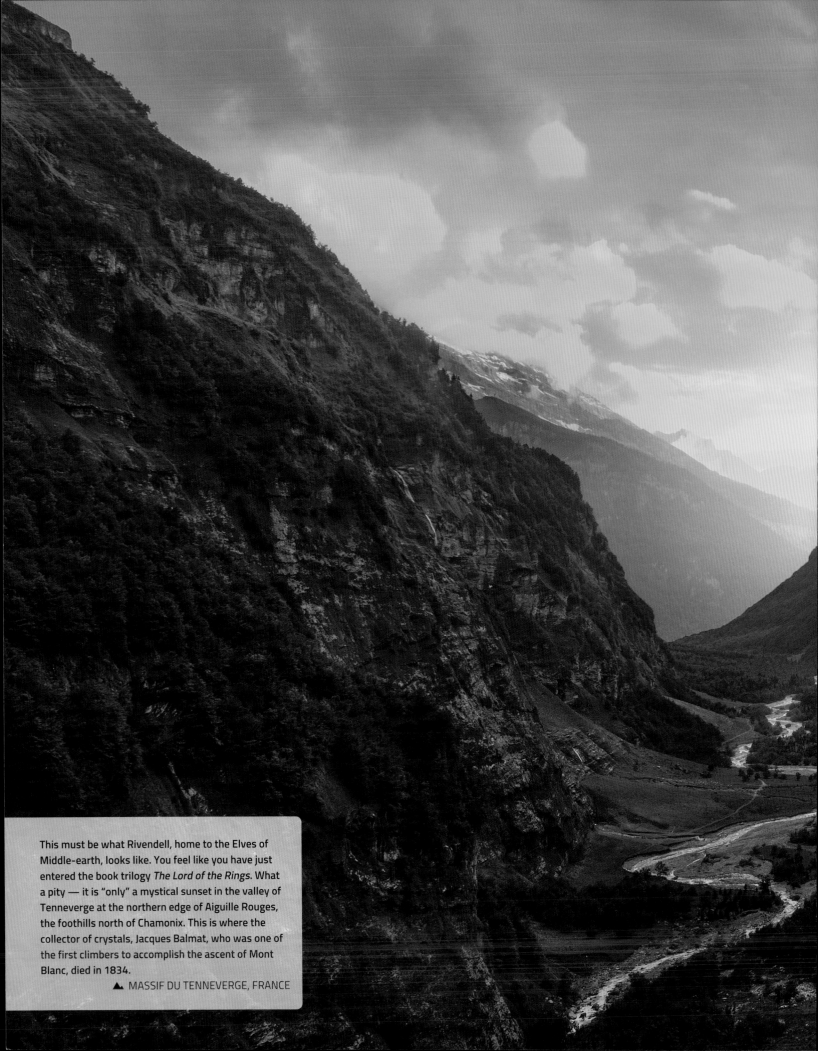

This must be what Rivendell, home to the Elves of Middle-earth, looks like. You feel like you have just entered the book trilogy *The Lord of the Rings*. What a pity — it is "only" a mystical sunset in the valley of Tenneverge at the northern edge of Aiguille Rouges, the foothills north of Chamonix. This is where the collector of crystals, Jacques Balmat, who was one of the first climbers to accomplish the ascent of Mont Blanc, died in 1834.

▲ MASSIF DU TENNEVERGE, FRANCE

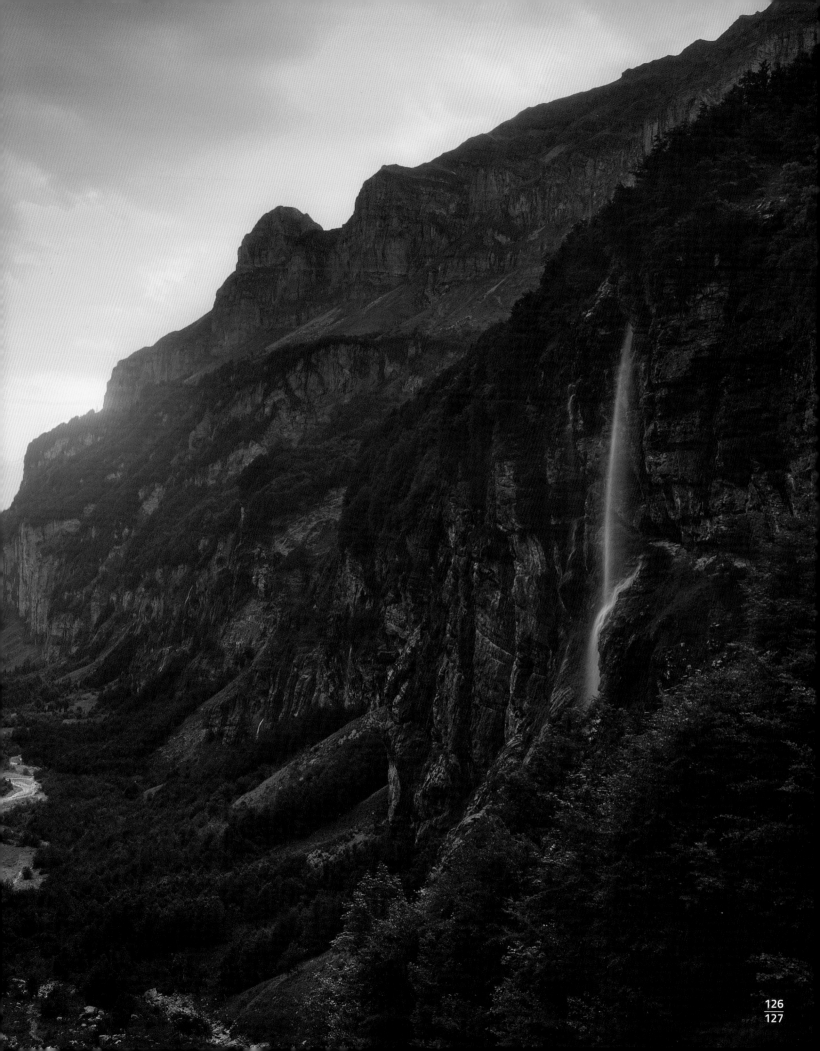

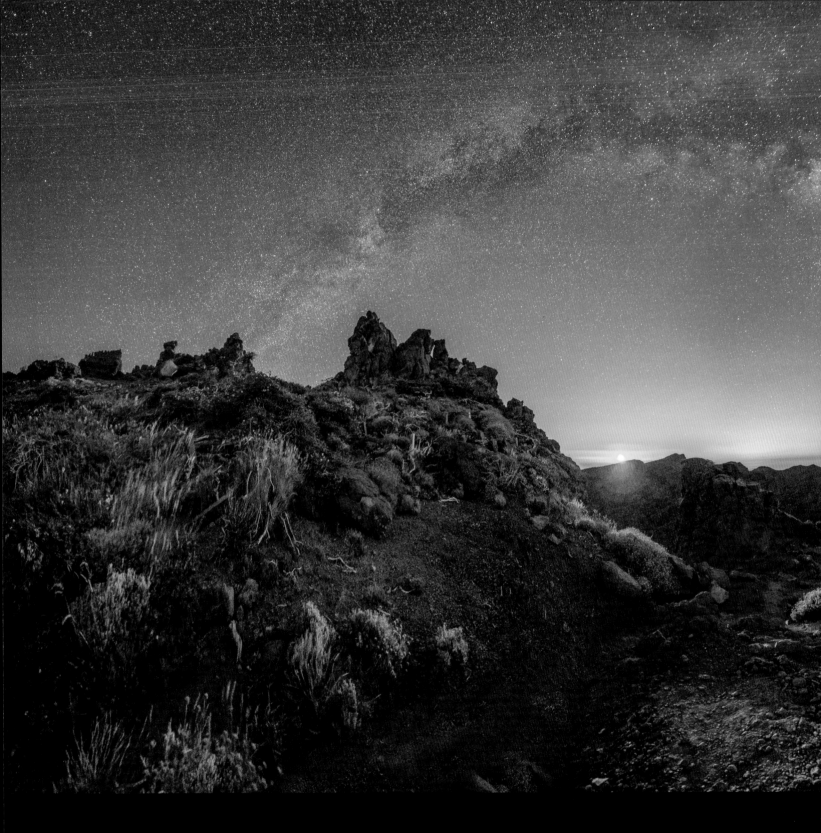

"La Palma is one of the the top spots in the world for stargazers. Last July in the Roque de los Muchachos mountains, I had just taken some breathtaking pictures of the Milky Way and was walking back to the car, when suddenly the moon rose on the horizon! Wow! I immediately set up my tripod, attached my mirrorless Sony a6000 with the Samyang-12-mm-f2.0 lens and was able to catch this panoramic view made of ten individual pictures (ISO 6400/f2.0/25 sec exposure time for each picture)."

▲ CALDERA DE TABURIENTE, LA PALMA

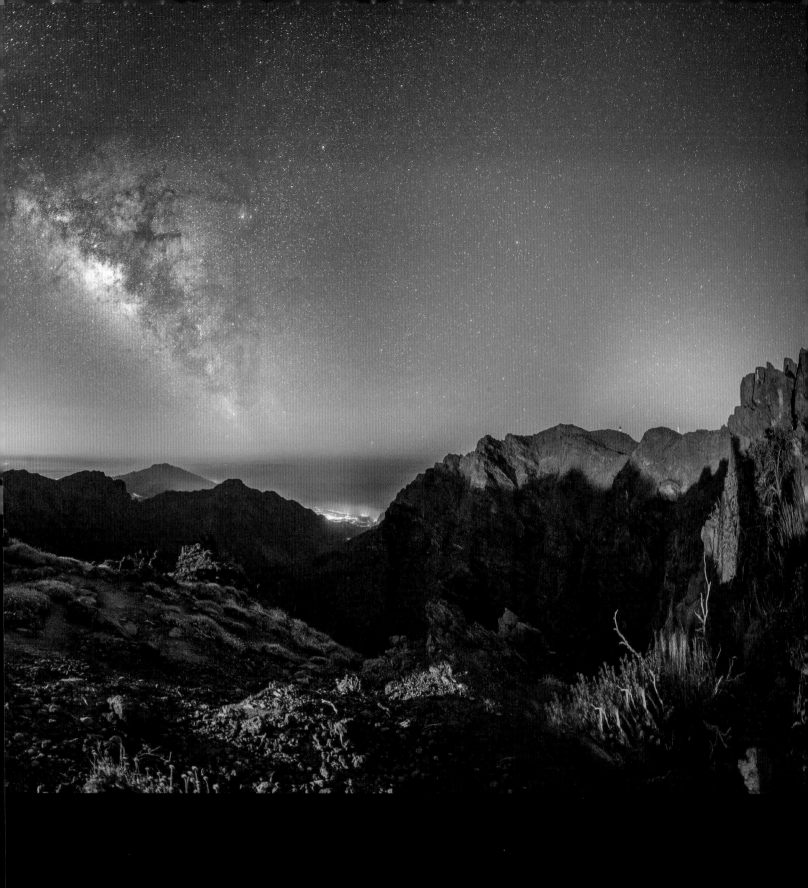

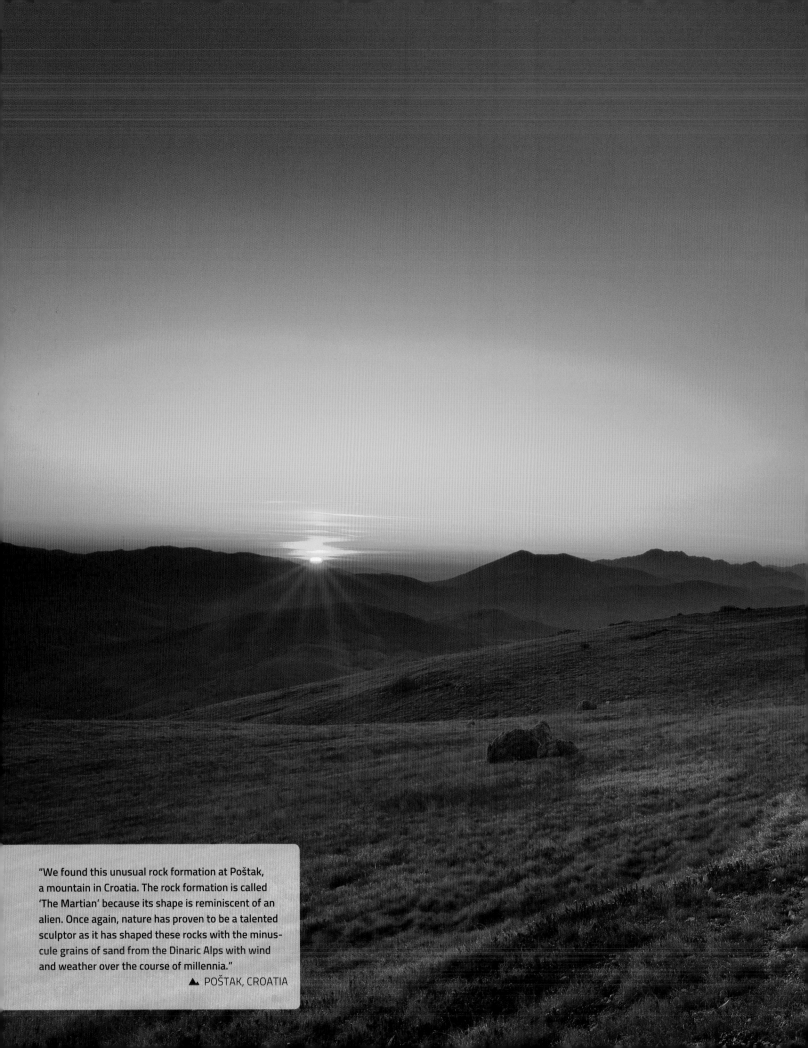

"We found this unusual rock formation at Poštak, a mountain in Croatia. The rock formation is called 'The Martian' because its shape is reminiscent of an alien. Once again, nature has proven to be a talented sculptor as it has shaped these rocks with the minuscule grains of sand from the Dinaric Alps with wind and weather over the course of millennia."

▲ POŠTAK, CROATIA

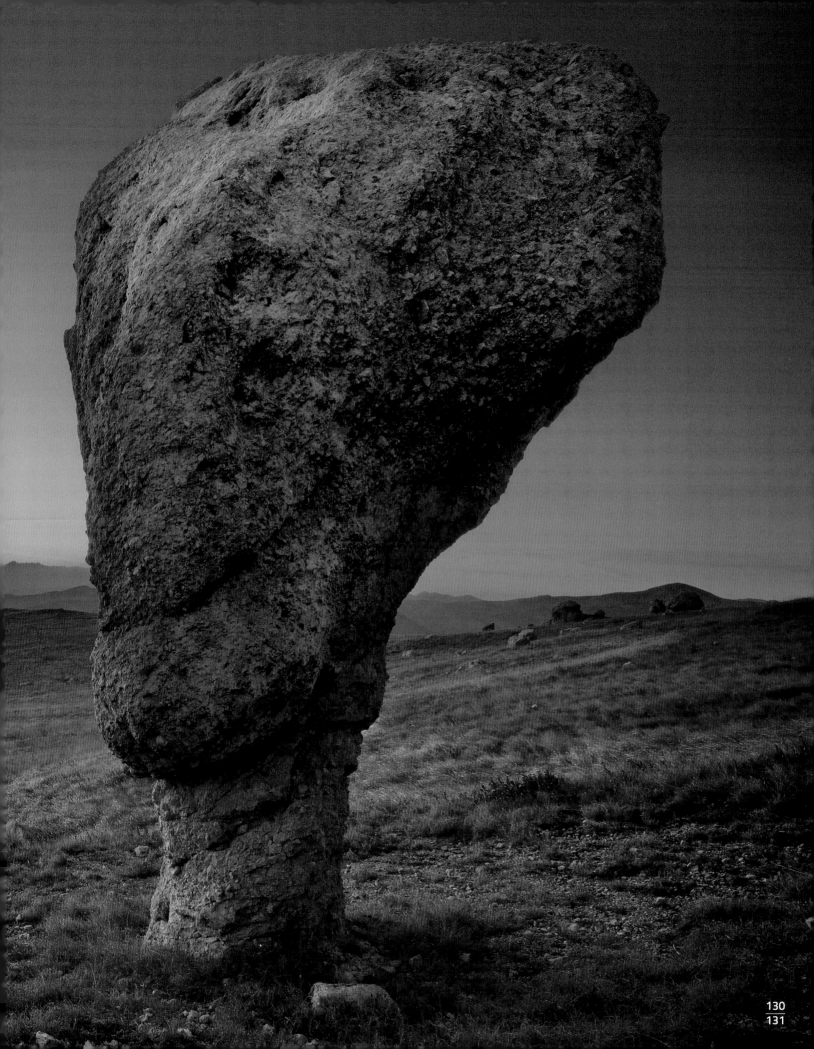

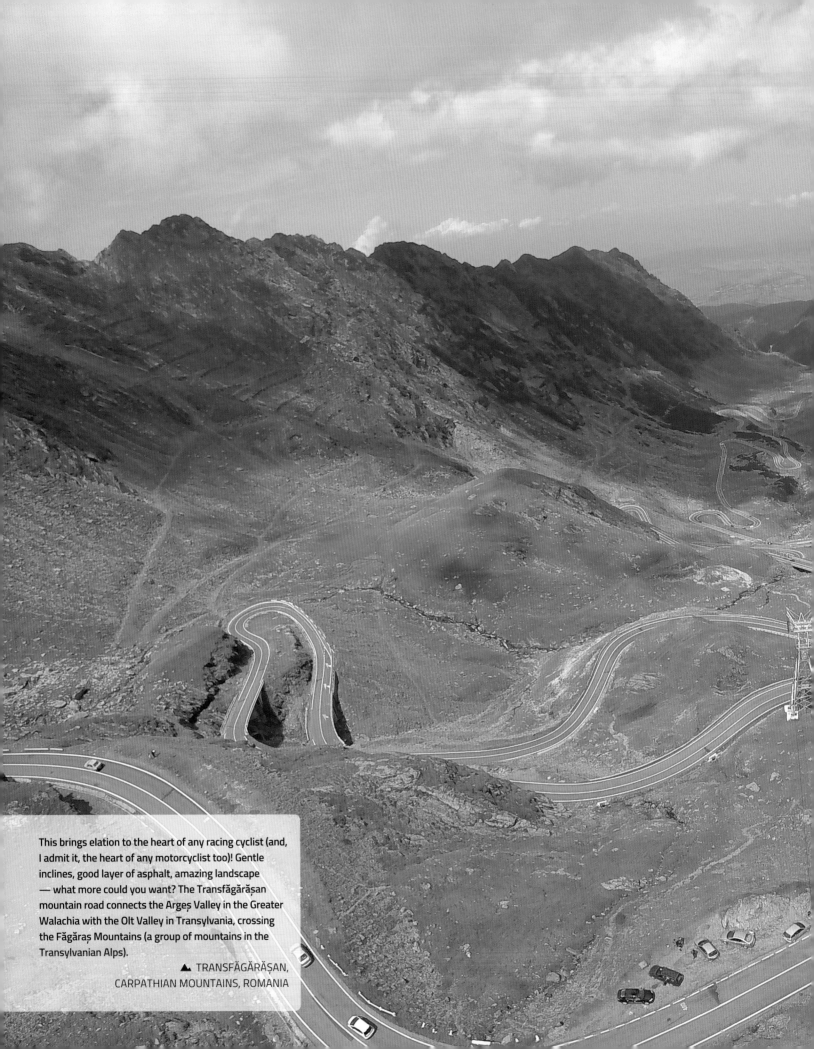

This brings elation to the heart of any racing cyclist (and, I admit it, the heart of any motorcyclist too)! Gentle inclines, good layer of asphalt, amazing landscape — what more could you want? The Transfăgărășan mountain road connects the Argeș Valley in the Greater Walachia with the Olt Valley in Transylvania, crossing the Făgăraș Mountains (a group of mountains in the Transylvanian Alps).

▲ TRANSFĂGĂRĂȘAN, CARPATHIAN MOUNTAINS, ROMANIA

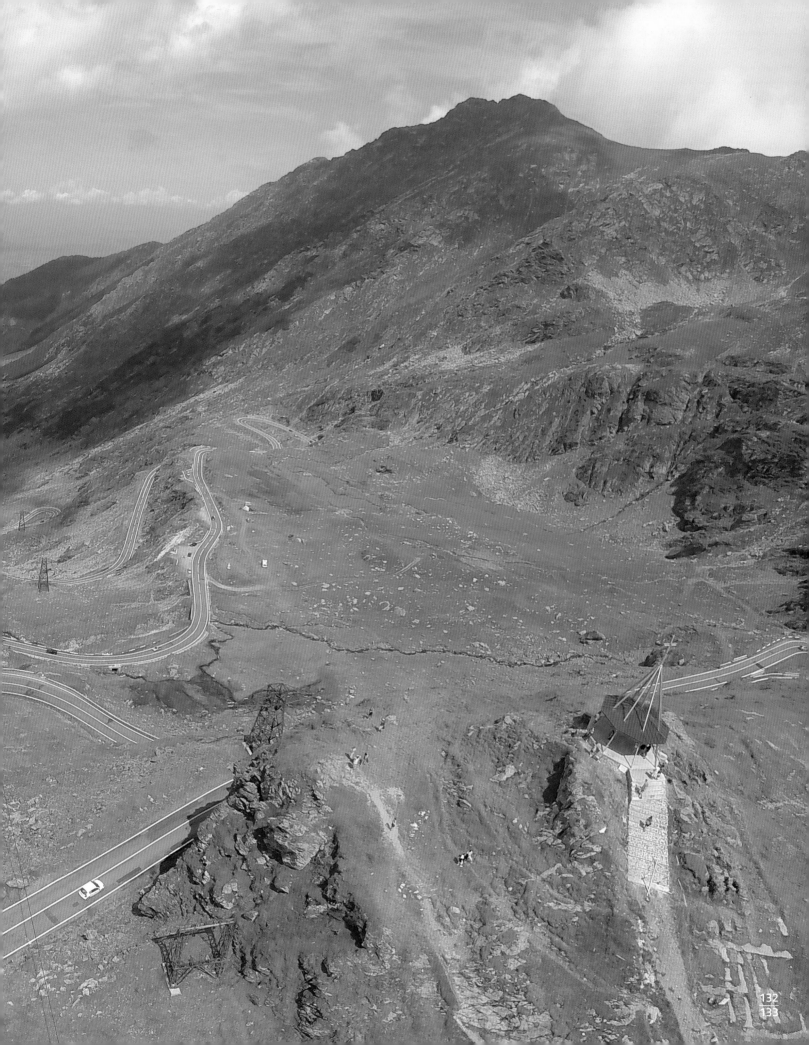

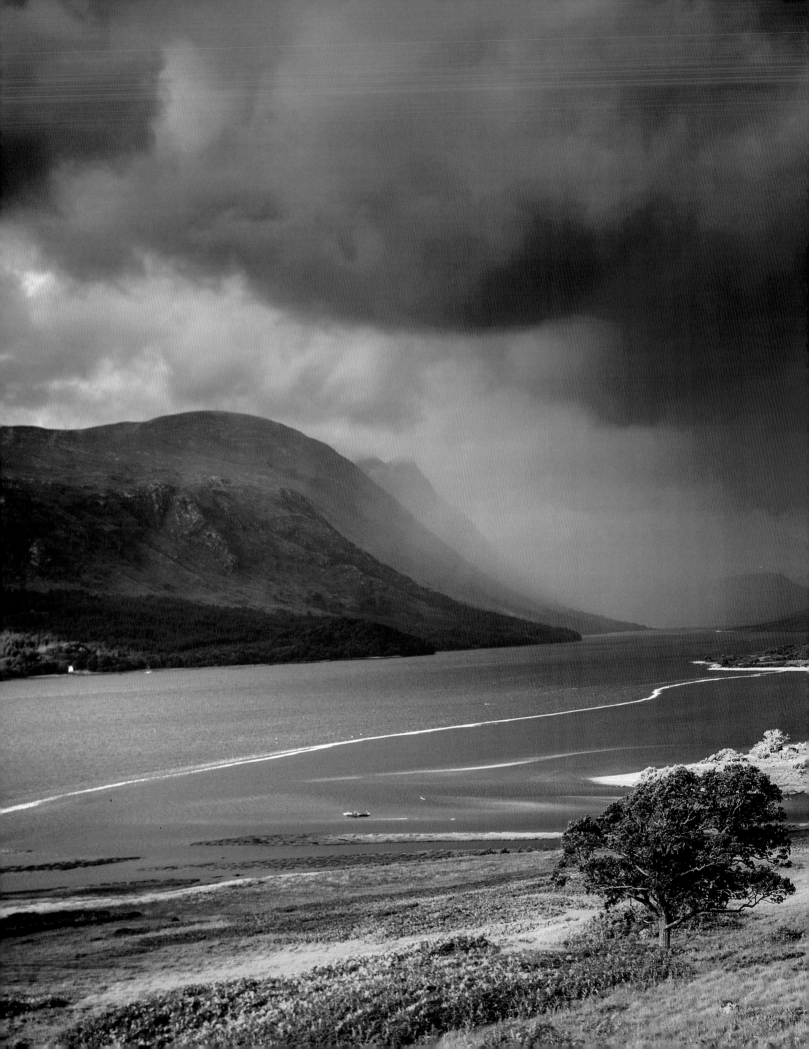

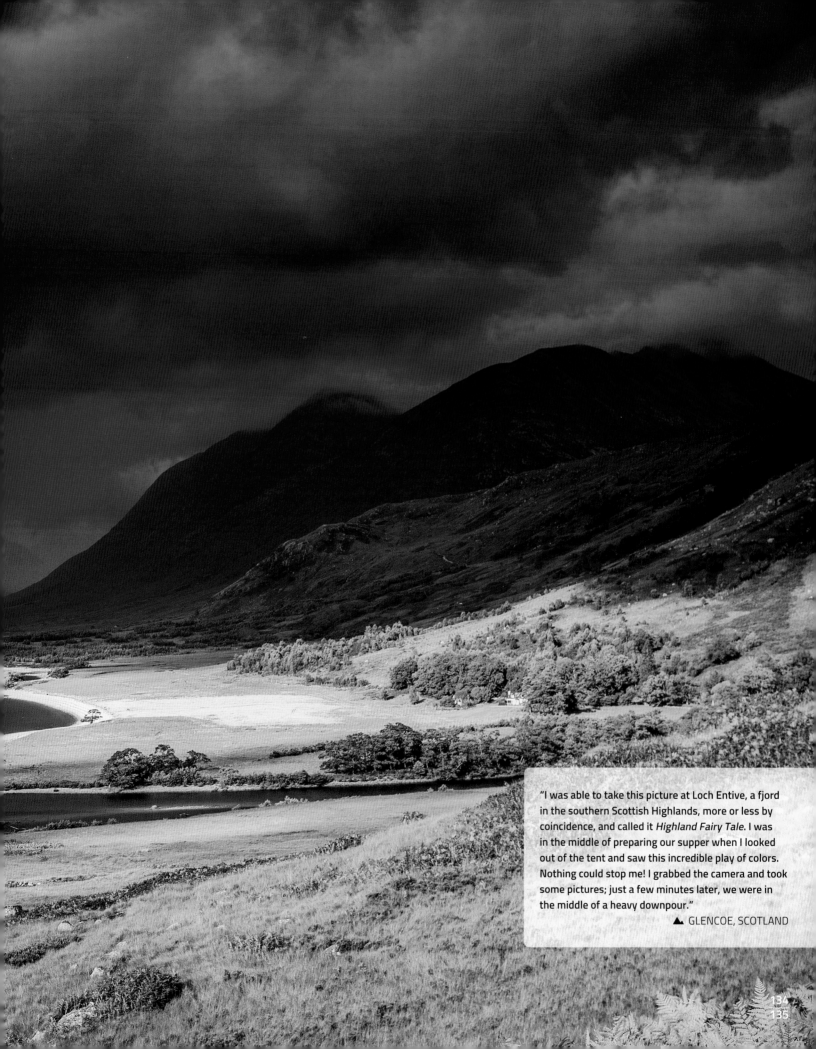

"I was able to take this picture at Loch Entive, a fjord in the southern Scottish Highlands, more or less by coincidence, and called it *Highland Fairy Tale*. I was in the middle of preparing our supper when I looked out of the tent and saw this incredible play of colors. Nothing could stop me! I grabbed the camera and took some pictures; just a few minutes later, we were in the middle of a heavy downpour."

▲ GLENCOE, SCOTLAND

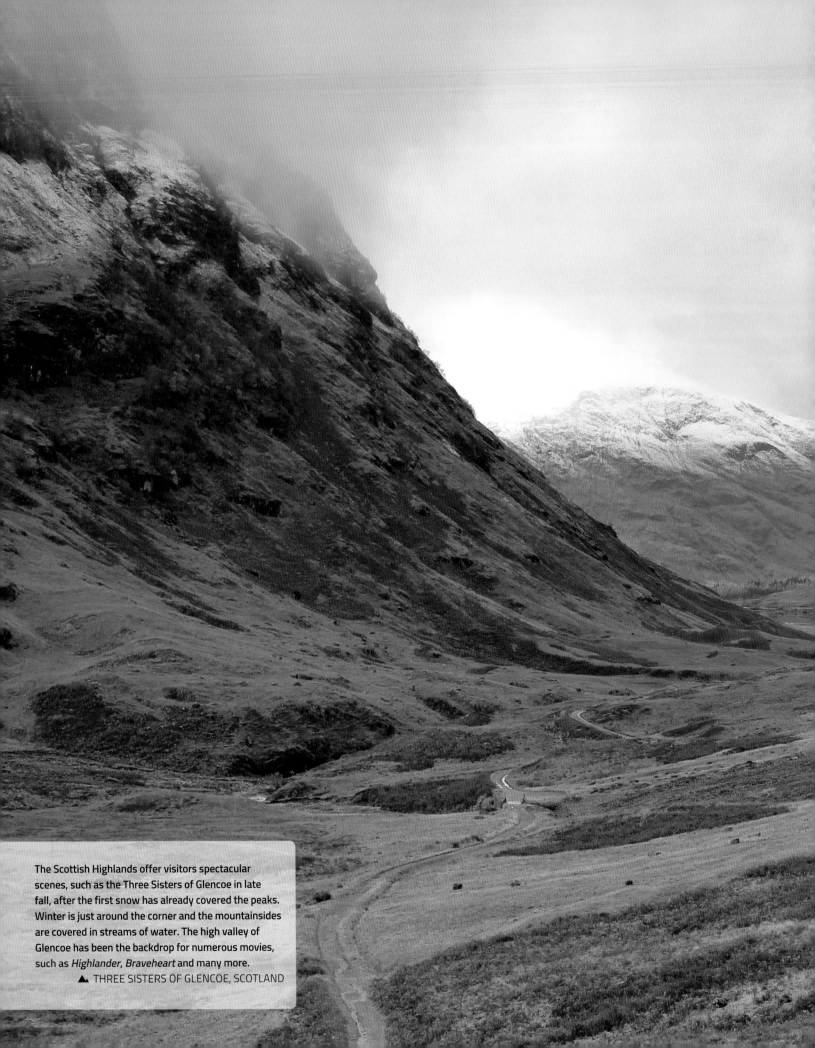

The Scottish Highlands offer visitors spectacular scenes, such as the Three Sisters of Glencoe in late fall, after the first snow has already covered the peaks. Winter is just around the corner and the mountainsides are covered in streams of water. The high valley of Glencoe has been the backdrop for numerous movies, such as *Highlander*, *Braveheart* and many more.

▲ THREE SISTERS OF GLENCOE, SCOTLAND

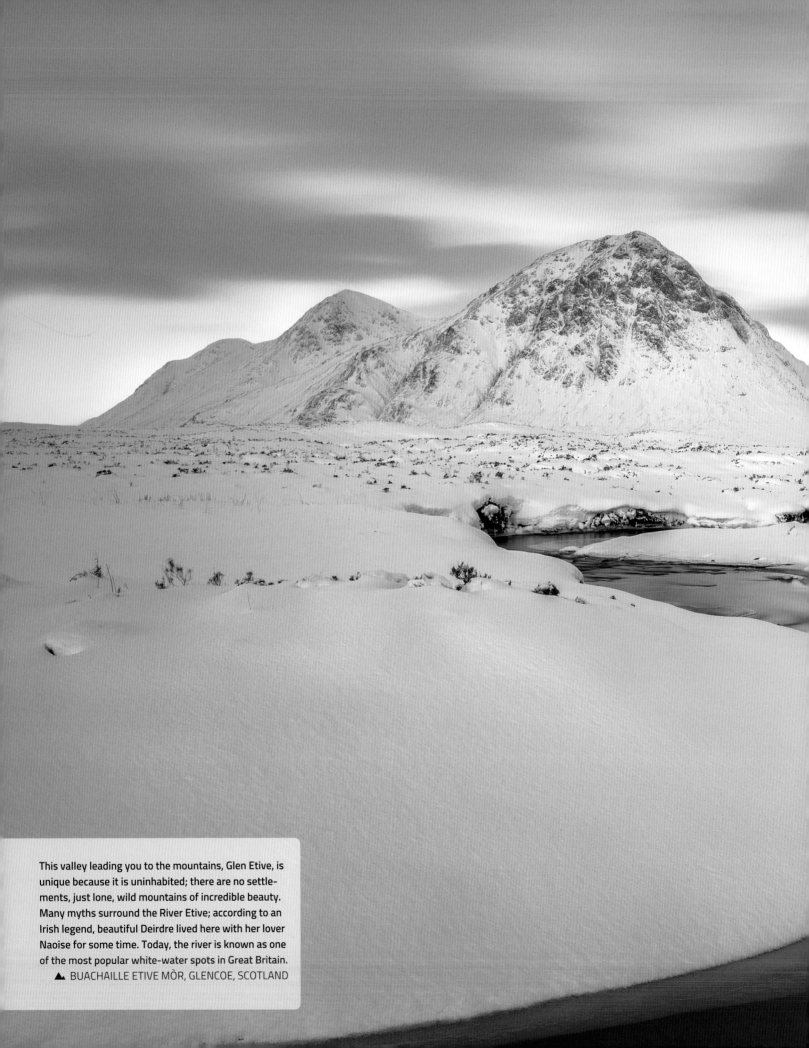

This valley leading you to the mountains, Glen Etive, is unique because it is uninhabited; there are no settlements, just lone, wild mountains of incredible beauty. Many myths surround the River Etive; according to an Irish legend, beautiful Deirdre lived here with her lover Naoise for some time. Today, the river is known as one of the most popular white-water spots in Great Britain.

▲ BUACHAILLE ETIVE MÒR, GLENCOE, SCOTLAND

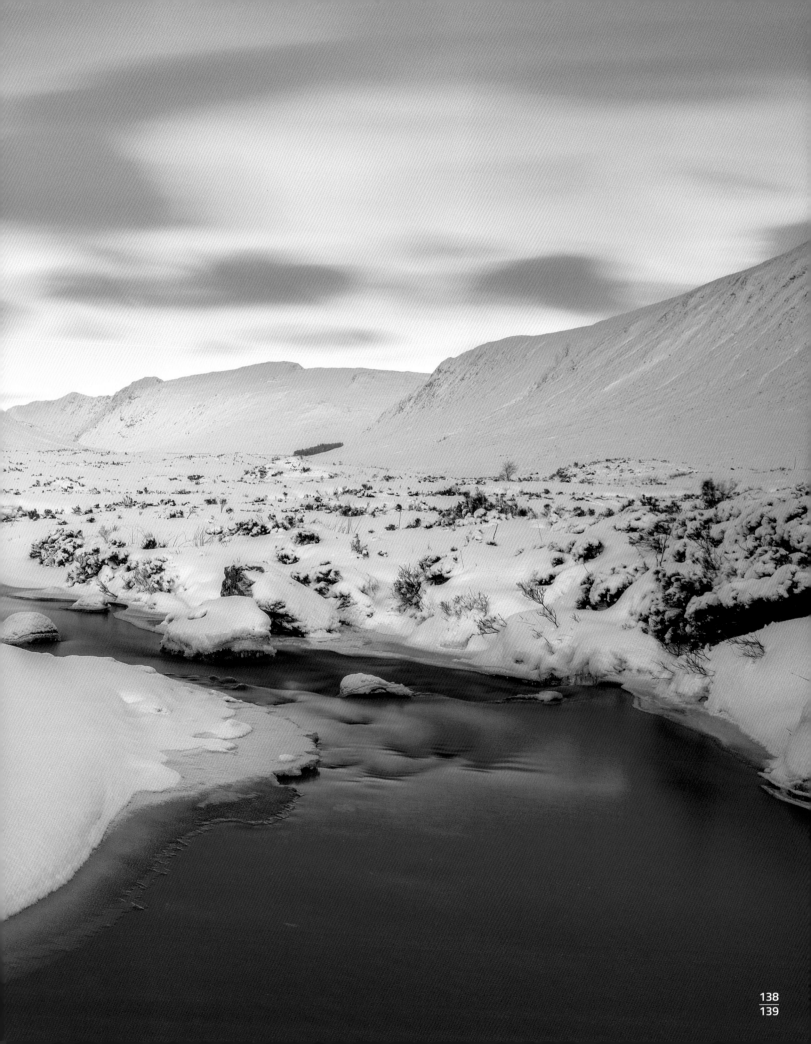

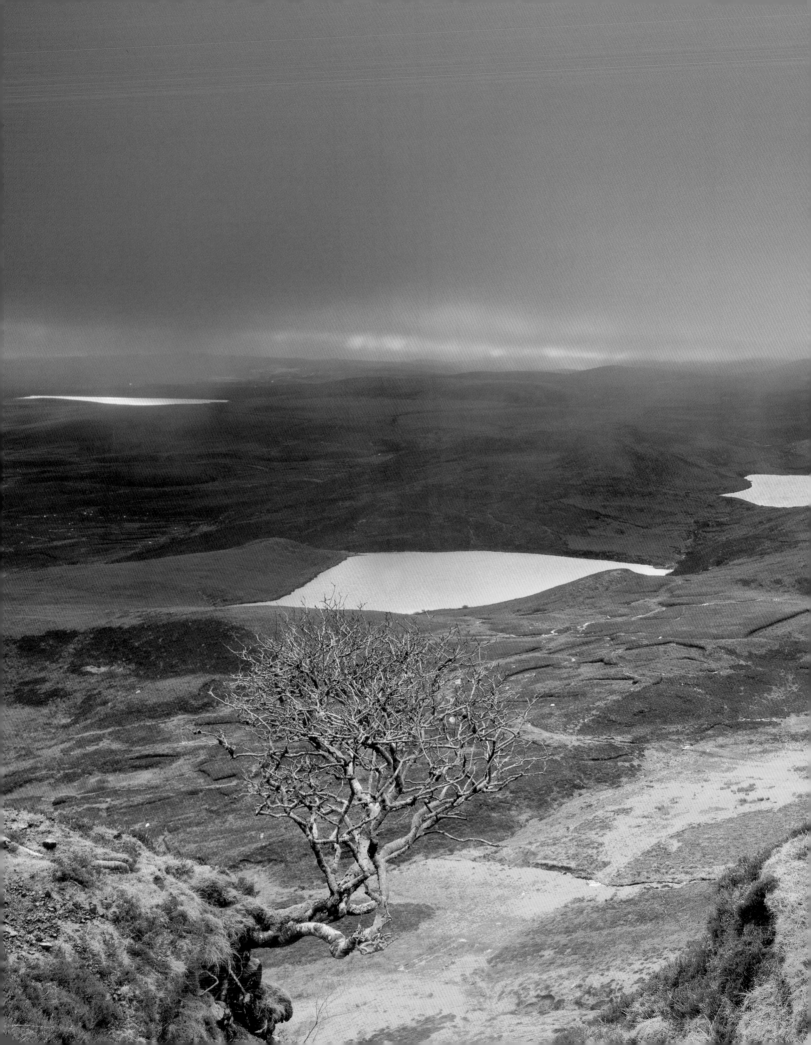

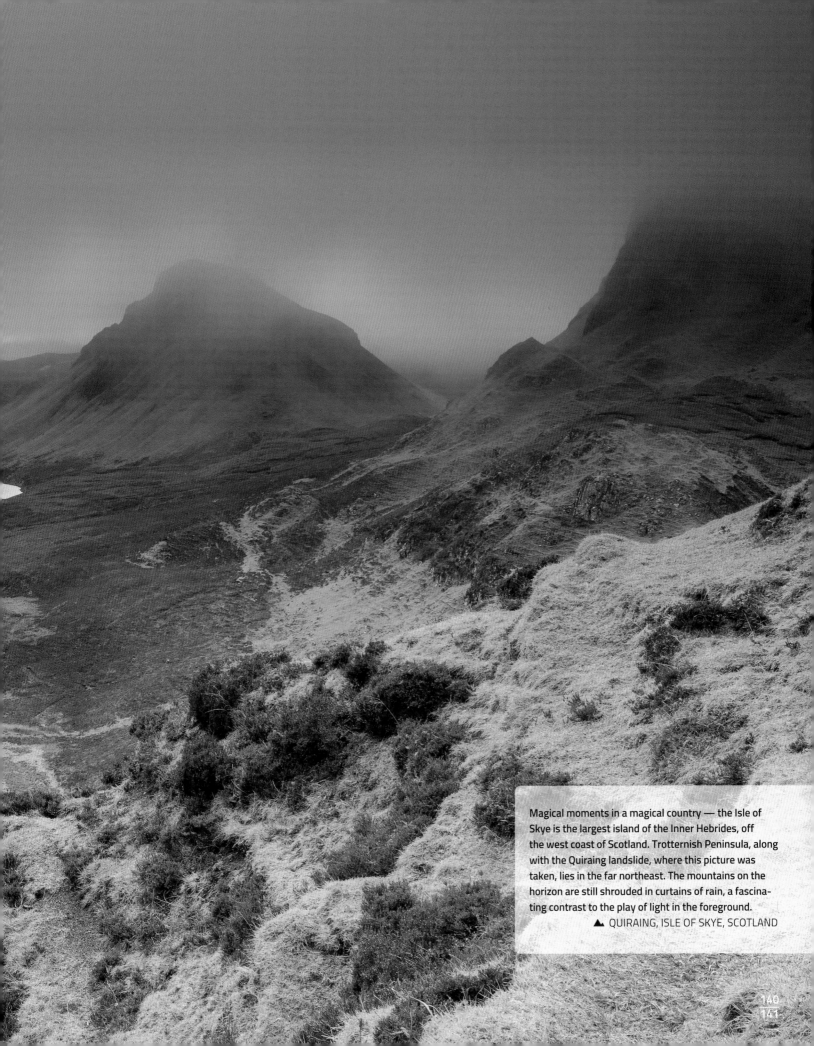

Magical moments in a magical country — the Isle of Skye is the largest island of the Inner Hebrides, off the west coast of Scotland. Trotternish Peninsula, along with the Quiraing landslide, where this picture was taken, lies in the far northeast. The mountains on the horizon are still shrouded in curtains of rain, a fascinating contrast to the play of light in the foreground.

▲ QUIRAING, ISLE OF SKYE, SCOTLAND

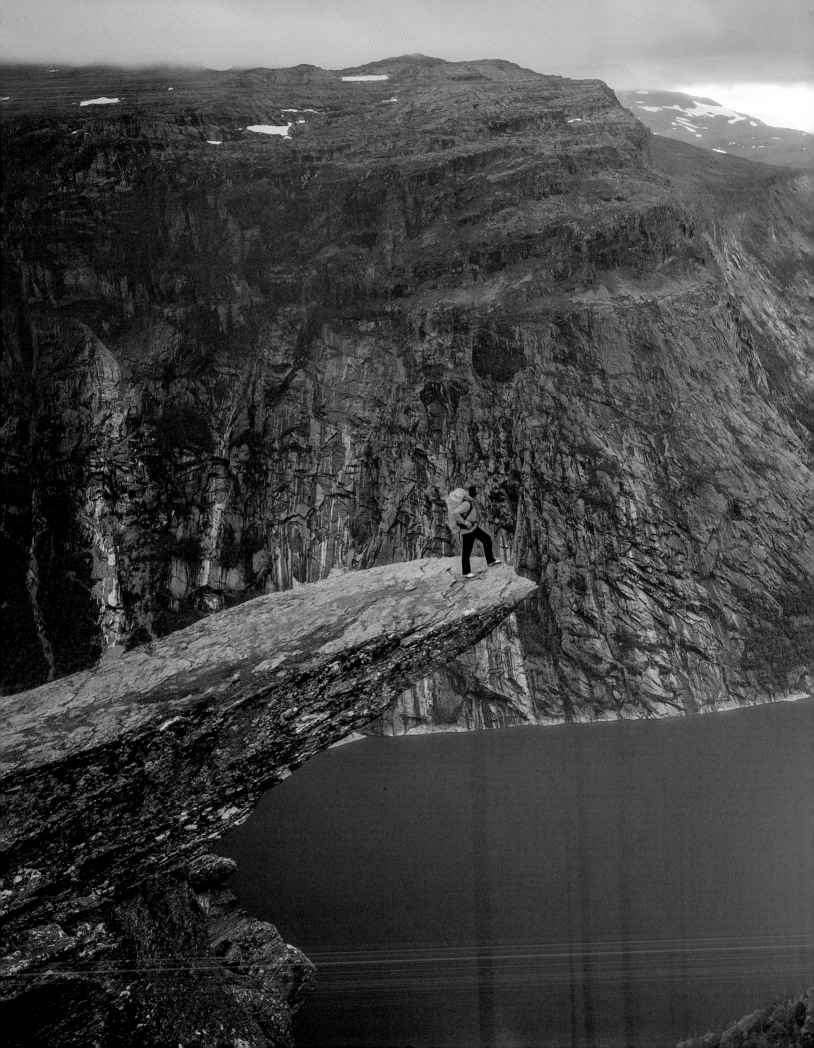

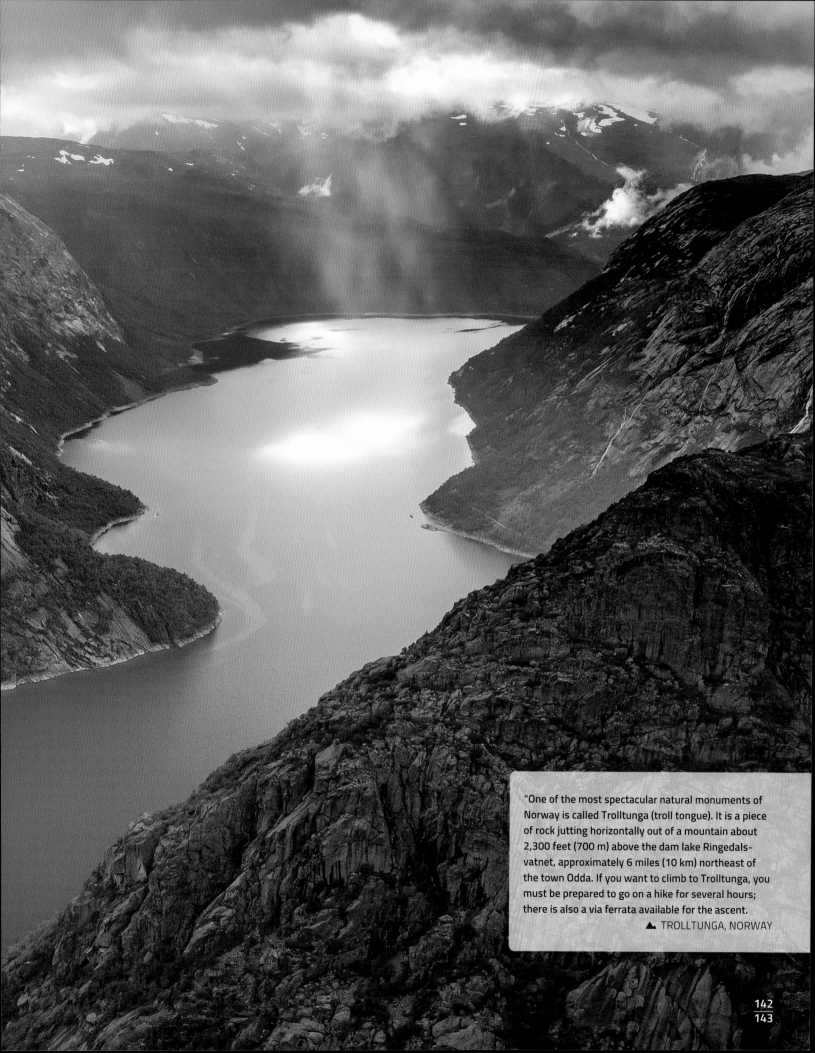

"One of the most spectacular natural monuments of Norway is called Trolltunga (troll tongue). It is a piece of rock jutting horizontally out of a mountain about 2,300 feet (700 m) above the dam lake Ringedals-vatnet, approximately 6 miles (10 km) northeast of the town Odda. If you want to climb to Trolltunga, you must be prepared to go on a hike for several hours; there is also a via ferrata available for the ascent.

▲ TROLLTUNGA, NORWAY

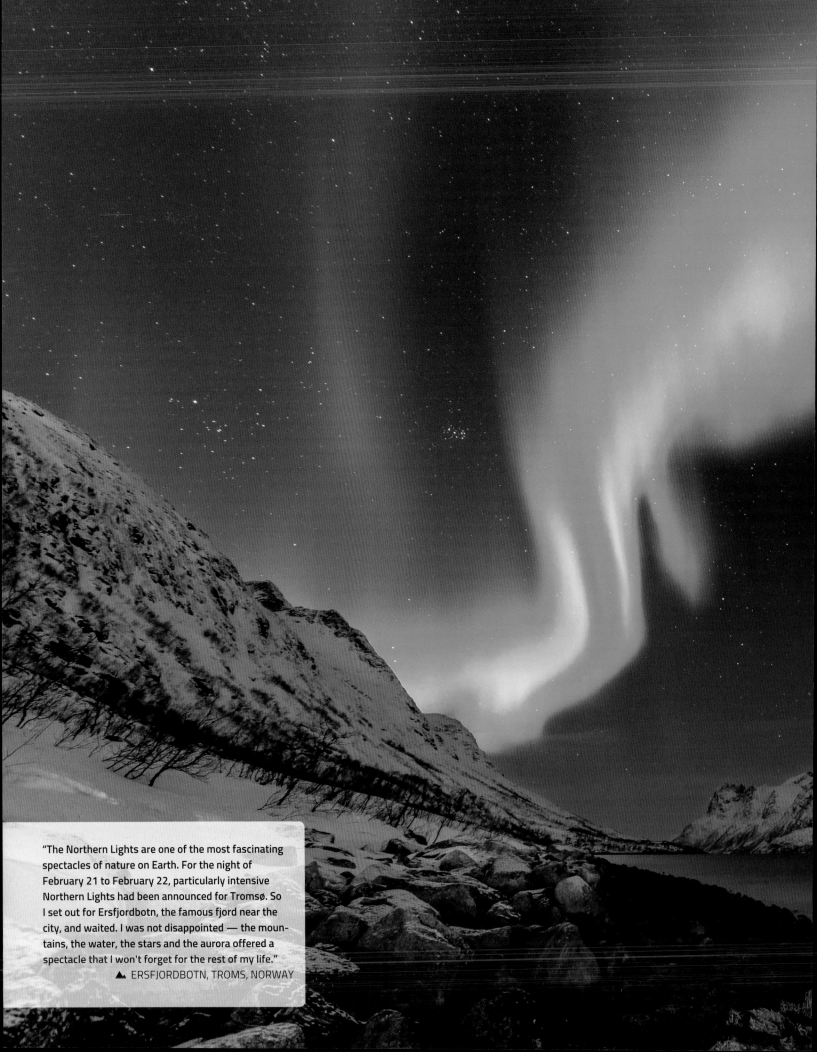

"The Northern Lights are one of the most fascinating spectacles of nature on Earth. For the night of February 21 to February 22, particularly intensive Northern Lights had been announced for Tromsø. So I set out for Ersfjordbotn, the famous fjord near the city, and waited. I was not disappointed — the mountains, the water, the stars and the aurora offered a spectacle that I won't forget for the rest of my life."

▲ ERSFJORDBOTN, TROMS, NORWAY

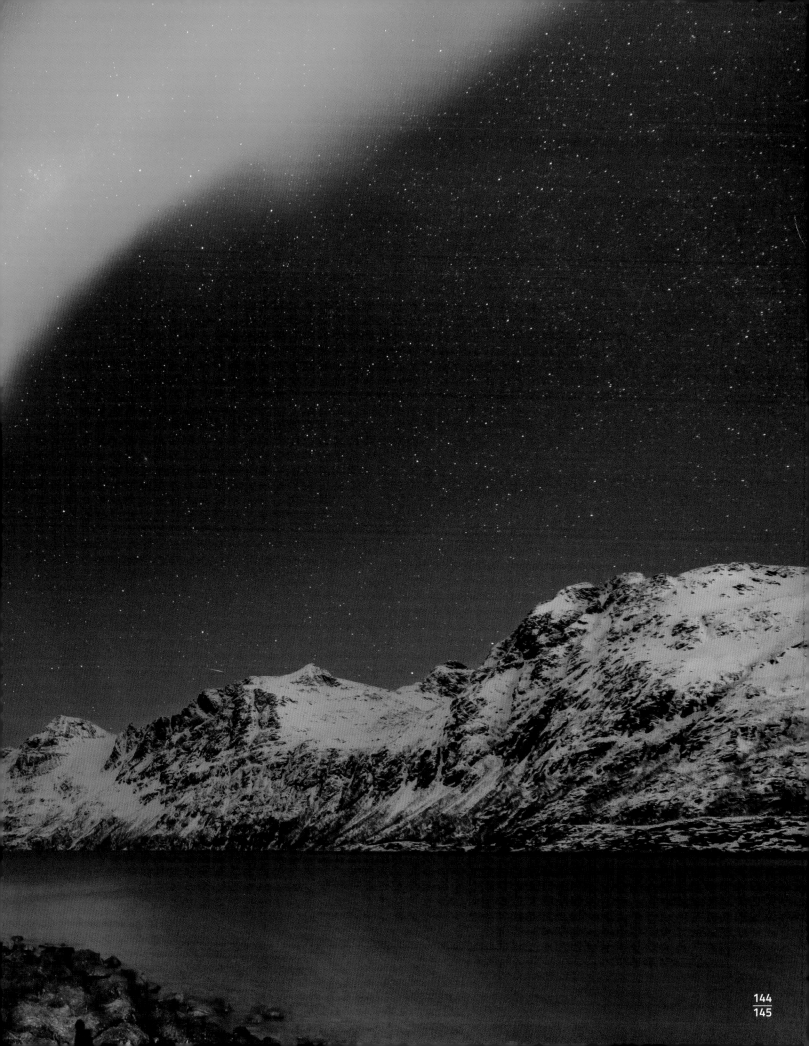

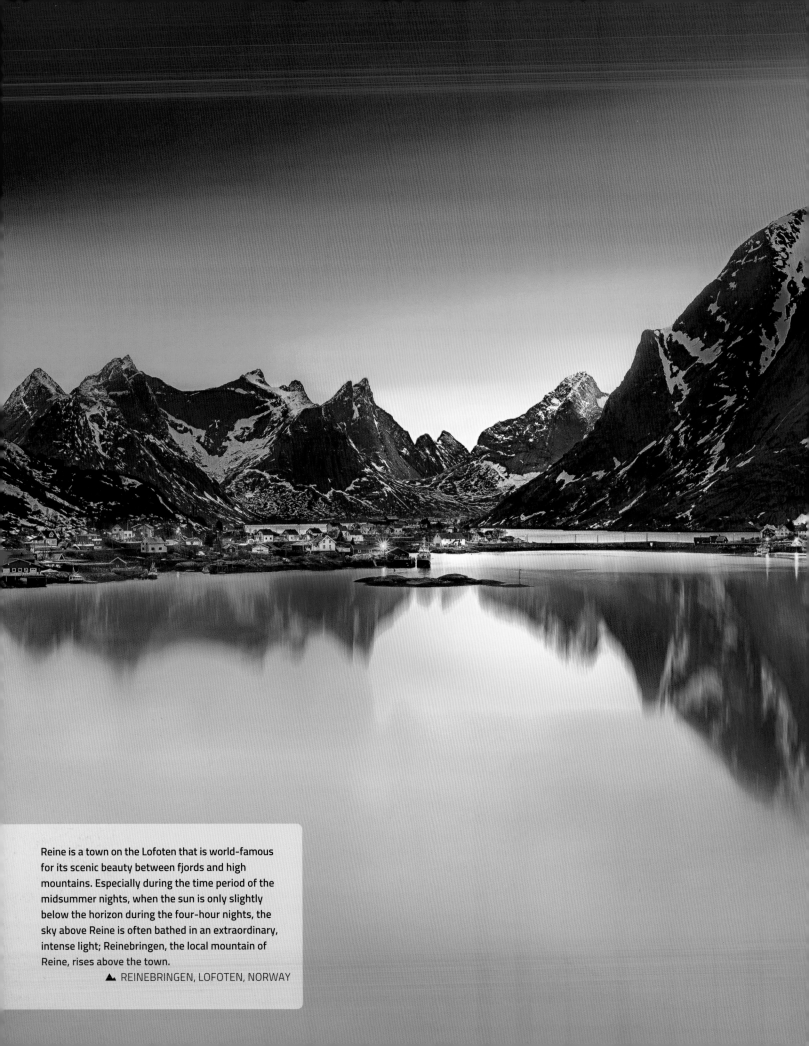

Reine is a town on the Lofoten that is world-famous for its scenic beauty between fjords and high mountains. Especially during the time period of the midsummer nights, when the sun is only slightly below the horizon during the four-hour nights, the sky above Reine is often bathed in an extraordinary, intense light; Reinebringen, the local mountain of Reine, rises above the town.

▲ REINEBRINGEN, LOFOTEN, NORWAY

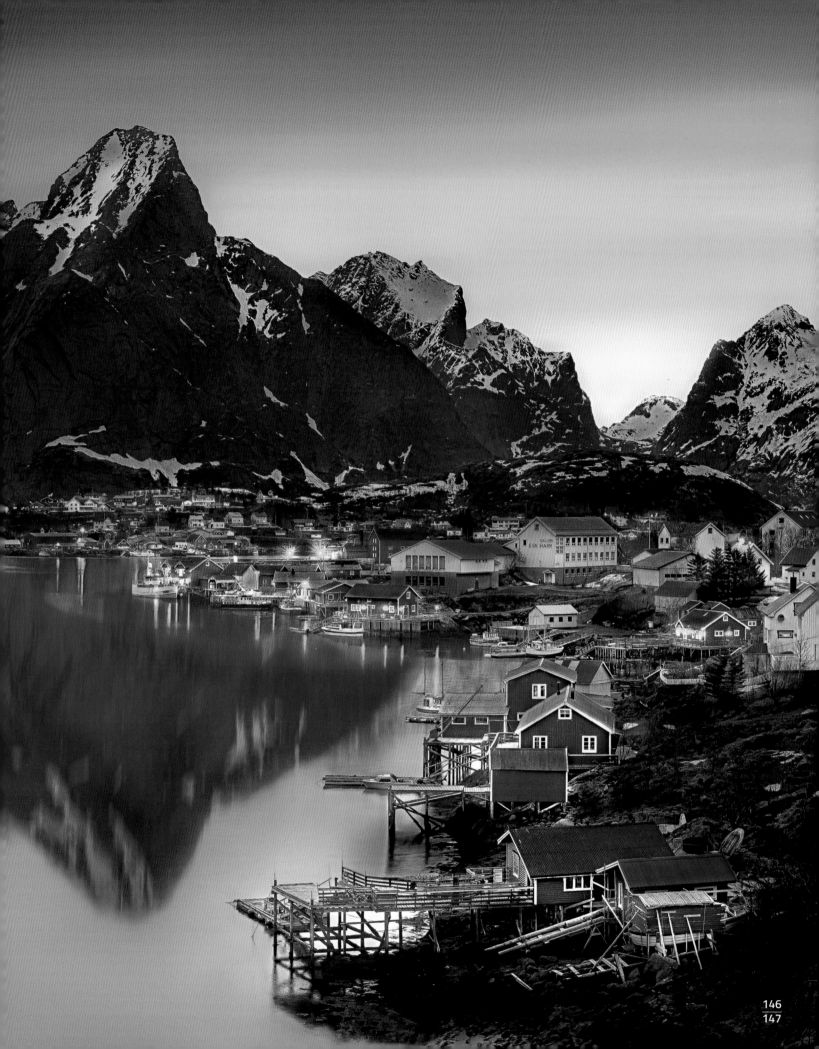

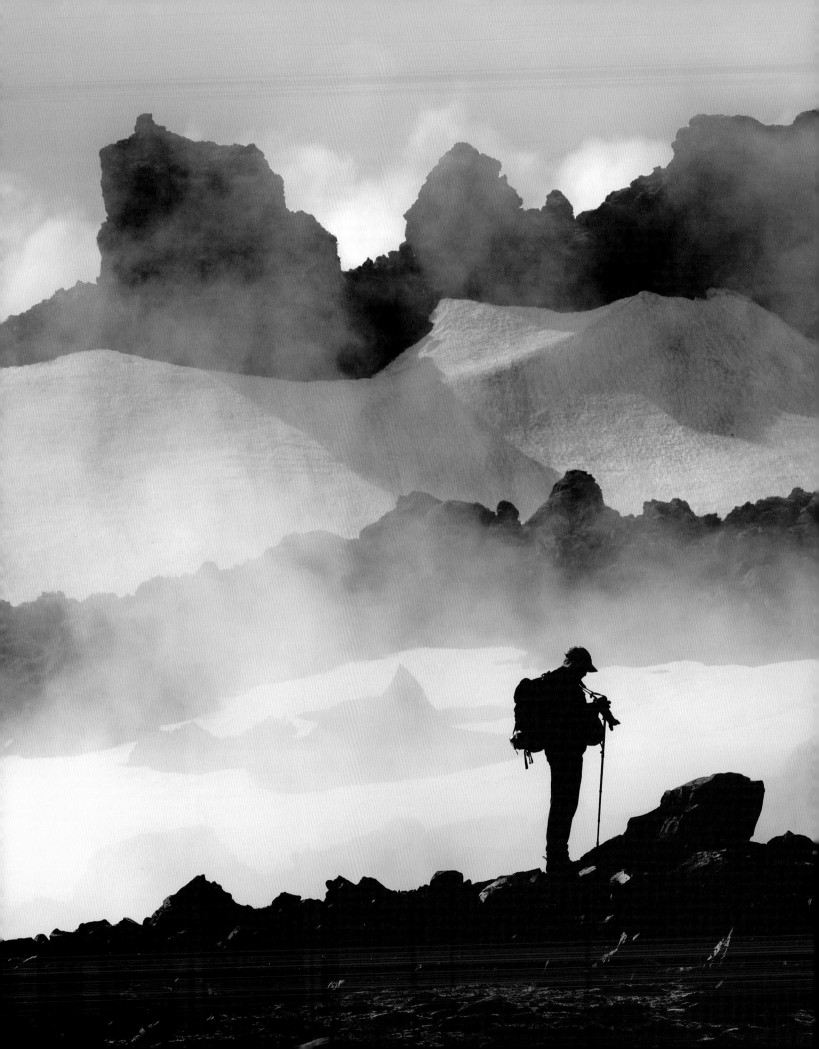

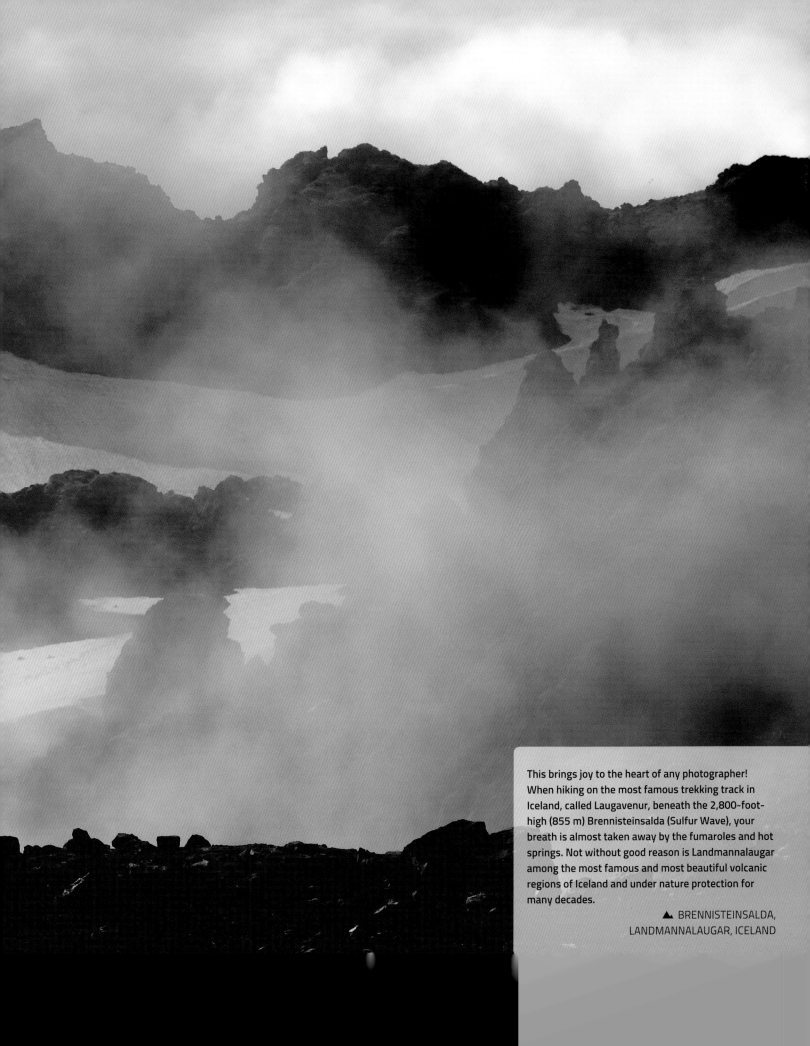

This brings joy to the heart of any photographer! When hiking on the most famous trekking track in Iceland, called Laugavenur, beneath the 2,800-foot-high (855 m) Brennisteinsalda (Sulfur Wave), your breath is almost taken away by the fumaroles and hot springs. Not without good reason is Landmannalaugar among the most famous and most beautiful volcanic regions of Iceland and under nature protection for many decades.

▲ BRENNISTEINSALDA, LANDMANNALAUGAR, ICELAND

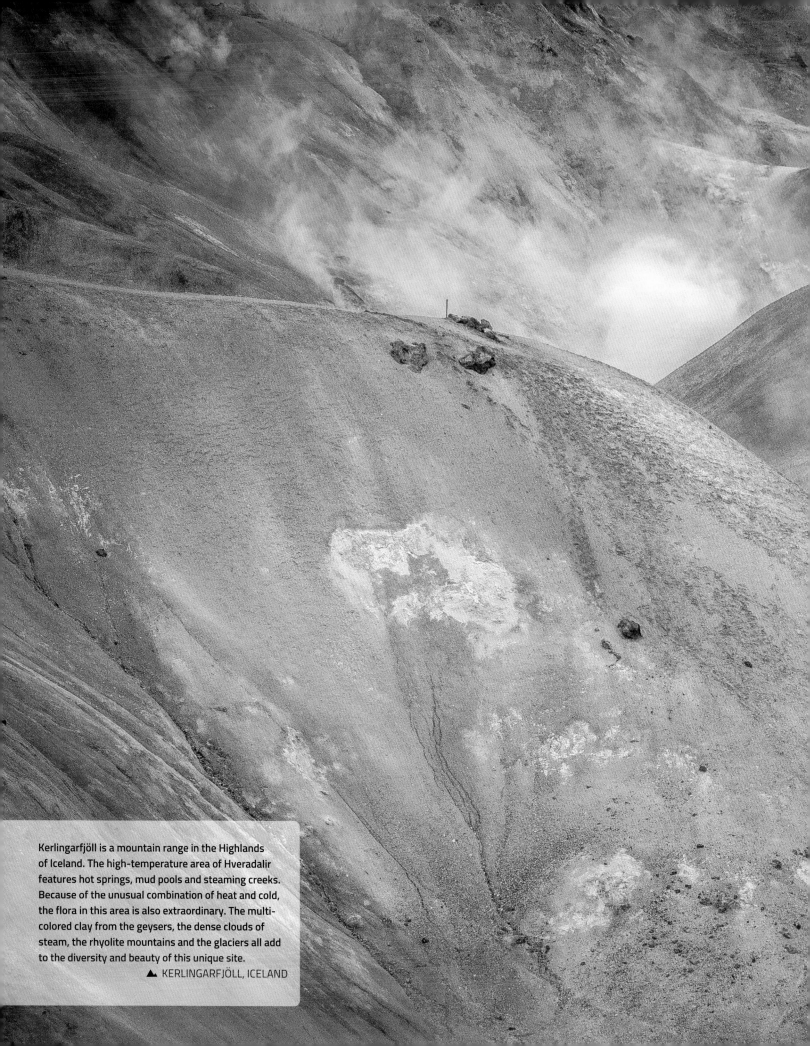

Kerlingarfjöll is a mountain range in the Highlands
of Iceland. The high-temperature area of Hveradalir
features hot springs, mud pools and steaming creeks.
Because of the unusual combination of heat and cold,
the flora in this area is also extraordinary. The multi-
colored clay from the geysers, the dense clouds of
steam, the rhyolite mountains and the glaciers all add
to the diversity and beauty of this unique site.

▲ KERLINGARFJÖLL, ICELAND

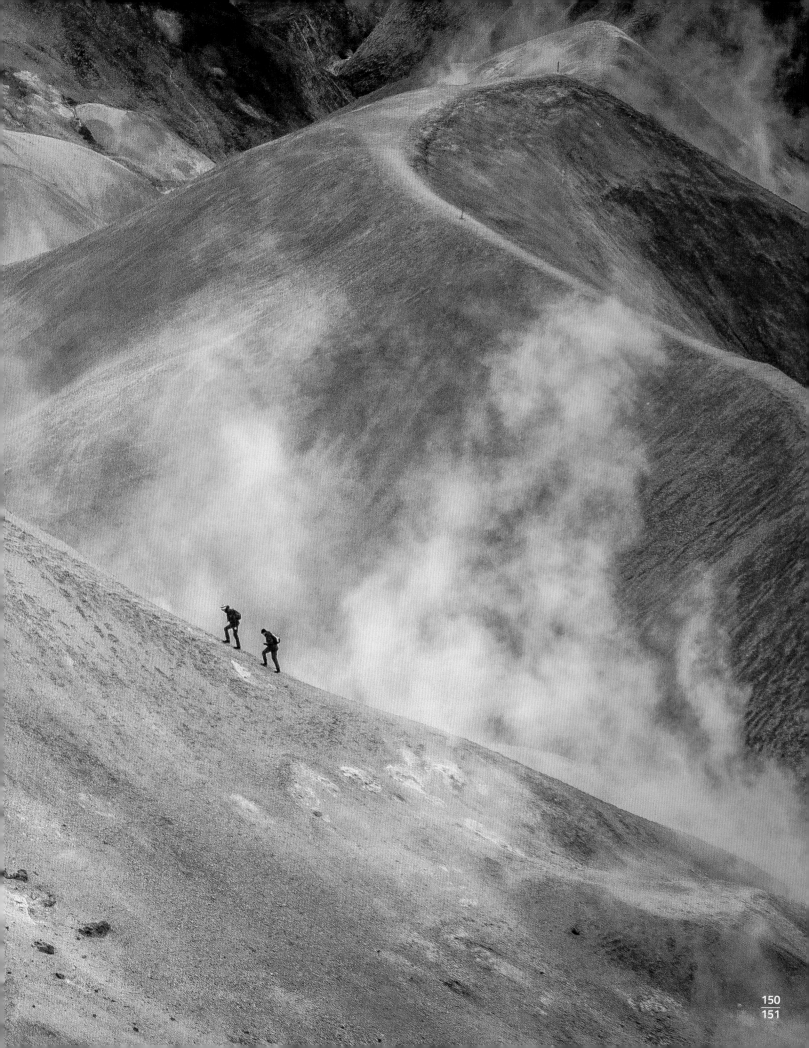

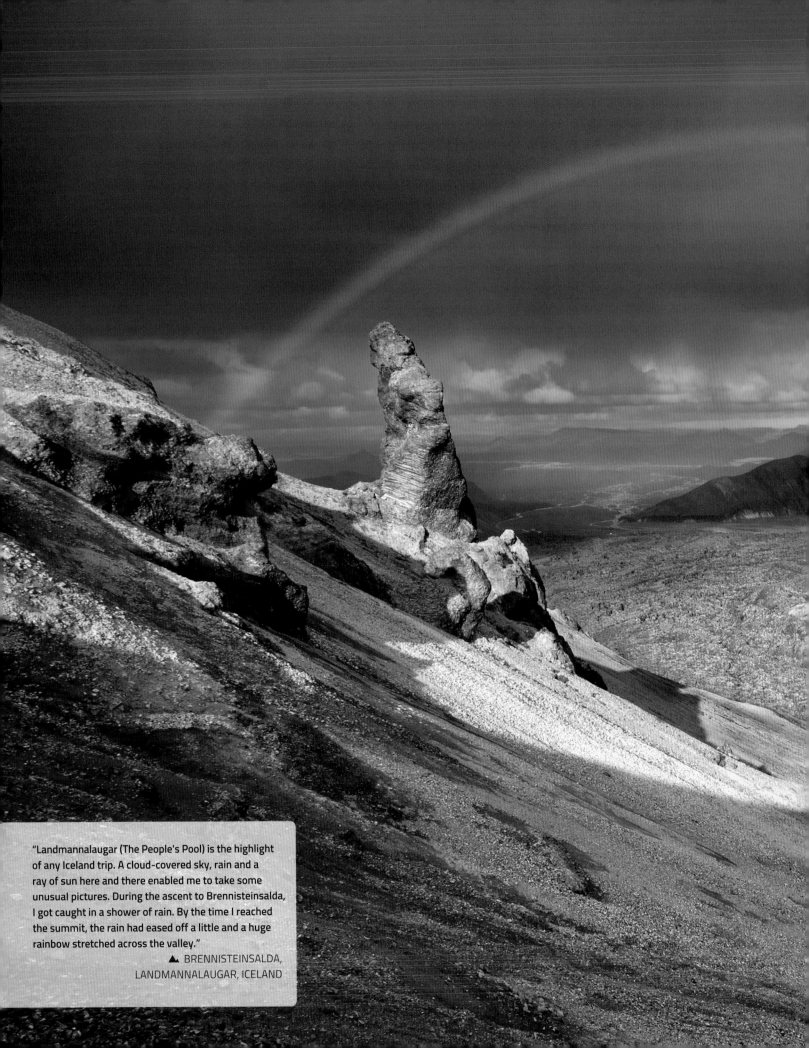

"Landmannalaugar (The People's Pool) is the highlight of any Iceland trip. A cloud-covered sky, rain and a ray of sun here and there enabled me to take some unusual pictures. During the ascent to Brennisteinsalda, I got caught in a shower of rain. By the time I reached the summit, the rain had eased off a little and a huge rainbow stretched across the valley."

▲ BRENNISTEINSALDA, LANDMANNALAUGAR, ICELAND

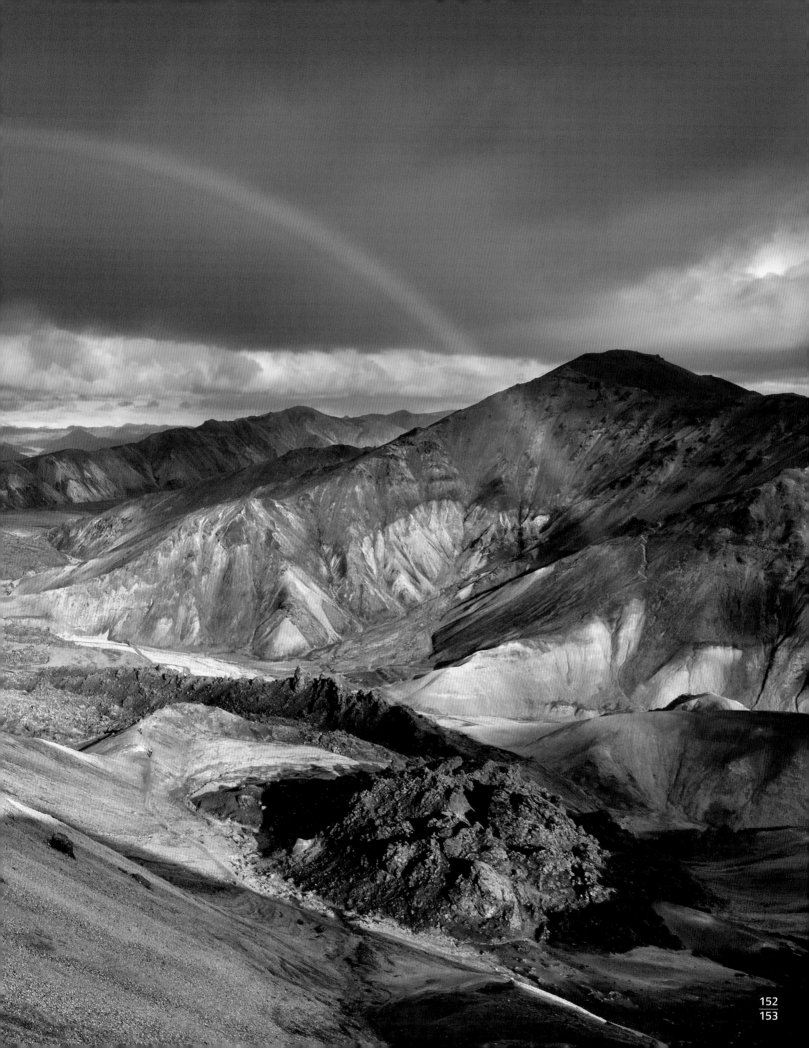

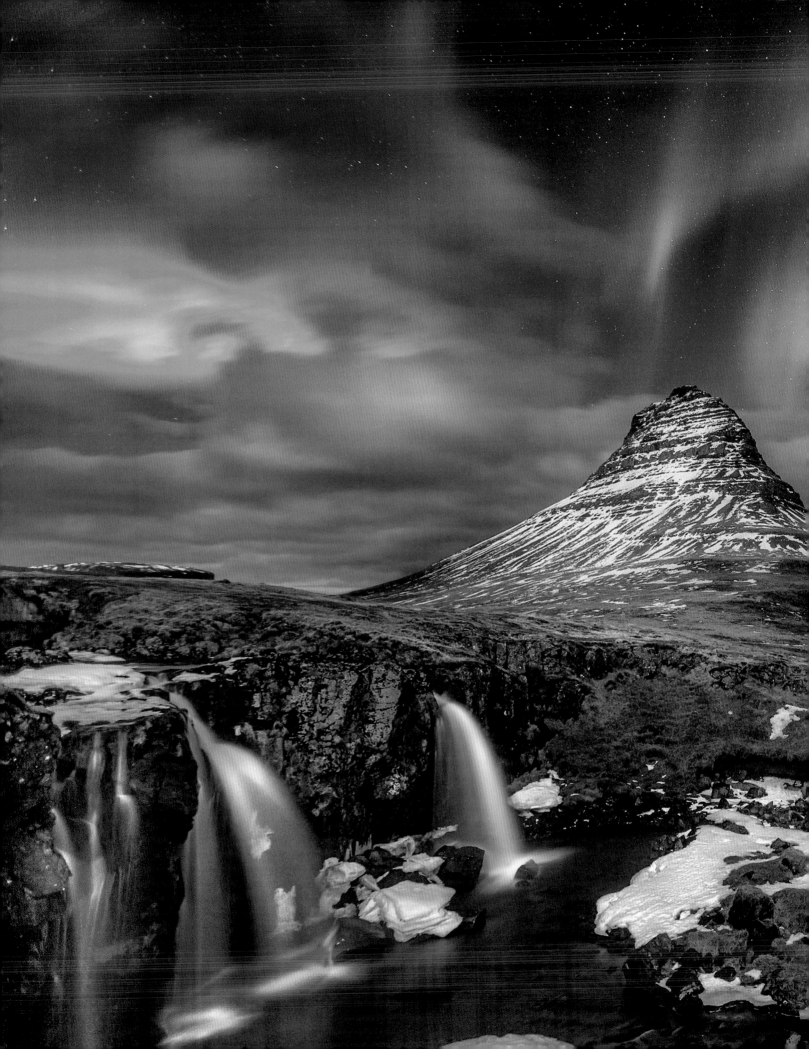

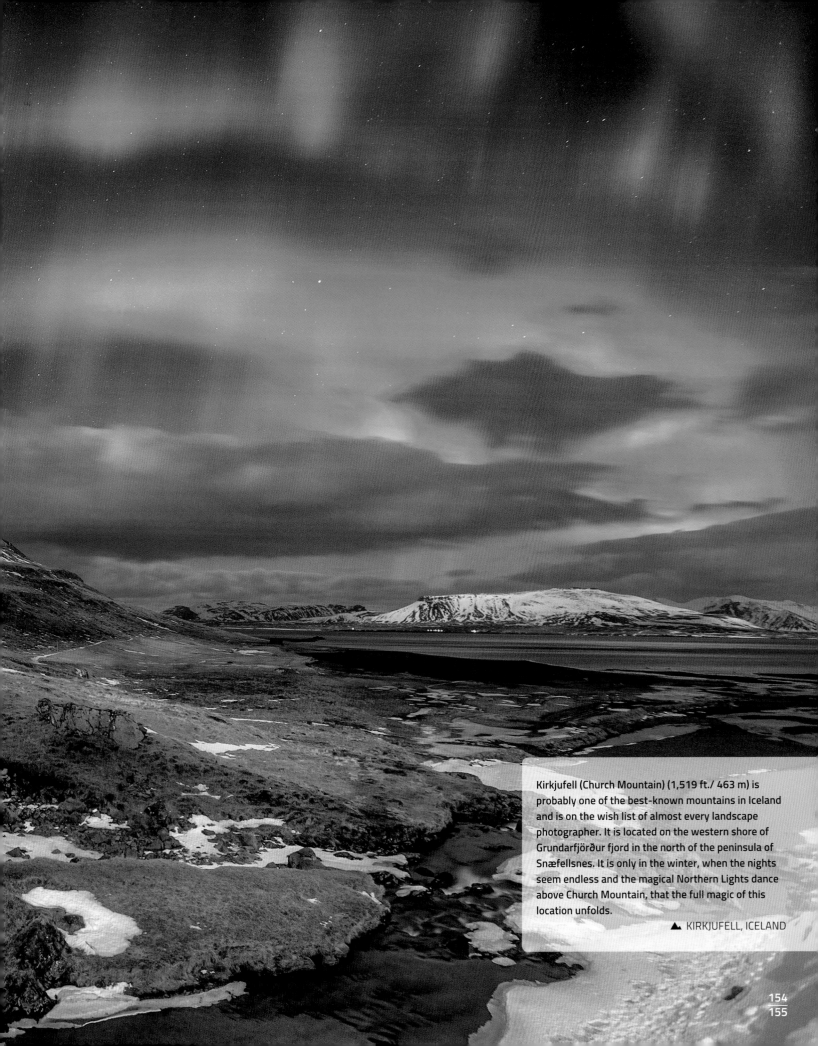

Kirkjufell (Church Mountain) (1,519 ft./ 463 m) is probably one of the best-known mountains in Iceland and is on the wish list of almost every landscape photographer. It is located on the western shore of Grundarfjörður fjord in the north of the peninsula of Snæfellsnes. It is only in the winter, when the nights seem endless and the magical Northern Lights dance above Church Mountain, that the full magic of this location unfolds.

▲ KIRKJUFELL, ICELAND

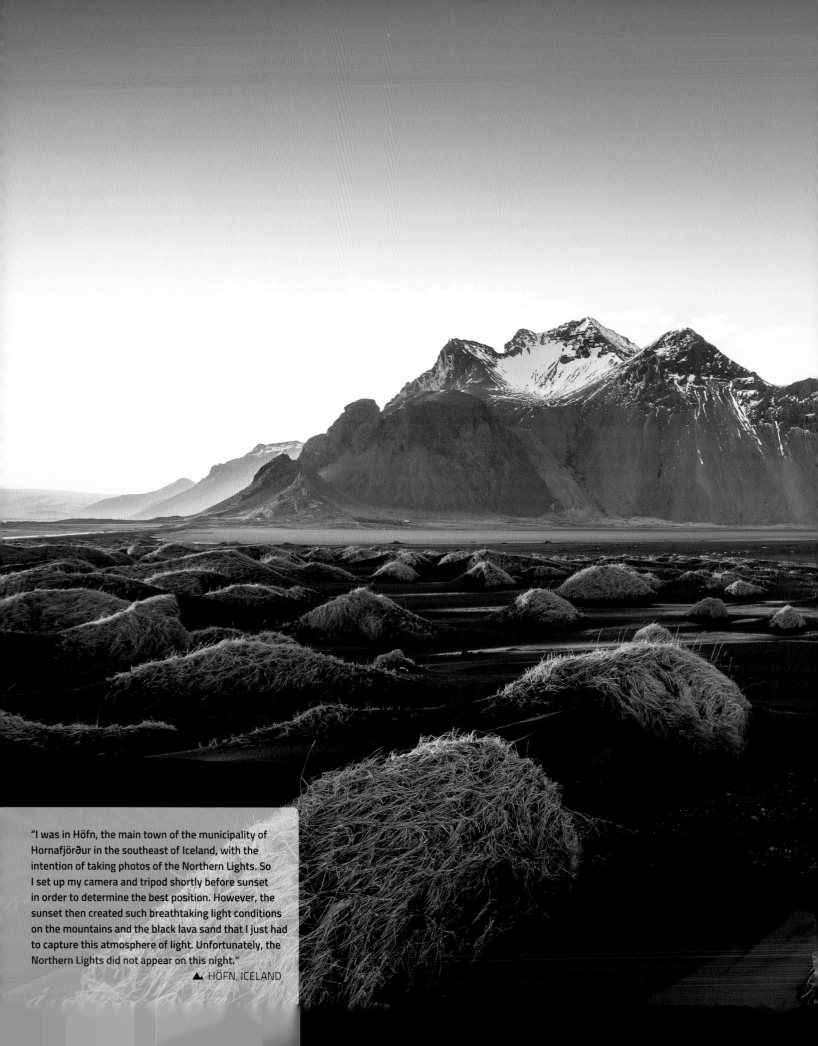

"I was in Höfn, the main town of the municipality of Hornafjörður in the southeast of Iceland, with the intention of taking photos of the Northern Lights. So I set up my camera and tripod shortly before sunset in order to determine the best position. However, the sunset then created such breathtaking light conditions on the mountains and the black lava sand that I just had to capture this atmosphere of light. Unfortunately, the Northern Lights did not appear on this night."

▲ HÖFN, ICELAND

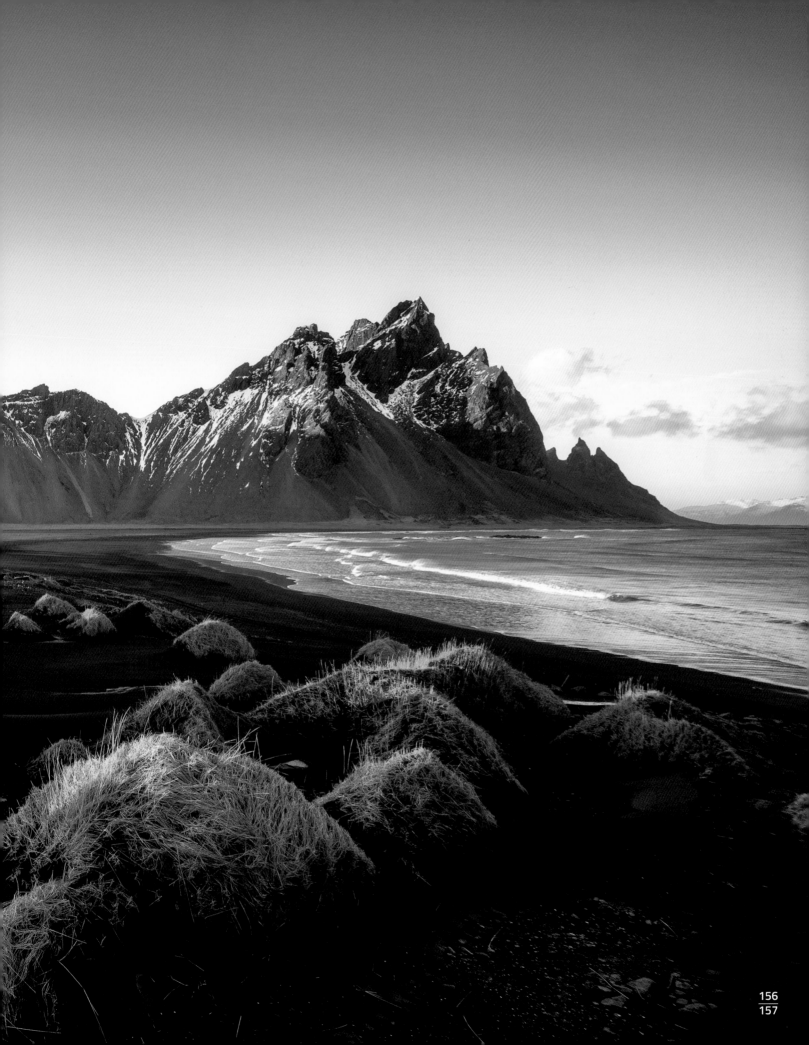

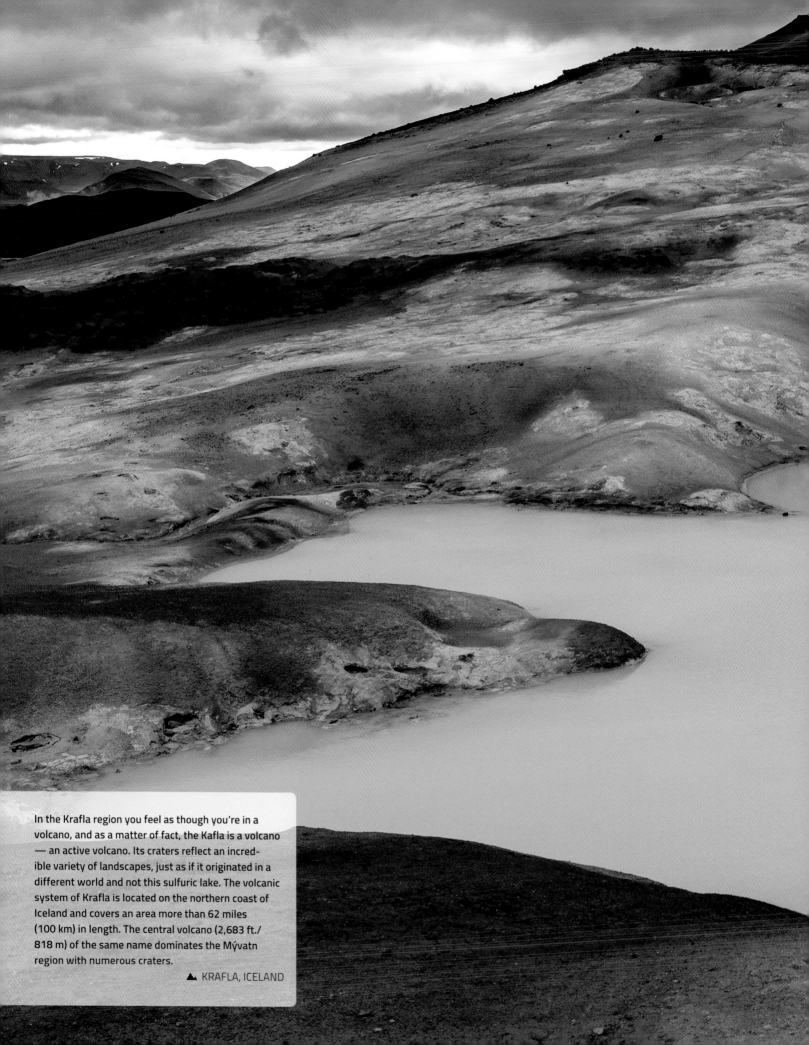

In the Krafla region you feel as though you're in a volcano, and as a matter of fact, the Kafla is a volcano — an active volcano. Its craters reflect an incredible variety of landscapes, just as if it originated in a different world and not this sulfuric lake. The volcanic system of Krafla is located on the northern coast of Iceland and covers an area more than 62 miles (100 km) in length. The central volcano (2,683 ft./ 818 m) of the same name dominates the Mývatn region with numerous craters.

▲ KRAFLA, ICELAND

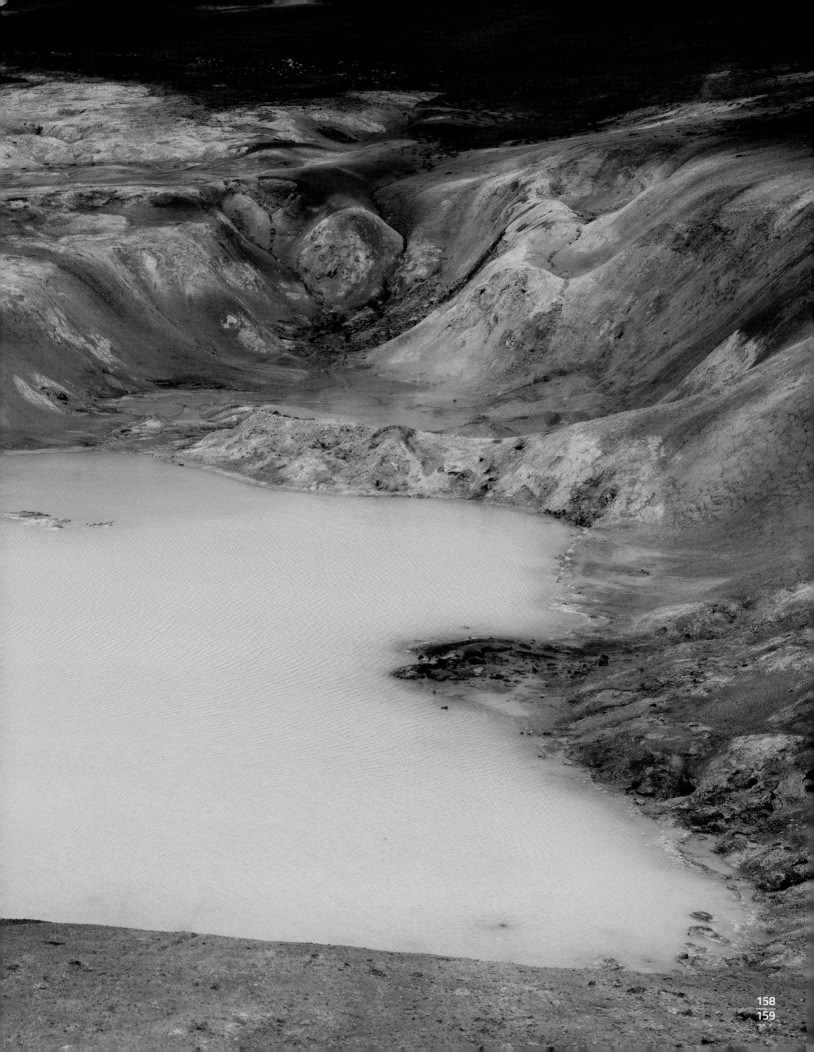

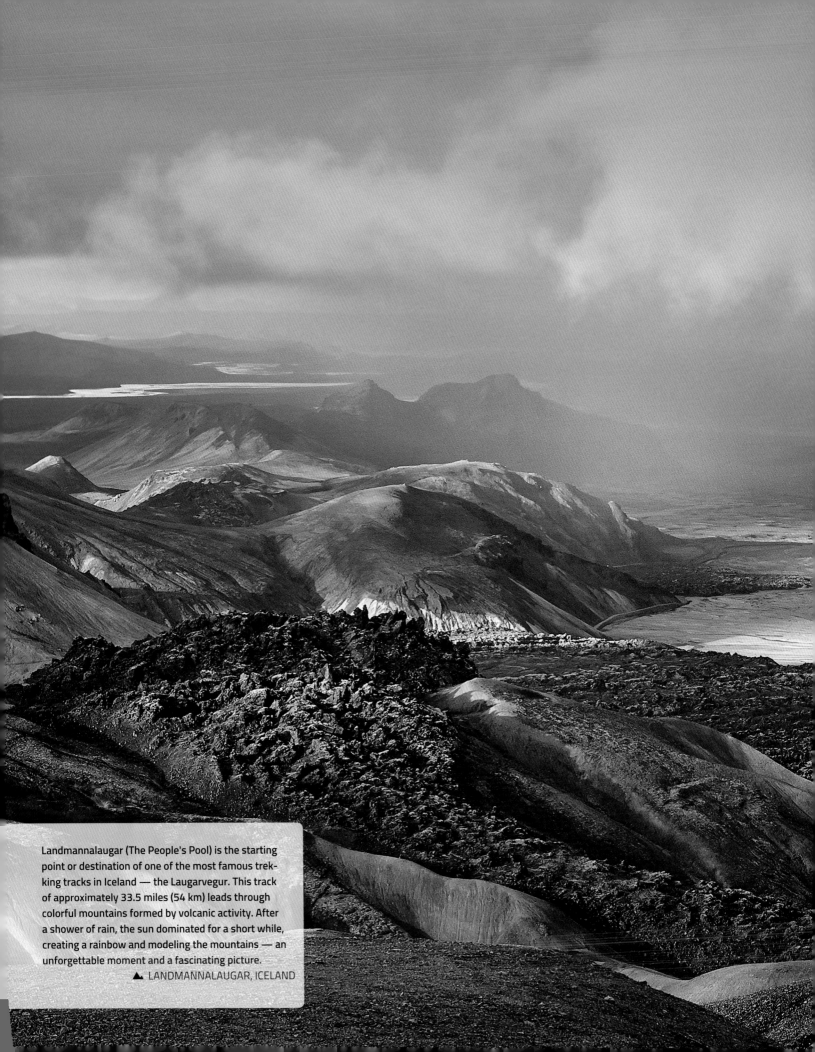

Landmannalaugar (The People's Pool) is the starting point or destination of one of the most famous trekking tracks in Iceland — the Laugarvegur. This track of approximately 33.5 miles (54 km) leads through colorful mountains formed by volcanic activity. After a shower of rain, the sun dominated for a short while, creating a rainbow and modeling the mountains — an unforgettable moment and a fascinating picture.

▲ LANDMANNALAUGAR, ICELAND

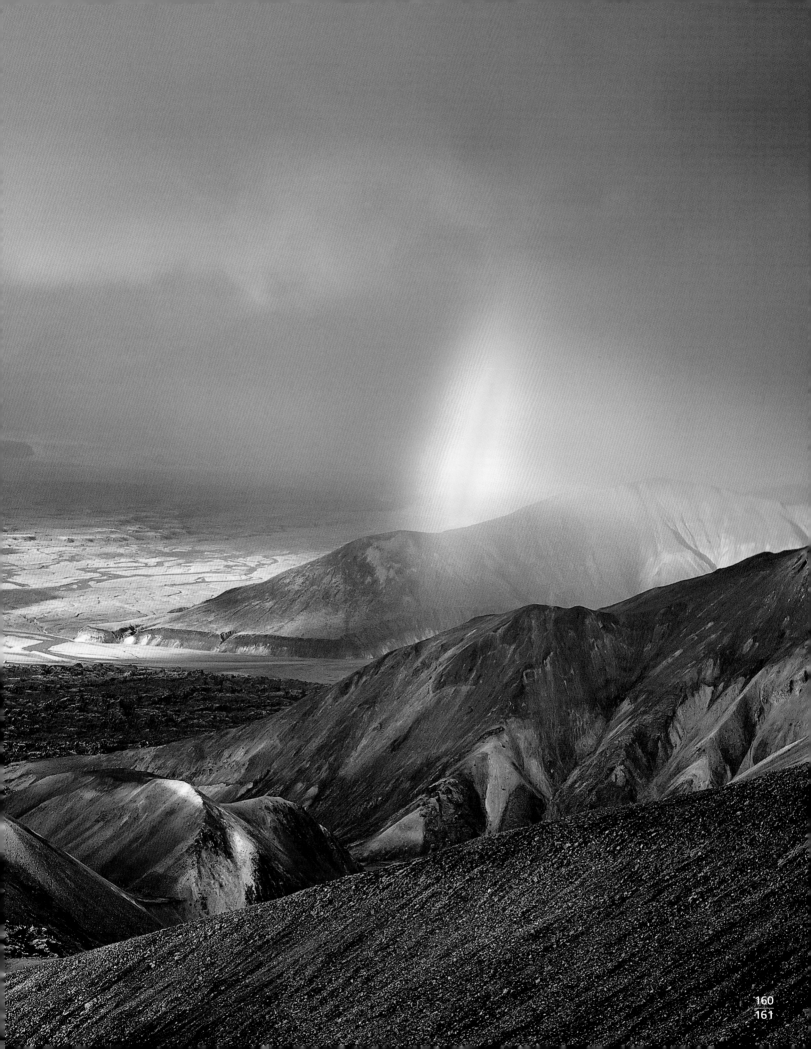

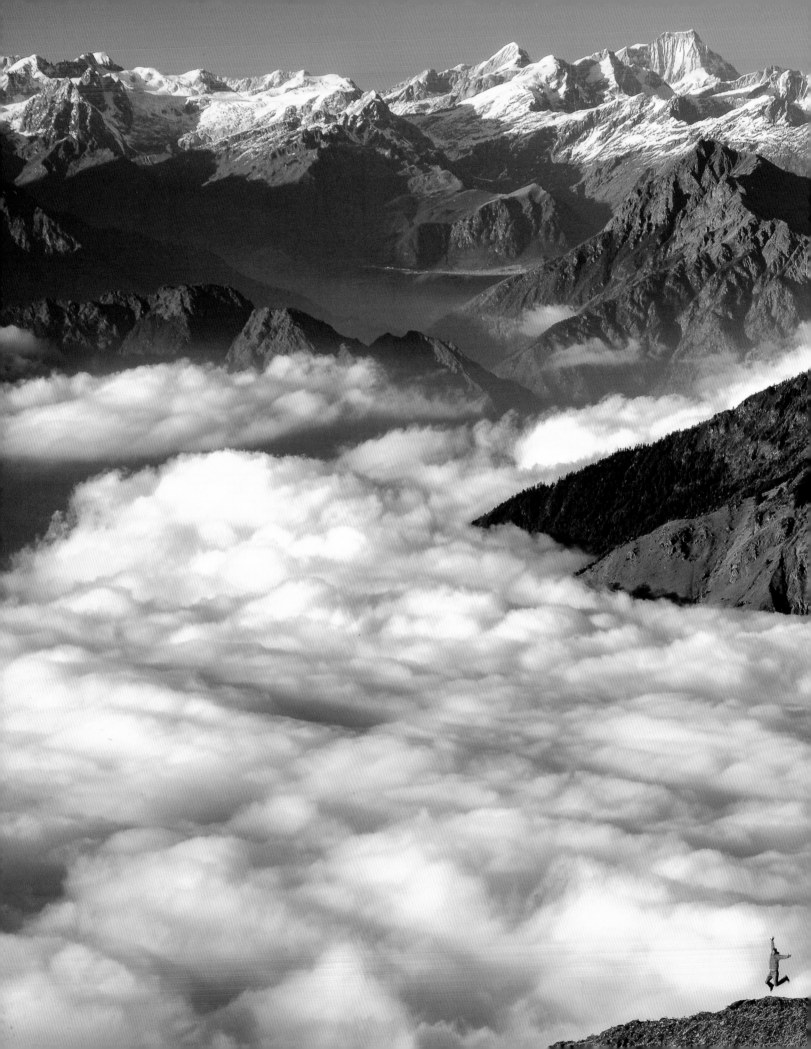

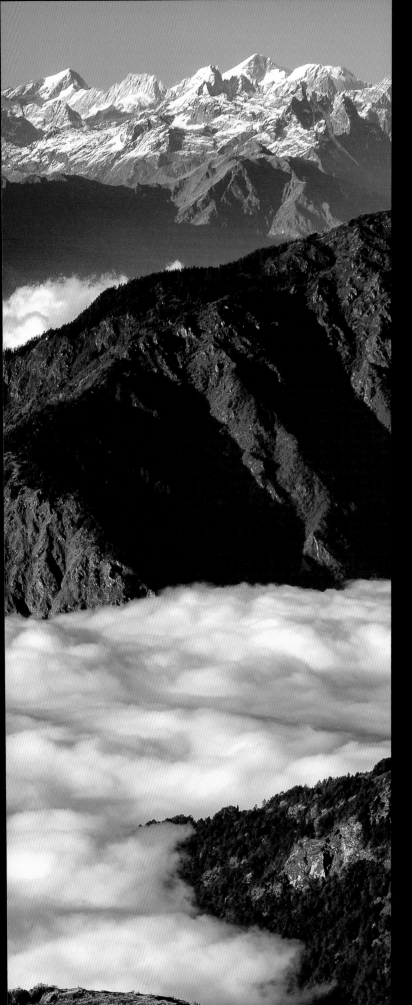

# The Roof of the World

PONTIC MOUNTAINS | ARMENIA | IRAN | CAUCASUS |
CRIMEA | UNITED ARAB EMIRATES | TAJIKISTAN |
KAMTCHATKA | KARAKORAM | NEPAL | INDIA |
HIMALAYAS | PHILIPPINES | INDONESIA

"Langtang Trek is one of the best-known trekking routes in Nepal, especially because of its scenic beauty. When a friend and I reached 12,500 feet (3,800 m), we were above the clouds and were as excited as children about the impressive mountain panorama that stretched out in front of us. With this picture, I intended to visualize the almost unlimited expanse of the mountains of the Himalayas."

▲▲ LANGTANG TREK, NEPAL

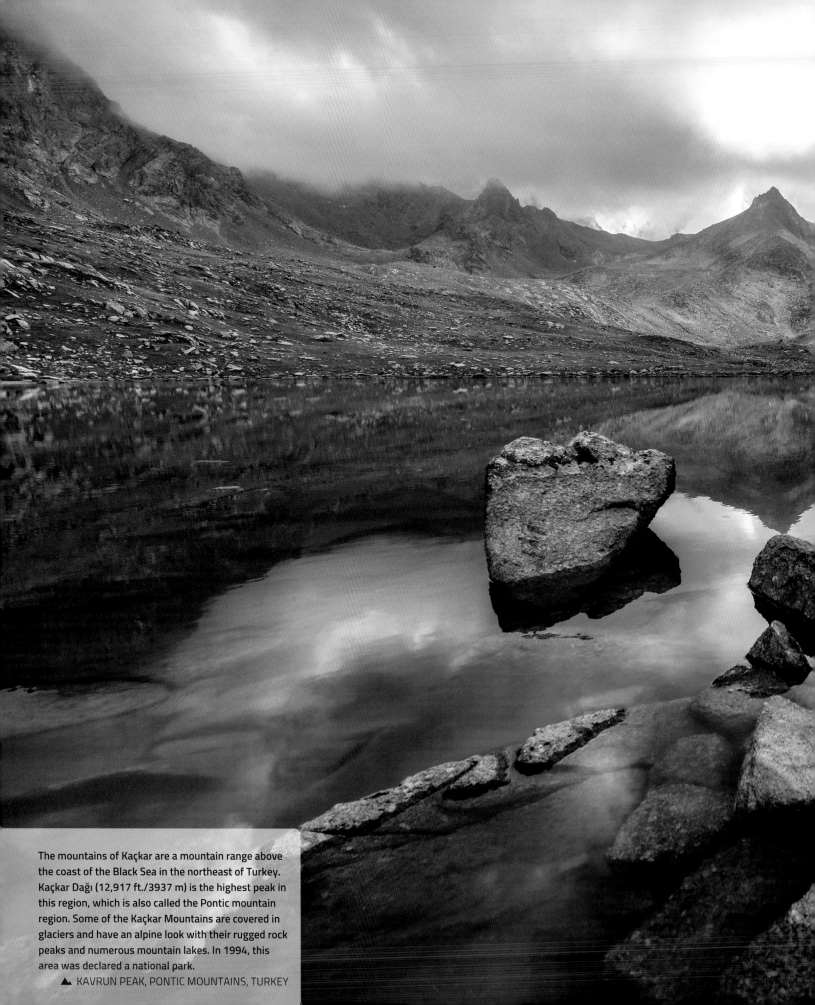

The mountains of Kaçkar are a mountain range above the coast of the Black Sea in the northeast of Turkey. Kaçkar Dağı (12,917 ft./3937 m) is the highest peak in this region, which is also called the Pontic mountain region. Some of the Kaçkar Mountains are covered in glaciers and have an alpine look with their rugged rock peaks and numerous mountain lakes. In 1994, this area was declared a national park.

▲ KAVRUN PEAK, PONTIC MOUNTAINS, TURKEY

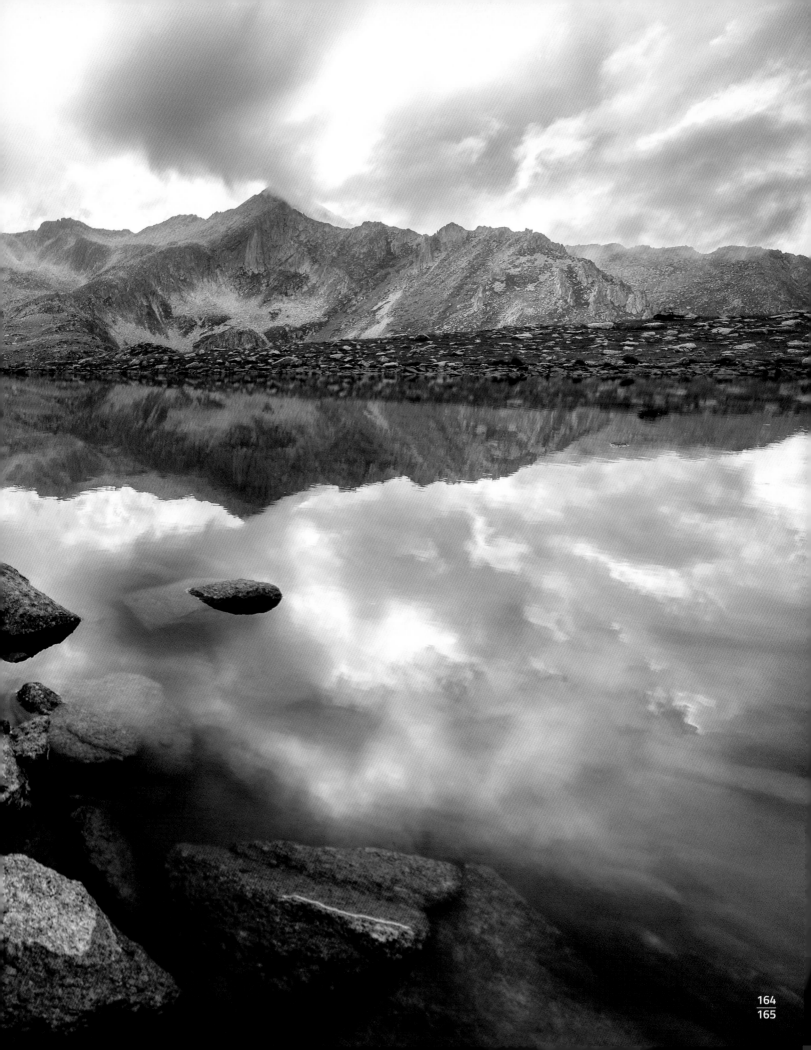

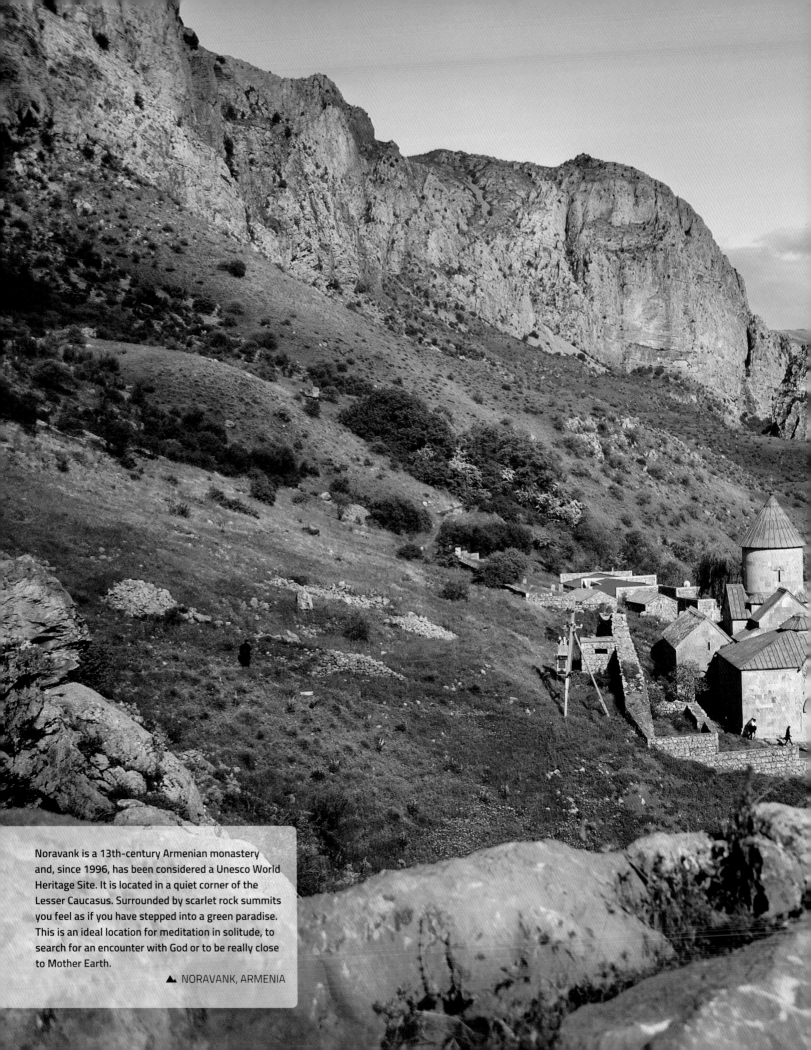

Noravank is a 13th-century Armenian monastery
and, since 1996, has been considered a Unesco World
Heritage Site. It is located in a quiet corner of the
Lesser Caucasus. Surrounded by scarlet rock summits
you feel as if you have stepped into a green paradise.
This is an ideal location for meditation in solitude, to
search for an encounter with God or to be really close
to Mother Earth.

▲ NORAVANK, ARMENIA

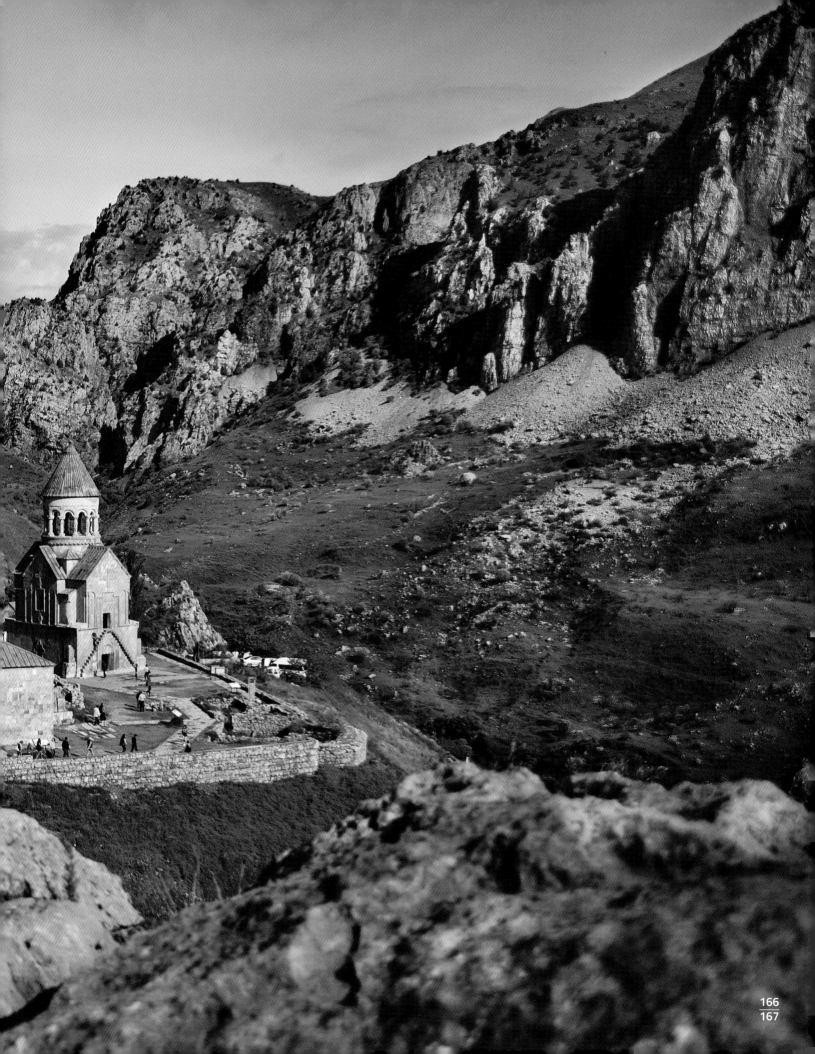

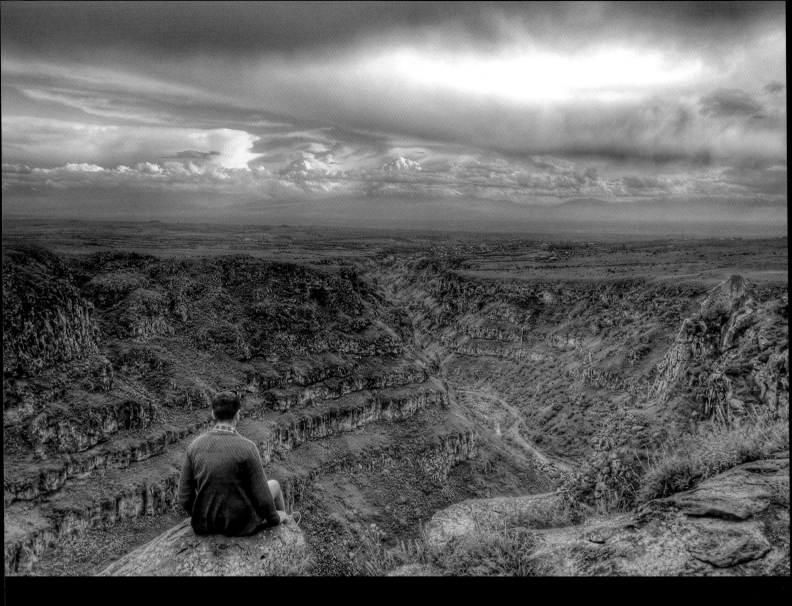

Aragasotn is a province in the western part of Armenia that features impressive mountains. The name Aragasotn means "at the foot of Mount Aragats." Kasakh canyon, with a depth of 590 feet (180 m), is on the left next to the old monastery of Saghmosavanq, which was built in 1215. The basaltic rock of the canyon is typical for Armenia. After his stay at the monastery, this young visitor sat down at the edge of the canyon and enjoyed the scenic beauty. He may have thought of the checkered history of this location where many wars and fights have taken place.

▲ ARAGASOTN, ARMENIA

"My camera is my companion every time I climb a mountain and sometimes she is like a lover that I talk to; like here in this picture, during the ascent to the summit of Gholleh Yakhchal in the Alvand Mountains near the city of Hamadan, in Iran's province of the same name. I will never forget this day because it was freezing and we had severely stormy weather."

▲ GHOLLEH YAKHCHAL, HAMADAN, IRAN

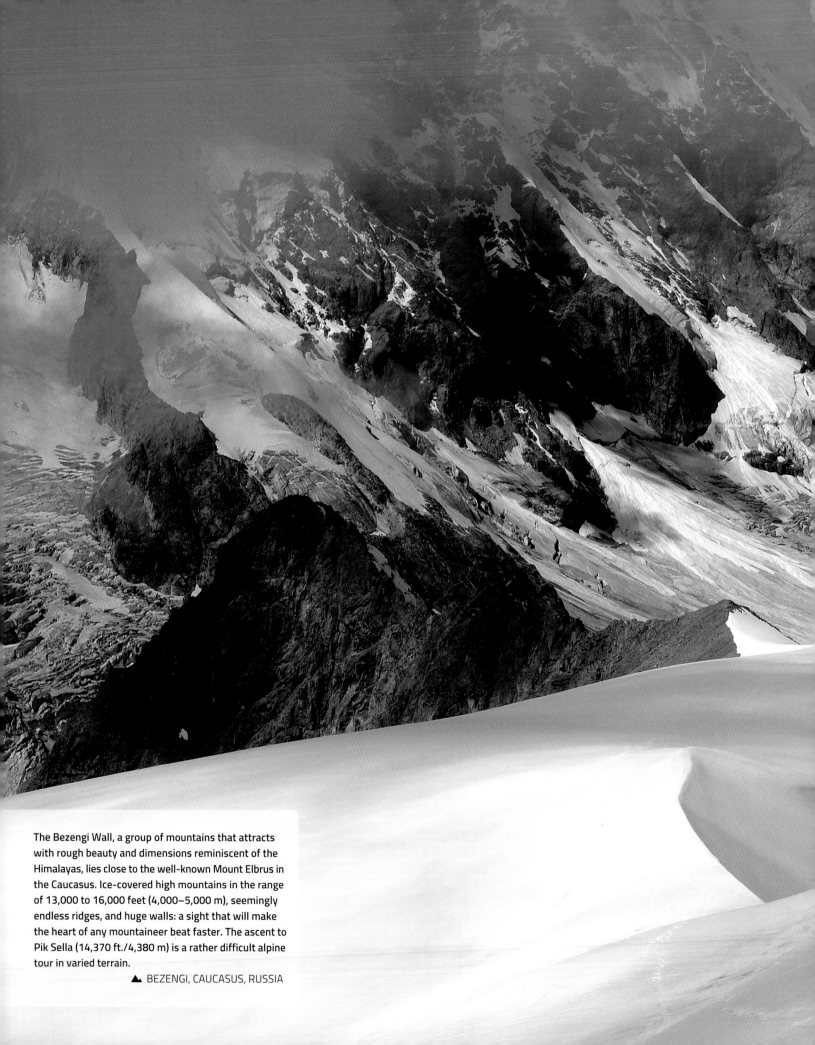

The Bezengi Wall, a group of mountains that attracts with rough beauty and dimensions reminiscent of the Himalayas, lies close to the well-known Mount Elbrus in the Caucasus. Ice-covered high mountains in the range of 13,000 to 16,000 feet (4,000–5,000 m), seemingly endless ridges, and huge walls: a sight that will make the heart of any mountaineer beat faster. The ascent to Pik Sella (14,370 ft./4,380 m) is a rather difficult alpine tour in varied terrain.

▲ BEZENGI, CAUCASUS, RUSSIA

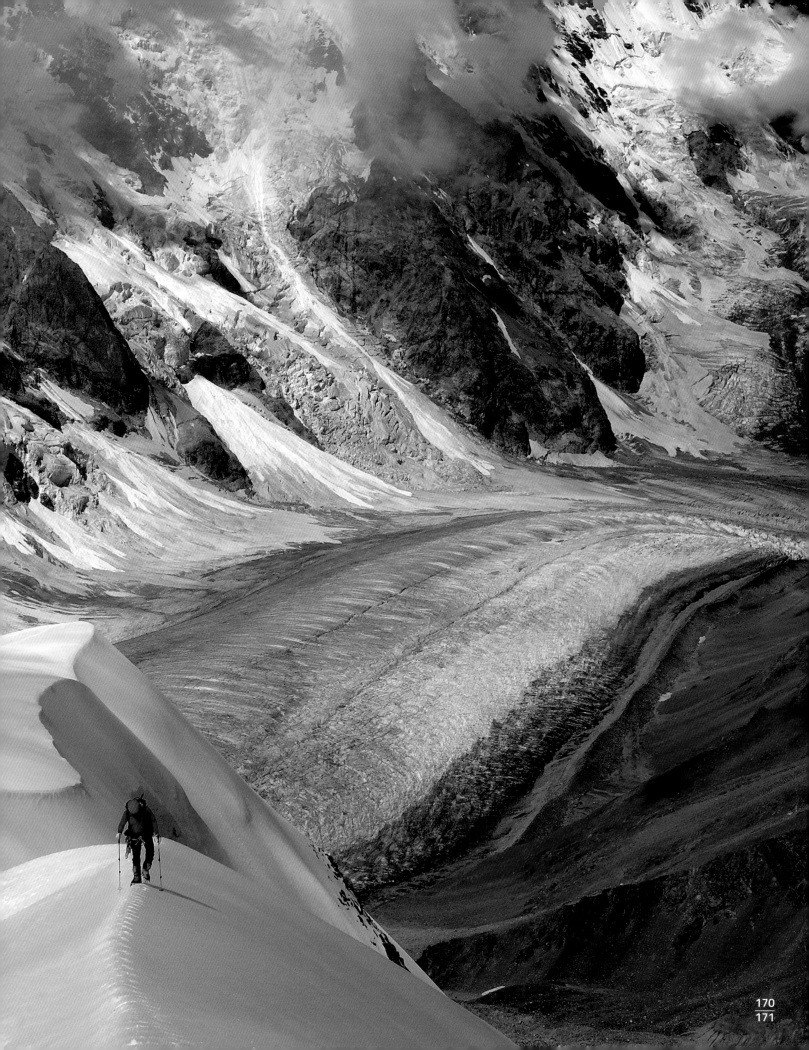

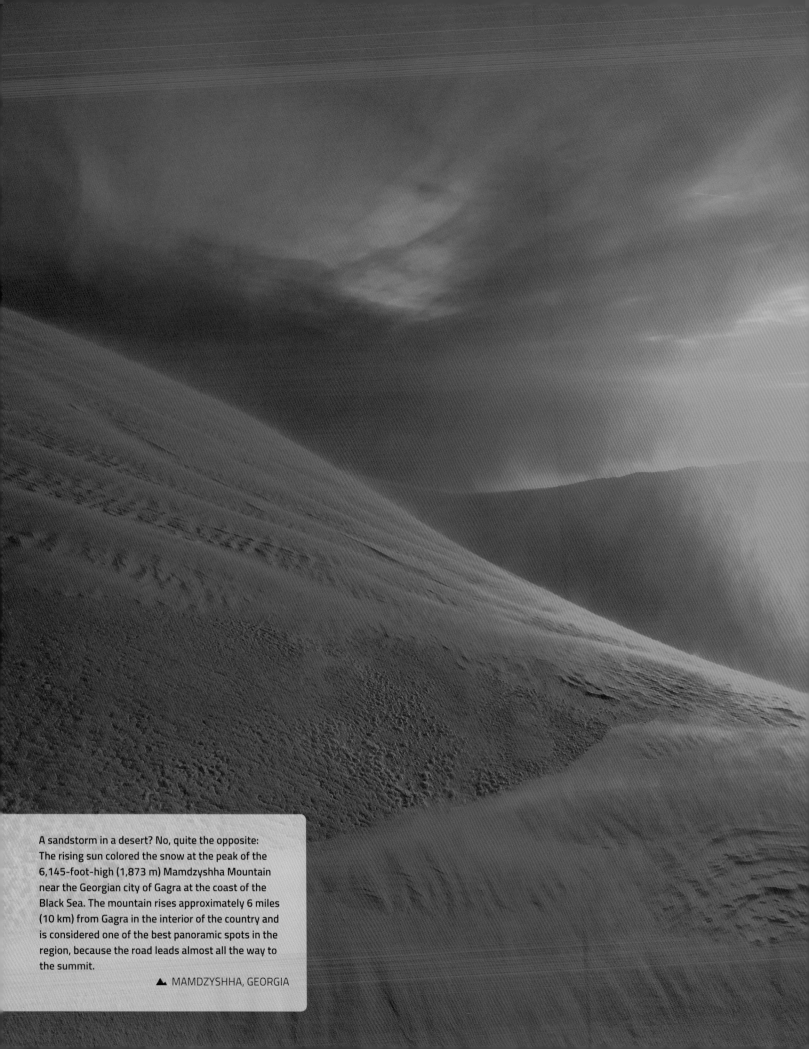

A sandstorm in a desert? No, quite the opposite:
The rising sun colored the snow at the peak of the
6,145-foot-high (1,873 m) Mamdzyshha Mountain
near the Georgian city of Gagra at the coast of the
Black Sea. The mountain rises approximately 6 miles
(10 km) from Gagra in the interior of the country and
is considered one of the best panoramic spots in the
region, because the road leads almost all the way to
the summit.

▲ MAMDZYSHHA, GEORGIA

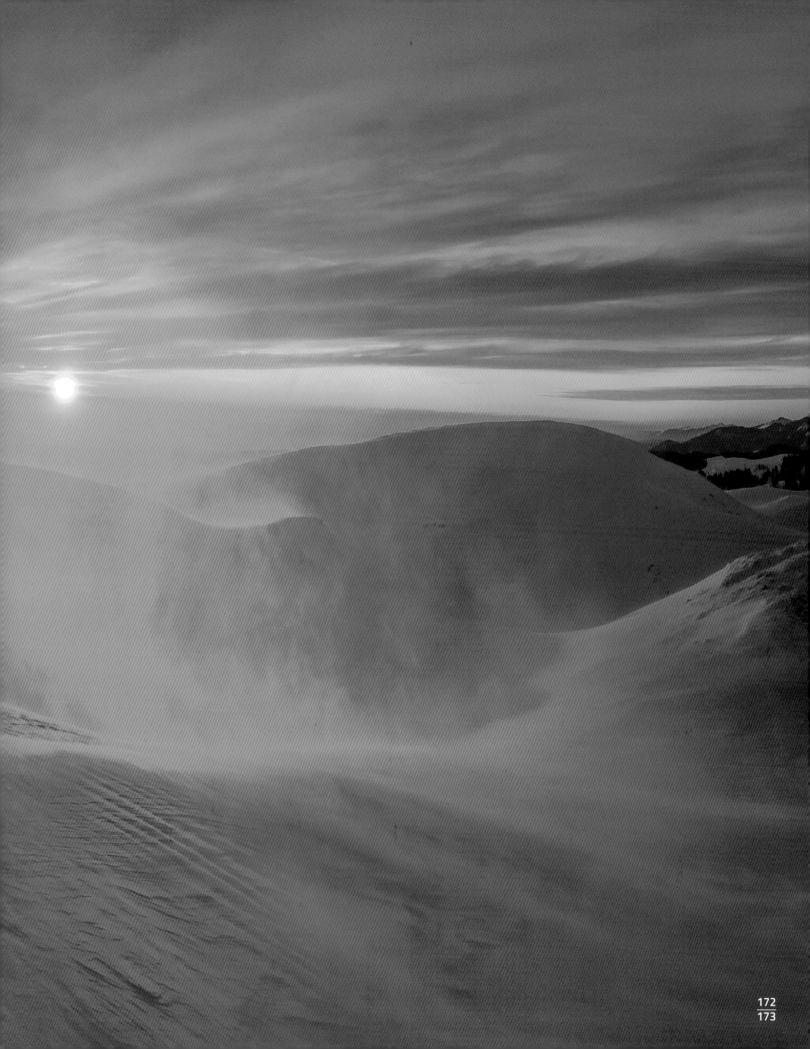

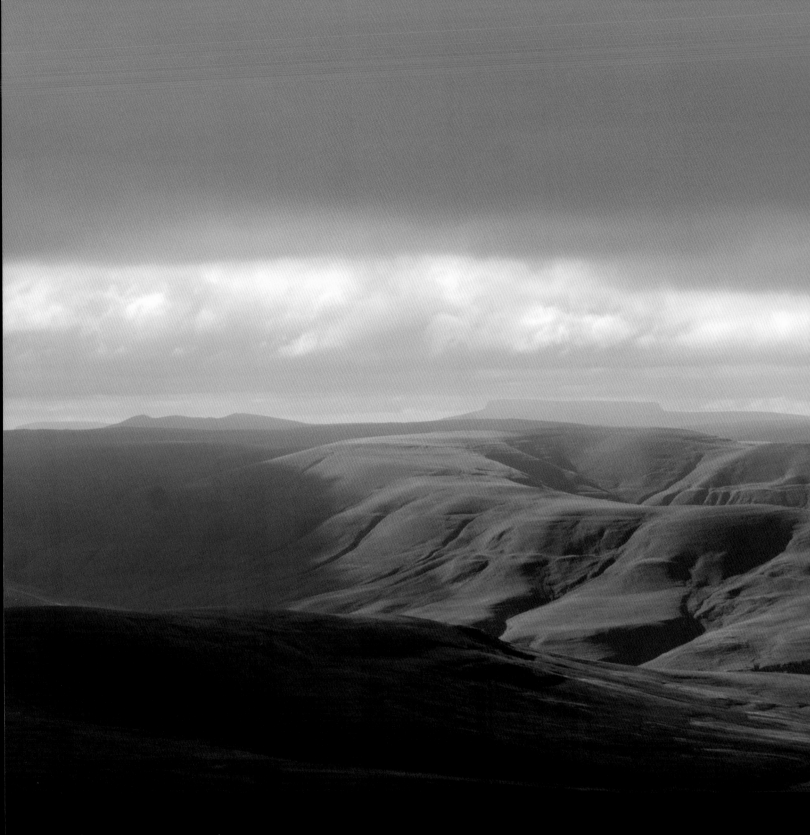

Djili-Su (Turkish for The Warm Waters) is a strange name for an exceptional landscape: thundering waterfalls, deep canyons, mineral springs and turquoise-colored ice, proud eagles in the sky and well-fed marmots on the ground, and above everything, Mount Elbrus (18,510 ft./5,642 m), the highest mountain in Russia and Europe, stands guard.

▲ DJILI-SU, CAUCASUS, RUSSIA

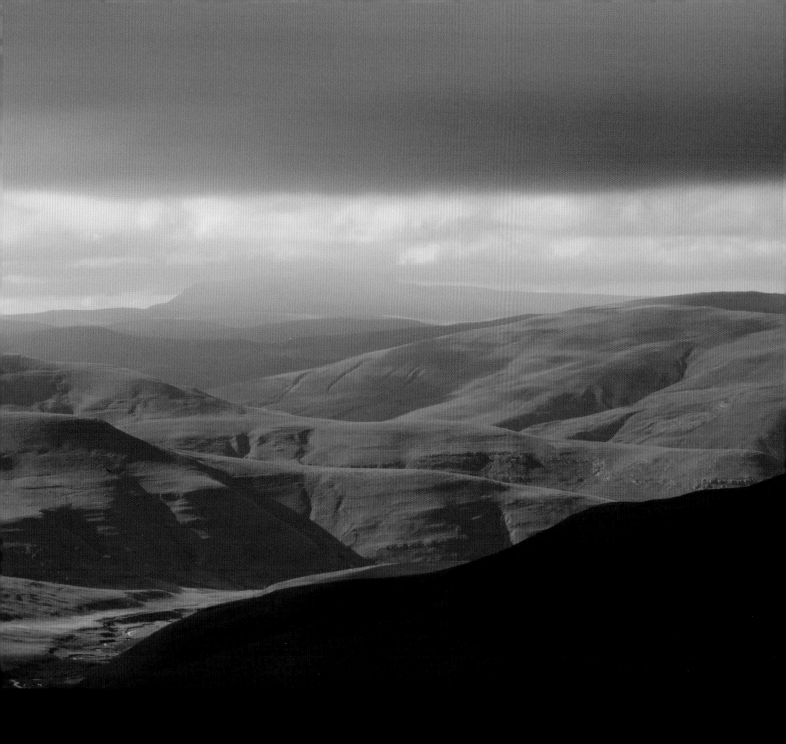

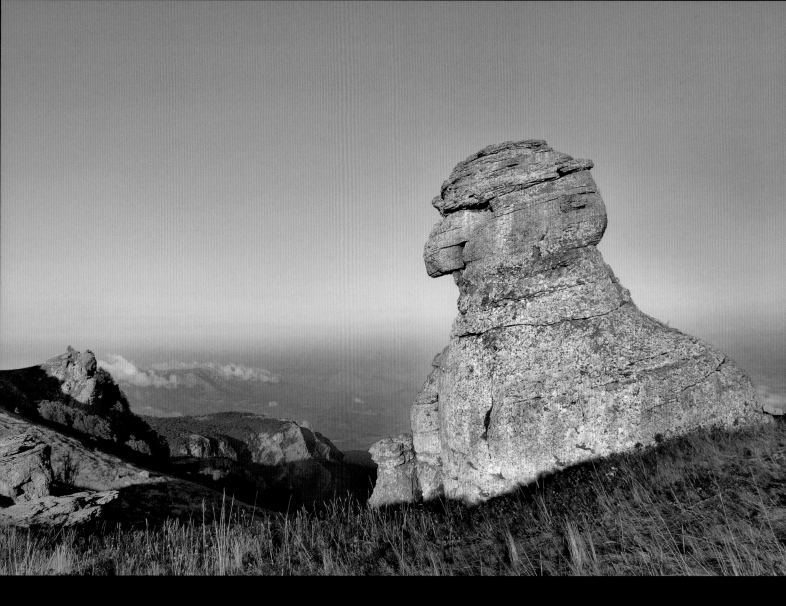

The trekking route through the Valley of Ghosts in the Highlands of Crimea is one of the most impressive trekking tours on the entire peninsula. Strange-looking rock formations, some on their own and others in groups, rise up along the way. And when the wafts of mists swirl above the plateau of Demerdji, revealing only partial views of the rock formations, you can understand why locals have given this area this name. The rock formation in this picture is "The Master of the Valley," who carefully scrutinizes every intruder.

▲ VALLEY OF GHOSTS, CRIMEA, UKRAINE

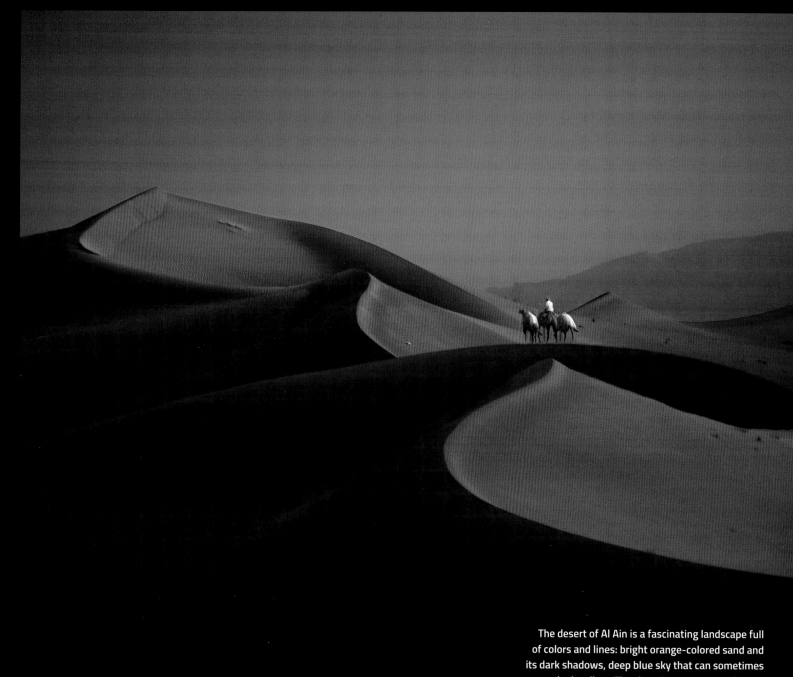

The desert of Al Ain is a fascinating landscape full of colors and lines: bright orange-colored sand and its dark shadows, deep blue sky that can sometimes even look yellow. The sheer immenseness of sand, with miles of only the curved lines of the dunes, and in between, looking like a foreign entity: a human...

▲▲ AL AIN, UNITED ARAB EMIRATES

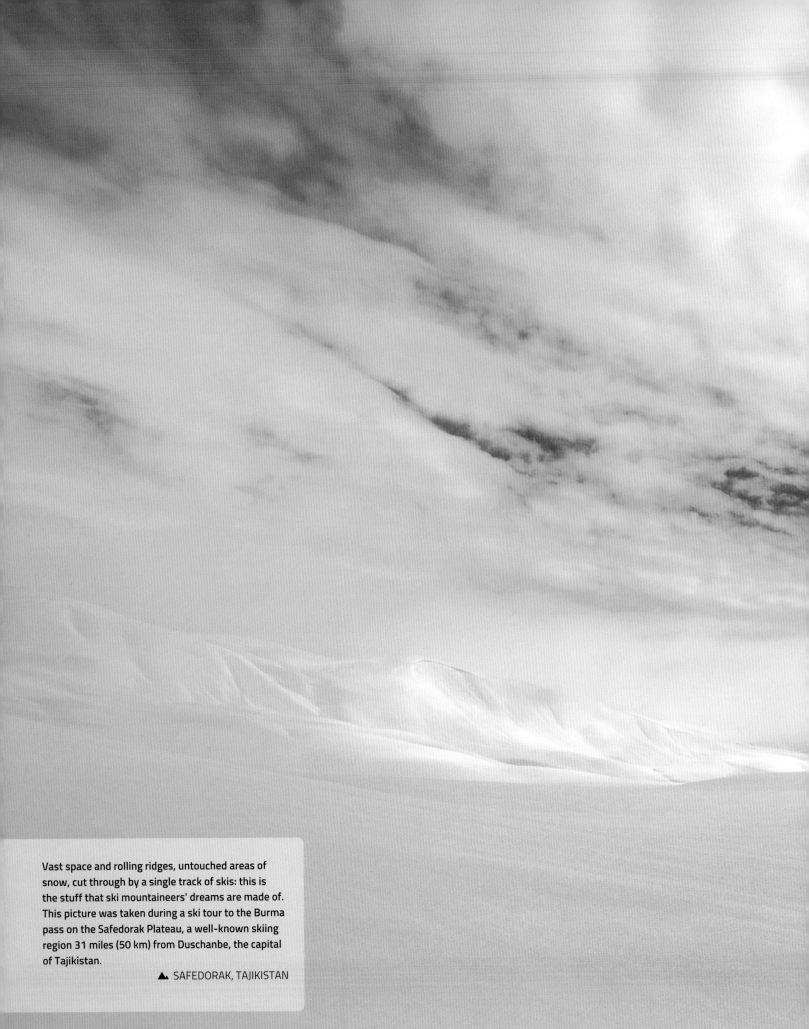

Vast space and rolling ridges, untouched areas of snow, cut through by a single track of skis: this is the stuff that ski mountaineers' dreams are made of. This picture was taken during a ski tour to the Burma pass on the Safedorak Plateau, a well-known skiing region 31 miles (50 km) from Duschanbe, the capital of Tajikistan.

▲ SAFEDORAK, TAJIKISTAN

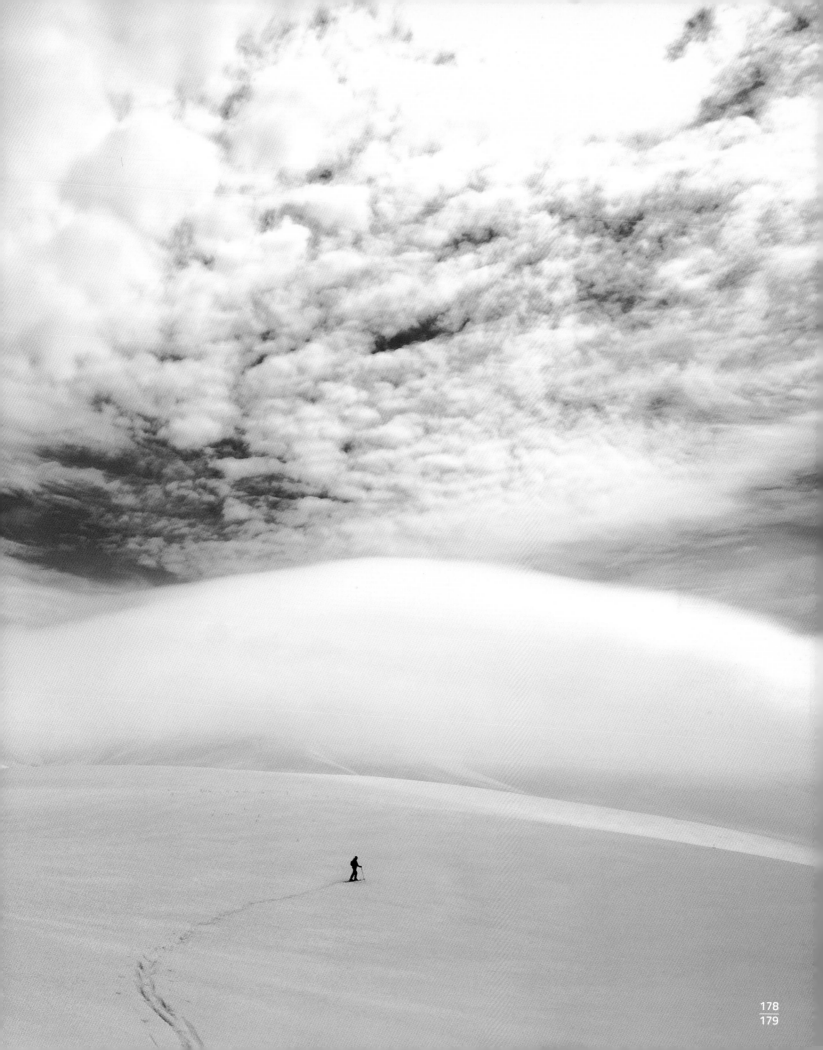

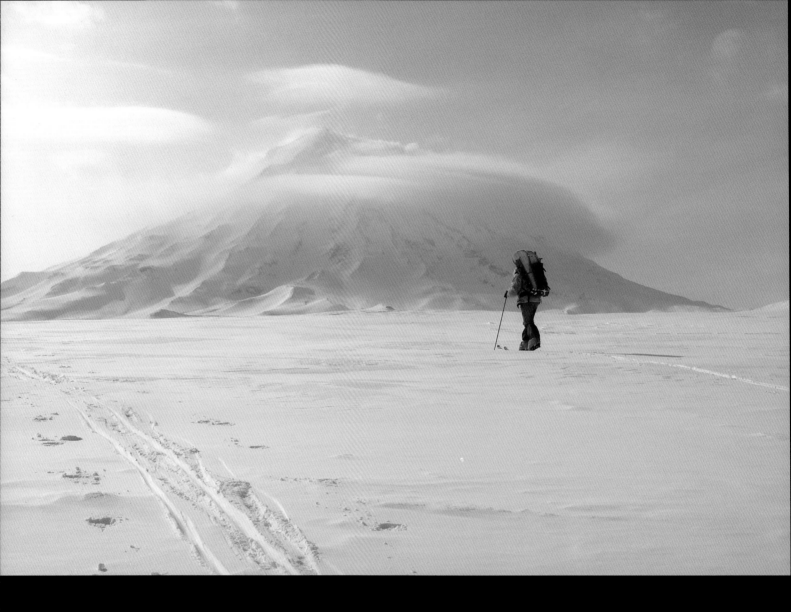

"In the winter, the Kamchatka peninsula in the
northeast of Russia with its volcanoes and geysers
is particularly challenging for ski tourists. The guide
of our mountaineering group carves his way to the
Avacha pass on the seventh day of our crossing. The
volcano Koryaksky Sopka, with its peak covered in
clouds, rises in the background."

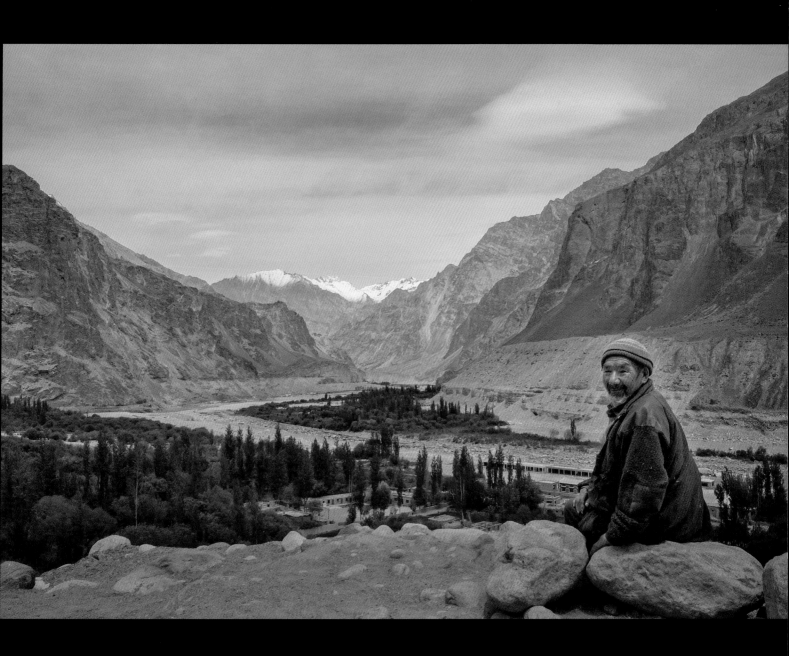

The Nubra Valley is a high valley between the Hima-
layas and Karakoram mountains; the last settlement
on the Indian side is Turtuk, a small village that is

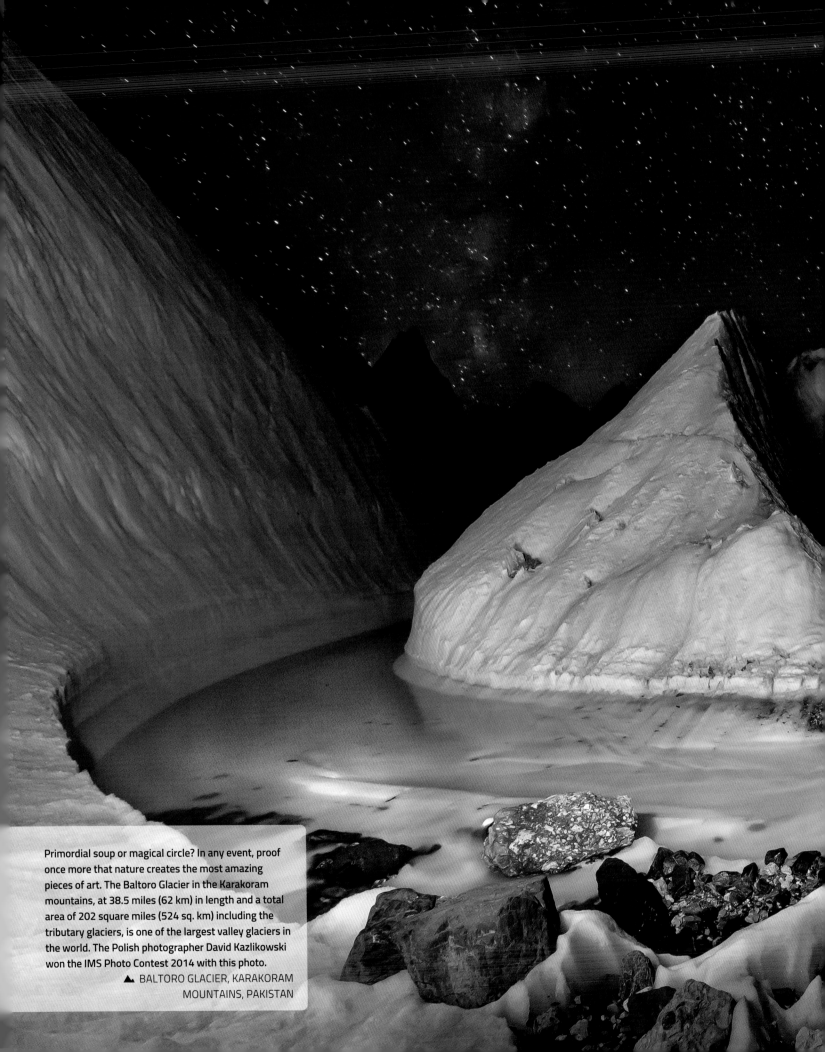

Primordial soup or magical circle? In any event, proof once more that nature creates the most amazing pieces of art. The Baltoro Glacier in the Karakoram mountains, at 38.5 miles (62 km) in length and a total area of 202 square miles (524 sq. km) including the tributary glaciers, is one of the largest valley glaciers in the world. The Polish photographer David Kazlikowski won the IMS Photo Contest 2014 with this photo.

▲ BALTORO GLACIER, KARAKORAM MOUNTAINS, PAKISTAN

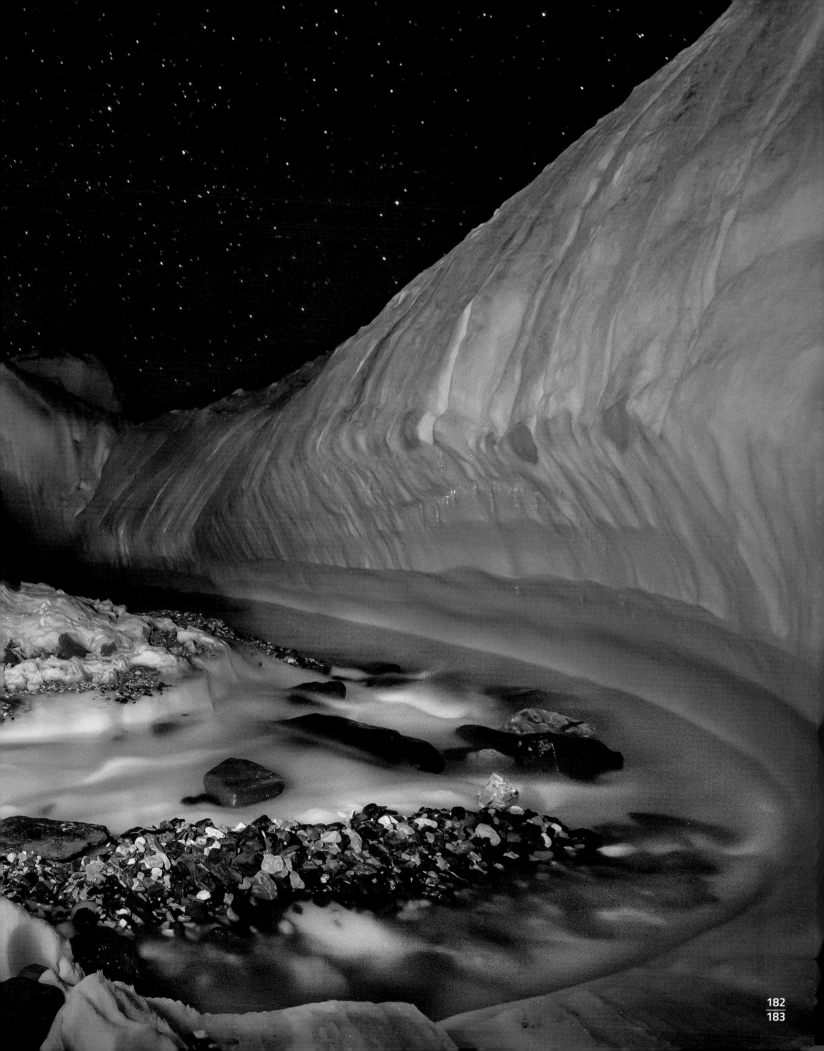

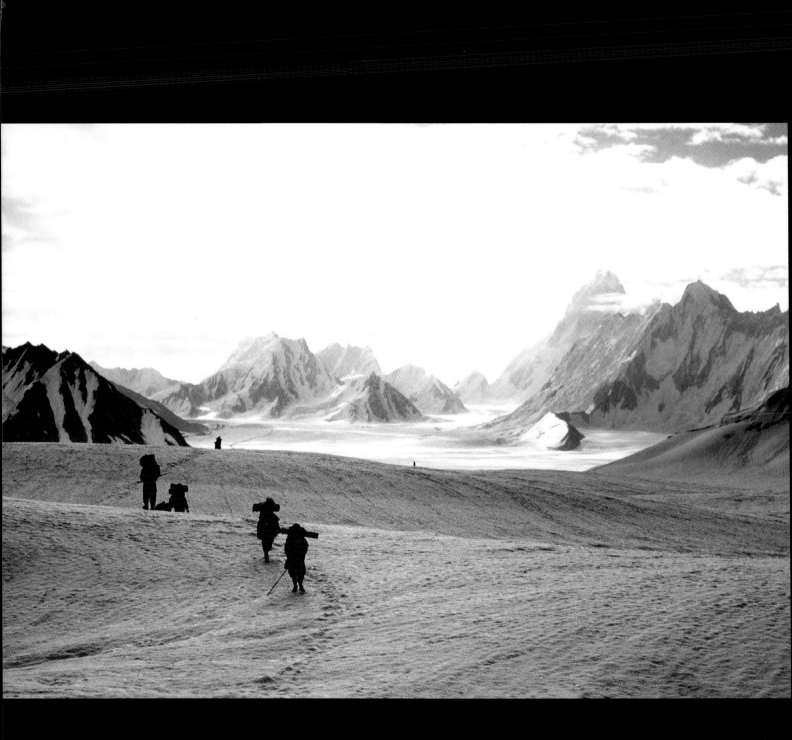

The Biafo Glacier, at 39 miles (63 km) in length, is the
longest glacier in the Karakoram mountains and, together
with the Hispar Glacier, forms the longest connected
ice system outside the polar regions. This picture, which

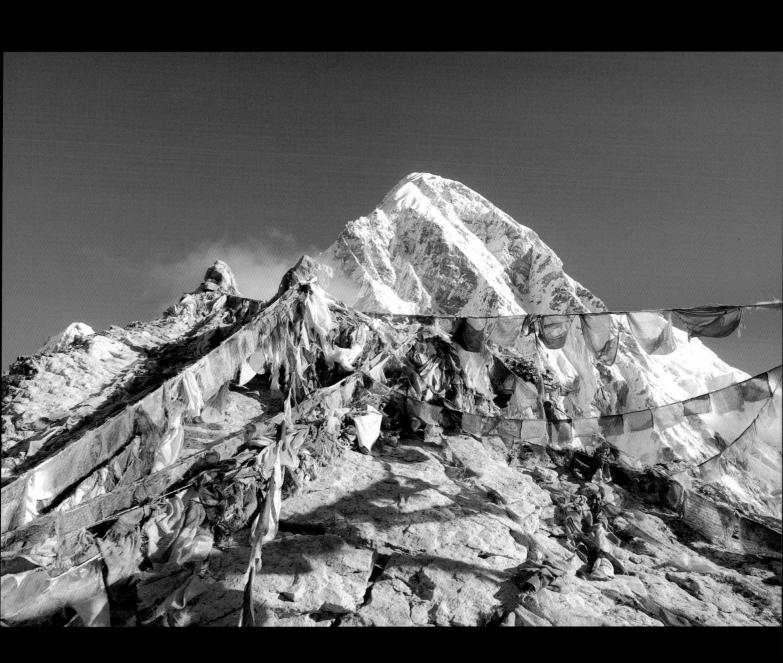

Without its large neighbors — such as Lhotse, Nuptse
or Everest — in the picture, the 23,500-foot-high
(7,160 m) Pumo Ri ("Mountain Daughter" in Sherpa)
looks almost like the regal sovereign of the autumn-blue

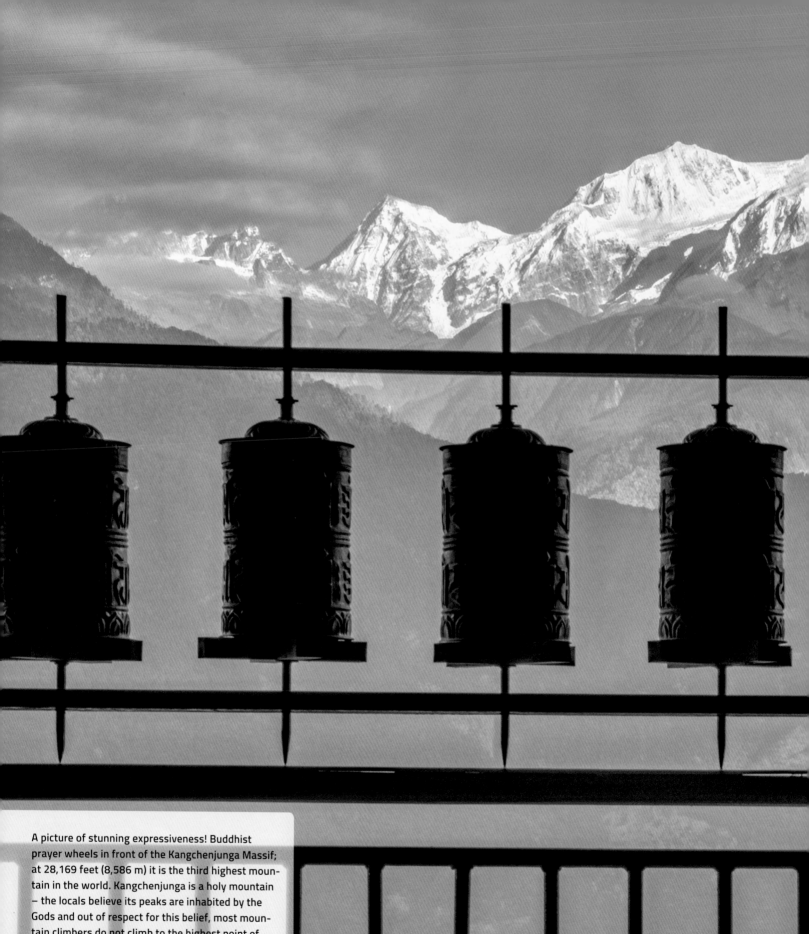

A picture of stunning expressiveness! Buddhist prayer wheels in front of the Kangchenjunga Massif; at 28,169 feet (8,586 m) it is the third highest mountain in the world. Kangchenjunga is a holy mountain – the locals believe its peaks are inhabited by the Gods and out of respect for this belief, most mountain climbers do not climb to the highest point of the summit. The name of the mountain means "Five Treasures of Snow."

▲ KANGCHENJUNGA, HIMALAYAS

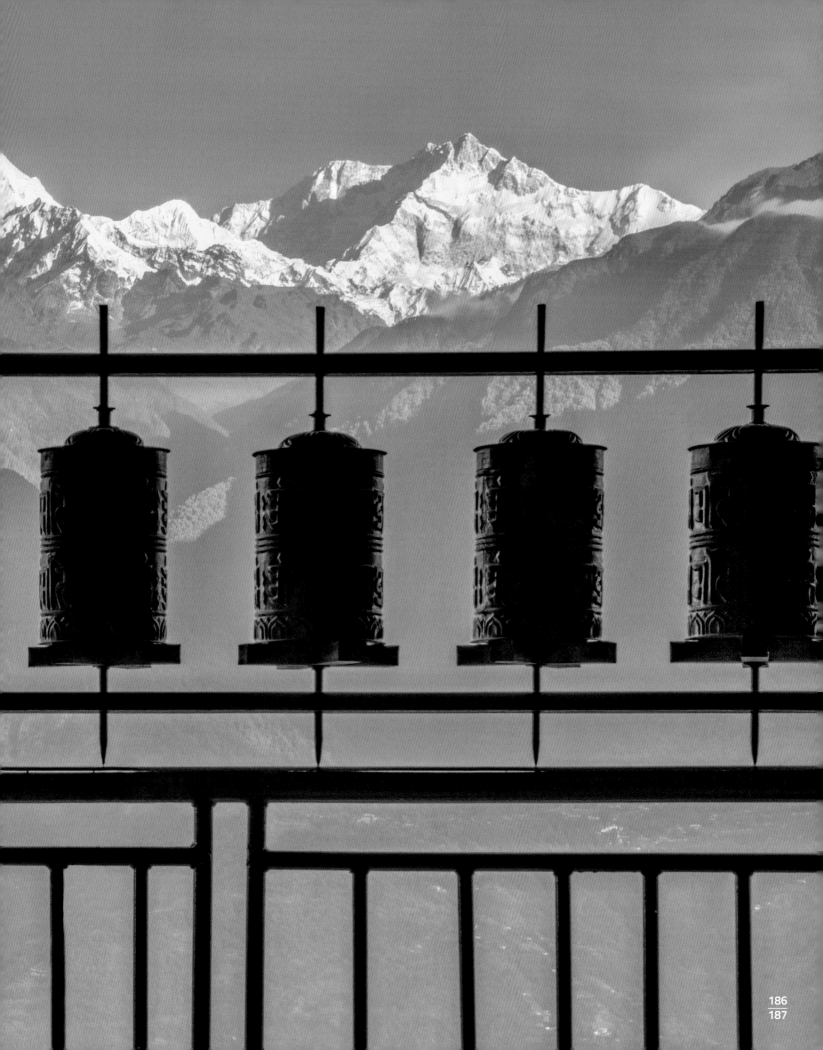

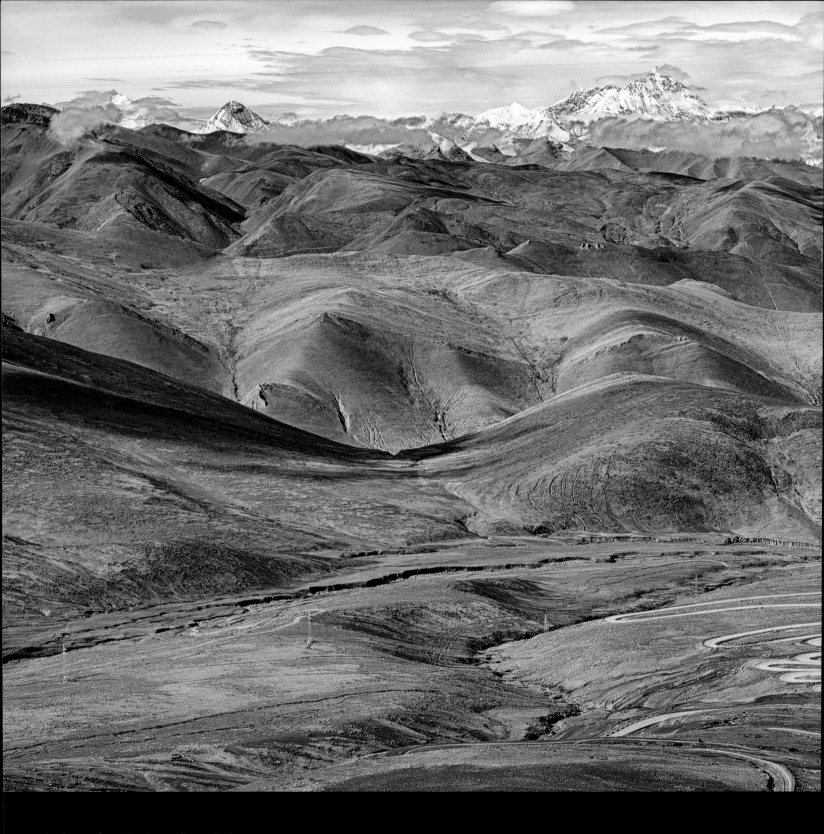

"On the way from Tingri, a small town in the autonomous region of Tibet, toward the Chinese-Nepalese border, we entered the Chomolangma National Park. At over 13,000 feet (4,000 m) above sea level, it is the highest natural park on Earth. Chomolangma is the Tibetan name for Mount Everest. This seemingly endless winding road that carves its way higher and higher soon made us feel dizzy in our SUV."

▲ MOUNT EVEREST, HIMALAYAS

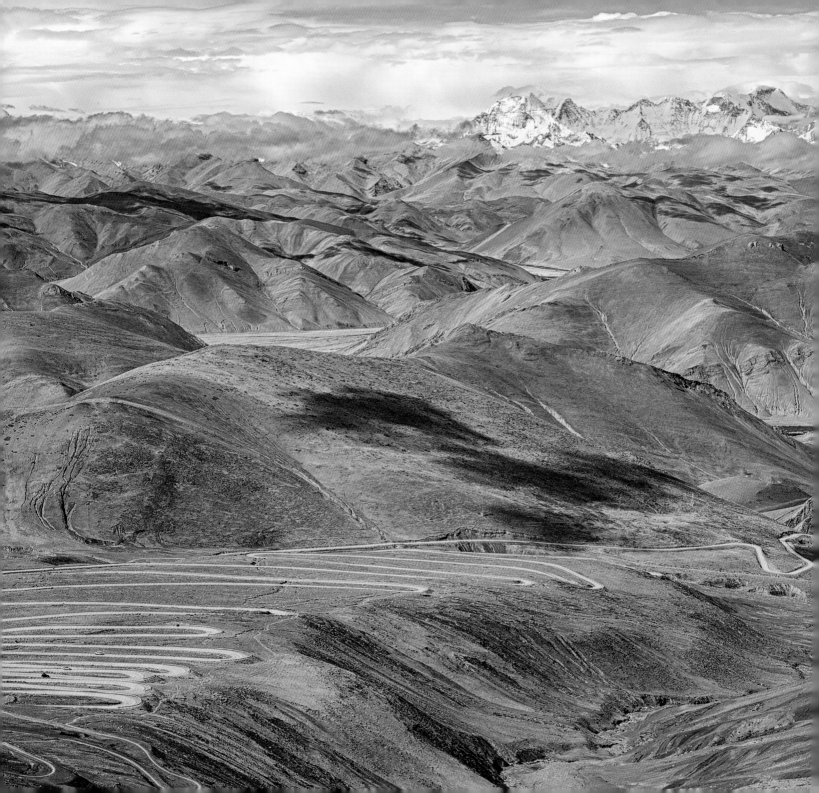

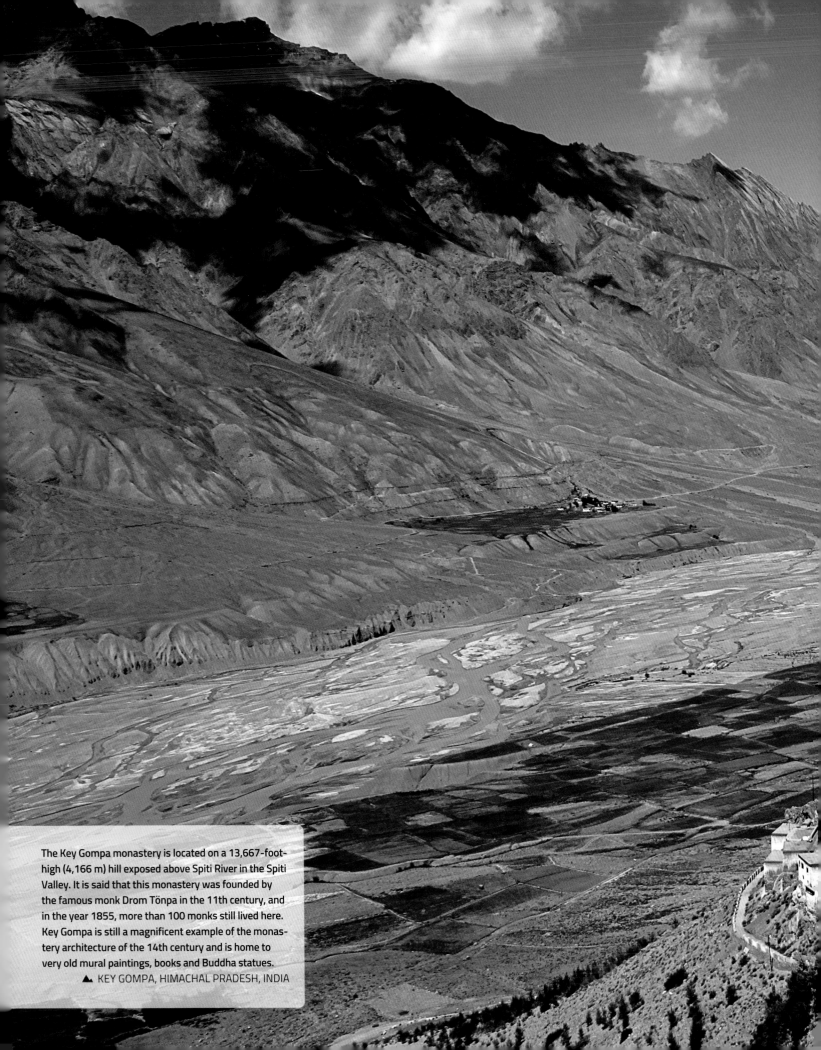

The Key Gompa monastery is located on a 13,667-foot-high (4,166 m) hill exposed above Spiti River in the Spiti Valley. It is said that this monastery was founded by the famous monk Drom Tönpa in the 11th century, and in the year 1855, more than 100 monks still lived here. Key Gompa is still a magnificent example of the monastery architecture of the 14th century and is home to very old mural paintings, books and Buddha statues.

▲ KEY GOMPA, HIMACHAL PRADESH, INDIA

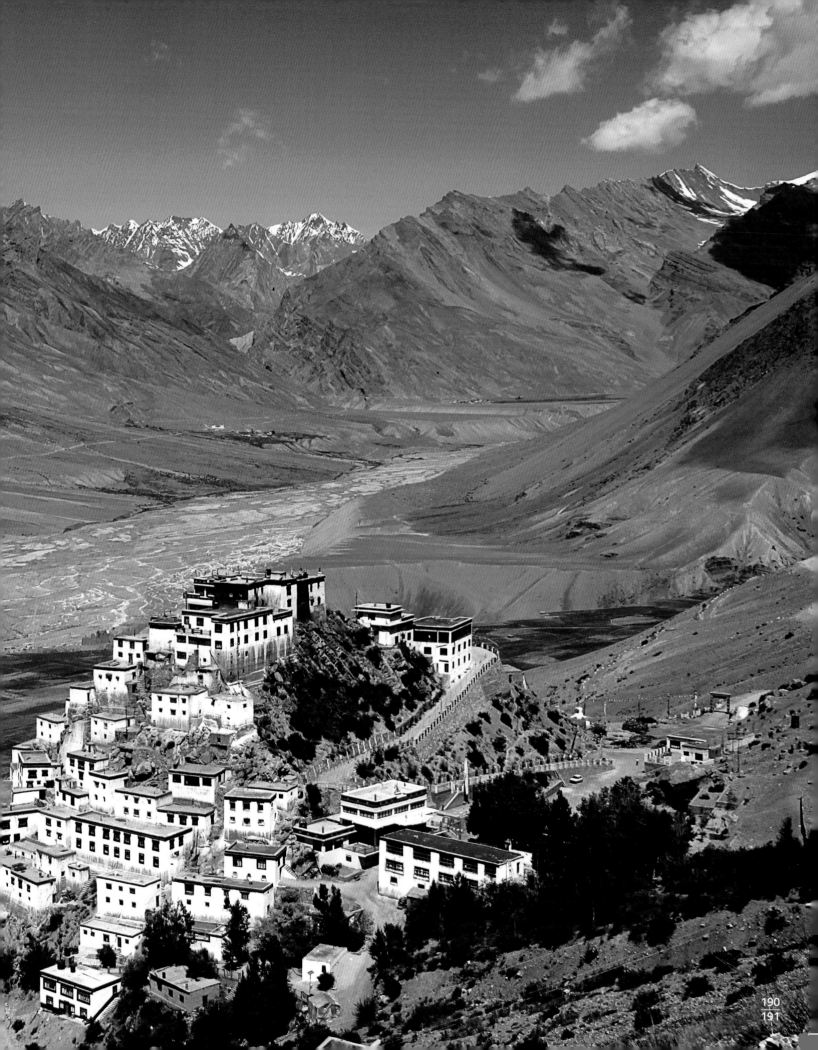

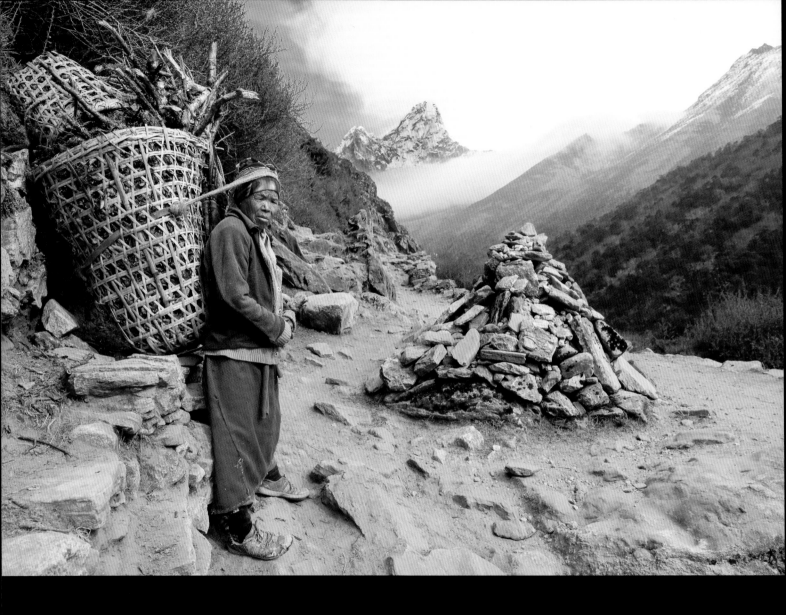

This Nepalese woman has collected firewood
and carries it to her house in the village of Debuche
(12,434 ft./3,790 m). It is located at the entrance
to Sagarmatha National Park. Every year countless
tourists flock here to view the highest mountain on
Earth: Mount Everest. But apart from Everest, there

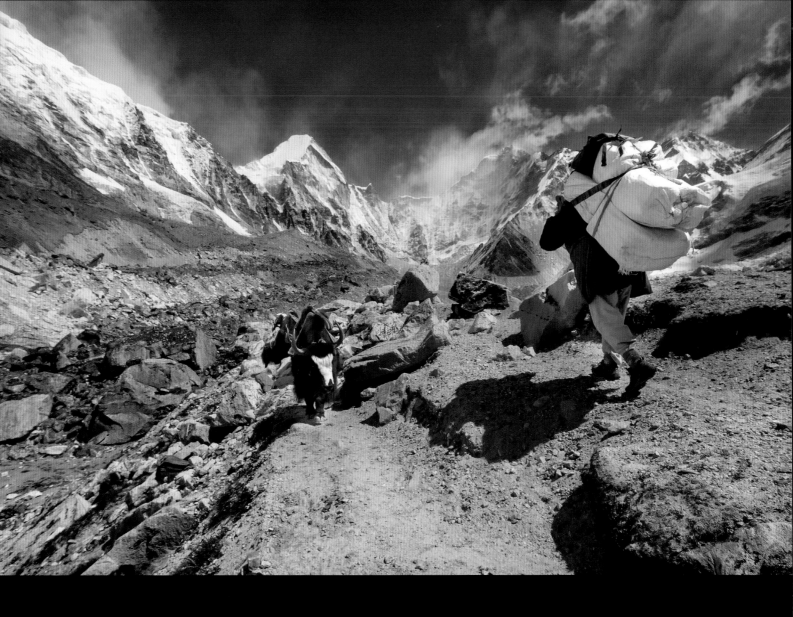

The mountains have always played an important role in the lives of locals — although they have changed due to global warming and the reckless use of nature by people. We must do everything possible to enable a continuation of life in and with the mountains. The Everest Base Camp is the end point for trekkers and where the "real" mountain climbing begins.

▲ NEAR THE EVEREST BASE CAMP, HIMALAYAS

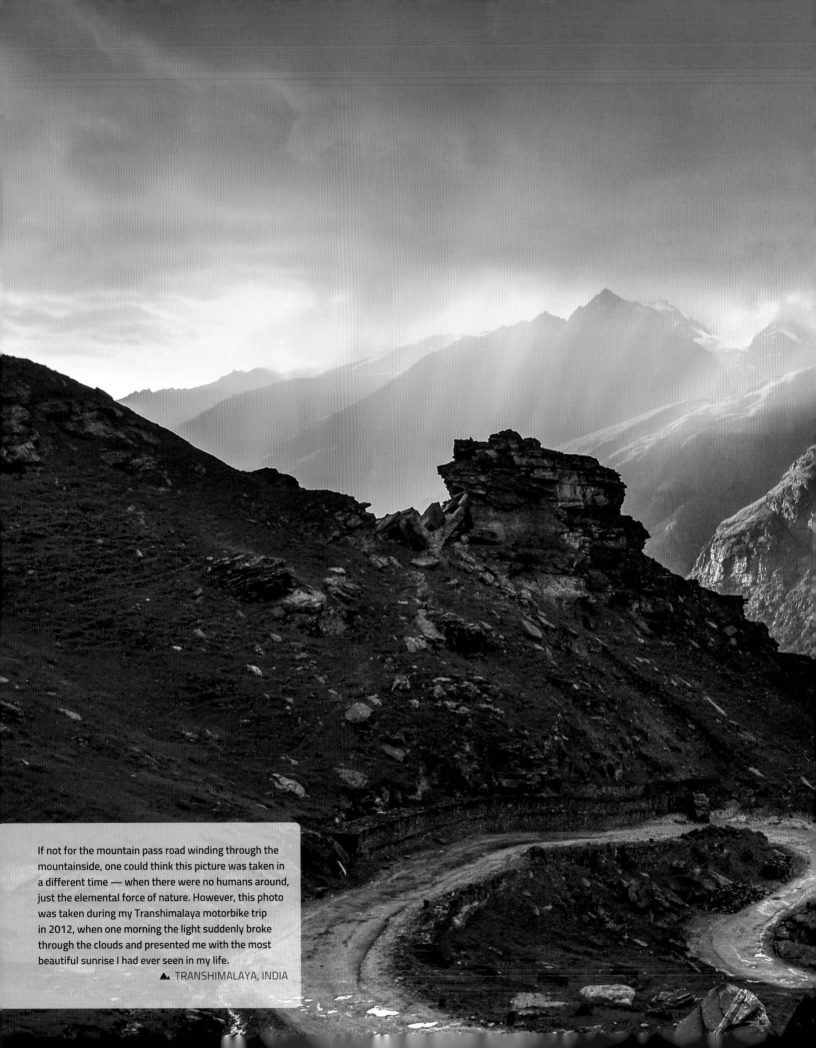

If not for the mountain pass road winding through the mountainside, one could think this picture was taken in a different time — when there were no humans around, just the elemental force of nature. However, this photo was taken during my Transhimalaya motorbike trip in 2012, when one morning the light suddenly broke through the clouds and presented me with the most beautiful sunrise I had ever seen in my life.

▲ TRANSHIMALAYA, INDIA

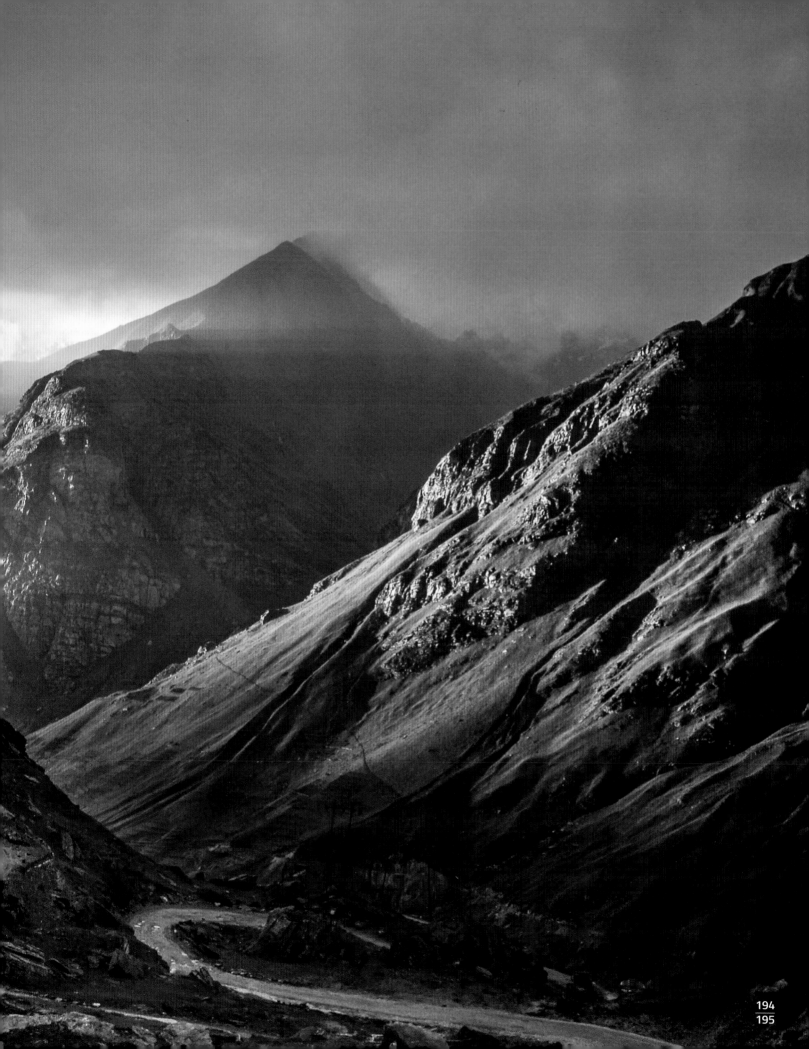

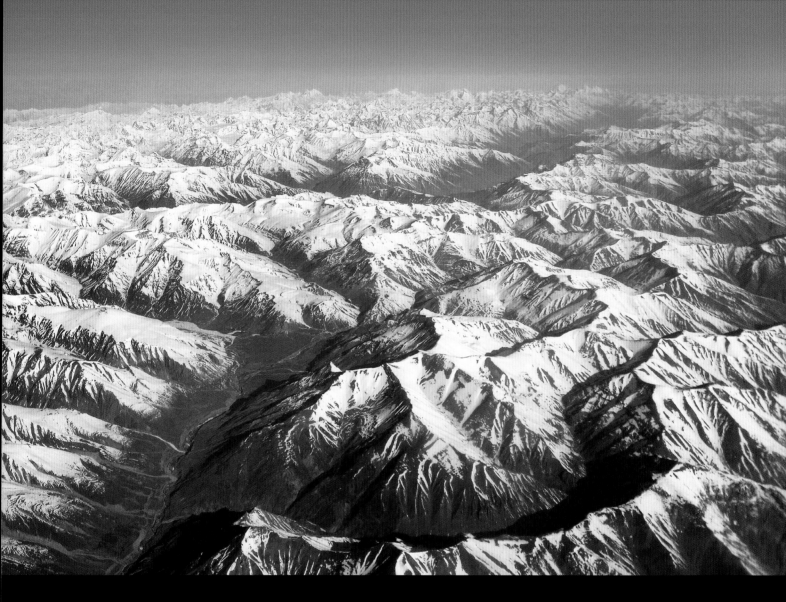

The Himalayas are a high mountain system in Asia, between India in the south and the Tibetan Highlands in the north. The mountains span a length of approximately 1,864 miles (3,000 km) from Pakistan to Myanmar and reach a maximum width of 217.5 miles (350 km); this is where the largest peaks of the world rise. This picture was taken on a flight above India from New Delhi to Leh.

▲ HIMALAYAS

A clear, star-spattered sky arches across K2, the "mountain of all mountains." The tents are set up at the base camp of Broad Peak (26,414 ft./8,051 m), the 12th-highest of the 14 mountains above 26,000 feet (8,000 m) in height. This picture was taken on an expedition during which I tried to climb Broad Peak without supplemental oxygen and without Sherpas.

▲ K2, KARAKORAM MOUNTAINS, PAKISTAN

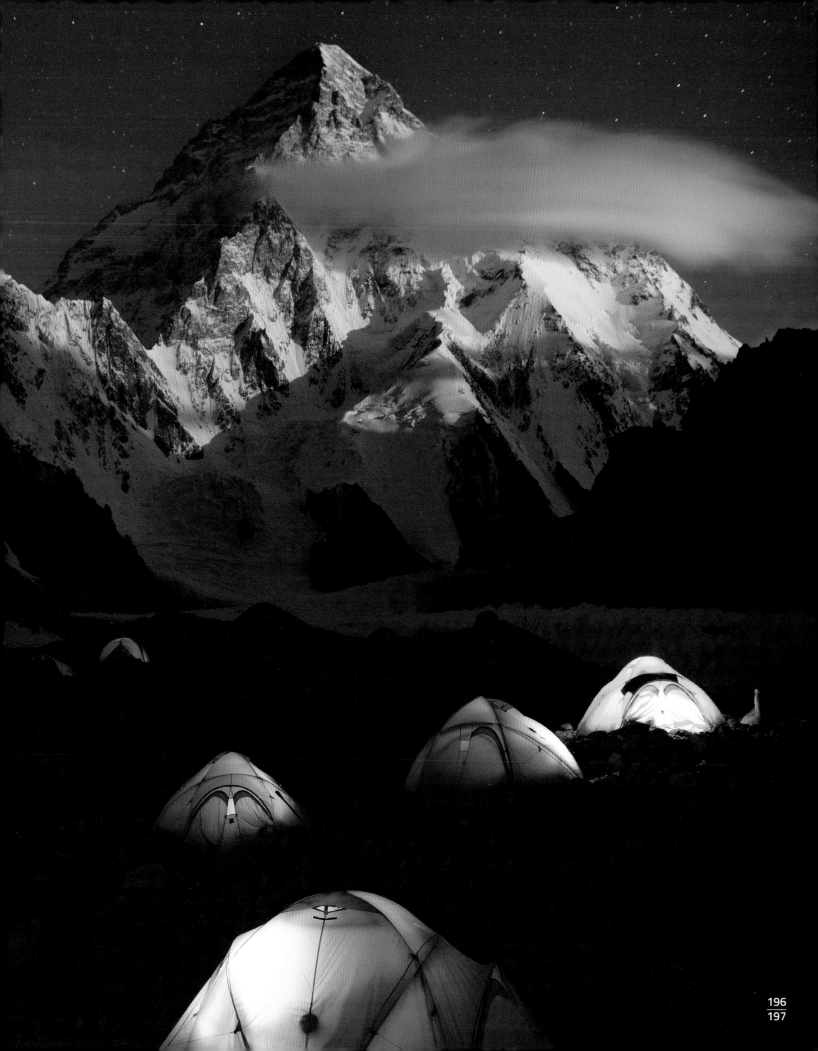

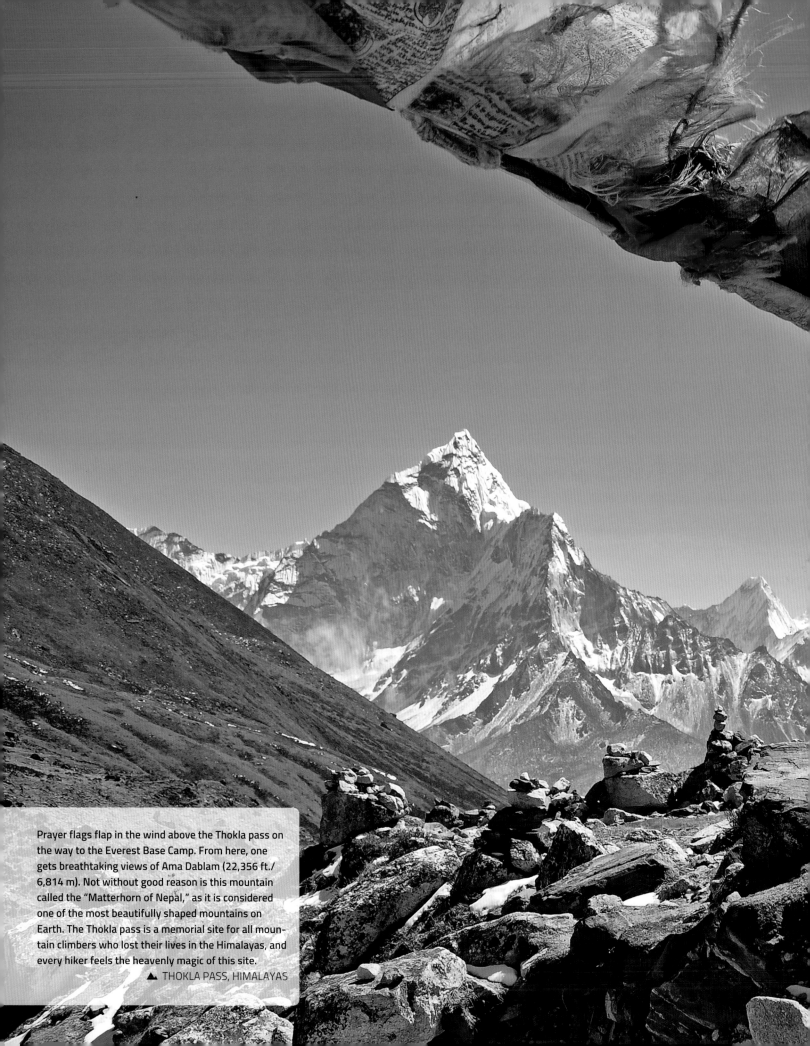

Prayer flags flap in the wind above the Thokla pass on the way to the Everest Base Camp. From here, one gets breathtaking views of Ama Dablam (22,356 ft./ 6,814 m). Not without good reason is this mountain called the "Matterhorn of Nepal," as it is considered one of the most beautifully shaped mountains on Earth. The Thokla pass is a memorial site for all mountain climbers who lost their lives in the Himalayas, and every hiker feels the heavenly magic of this site.

▲ THOKLA PASS, HIMALAYAS

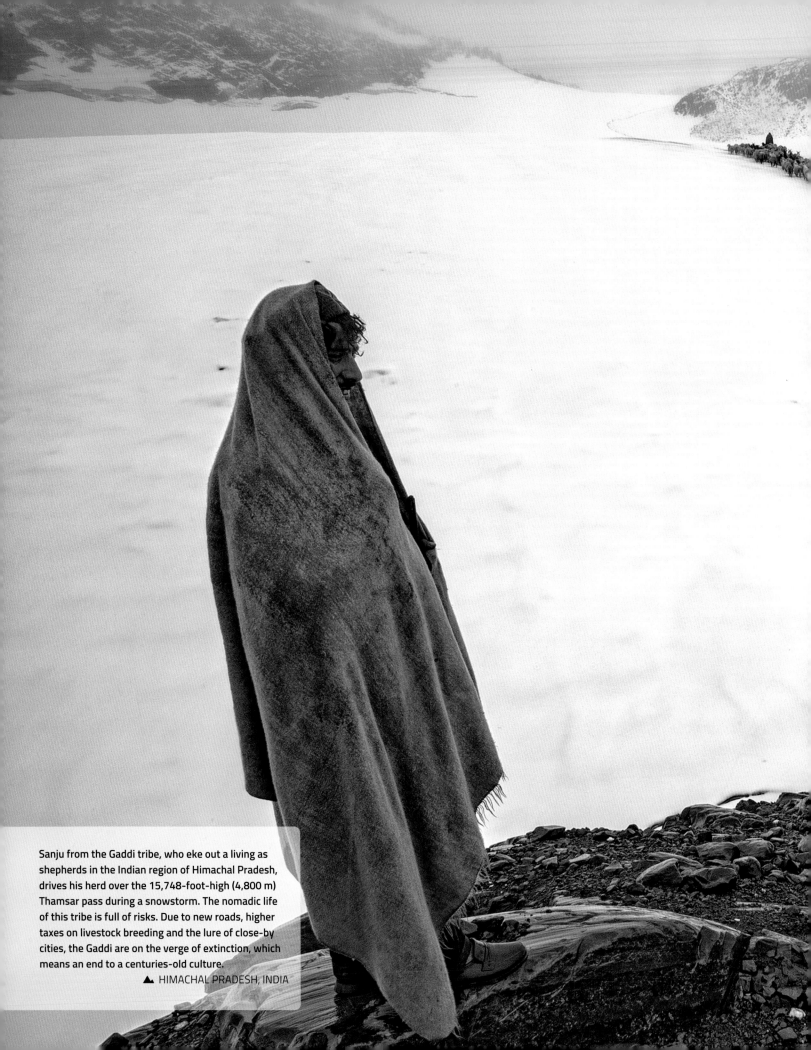

Sanju from the Gaddi tribe, who eke out a living as shepherds in the Indian region of Himachal Pradesh, drives his herd over the 15,748-foot-high (4,800 m) Thamsar pass during a snowstorm. The nomadic life of this tribe is full of risks. Due to new roads, higher taxes on livestock breeding and the lure of close-by cities, the Gaddi are on the verge of extinction, which means an end to a centuries-old culture.

▲ HIMACHAL PRADESH, INDIA

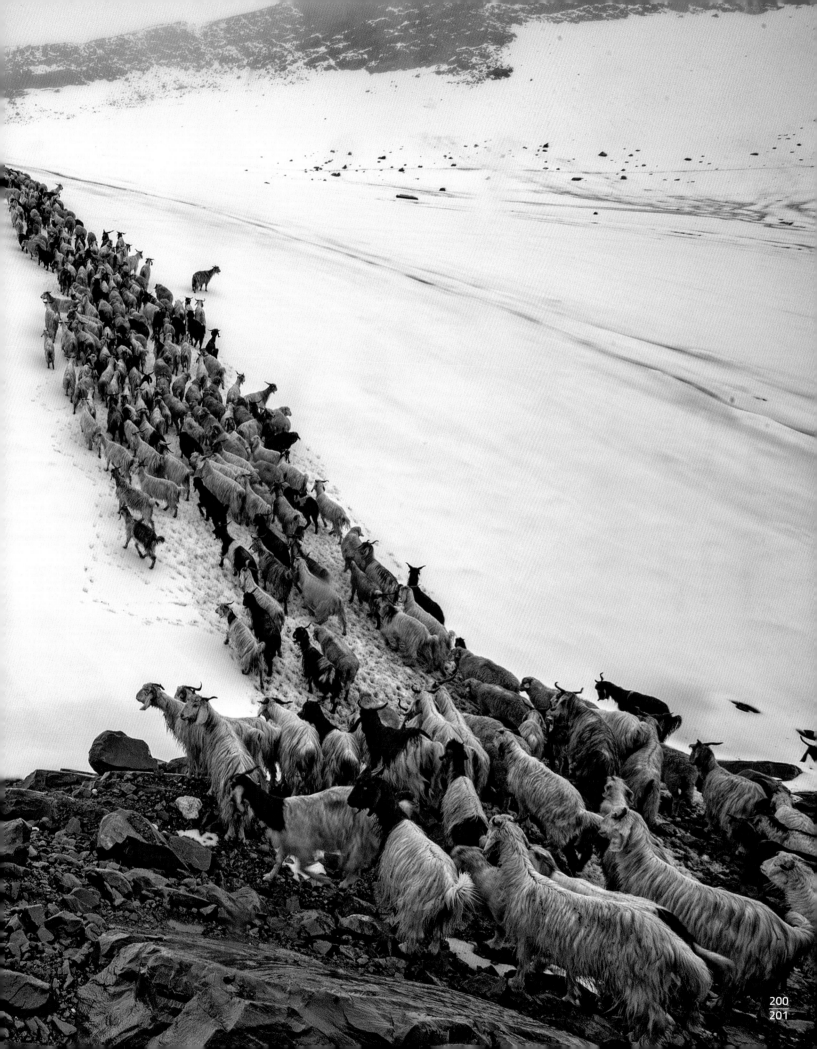

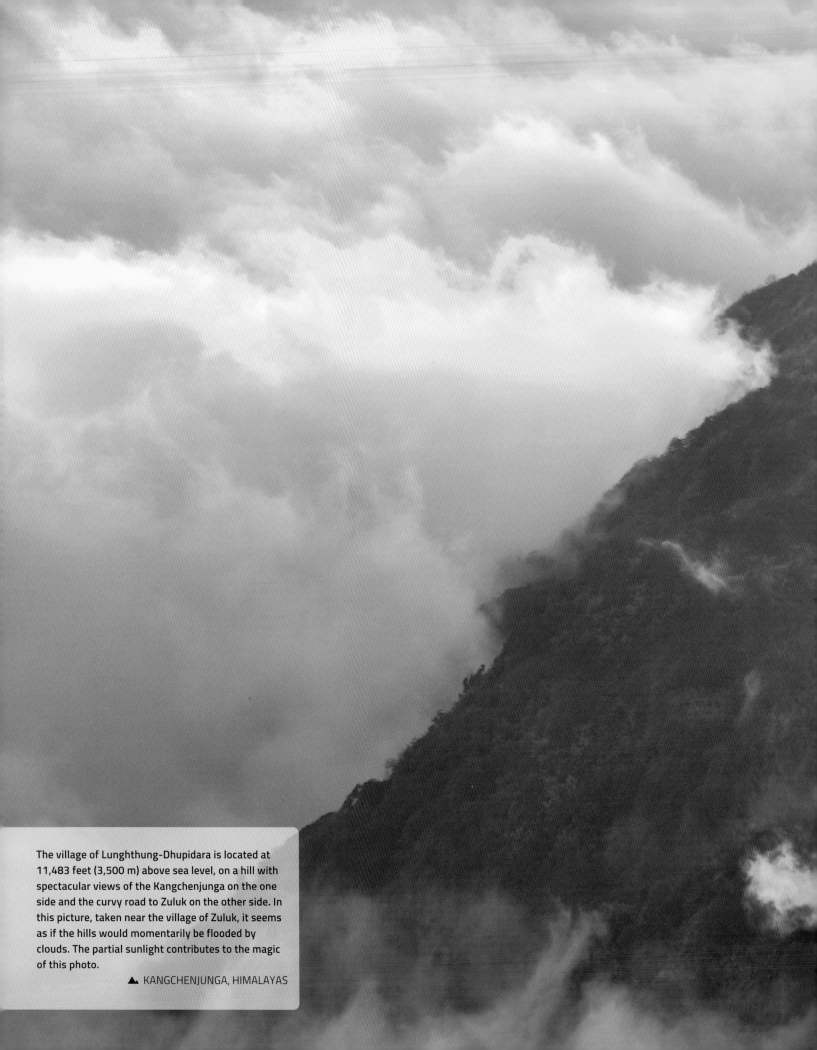

The village of Lunghthung-Dhupidara is located at 11,483 feet (3,500 m) above sea level, on a hill with spectacular views of the Kangchenjunga on the one side and the curvy road to Zuluk on the other side. In this picture, taken near the village of Zuluk, it seems as if the hills would momentarily be flooded by clouds. The partial sunlight contributes to the magic of this photo.

▲ KANGCHENJUNGA, HIMALAYAS

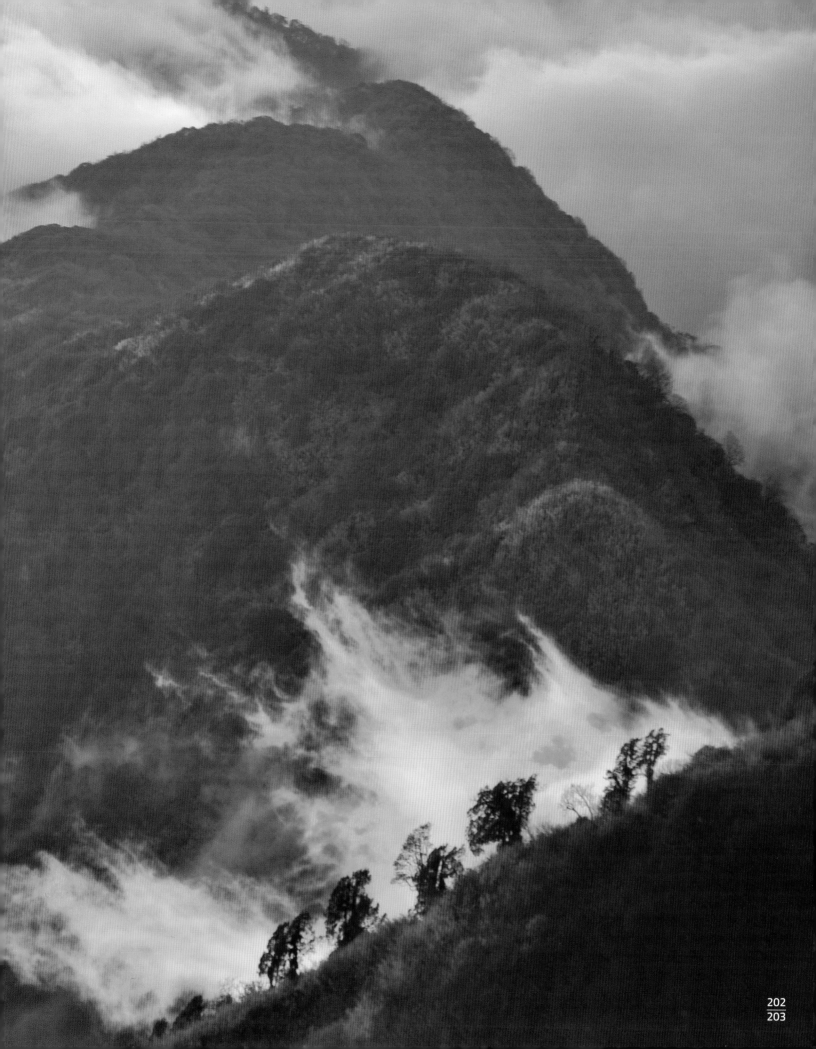

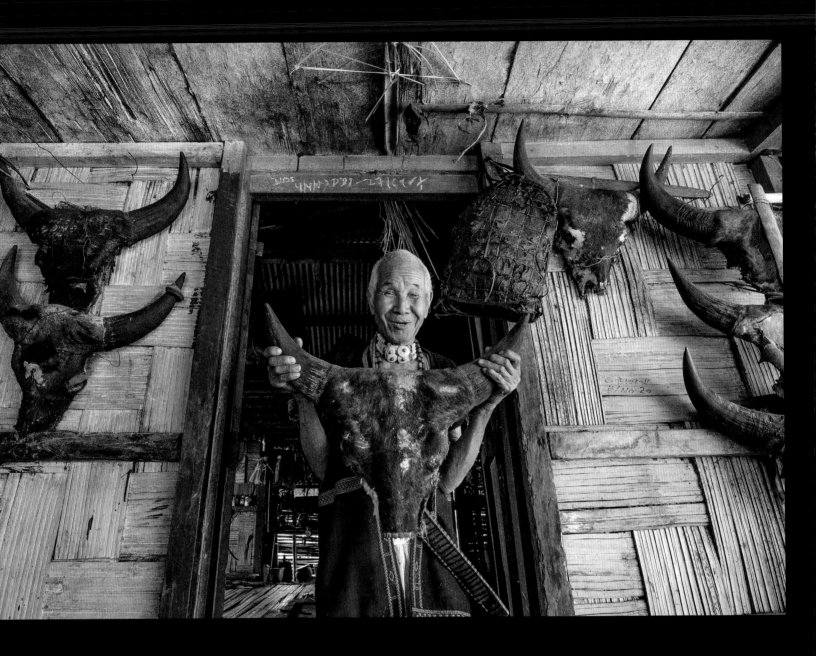

This old man belongs to one of the oldest tribes living in Arunachal Pradesh in the northeast of India. The name of the region means "Land of the Dawn-lit Mountains" in Sanskrit. This tribe believes that the skull of a bovine called mithun or gayal drives away evil spirits from their houses and land.

▲ ARUNACHAL PRADESH, INDIA

"While waiting for the annual teachings of the 14th Dalai Lama, I explored the surroundings of McLeod Ganj, a small village in Himachal Pradesh, and found the Bhagsu Waterfall Trail. Buddhist monks wash their clothes, shave their heads or meditate."

▲ HIMACHAL PRADESH, INDIA

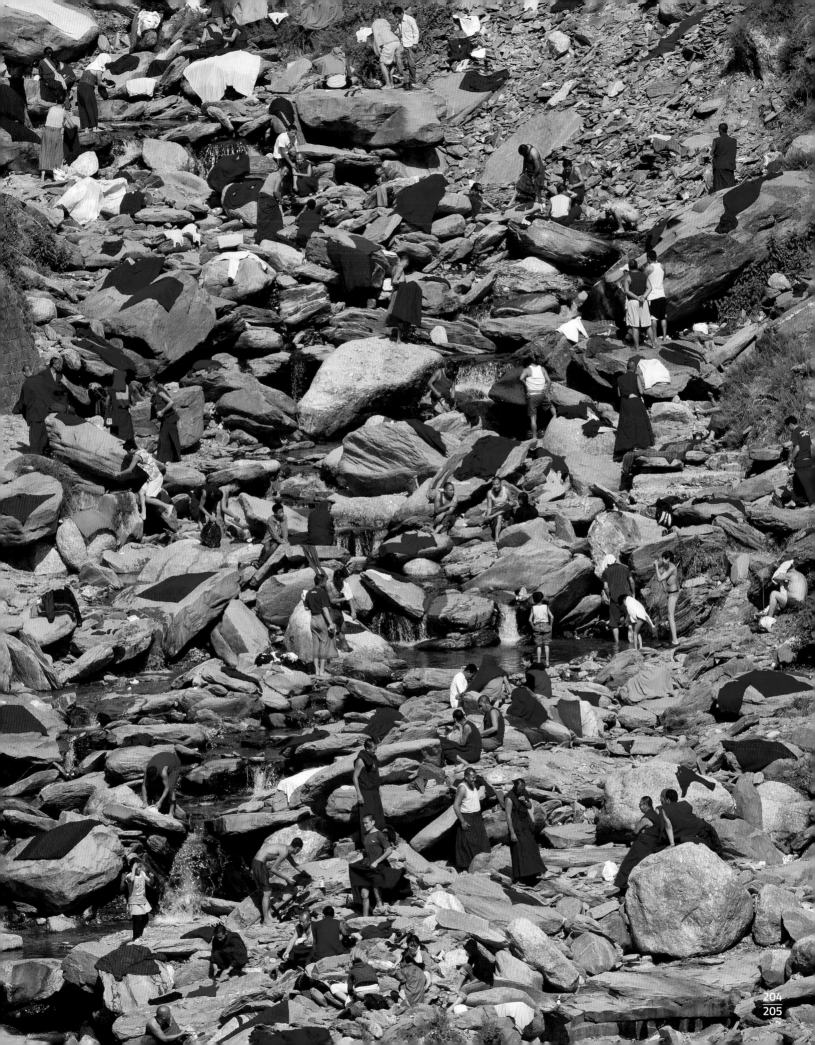

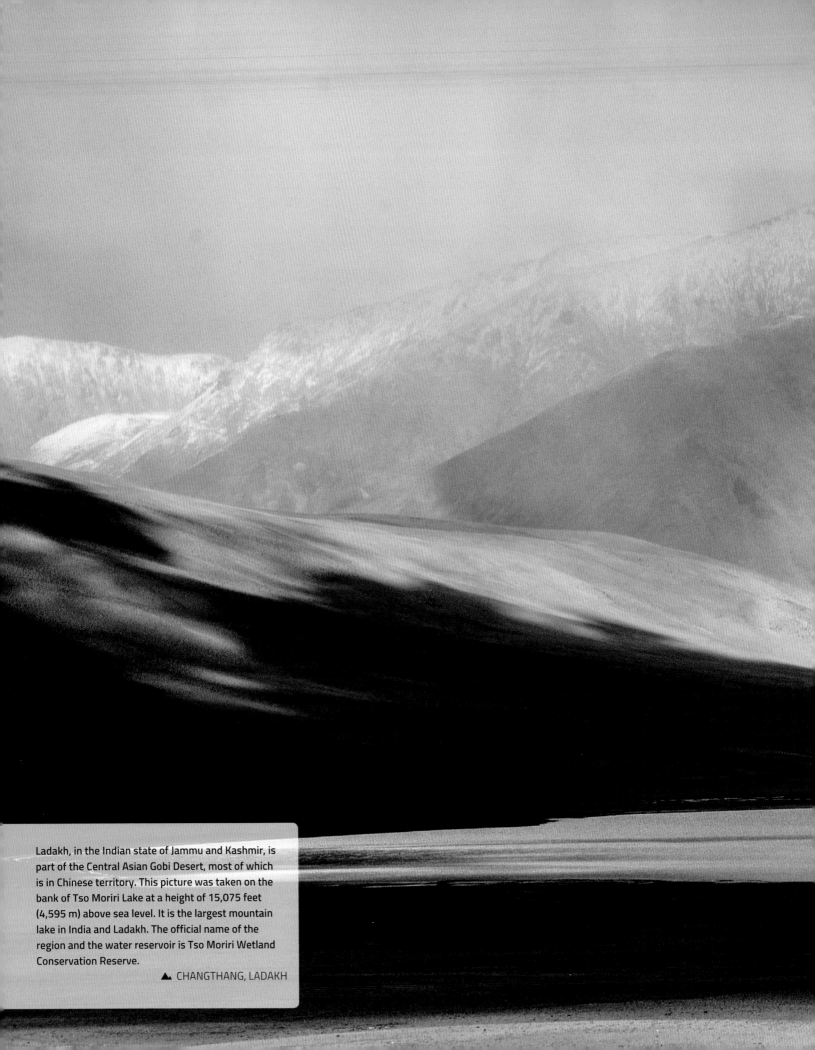

Ladakh, in the Indian state of Jammu and Kashmir, is part of the Central Asian Gobi Desert, most of which is in Chinese territory. This picture was taken on the bank of Tso Moriri Lake at a height of 15,075 feet (4,595 m) above sea level. It is the largest mountain lake in India and Ladakh. The official name of the region and the water reservoir is Tso Moriri Wetland Conservation Reserve.

▲ CHANGTHANG, LADAKH

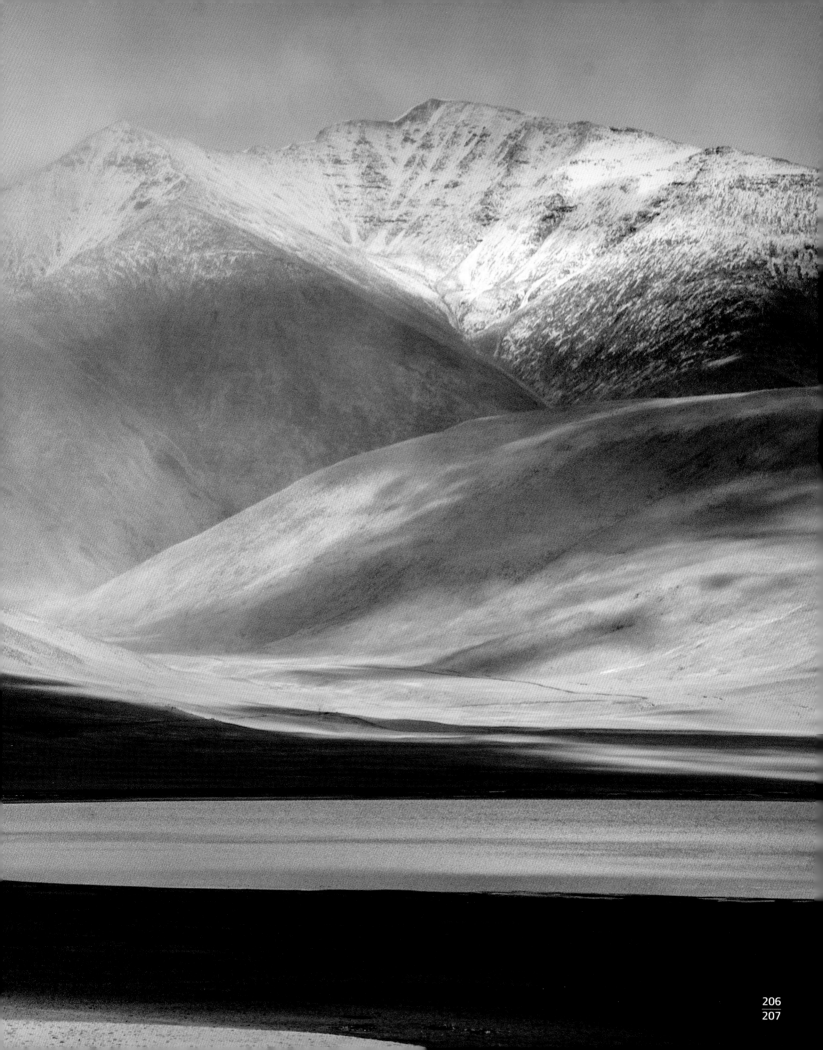

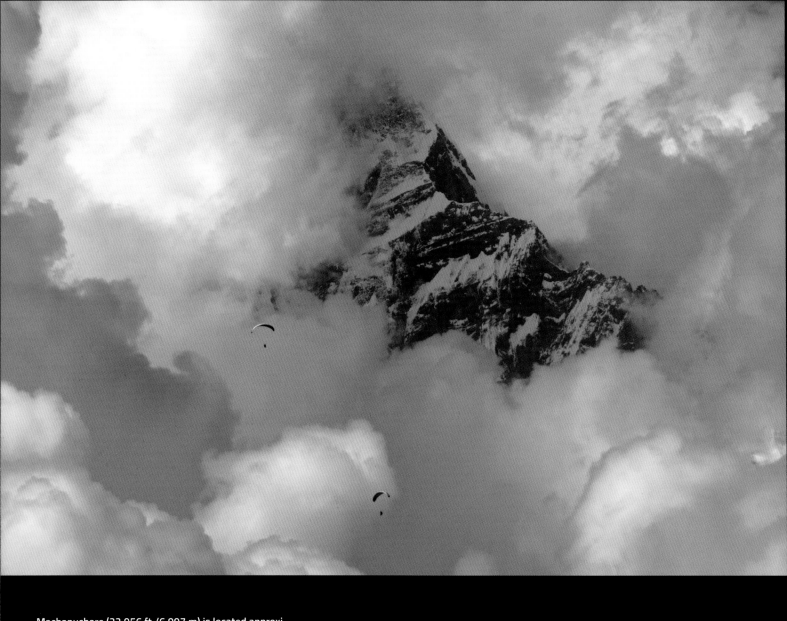

Machapuchare (22,956 ft./6,997 m) is located approximately 15.5 miles (25 km) north of Pokhara and is considered a sacred mountain. In 1964, the king of Nepal declared

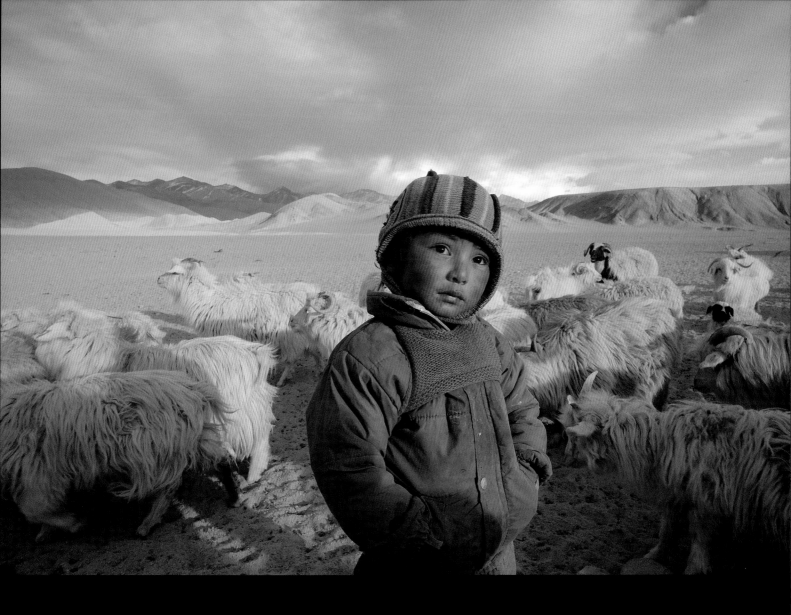

The Changpa are among the oldest nomadic tribes in the Tibetan Highlands and in Ladakh. They move from one pasture to another with their goat herds; as a result of climate change these pastures have become rarer and more barren. Tenzin, this shepherd boy, and his parents might not survive the nomad life as early as next year; instead he might go to school in a city in the valley.

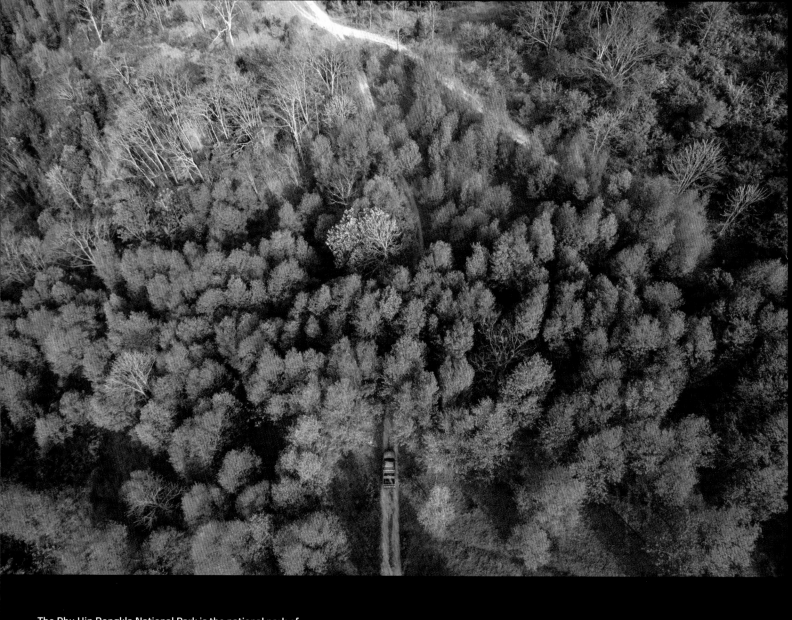

The Phu Hin Rongkla National Park is the national park of
the provinces Phitsanulok and Phetchabun in the north of
Thailand. The photographer who took this picture in the winter

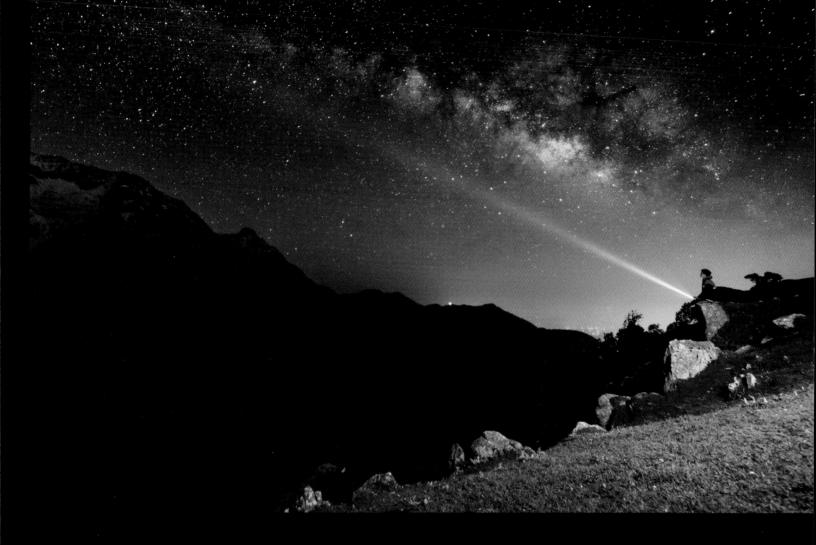

The village of Triund is located in the middle of the Himalayan region of Dhauladhar at a height of almost 9,842 feet (3,000 m). You can reach it only via a hike of 5.6 miles (9 km) from the mountain village of Dharamkot. When the first rays of sun showed on the horizon, the flakes of a snow shower shimmered like diamonds over the night sky and when we looked up at the Milky Way, we realized how small humans are compared to the grandness of nature.

▲ DHAULADHAR, INDIA

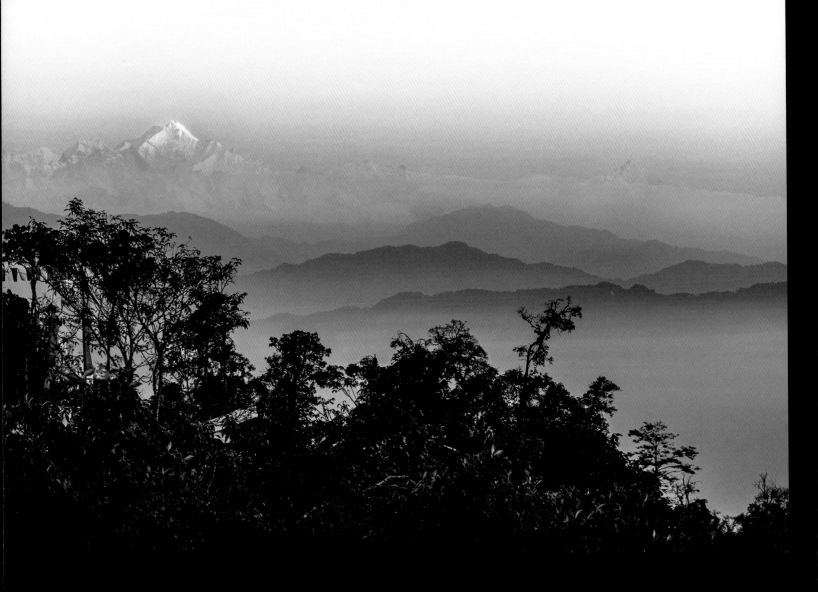

The sun rises above the small town of Sillery Gaon in
the Indian State of Sikkim. The town lies at a picturesque
location between pine forests and is famous for its
breathtaking views of the Kangchenjunga Massif, the
third-highest mountain in the world.

▲ KANGCHENJUNGA, HIMALAYAS, INDIA

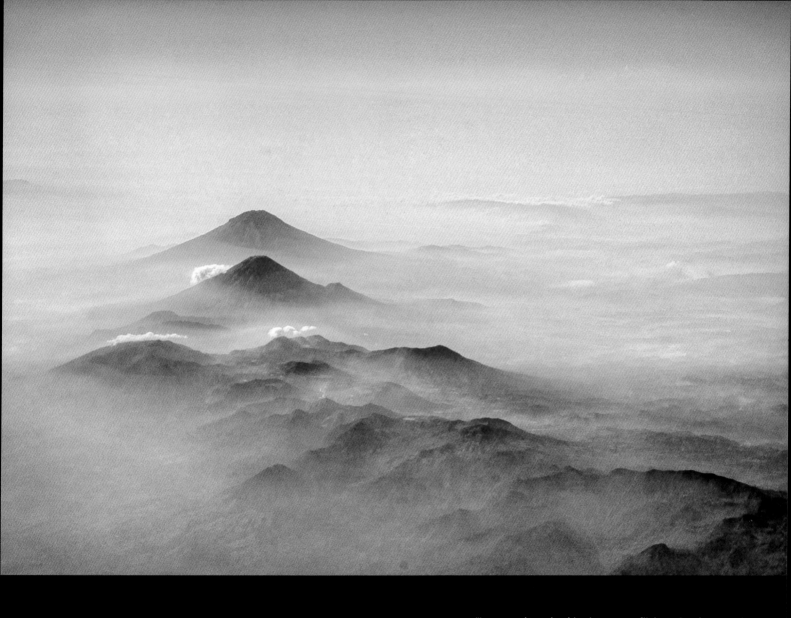

"I managed to take this picture on a flight to Surabaya on the
Indonesian main island of Java. It was in the morning between
7:30 and 8:30 and mist hung like the layers of a painting

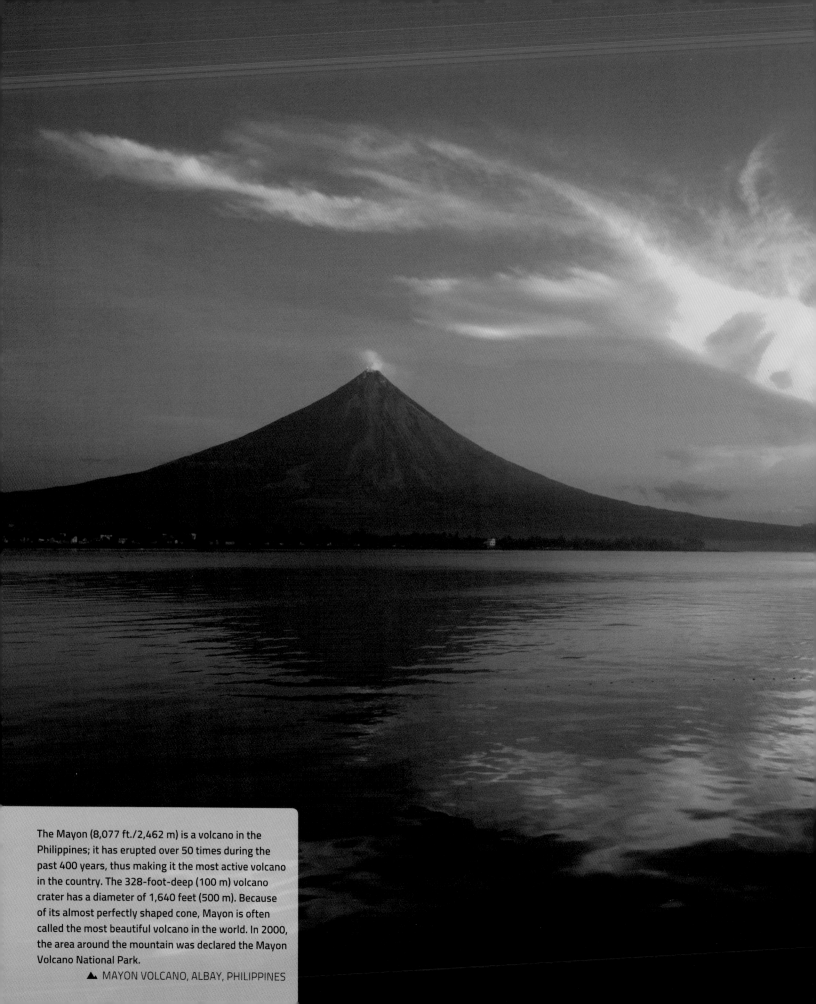

The Mayon (8,077 ft./2,462 m) is a volcano in the
Philippines; it has erupted over 50 times during the
past 400 years, thus making it the most active volcano
in the country. The 328-foot-deep (100 m) volcano
crater has a diameter of 1,640 feet (500 m). Because
of its almost perfectly shaped cone, Mayon is often
called the most beautiful volcano in the world. In 2000,
the area around the mountain was declared the Mayon
Volcano National Park.

▲ MAYON VOLCANO, ALBAY, PHILIPPINES

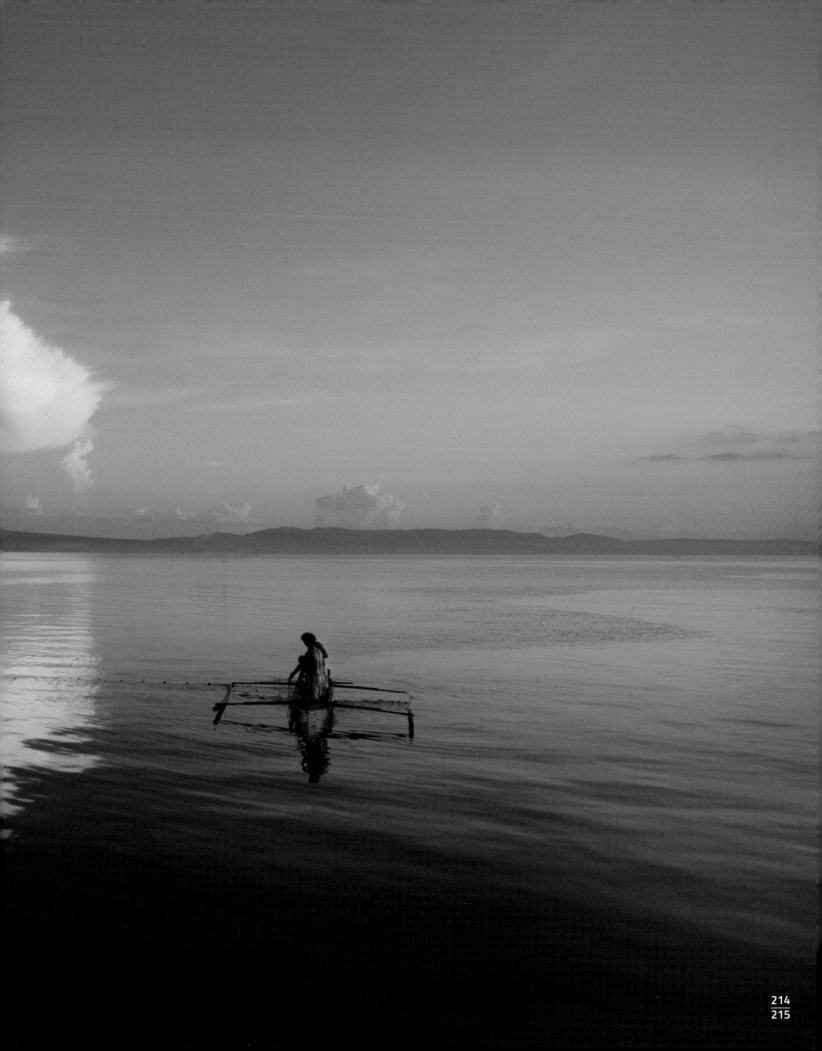

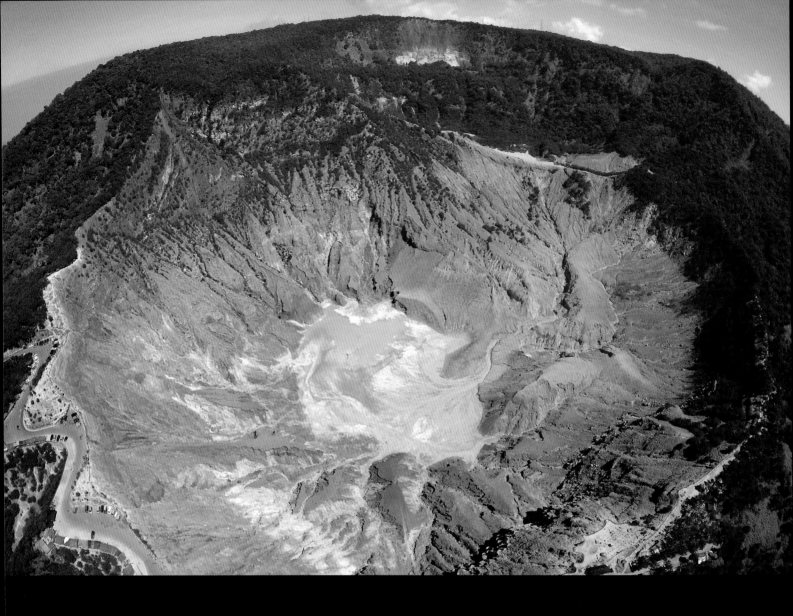

The Tangkuban Perahu (6,837 ft./2,084 m) is a volcano north of Lembang on the island of Java. This picture was taken with a drone approximately 656 feet (200 m) above the crater. After almost 30 years of inactivity, the last eruption took place on March 4, 2013, during which the volcano flung ash and rocks 1,640 feet (500 m) high. A road leads to the edge

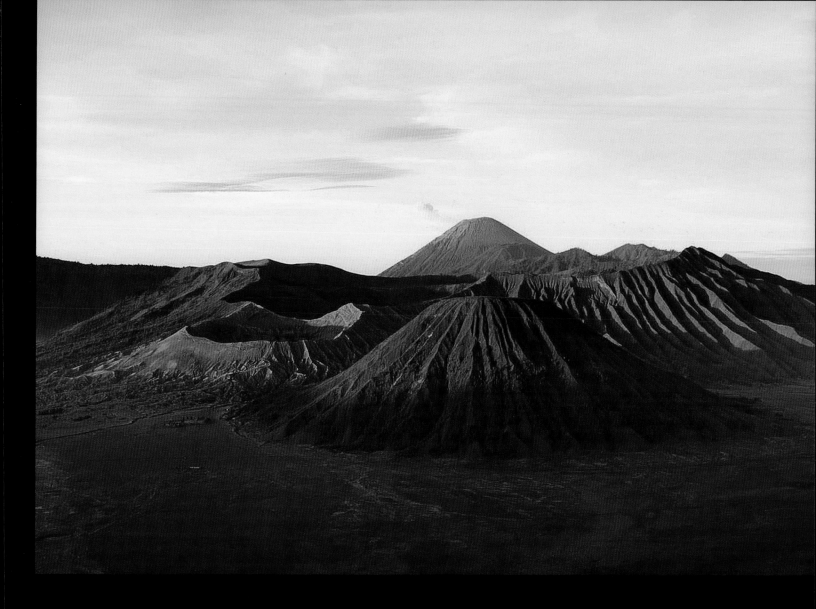

The rising sun traces the detail and sharpness of the structures of the mountainsides, and the day slowly takes over in the Bromo-Tengger-Semeru National Park. It is located in the east of the island of Java and has been a national park since 1982. At 12,060 feet (3,676 m), the stratovolcano Semeru is the highest peak of the region, and also the highest mountain of the island.

▲ BROMO-TENGGER-SEMERU, JAVA, INDONESIA

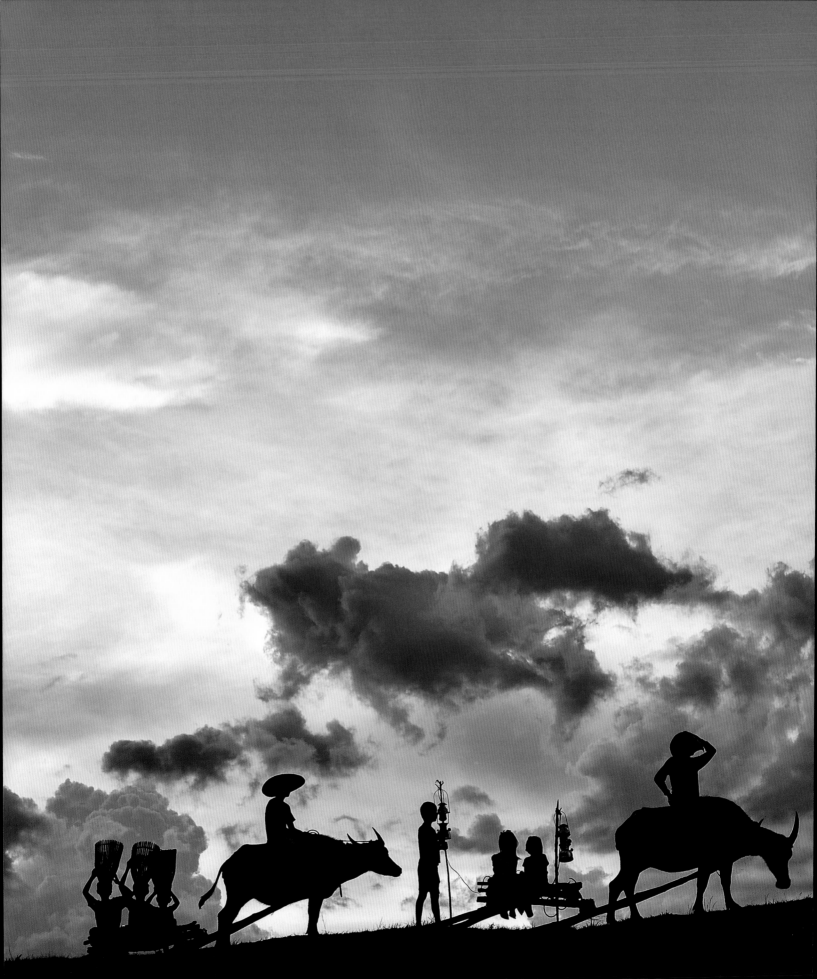

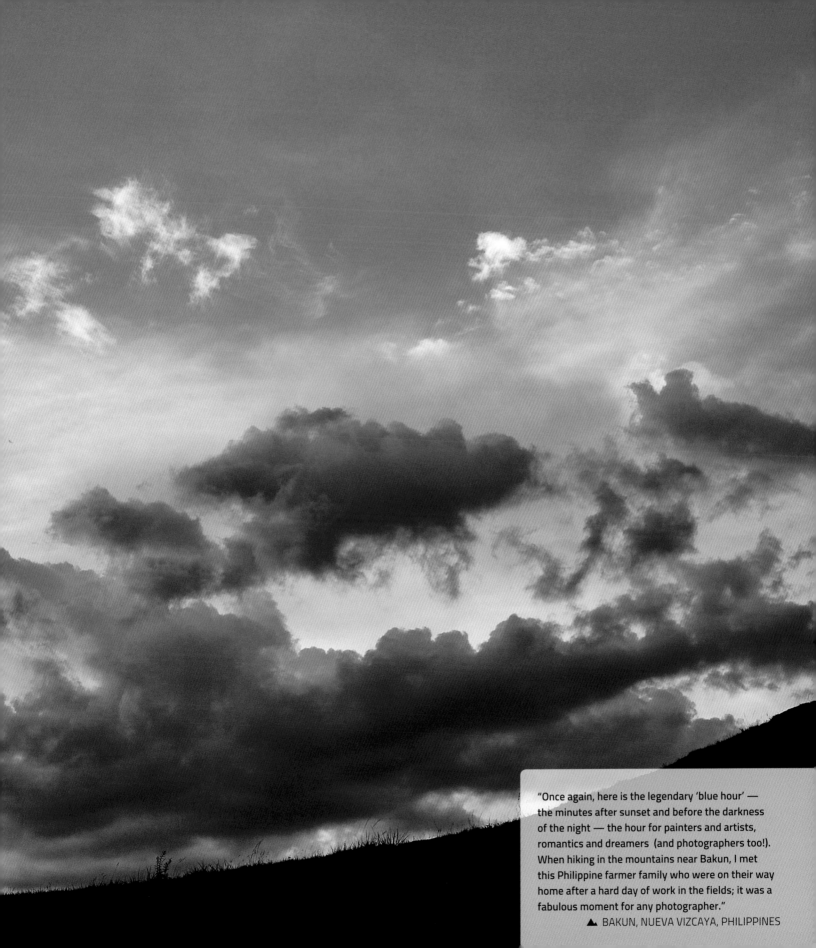

"Once again, here is the legendary 'blue hour' — the minutes after sunset and before the darkness of the night — the hour for painters and artists, romantics and dreamers (and photographers too!). When hiking in the mountains near Bakun, I met this Philippine farmer family who were on their way home after a hard day of work in the fields; it was a fabulous moment for any photographer."

▲ BAKUN, NUEVA VIZCAYA, PHILIPPINES

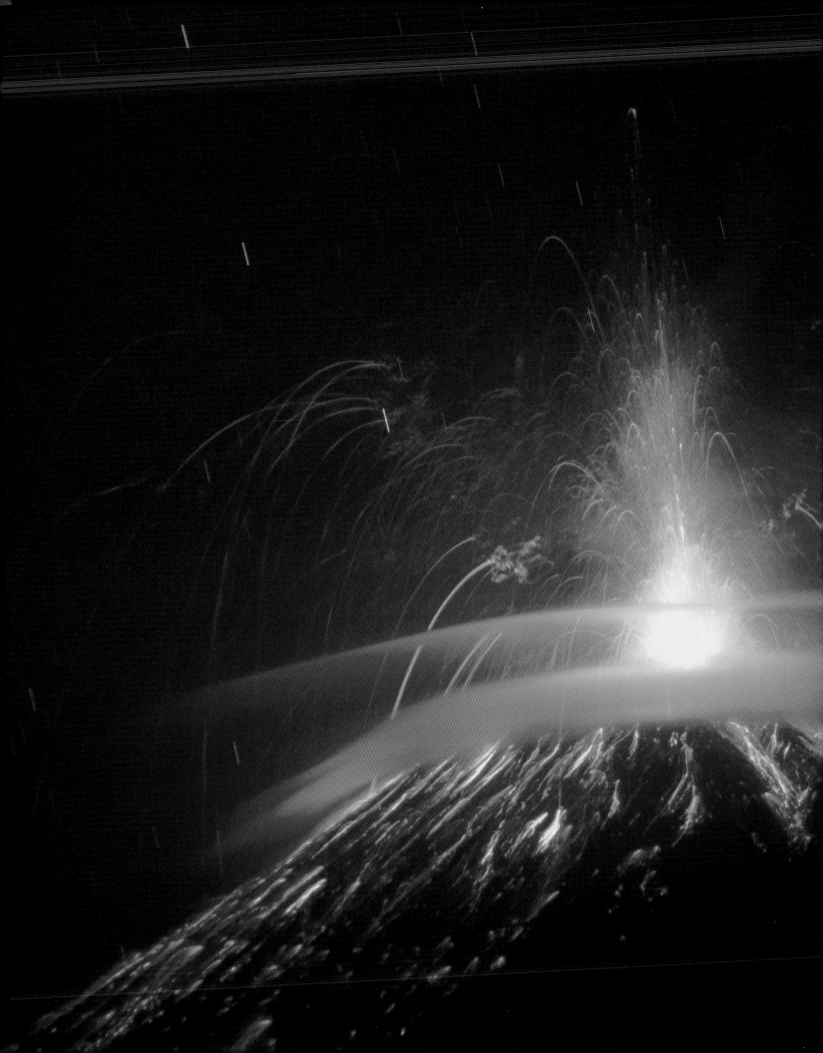

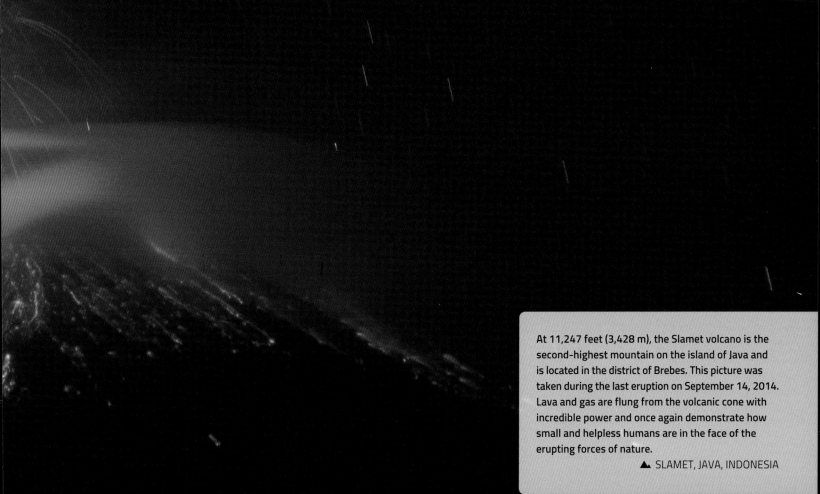

At 11,247 feet (3,428 m), the Slamet volcano is the second-highest mountain on the island of Java and is located in the district of Brebes. This picture was taken during the last eruption on September 14, 2014. Lava and gas are flung from the volcanic cone with incredible power and once again demonstrate how small and helpless humans are in the face of the erupting forces of nature.

▲ SLAMET, JAVA, INDONESIA

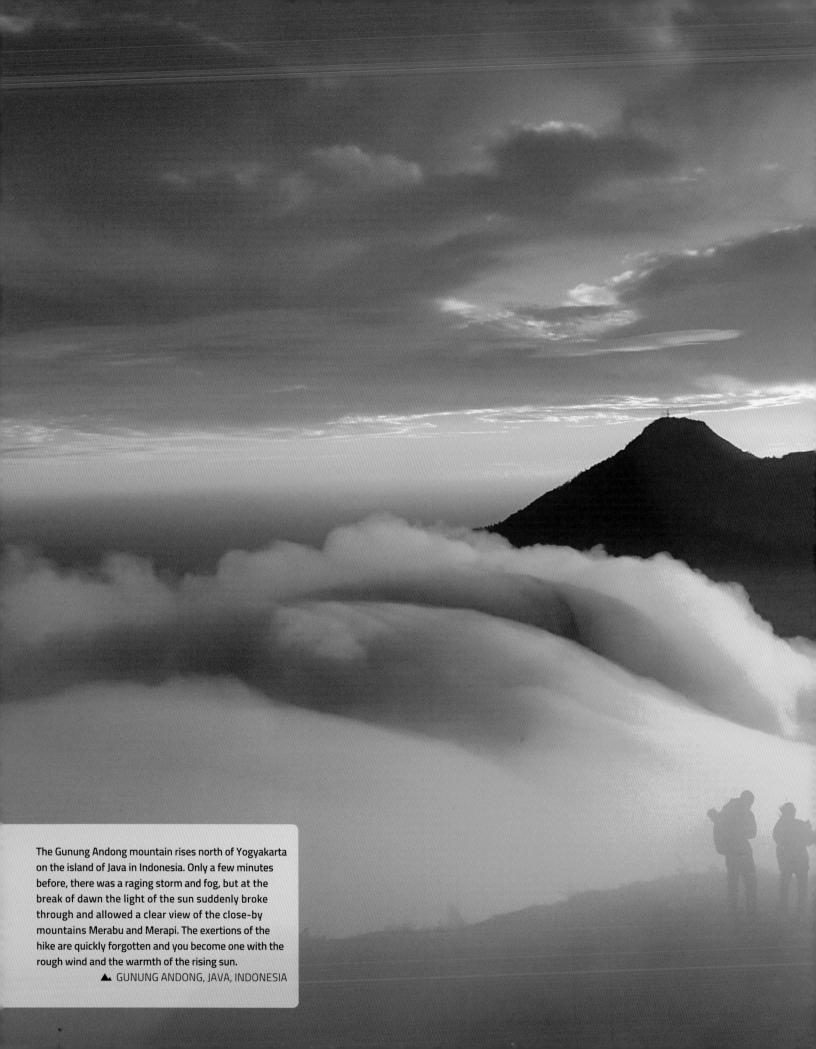

The Gunung Andong mountain rises north of Yogyakarta on the island of Java in Indonesia. Only a few minutes before, there was a raging storm and fog, but at the break of dawn the light of the sun suddenly broke through and allowed a clear view of the close-by mountains Merabu and Merapi. The exertions of the hike are quickly forgotten and you become one with the rough wind and the warmth of the rising sun.

▲ GUNUNG ANDONG, JAVA, INDONESIA

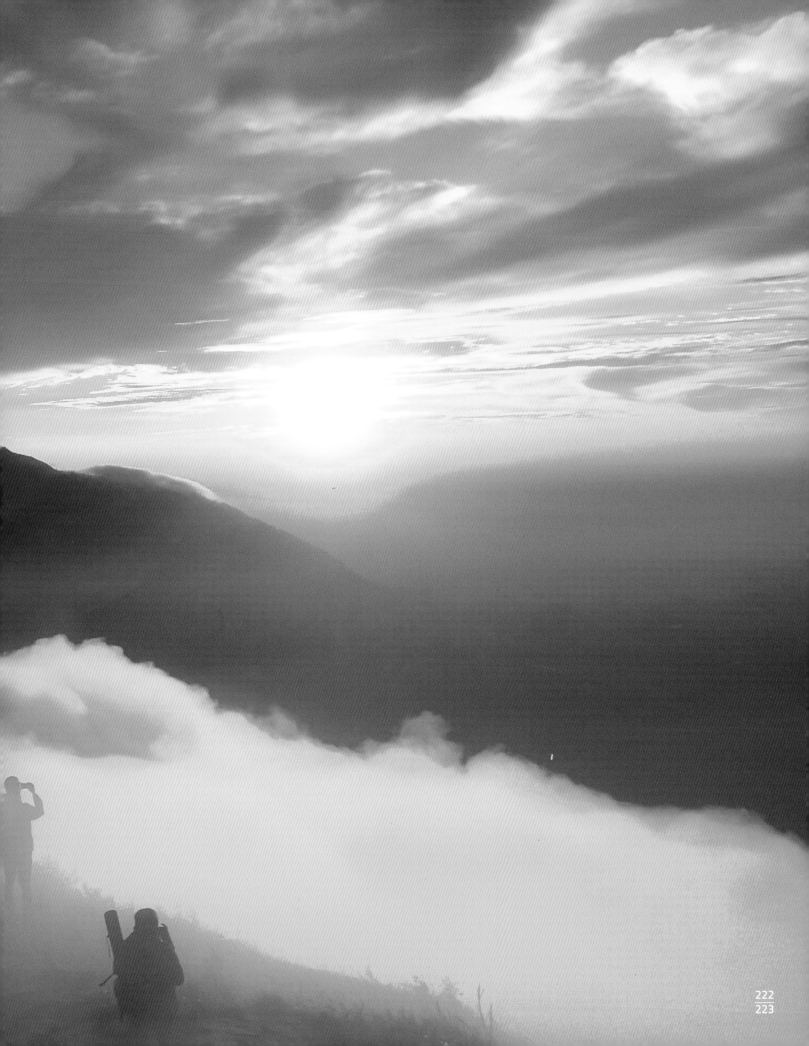

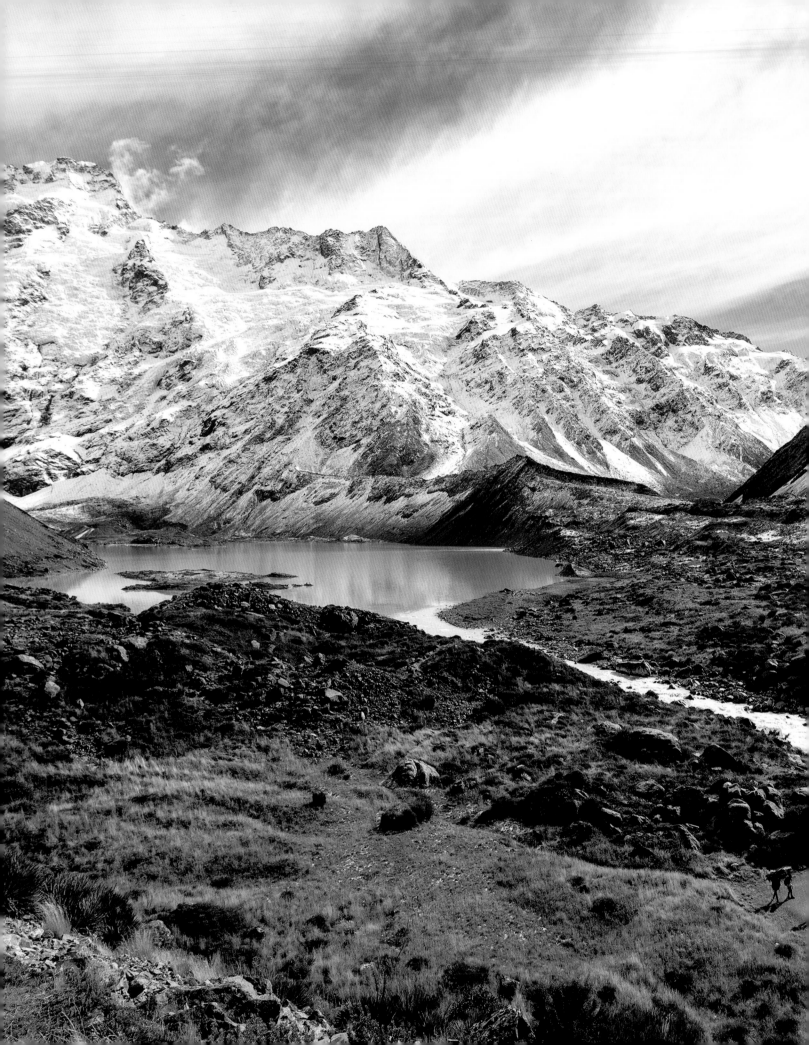

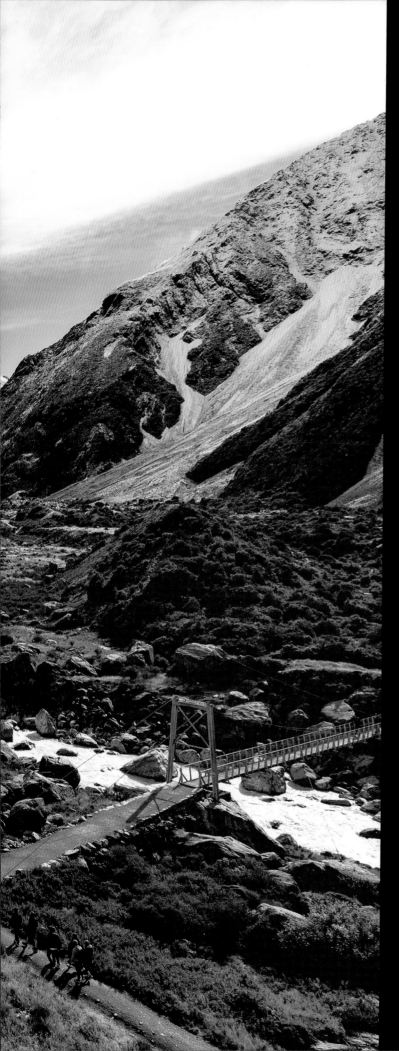

# The Other Side of the World

ETHIOPIA | NEW ZEALAND | ANTARCTICA

Hooker Trek leads through the identically named valley up to a glacial lake below the highest peak in New Zealand, known by the Māori name Aoraki and by the later English name Mount Cook (12,218 ft./3,724 m).

▲ AORAKI / MOUNT COOK, NEW ZEALAND

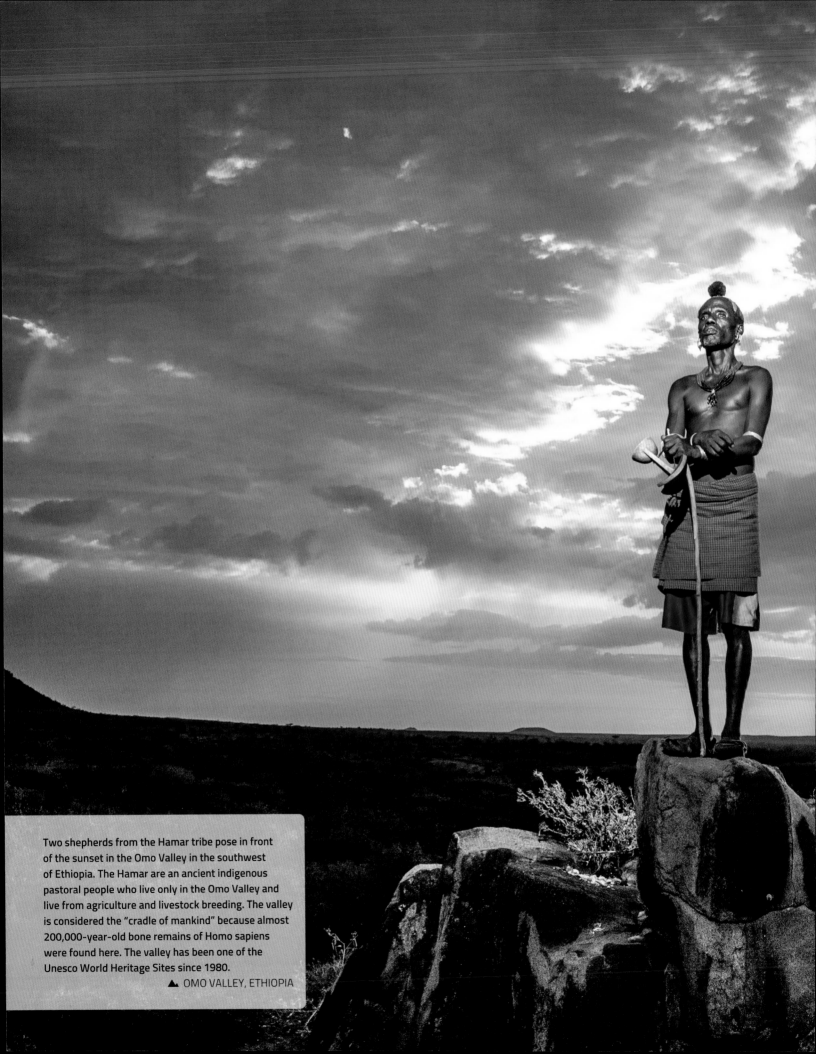

Two shepherds from the Hamar tribe pose in front of the sunset in the Omo Valley in the southwest of Ethiopia. The Hamar are an ancient indigenous pastoral people who live only in the Omo Valley and live from agriculture and livestock breeding. The valley is considered the "cradle of mankind" because almost 200,000-year-old bone remains of Homo sapiens were found here. The valley has been one of the Unesco World Heritage Sites since 1980.

▲ OMO VALLEY, ETHIOPIA

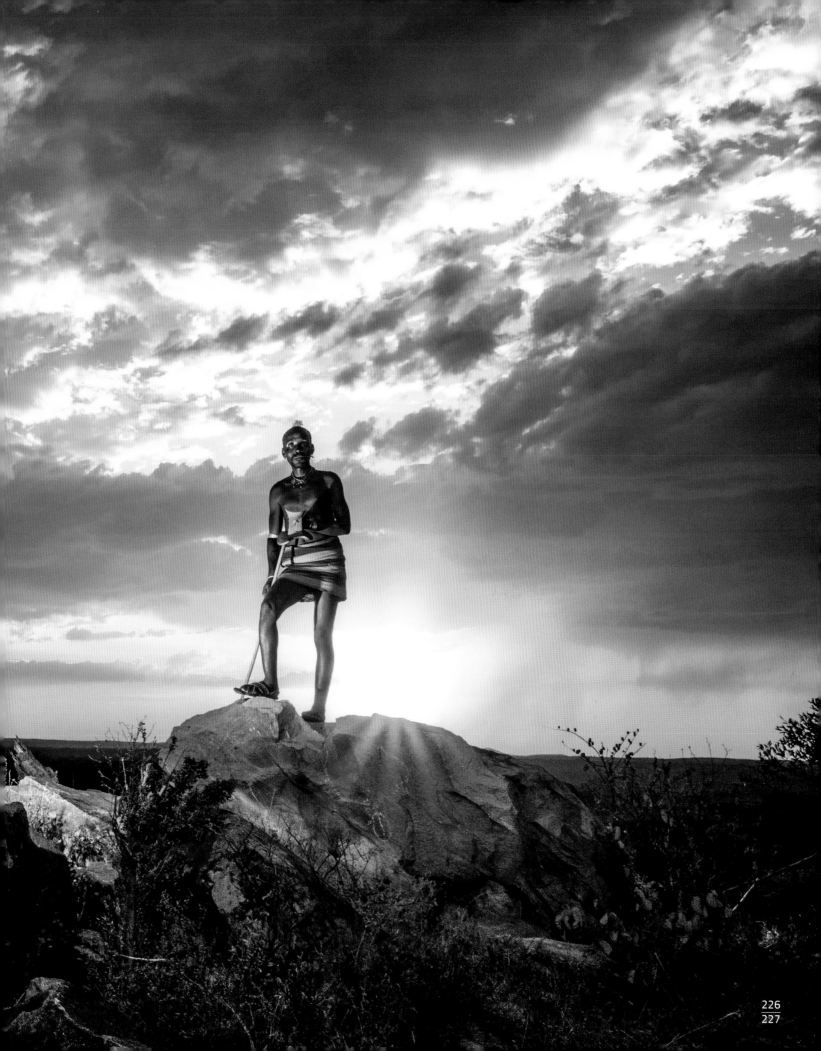

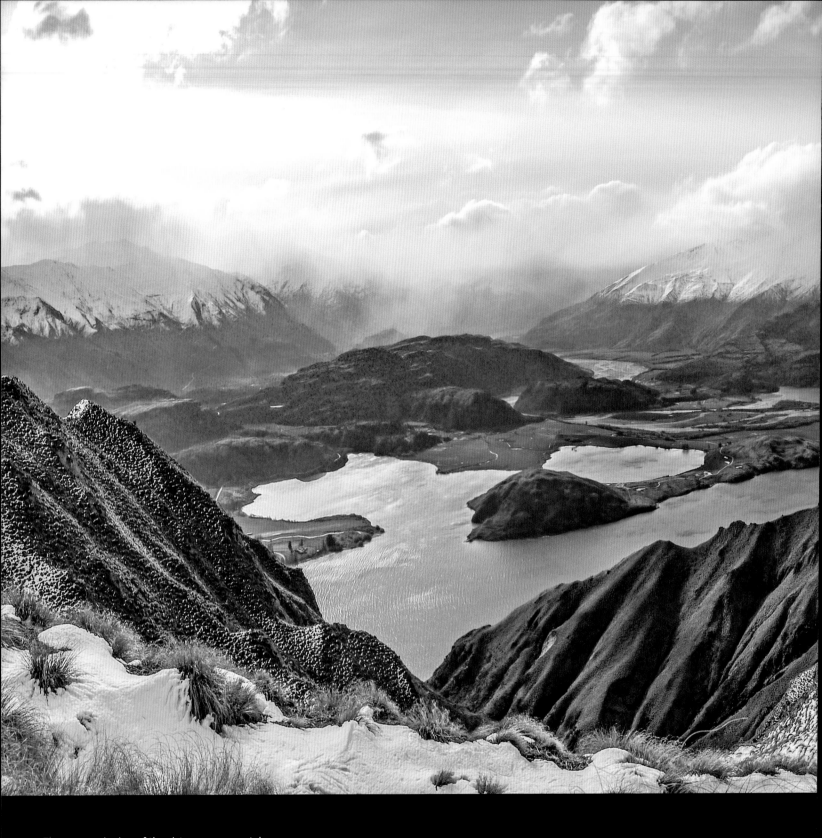

The panoramic view of the picturesque mountains
from the summit of Mount Roy on the South Island
of New Zealand is breathtaking. Mount Aspiring
(9,950 ft./3,033 m), a sacred mountain for the Māori,
the indigenous people of New Zealand, towers above
the Wanaka glacial lake in the distance. This region of

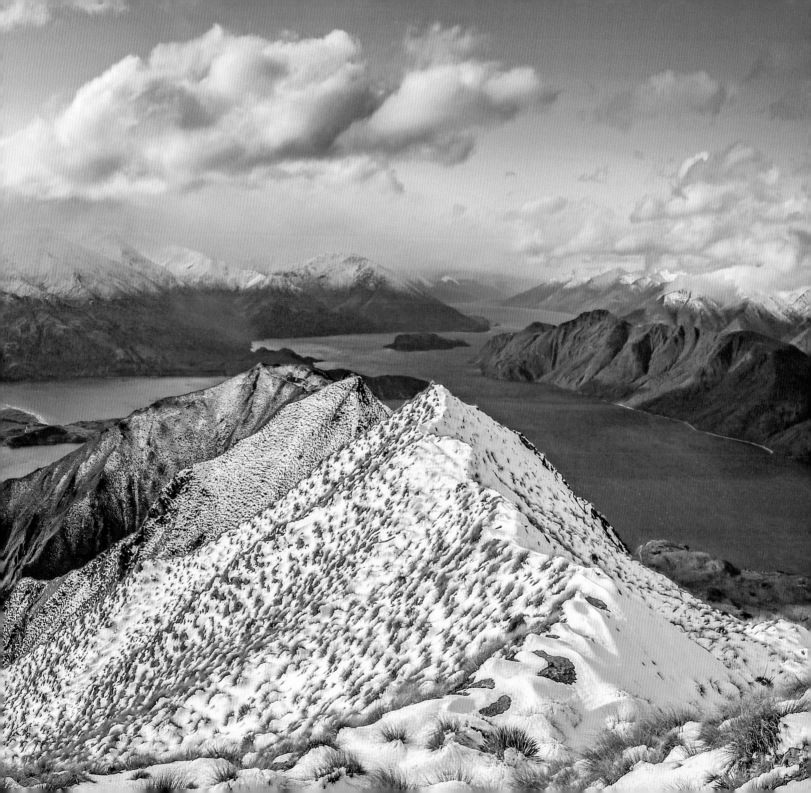

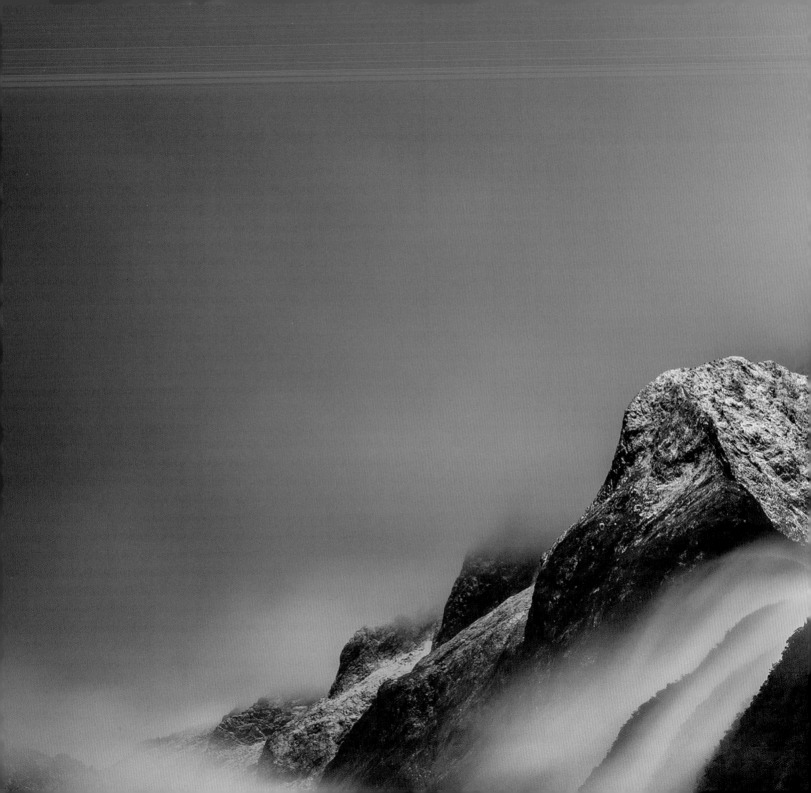

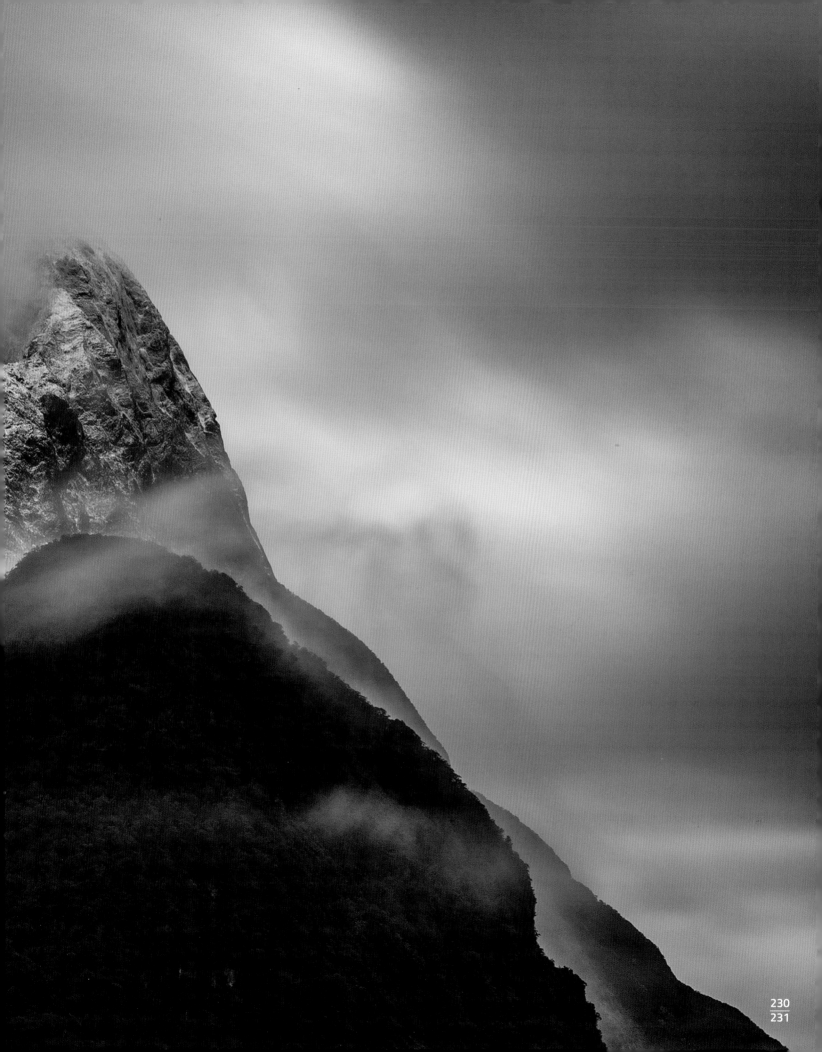

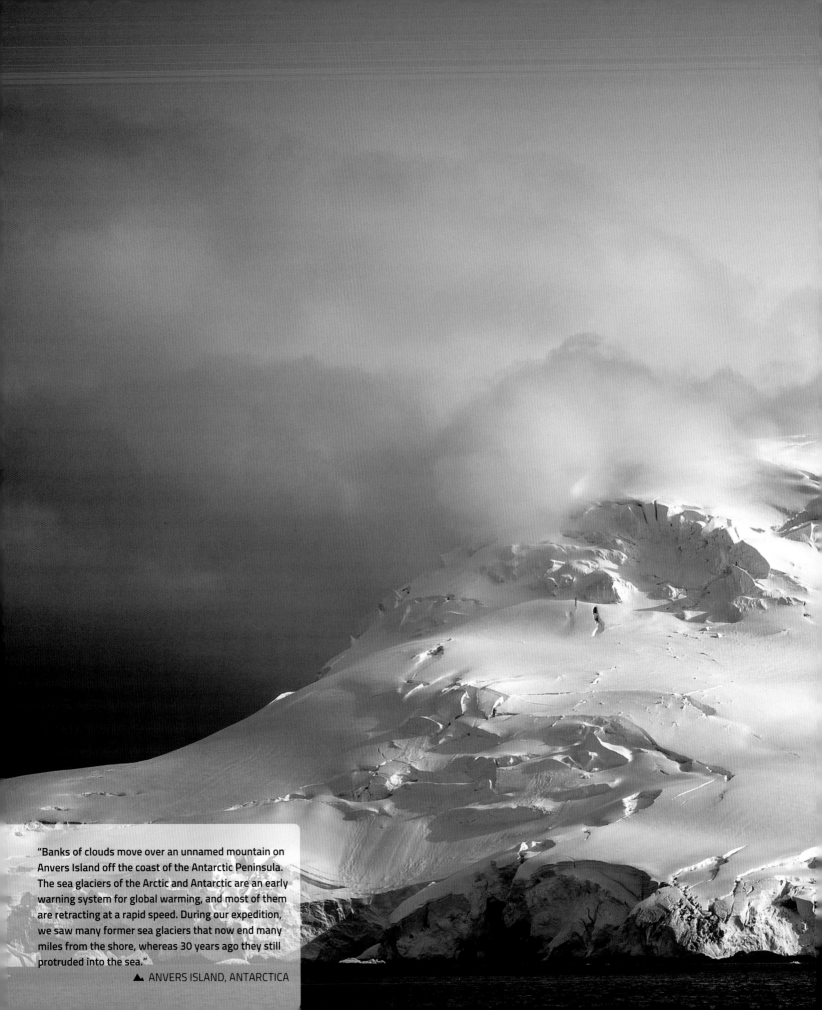

"Banks of clouds move over an unnamed mountain on Anvers Island off the coast of the Antarctic Peninsula. The sea glaciers of the Arctic and Antarctic are an early warning system for global warming, and most of them are retracting at a rapid speed. During our expedition, we saw many former sea glaciers that now end many miles from the shore, whereas 30 years ago they still protruded into the sea."

▲ ANVERS ISLAND, ANTARCTICA

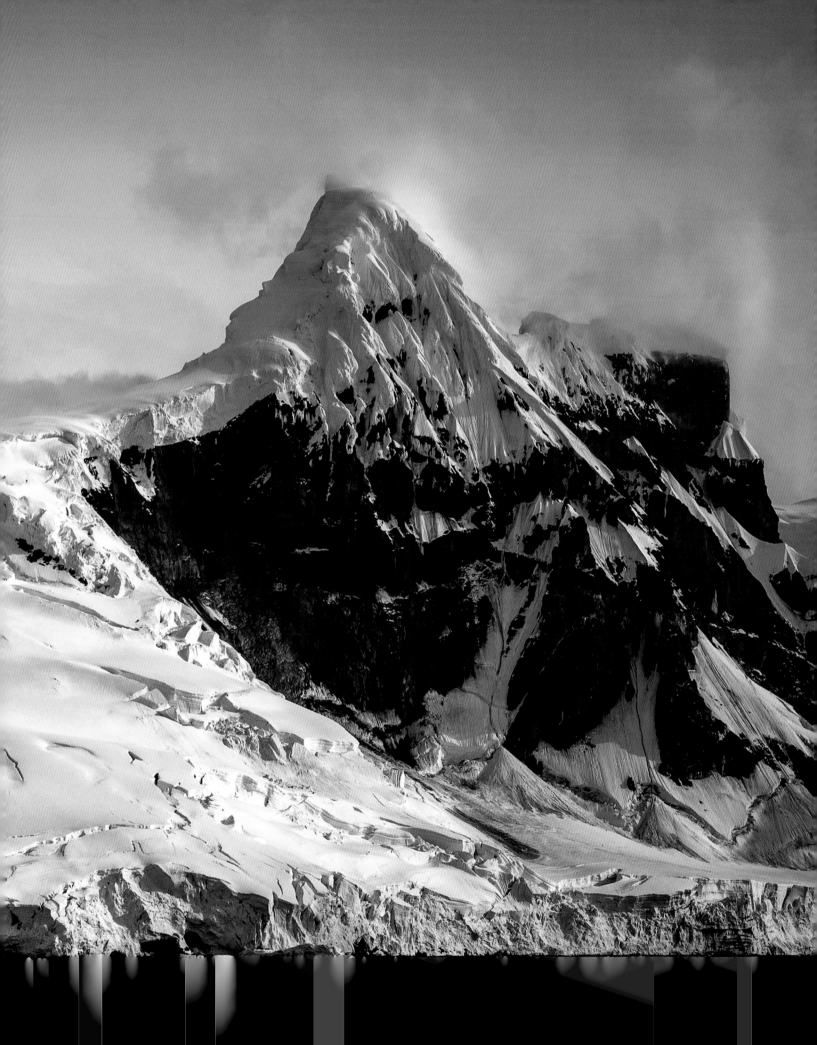

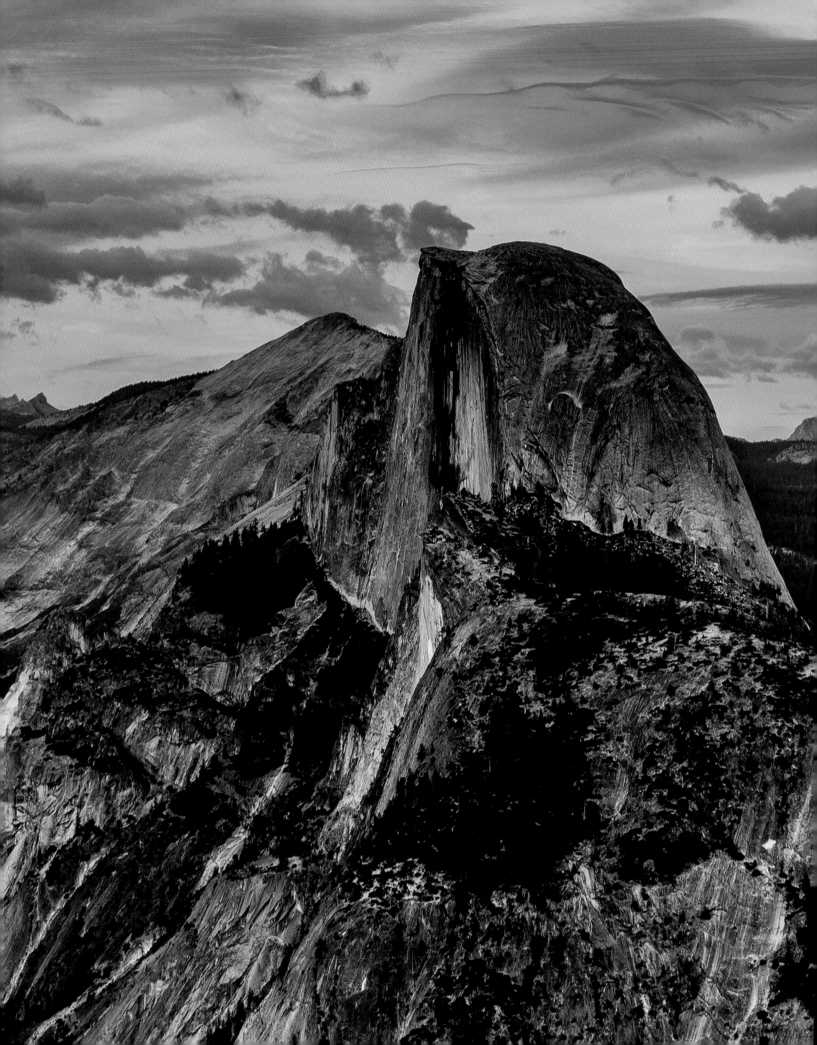

# Beautiful New World

GREENLAND | CANADA | UNITED STATES |
GUYANA | PERU | BOLIVIA | ARGENTINA | CHILE

The Half Dome is the most distinctive peak in the
world-famous Yosemite National Park. Its Northwest
Face rises 2,625 feet (800 m) and is a must for every
big-wall climber. The Half Dome is mostly famous for its
sunsets, which transform the black and yellow striped
wall into a spectacular play of colors.

▲ HALF DOME, YOSEMITE NATIONAL PARK,
CALIFORNIA, UNITED STATES

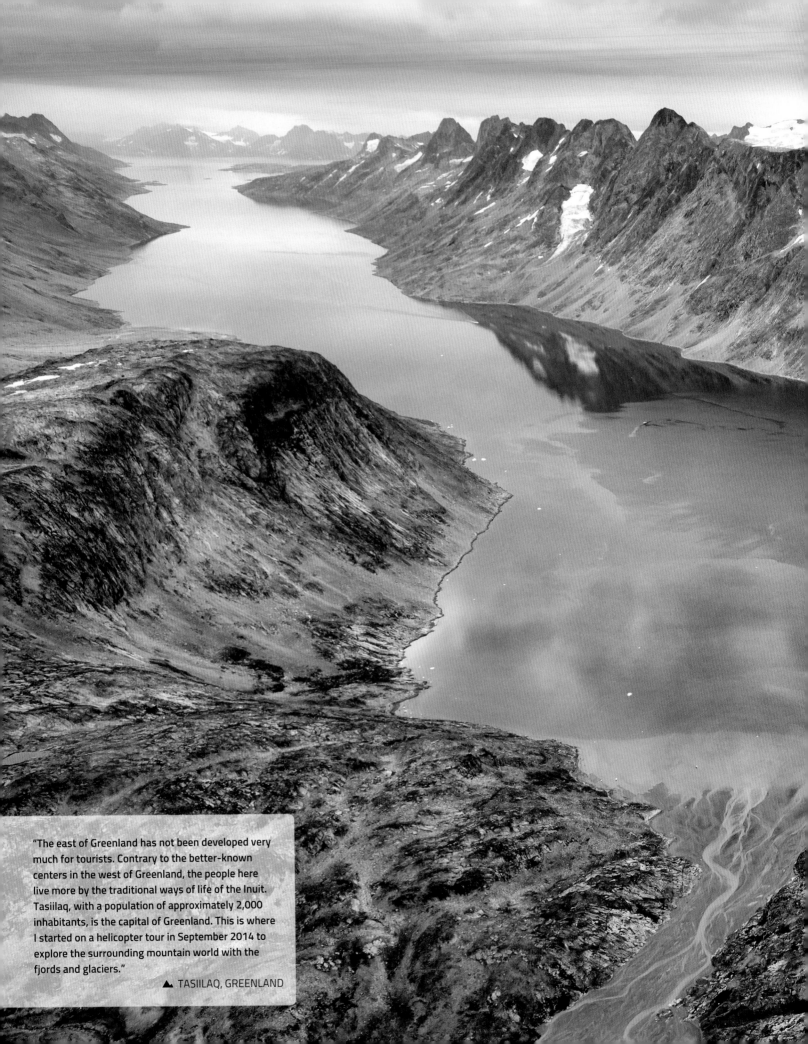

"The east of Greenland has not been developed very much for tourists. Contrary to the better-known centers in the west of Greenland, the people here live more by the traditional ways of life of the Inuit. Tasiilaq, with a population of approximately 2,000 inhabitants, is the capital of Greenland. This is where I started on a helicopter tour in September 2014 to explore the surrounding mountain world with the fjords and glaciers."

▲ TASIILAQ, GREENLAND

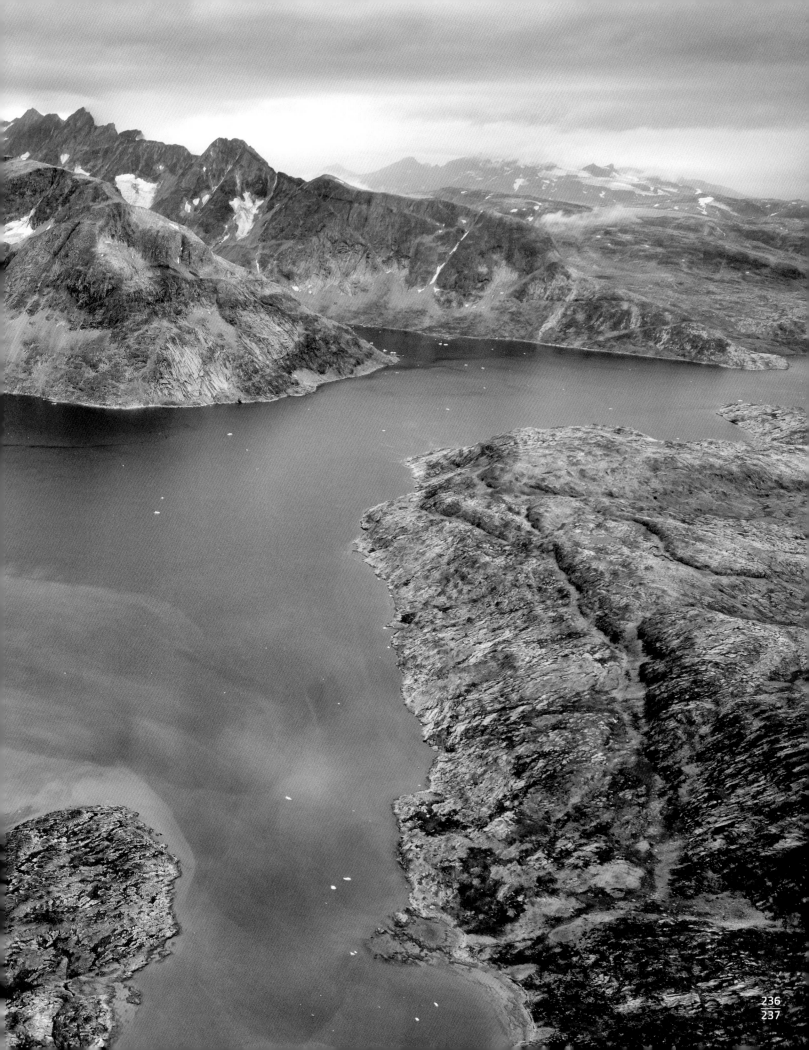

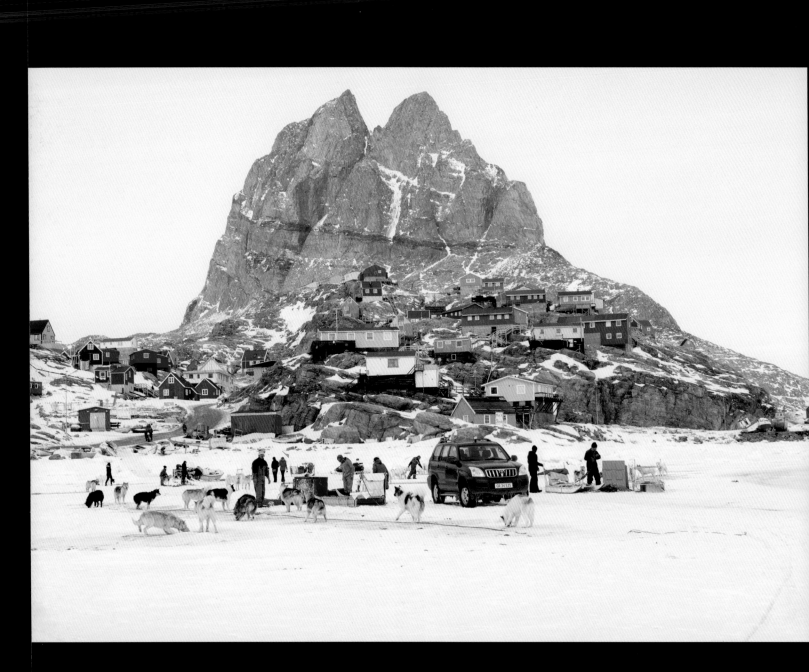

Uummannaq (Shaped Like the Heart of a Seal) is a
small settlement in the northwest of Greenland on an
island. At 4.6 square miles (12 sq. km) in size, in the
identically named fjord, it was named for the appearance
of the mountain rising 3,855 feet (1,175 m), a sight that
dominates the island. The Inuit here live between the
modern world and tradition, and between resignation
and resistance. The landscape is as amazingly beautiful
as it is unsettling.

▲ UUMMANNAQ, GREENLAND

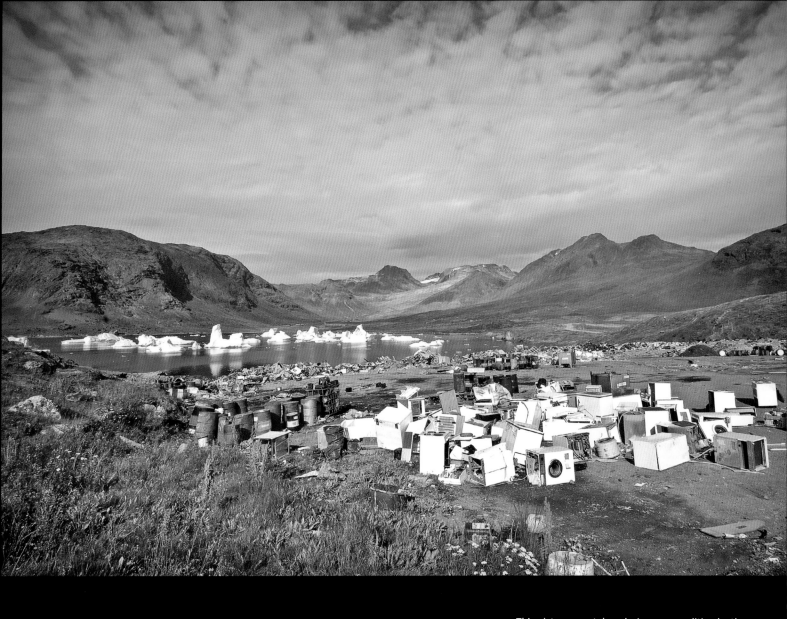

This picture was taken during an expedition by the geological faculty of the University of Tuebingen to South Greenland, which I accompanied as a freelance photographer. I discovered this garbage dump near the small town of Narsaq — one of the larger towns in Greenland with its population of 1,500 — and was

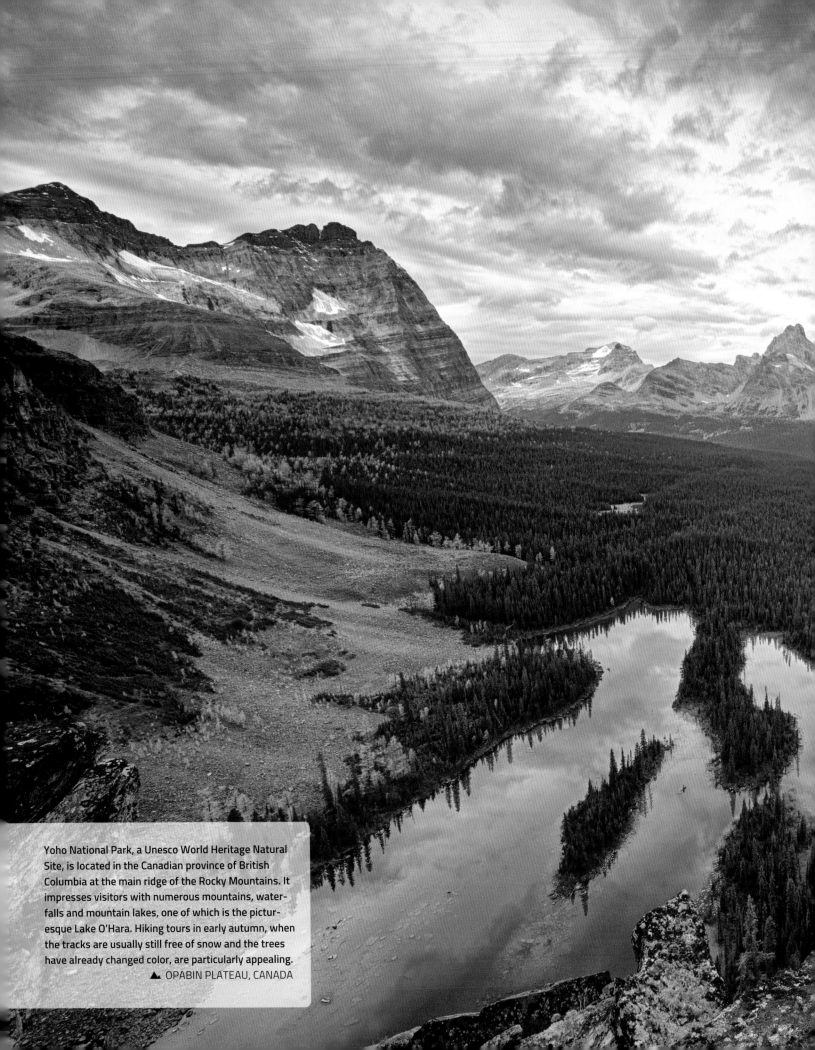

Yoho National Park, a Unesco World Heritage Natural Site, is located in the Canadian province of British Columbia at the main ridge of the Rocky Mountains. It impresses visitors with numerous mountains, waterfalls and mountain lakes, one of which is the picturesque Lake O'Hara. Hiking tours in early autumn, when the tracks are usually still free of snow and the trees have already changed color, are particularly appealing.

▲ OPABIN PLATEAU, CANADA

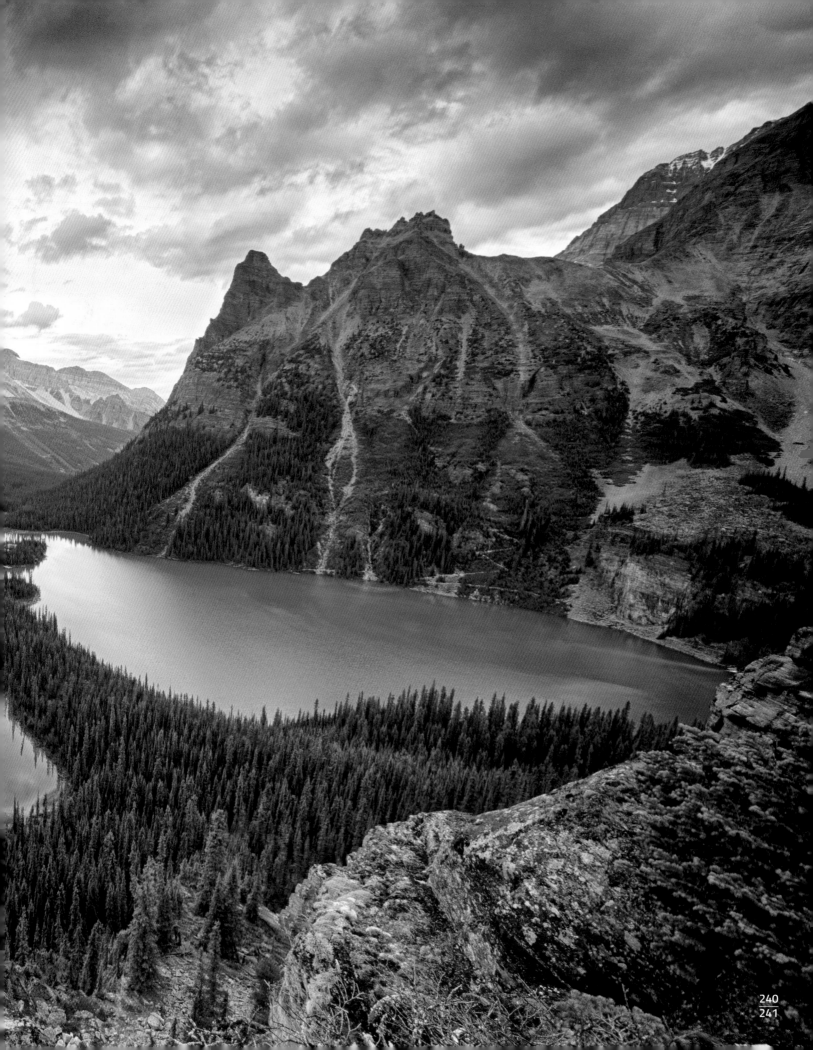

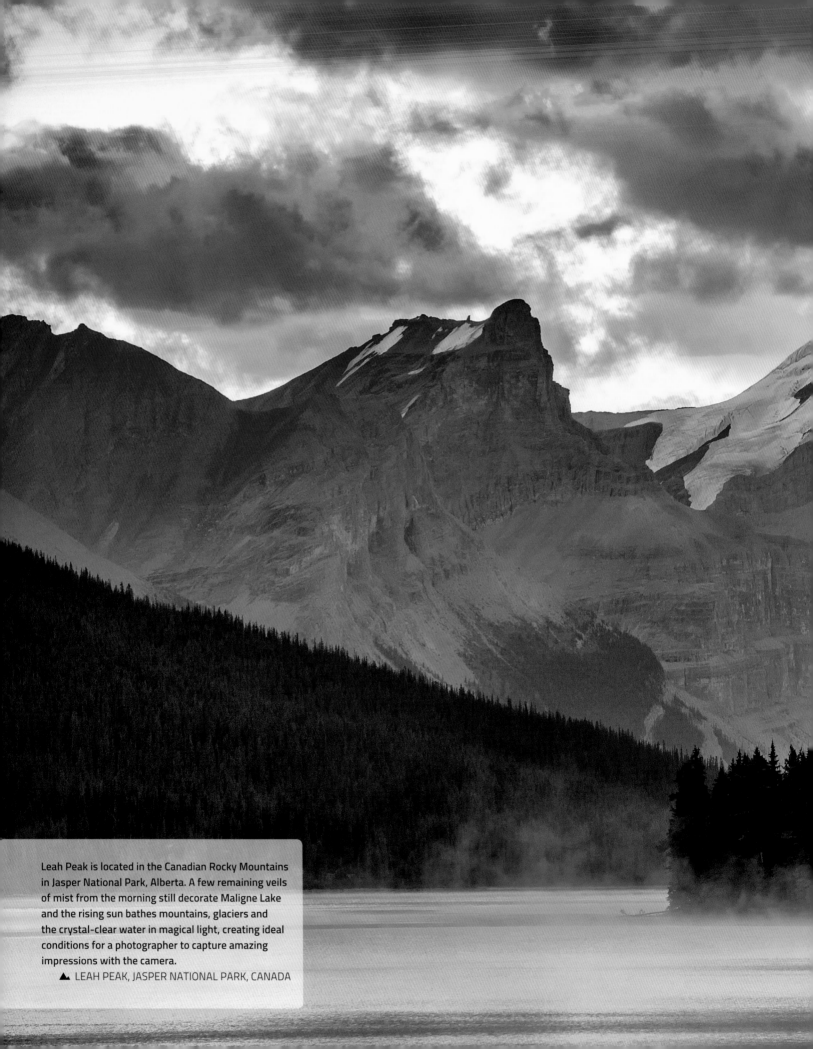

Leah Peak is located in the Canadian Rocky Mountains in Jasper National Park, Alberta. A few remaining veils of mist from the morning still decorate Maligne Lake and the rising sun bathes mountains, glaciers and the crystal-clear water in magical light, creating ideal conditions for a photographer to capture amazing impressions with the camera.

▲ LEAH PEAK, JASPER NATIONAL PARK, CANADA

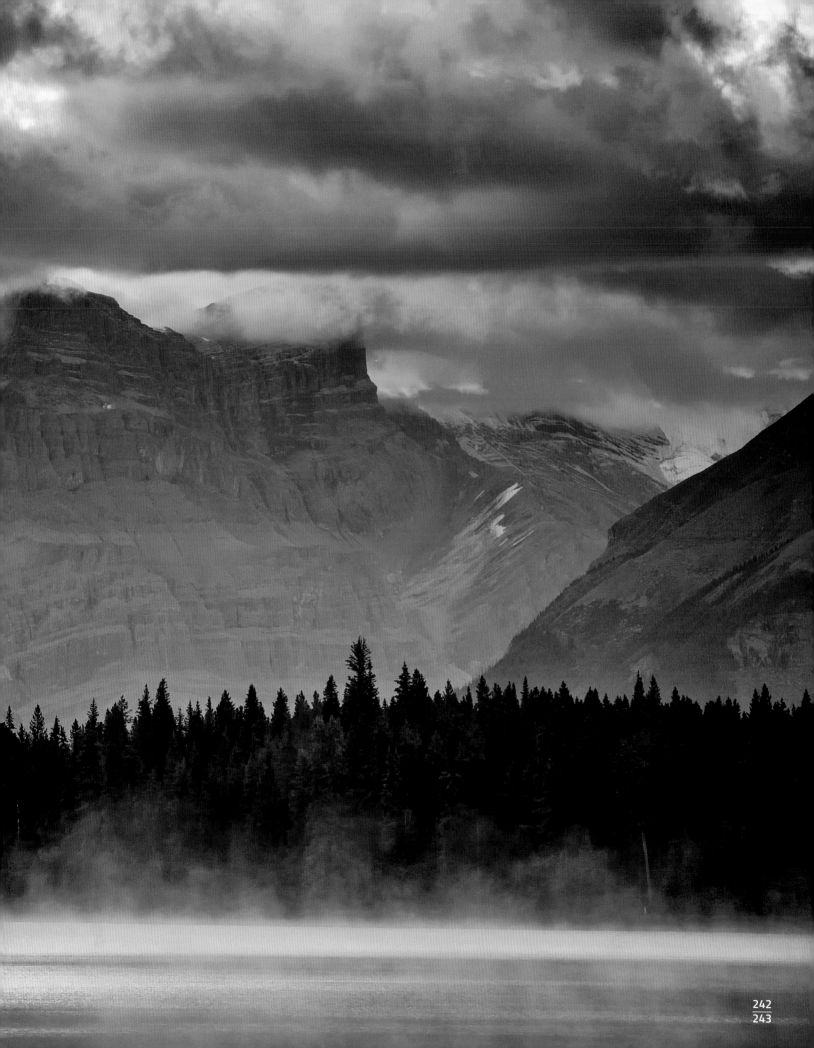

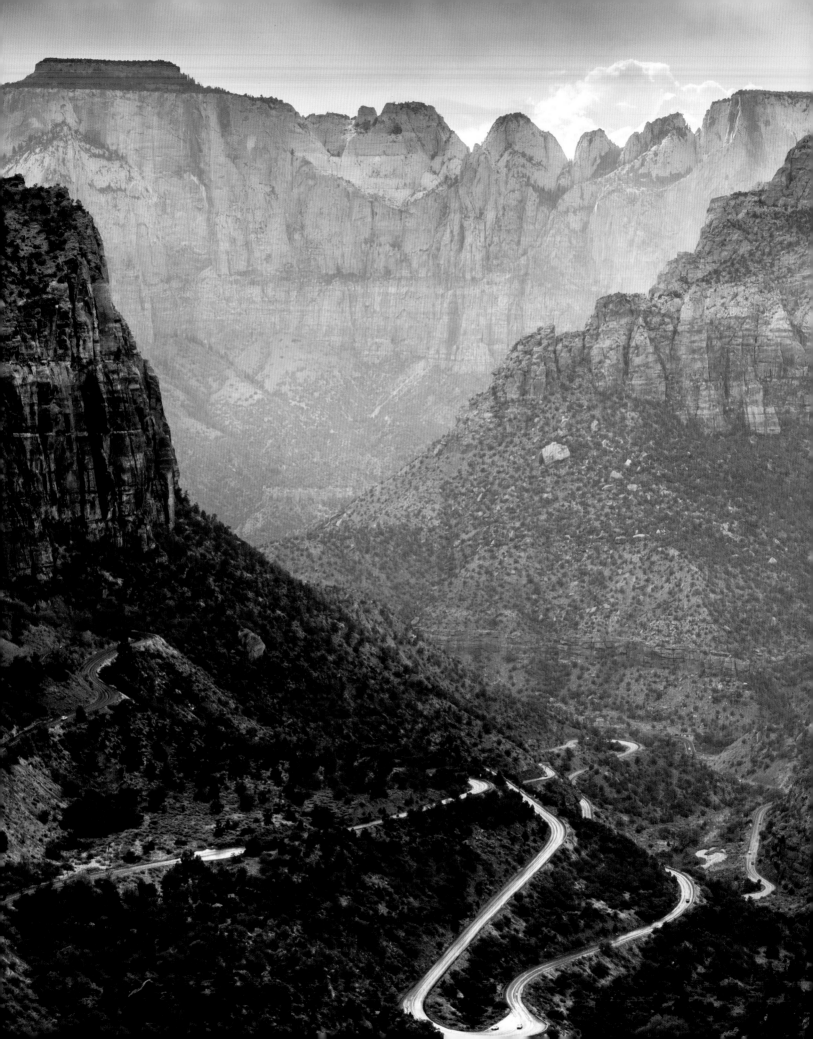

"During a road trip through the Southwest of the United States in 2014, I was able to take this picture, which shows Zion Valley in the heart of Zion National Park in the state of Utah. The sky cleared for a short moment between drizzle and a severe storm, and the sun shone through the clouds. This was exactly the moment I had been waiting for!"

▲ ZION NATIONAL PARK, UTAH, UNITED STATES

"On my first visit to the United States, I visited the famous climbing area City of Rocks with my friends. This wonderland of granite and bizarre rock formations is located in the far south of Idaho, in the middle of desert. This picture shows Markus Eder climbing a fantastic line called 'Heartbreaker.'"

▲ CITY OF ROCKS, IDAHO, UNITED STATES

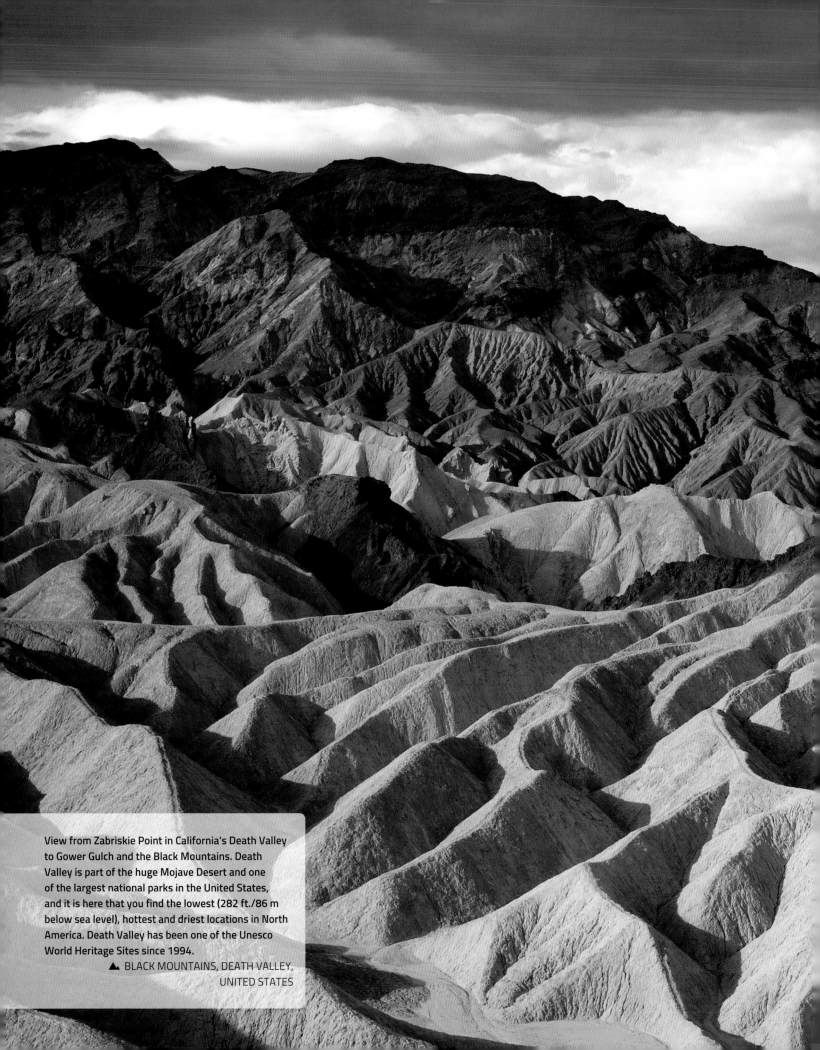

View from Zabriskie Point in California's Death Valley to Gower Gulch and the Black Mountains. Death Valley is part of the huge Mojave Desert and one of the largest national parks in the United States, and it is here that you find the lowest (282 ft./86 m below sea level), hottest and driest locations in North America. Death Valley has been one of the Unesco World Heritage Sites since 1994.

▲ BLACK MOUNTAINS, DEATH VALLEY,
UNITED STATES

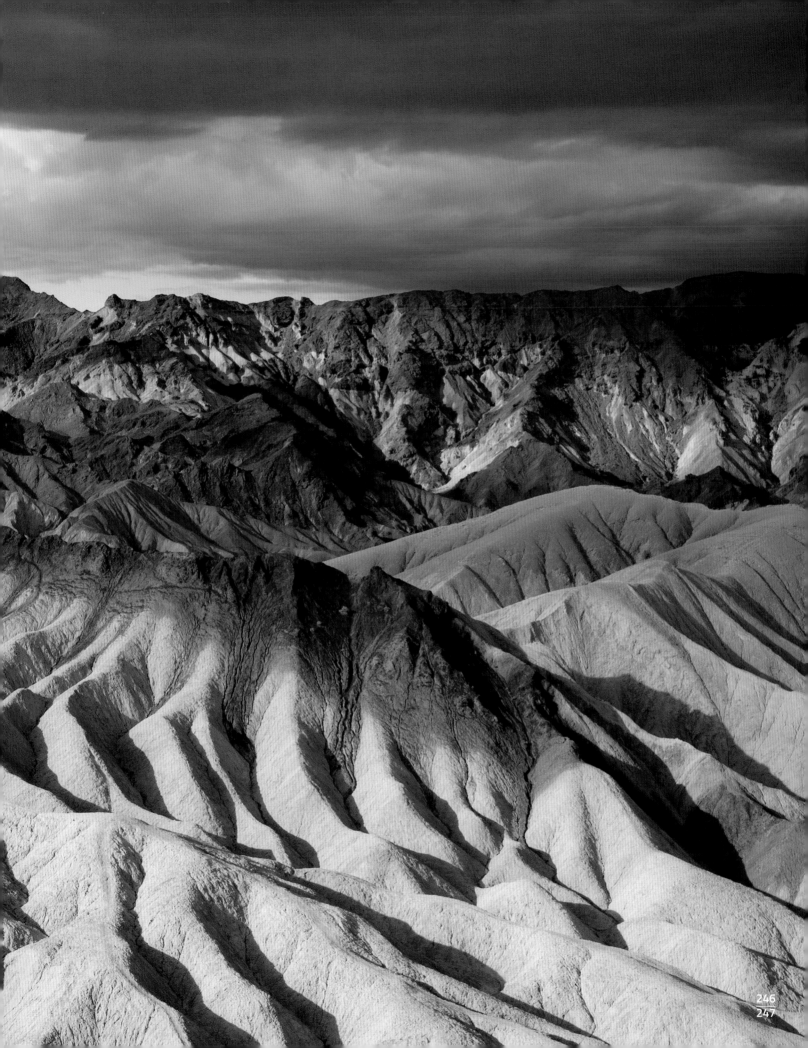

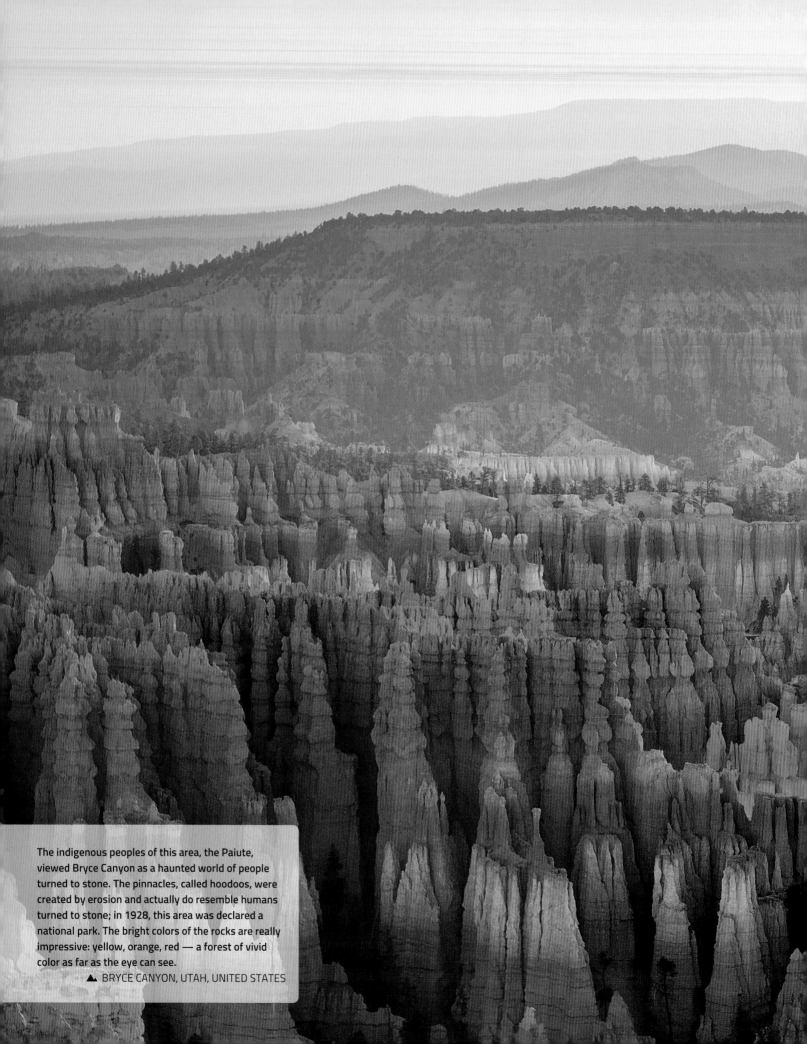

The indigenous peoples of this area, the Paiute, viewed Bryce Canyon as a haunted world of people turned to stone. The pinnacles, called hoodoos, were created by erosion and actually do resemble humans turned to stone; in 1928, this area was declared a national park. The bright colors of the rocks are really impressive: yellow, orange, red — a forest of vivid color as far as the eye can see.

▲ BRYCE CANYON, UTAH, UNITED STATES

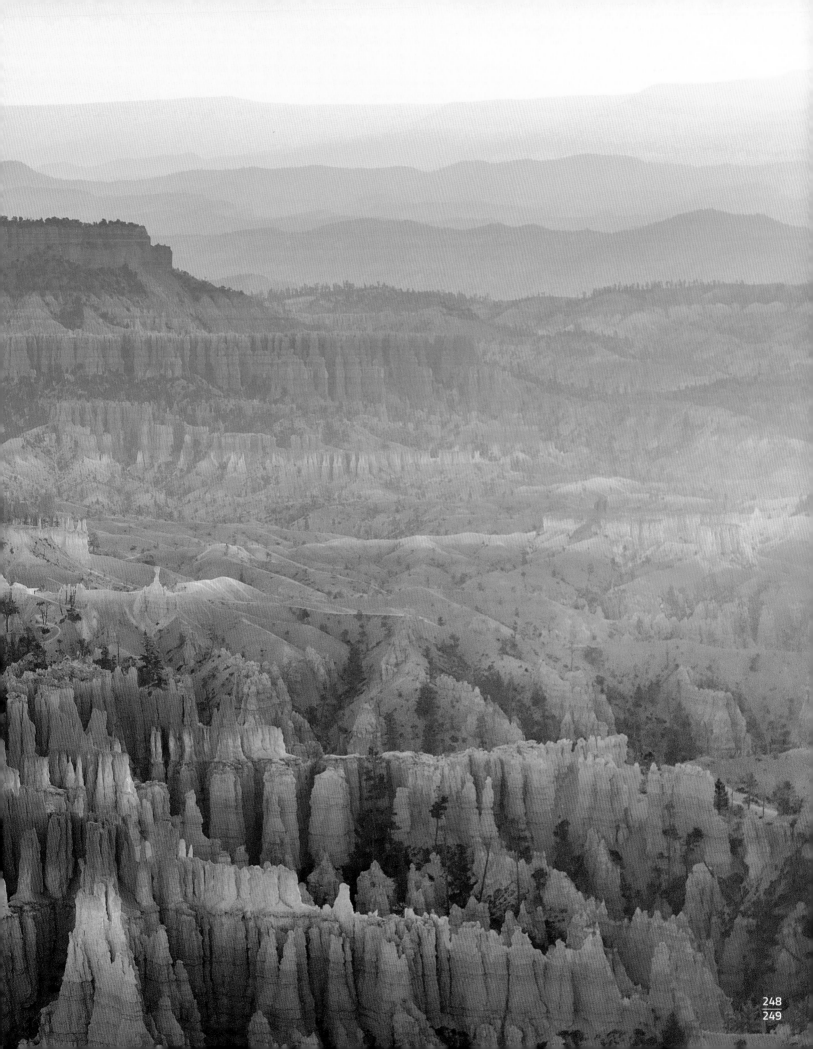

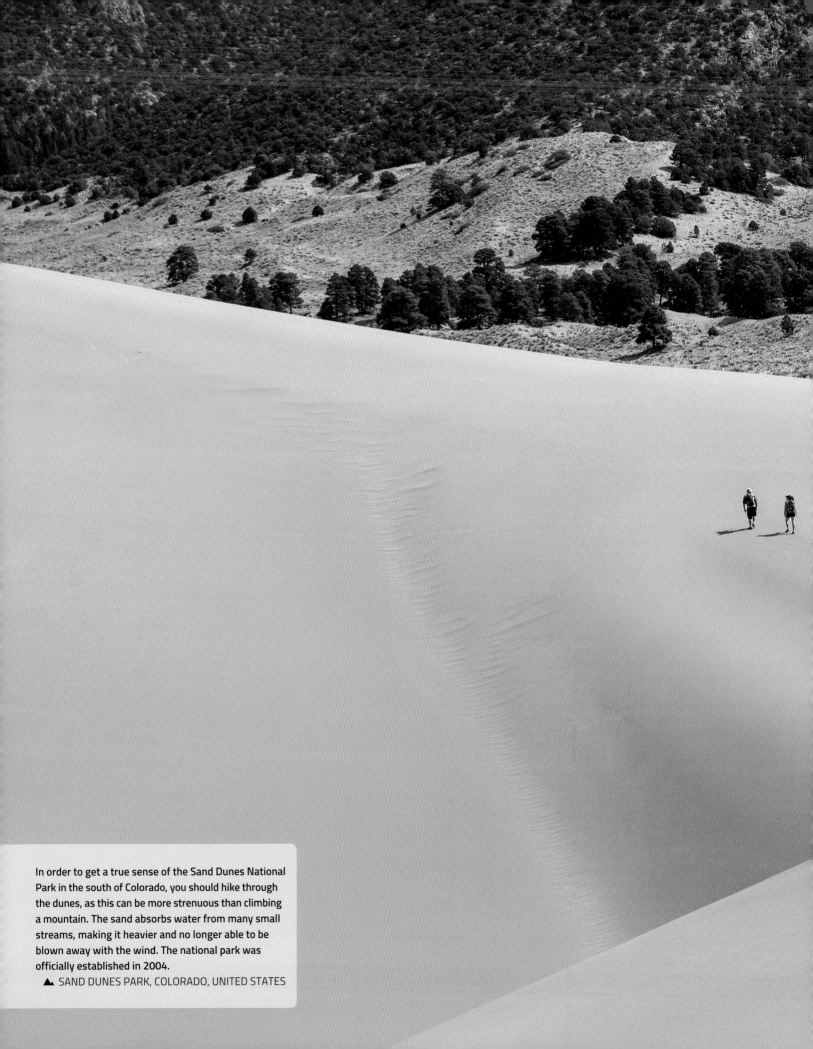

In order to get a true sense of the Sand Dunes National Park in the south of Colorado, you should hike through the dunes, as this can be more strenuous than climbing a mountain. The sand absorbs water from many small streams, making it heavier and no longer able to be blown away with the wind. The national park was officially established in 2004.

▲ SAND DUNES PARK, COLORADO, UNITED STATES

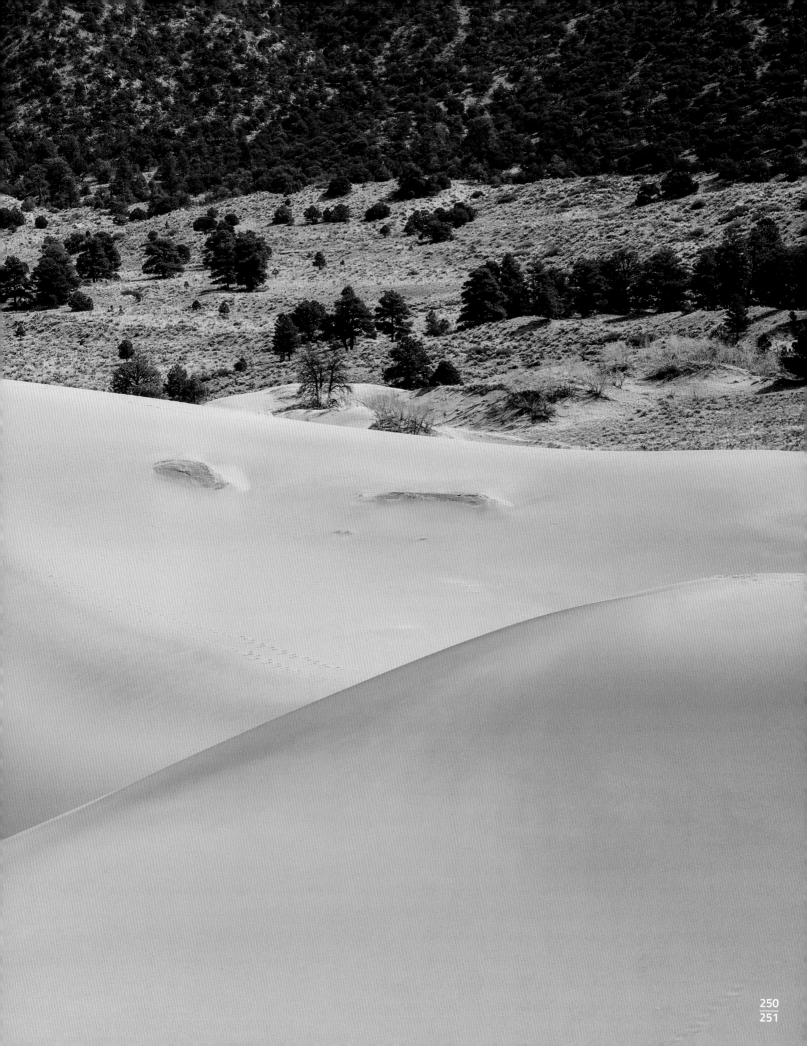

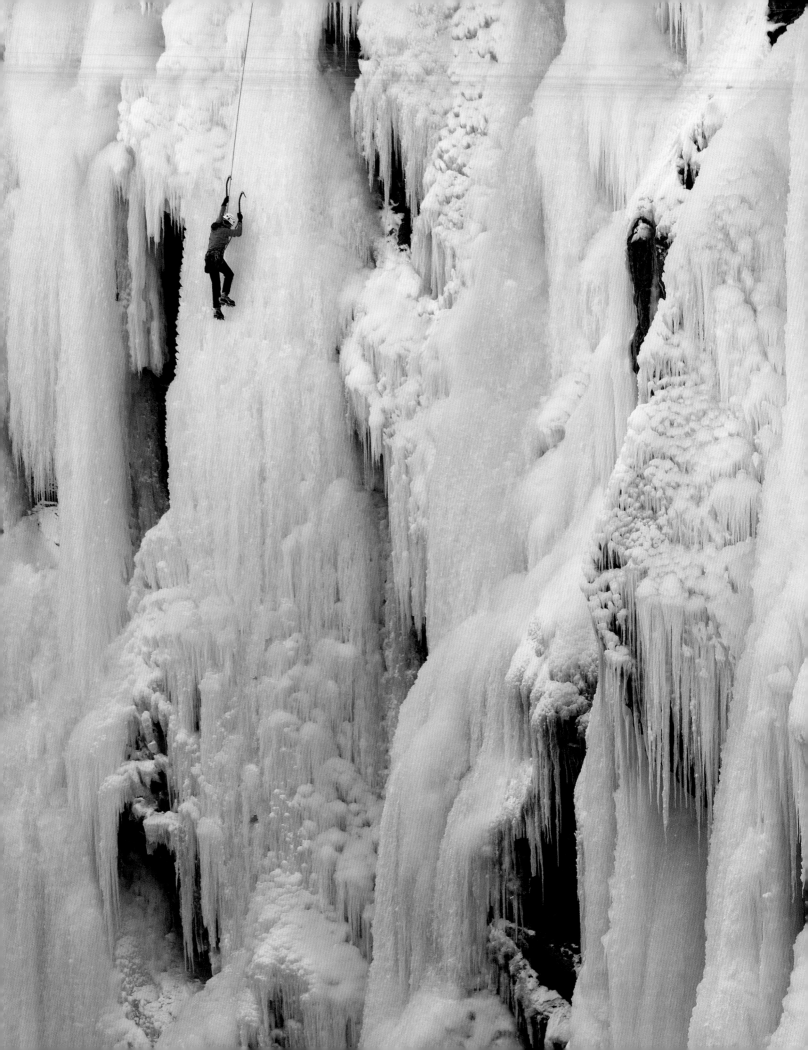

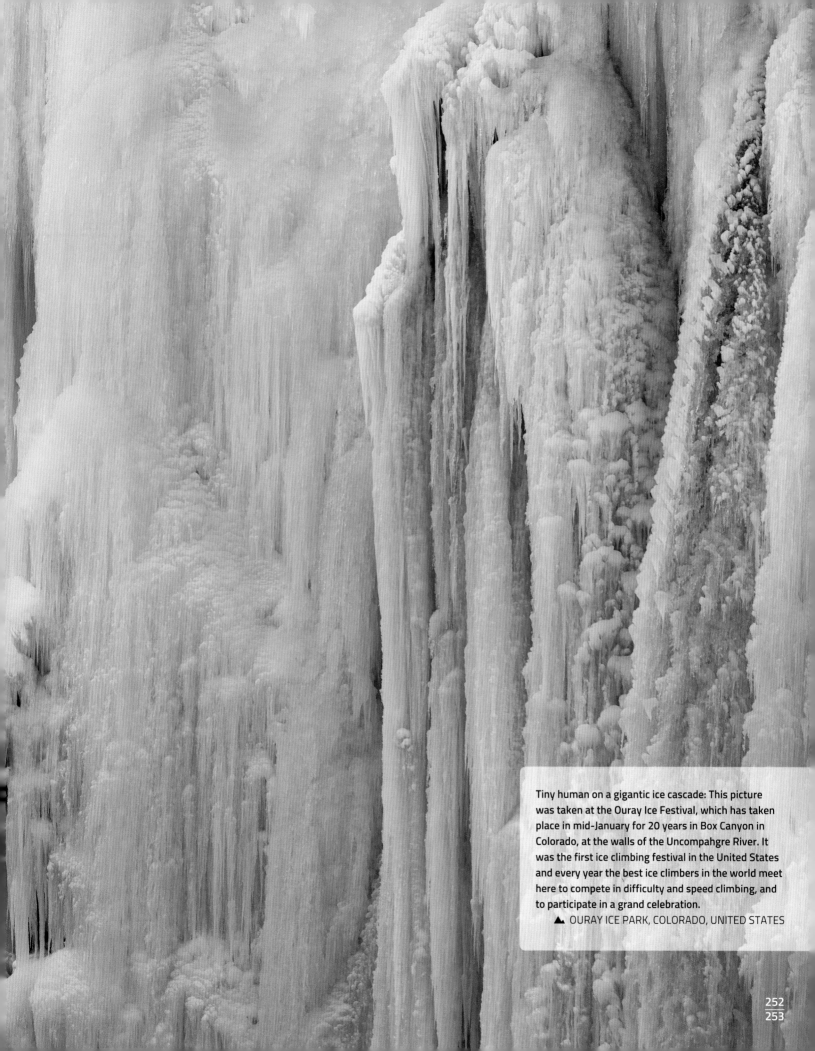

Tiny human on a gigantic ice cascade: This picture was taken at the Ouray Ice Festival, which has taken place in mid-January for 20 years in Box Canyon in Colorado, at the walls of the Uncompahgre River. It was the first ice climbing festival in the United States and every year the best ice climbers in the world meet here to compete in difficulty and speed climbing, and to participate in a grand celebration.

▲ OURAY ICE PARK, COLORADO, UNITED STATES

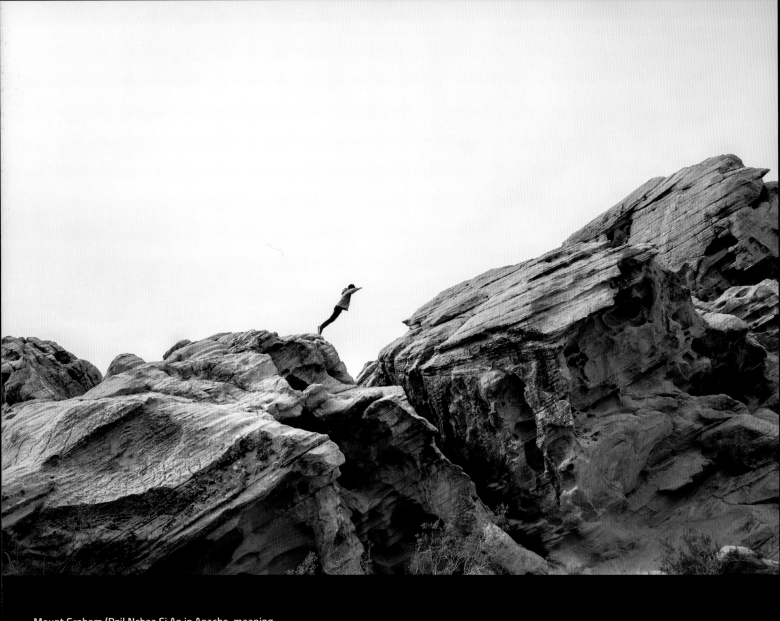

Mount Graham (Dzil Nchaa Si An in Apache, meaning
Big Seated Mountain) is a 10,720-foot-high (3,267 m)
mountain in southeastern Arizona. A huge telescope was
constructed at its summit, an undertaking that has been
heavily criticized by the local indigenous people. Mount
Graham is a unique biotope on the American continent and

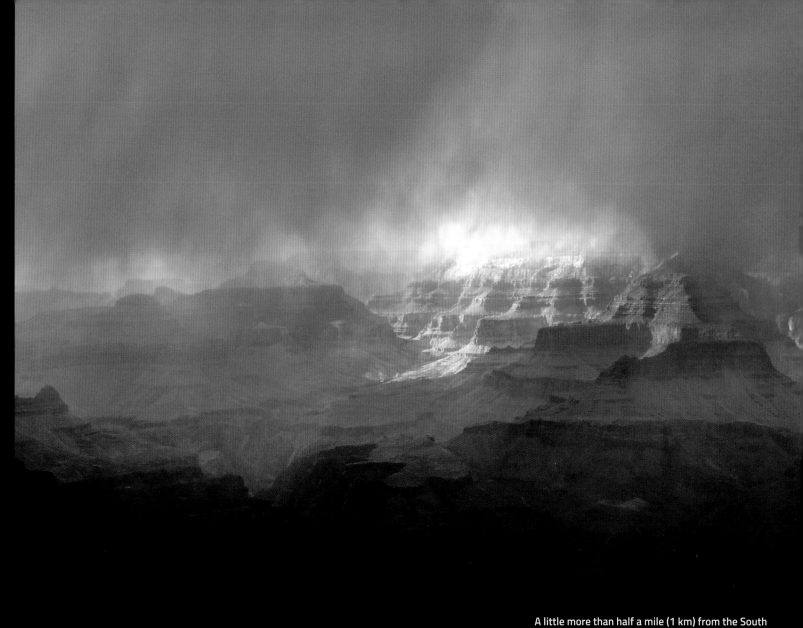

A little more than half a mile (1 km) from the South
Kaibab Trail, a breathtaking view into the majestic Grand
Canyon presents itself from Ooh Aah Point. A rare snow-
storm moves through the canyon and creates a theatrical
background 3,300 feet (1,006 m) above the Colorado
River. The rugged peaks and ridges, shaped by the river,
shine in every variation of orange in the sun.
▲ GRAND CANYON, ARIZONA, UNITED STATES

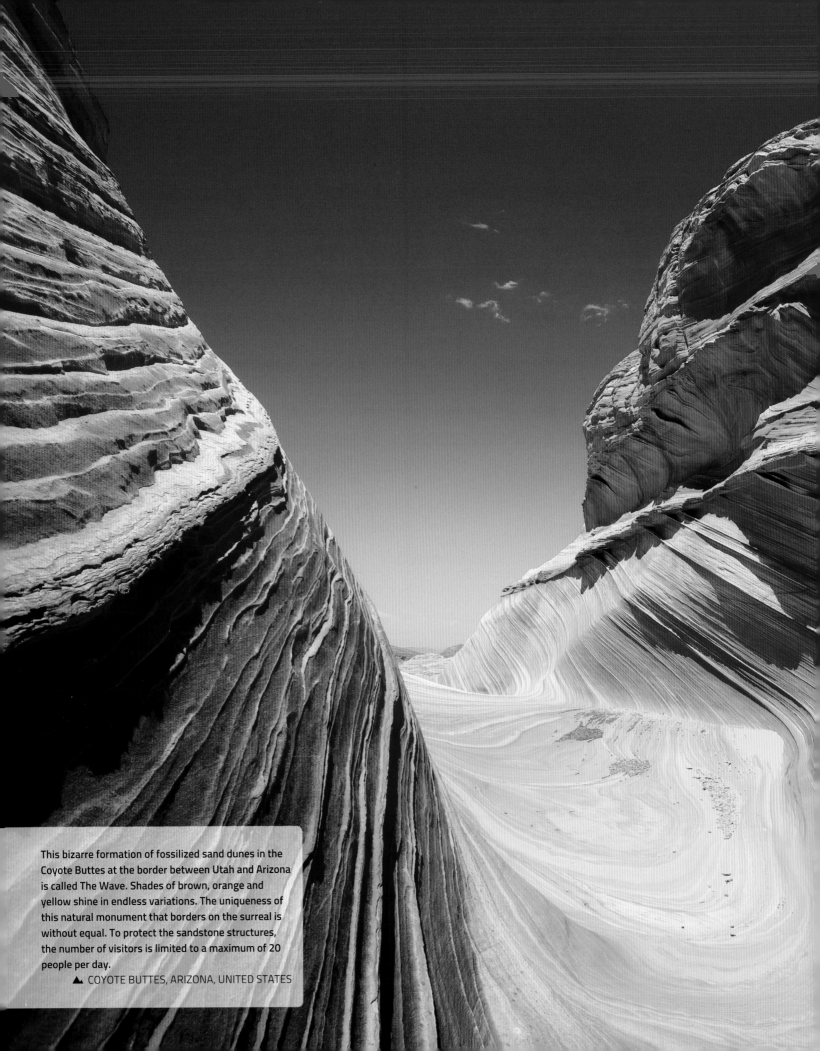

This bizarre formation of fossilized sand dunes in the Coyote Buttes at the border between Utah and Arizona is called The Wave. Shades of brown, orange and yellow shine in endless variations. The uniqueness of this natural monument that borders on the surreal is without equal. To protect the sandstone structures, the number of visitors is limited to a maximum of 20 people per day.

▲ COYOTE BUTTES, ARIZONA, UNITED STATES

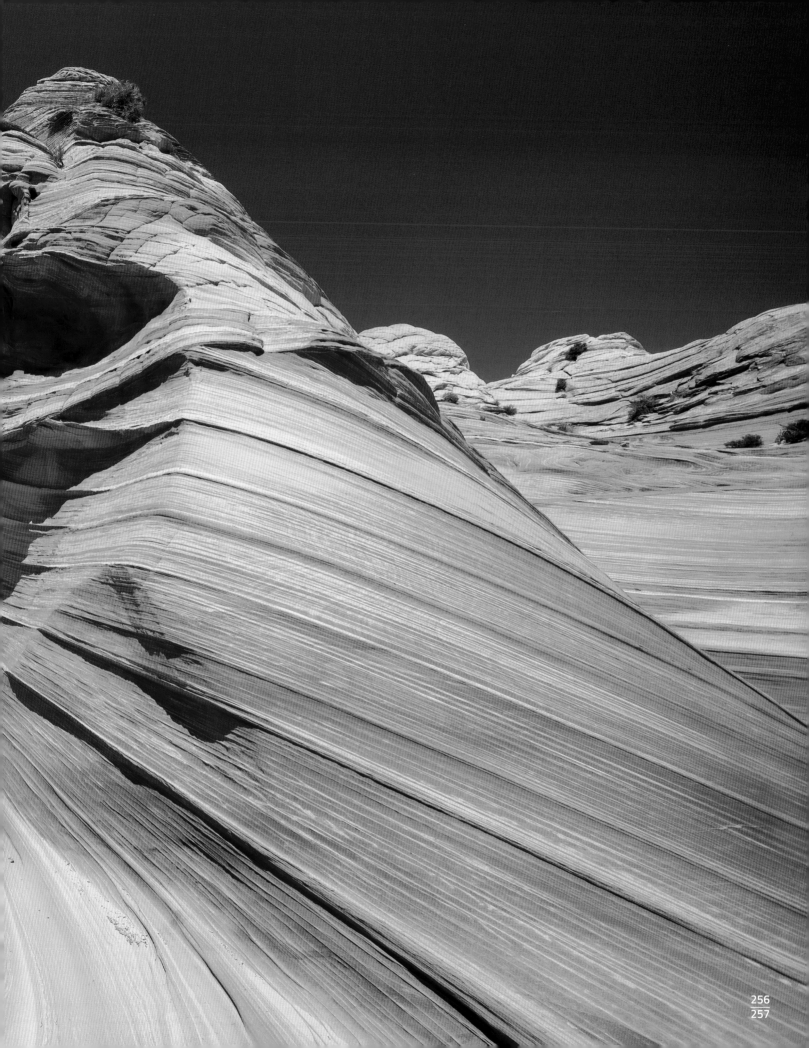

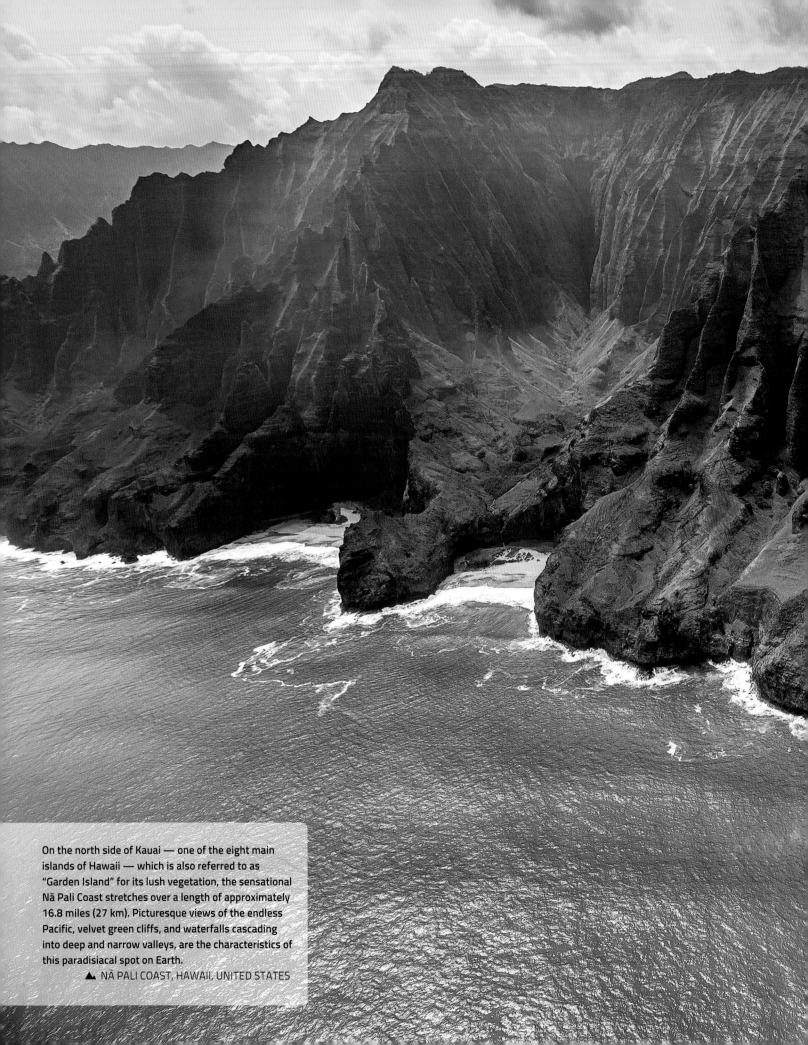

On the north side of Kauai — one of the eight main islands of Hawaii — which is also referred to as "Garden Island" for its lush vegetation, the sensational Nā Pali Coast stretches over a length of approximately 16.8 miles (27 km). Picturesque views of the endless Pacific, velvet green cliffs, and waterfalls cascading into deep and narrow valleys, are the characteristics of this paradisiacal spot on Earth.

▲ NĀ PALI COAST, HAWAII, UNITED STATES

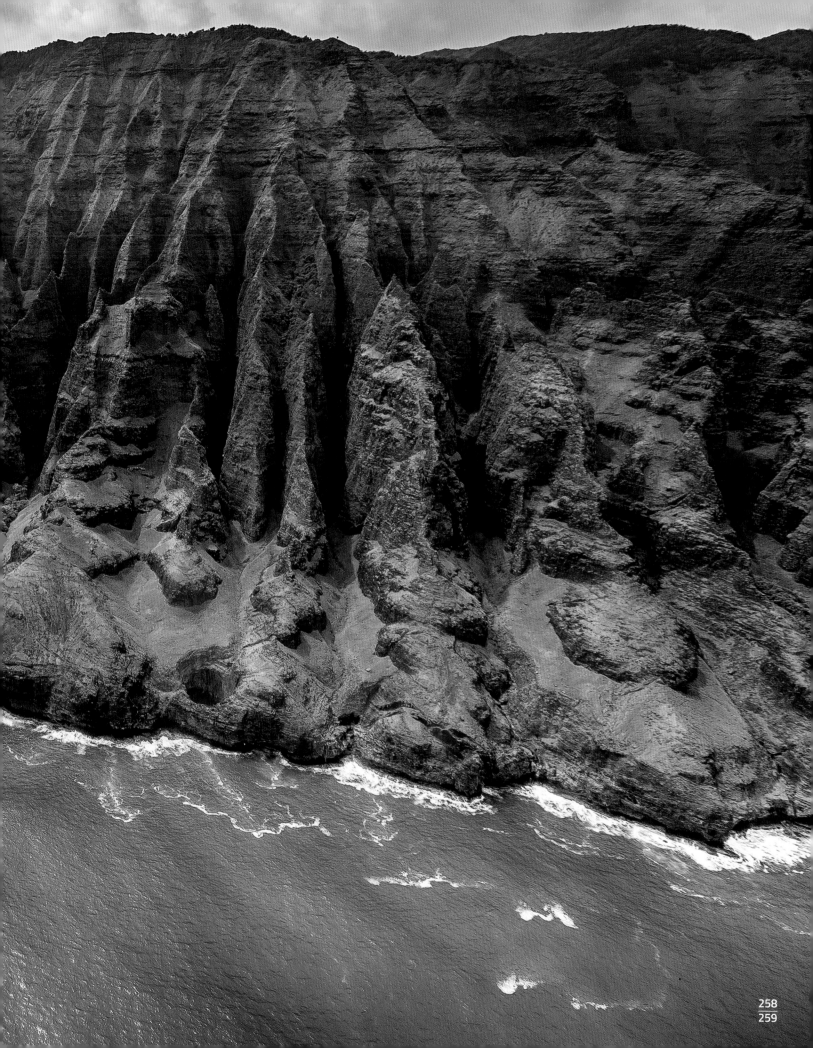

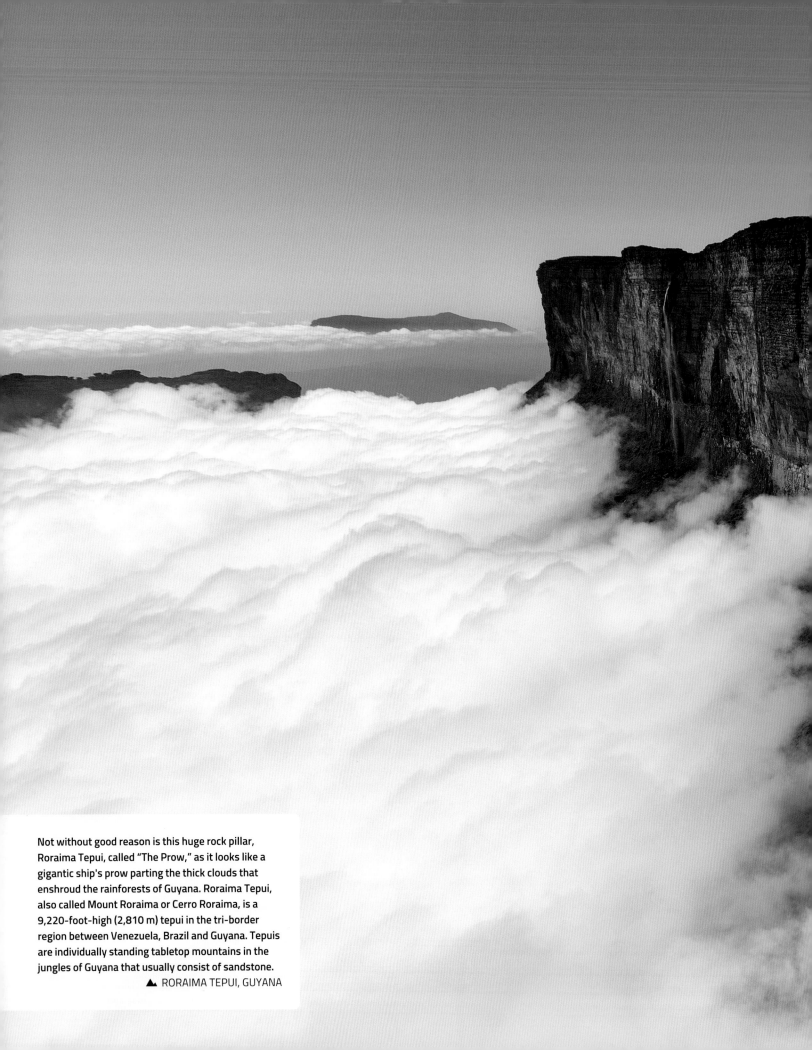

Not without good reason is this huge rock pillar, Roraima Tepui, called "The Prow," as it looks like a gigantic ship's prow parting the thick clouds that enshroud the rainforests of Guyana. Roraima Tepui, also called Mount Roraima or Cerro Roraima, is a 9,220-foot-high (2,810 m) tepui in the tri-border region between Venezuela, Brazil and Guyana. Tepuis are individually standing tabletop mountains in the jungles of Guyana that usually consist of sandstone.

▲ RORAIMA TEPUI, GUYANA

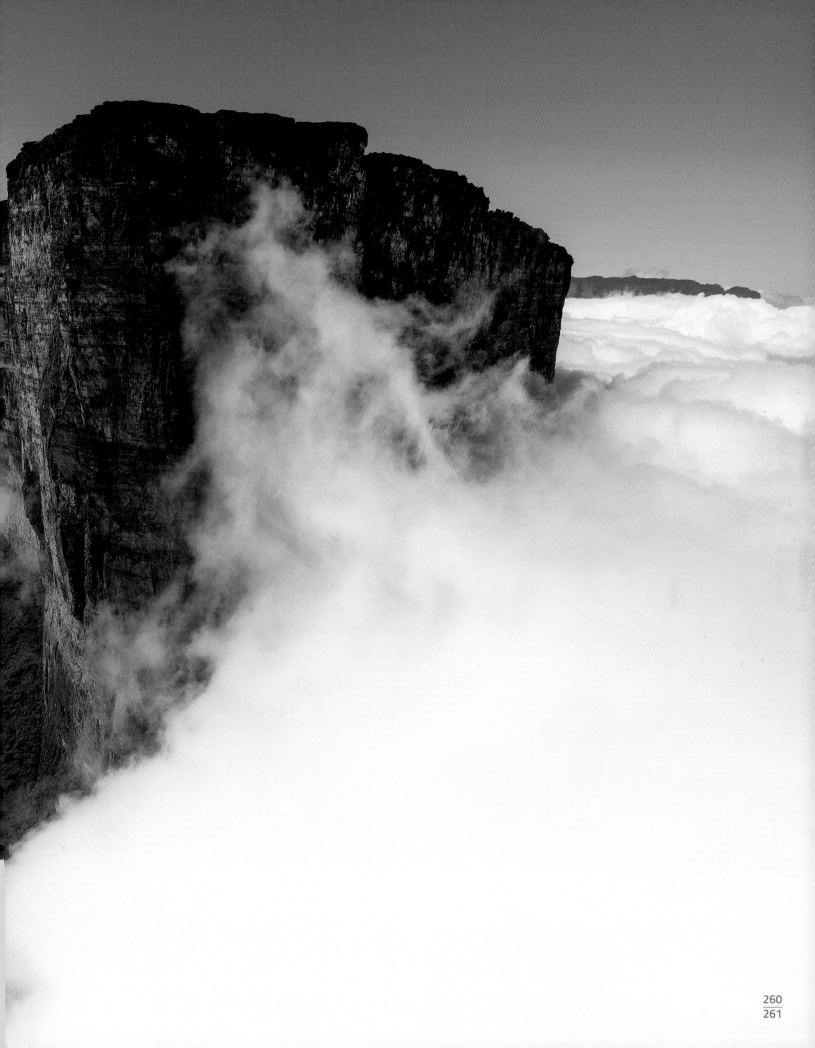

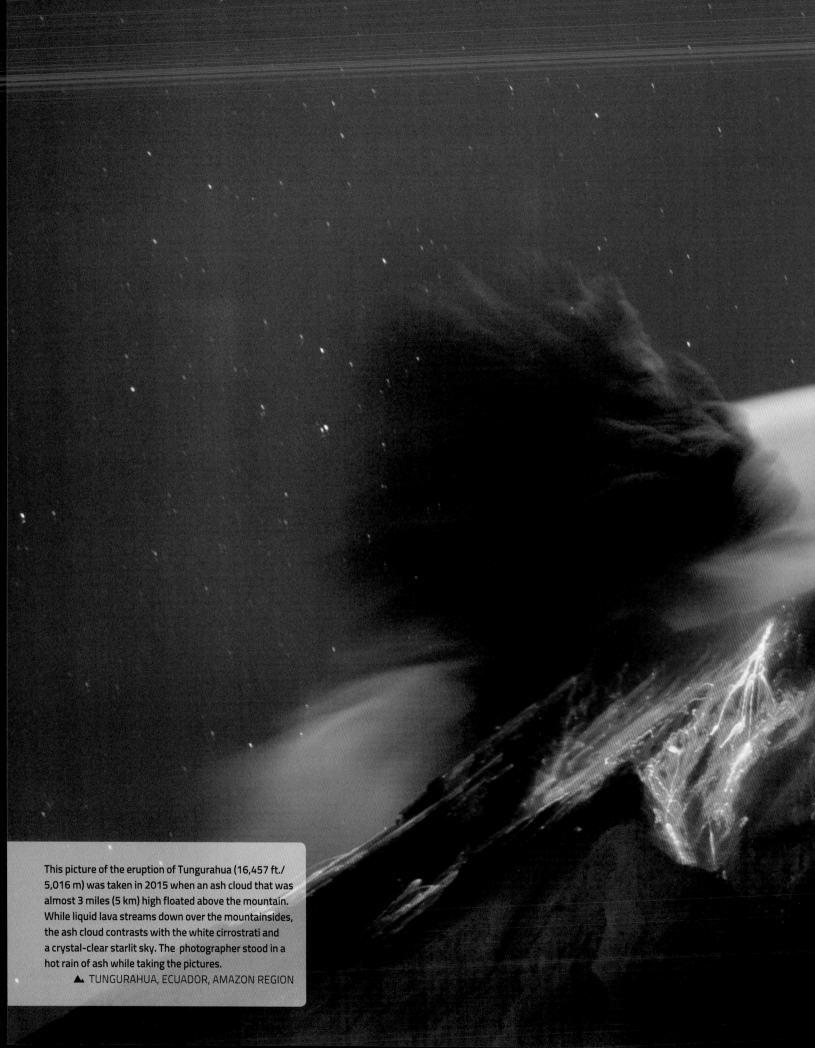

This picture of the eruption of Tungurahua (16,457 ft./
5,016 m) was taken in 2015 when an ash cloud that was
almost 3 miles (5 km) high floated above the mountain.
While liquid lava streams down over the mountainsides,
the ash cloud contrasts with the white cirrostrati and
a crystal-clear starlit sky. The  photographer stood in a
hot rain of ash while taking the pictures.

▲ TUNGURAHUA, ECUADOR, AMAZON REGION

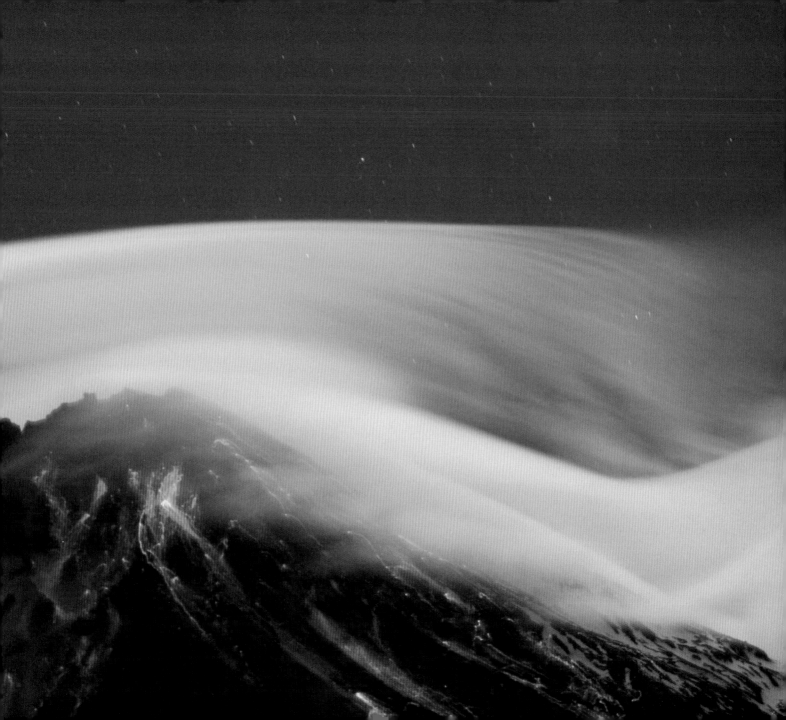

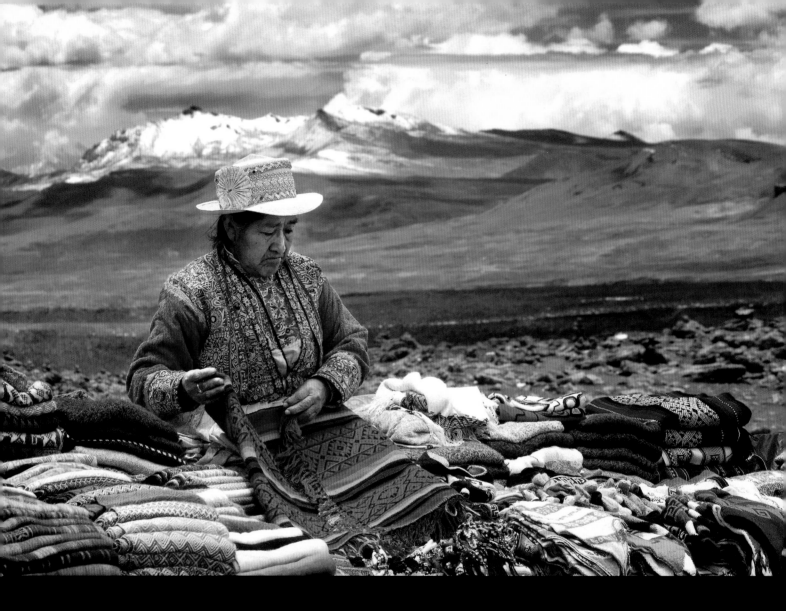

It is never easy being a marketeer in a market. But it is even more difficult when your sales stall is located at an altitude of almost 16,400 feet (5,000 m). This is the life the market women in Mirador de Los Andes, also called Patapampa Pass, are leading. It is a breathtaking (pun intended) vantage point in Peru.

▲ MIRADOR DE LOS ANDES, AREQUIPA, PERU

"On the last day of our 99-mile (160 km) trek through the Cordillera Huayhuash in Peru, we stayed overnight at the one-of-a-kind Laguna Jahuacocha. At dusk, I climbed along a waterfall to the top and waited for the sun to set. The setting sun bathed the clouds into blazing red light and illuminated the glacier-covered walls of Jirishanca (20,100 ft./6,126 m).

▲ JAHUACOCHA, ANDEN, PERU

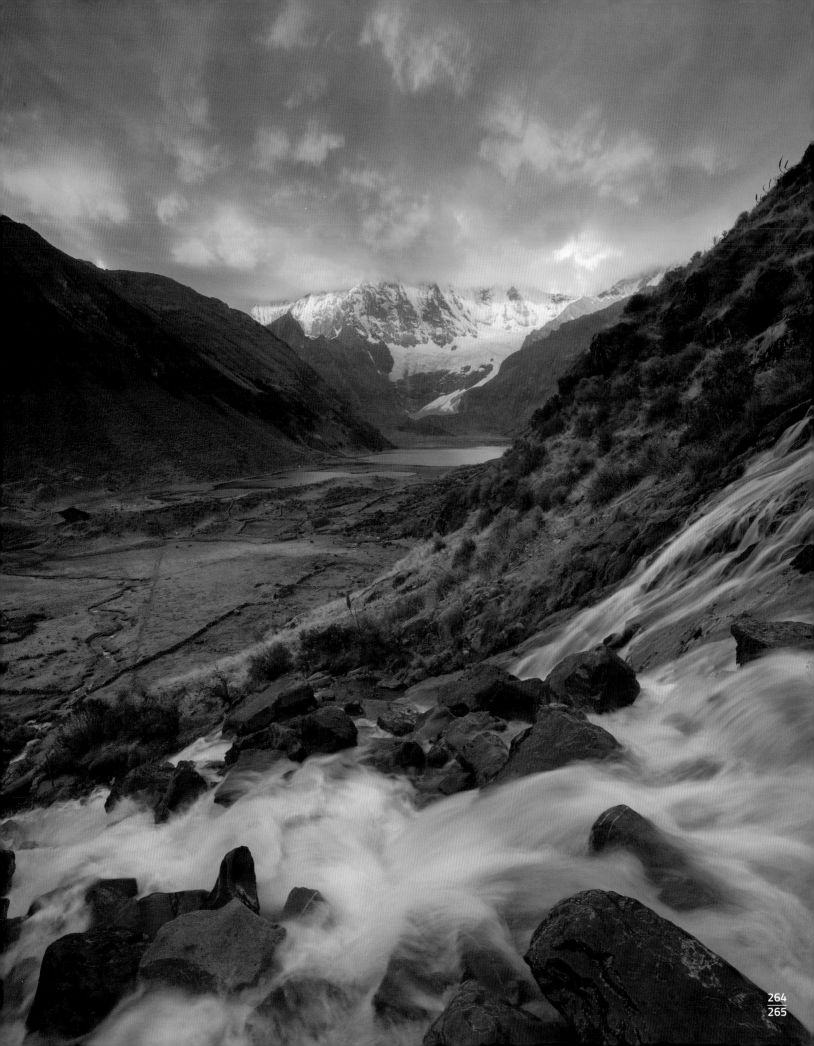

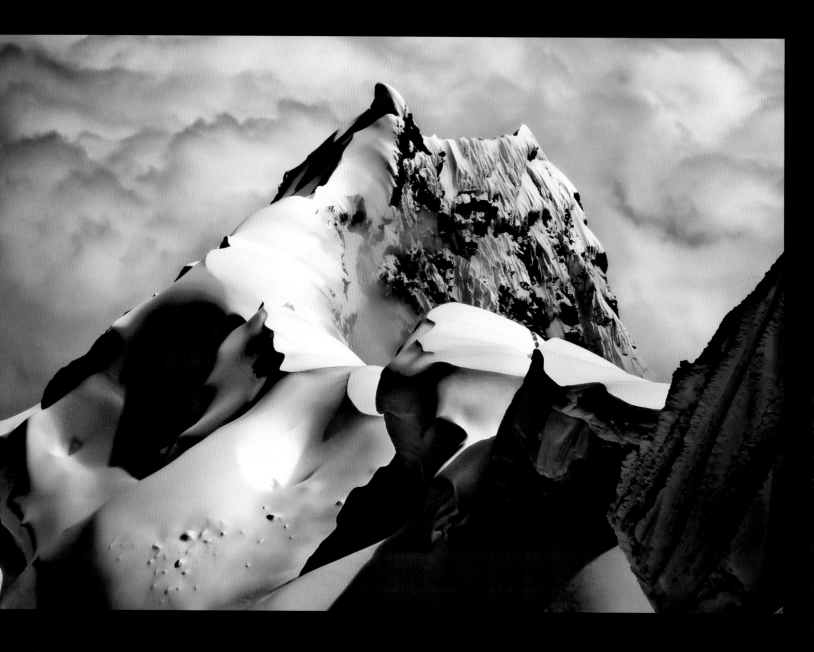

The northwest ridge of Nevado Chopicalqui (20,817 ft./
6,345 m) is one of the most difficult routes to this neighboring
peak of Huascarán, which, at 22,205 feet (6,768 m), is the
highest peak in Peru. Due to its adventurous cornices this ridge
route is usually only taken once. However, even the regular
ascent to Chopicalqui is considered one of the challenging
undertakings in the region, as the peak itself consists of huge
cornices 330 feet (100 m) in length.

▲ NEVADO CHOPICALQUI, CORDILLERA BLANCA, PERU

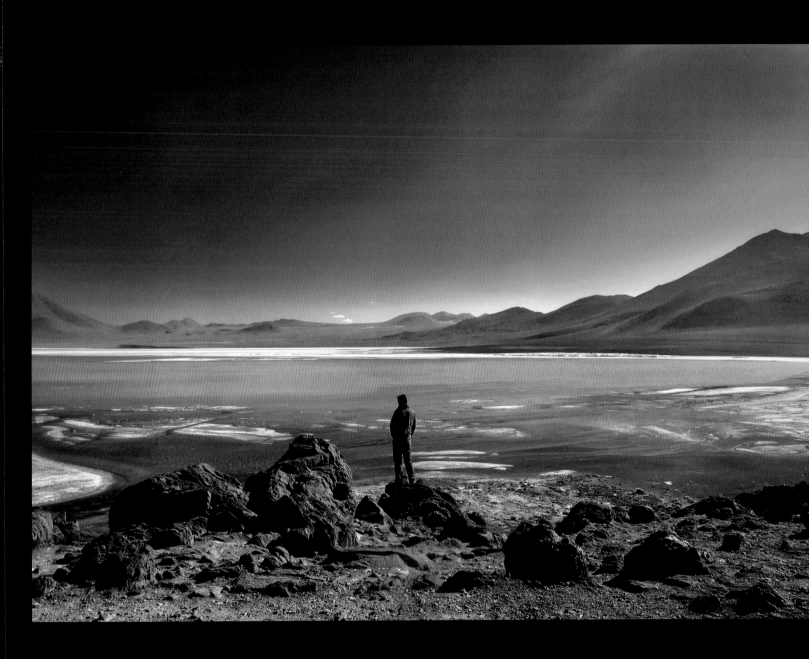

At an altitude of 14,035 feet (4,278 m), Laguna Colorada is a flat lake that is on average 1.6 feet (50 cm) deep, at its deepest point 4.9 feet (1.5 m) deep, and 23.16 square miles (60 sq. km) in size, in the national park Reserva Nacional de Fauna Andina Eduardo Abaroa in the Bolivian Altiplano. The striking red color of the lake is due to an algae species and the high mineral content of the water.

▲ LAGUNA COLORADA, BOLIVIA

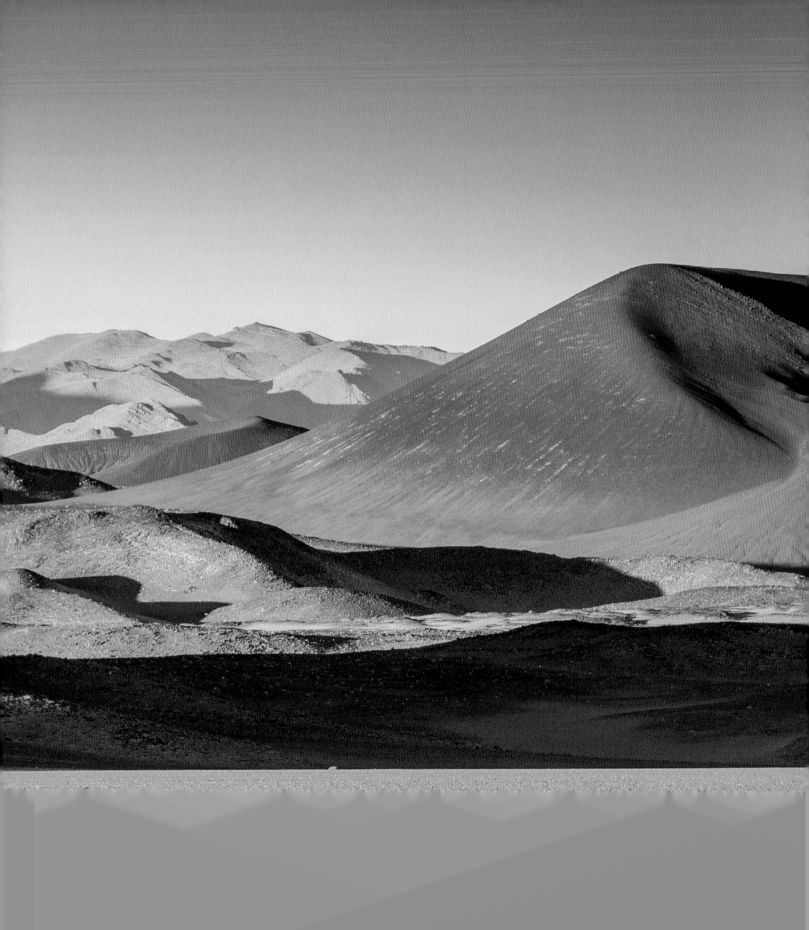

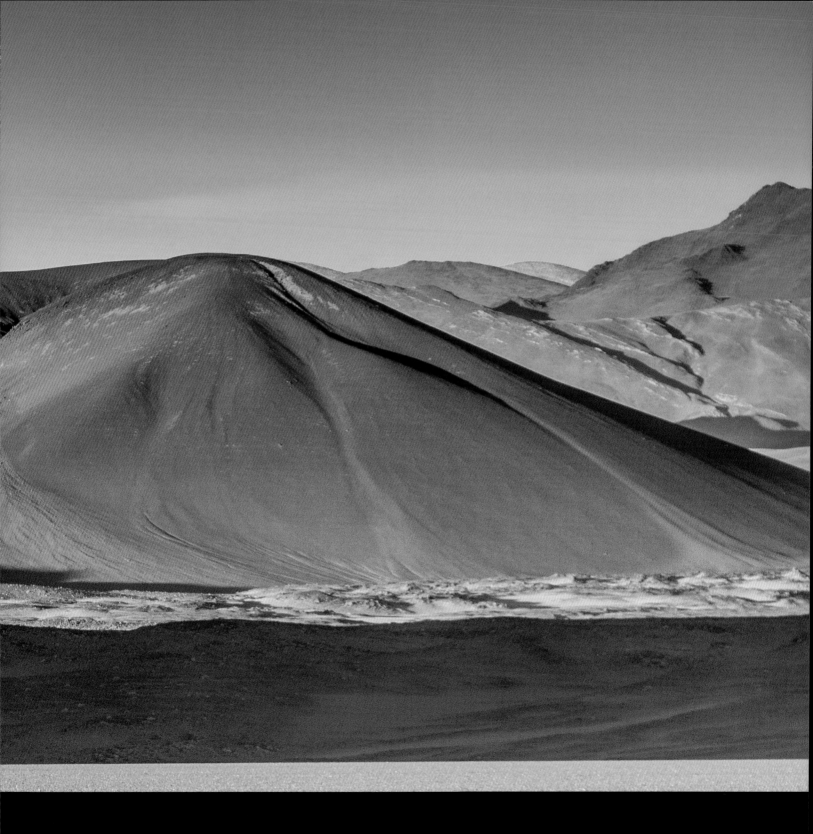

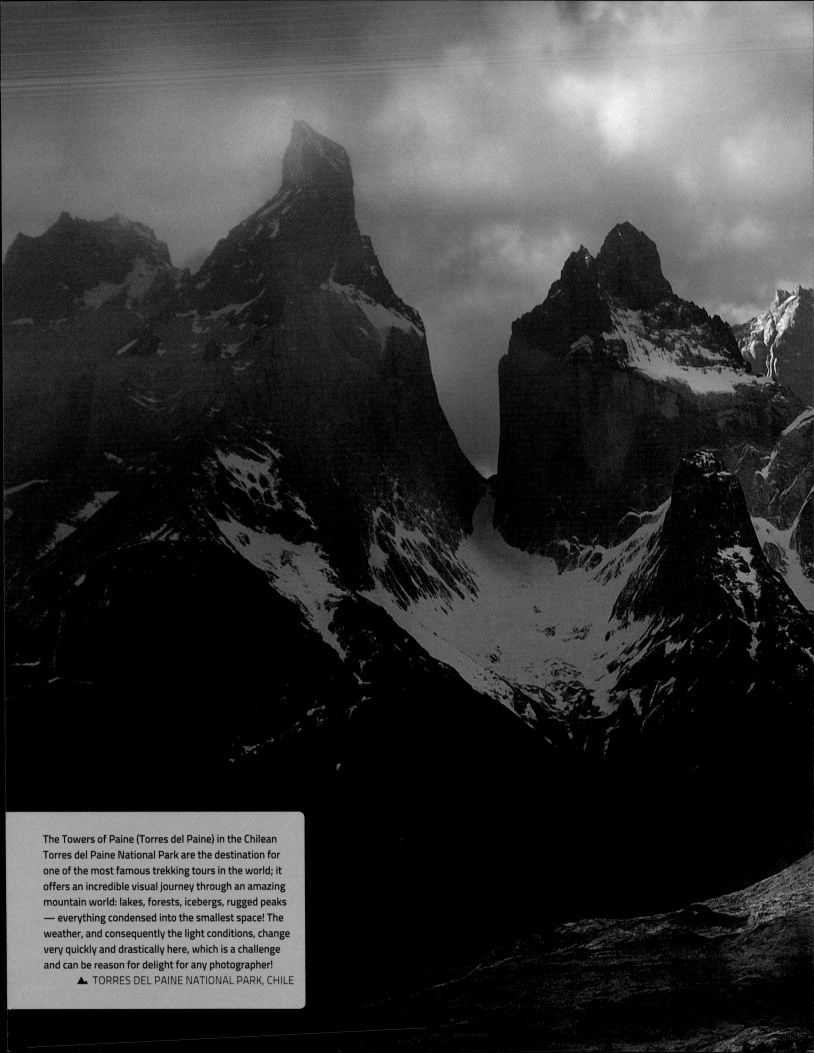

The Towers of Paine (Torres del Paine) in the Chilean
Torres del Paine National Park are the destination for
one of the most famous trekking tours in the world; it
offers an incredible visual journey through an amazing
mountain world: lakes, forests, icebergs, rugged peaks
— everything condensed into the smallest space! The
weather, and consequently the light conditions, change
very quickly and drastically here, which is a challenge
and can be reason for delight for any photographer!

▲ TORRES DEL PAINE NATIONAL PARK, CHILE

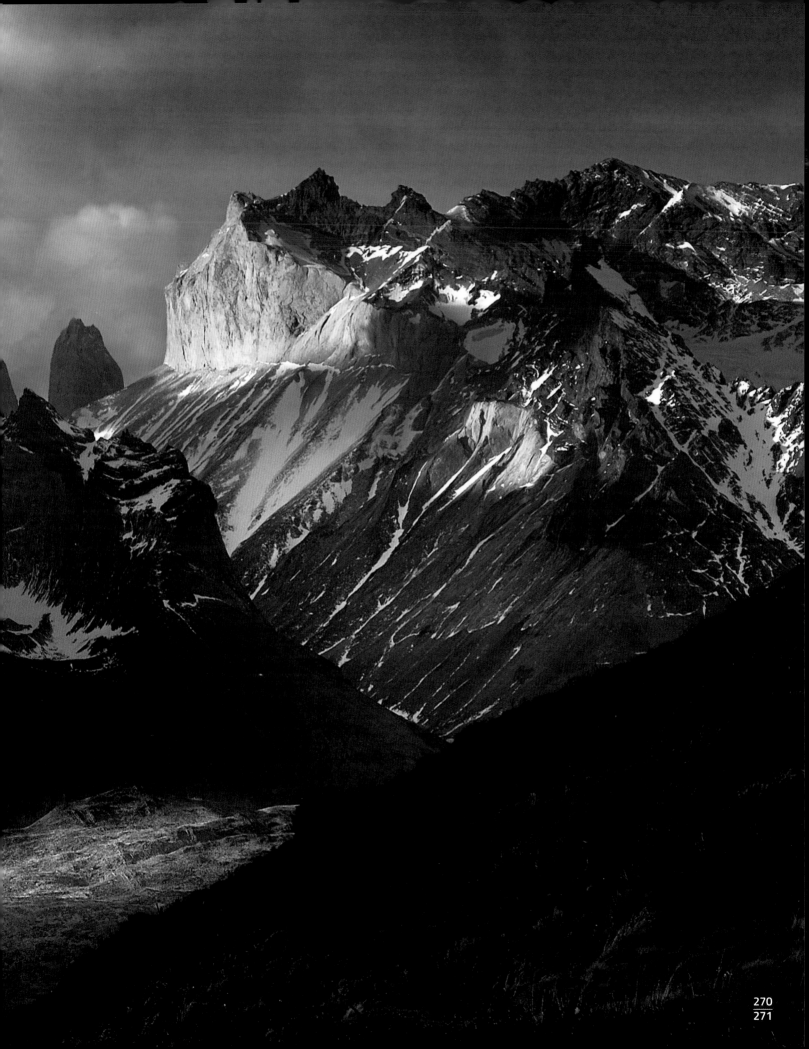

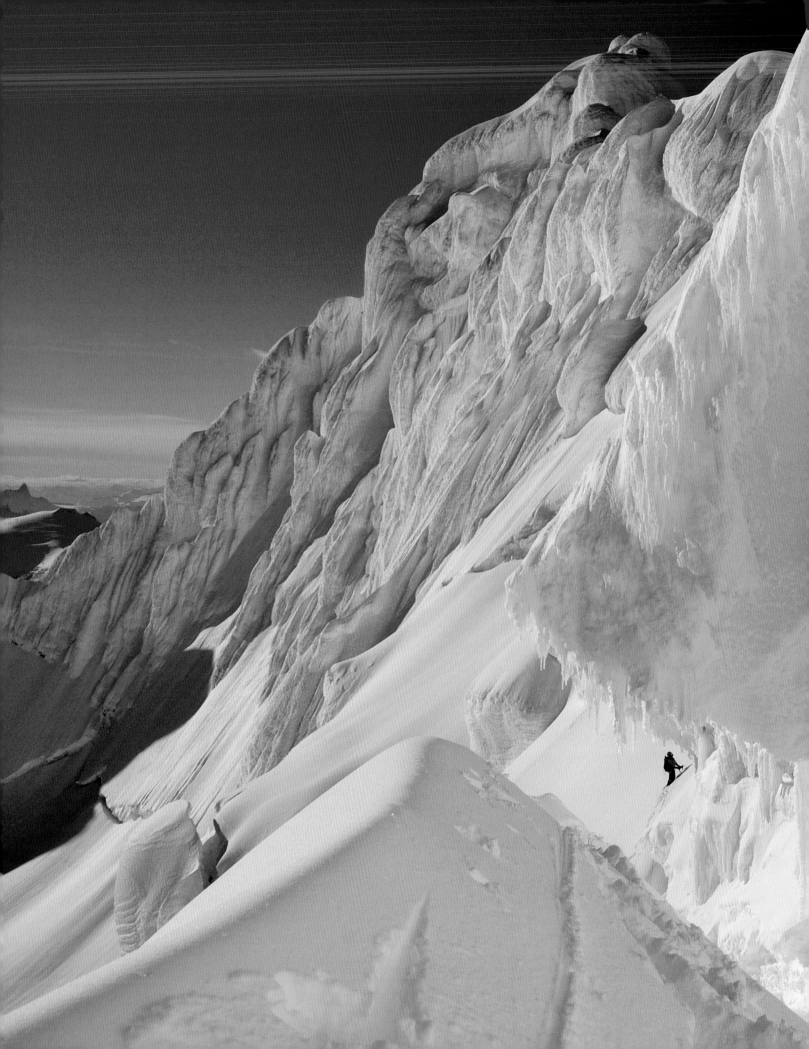

Monte Sarmiento (7,369 ft./2,246 m) is a pyramidal
peak with a heavily glaciated saddle-shaped summit,
located within Alberto De Agostini National Park in
the Chilean portion of Tierra del Fuego. It is consid-
ered the mountain with the worst weather world-
wide. In 1956, the Italians Carlo Mauri and Clemente
Maffei were the first to climb the summit; in 2010,
Robert Jasper (in the picture) and Jörn Heller climbed
the north face of Monte Sarmiento.

▲ MONTE SARMIENTO, TIERRA DEL FUEGO, CHILE

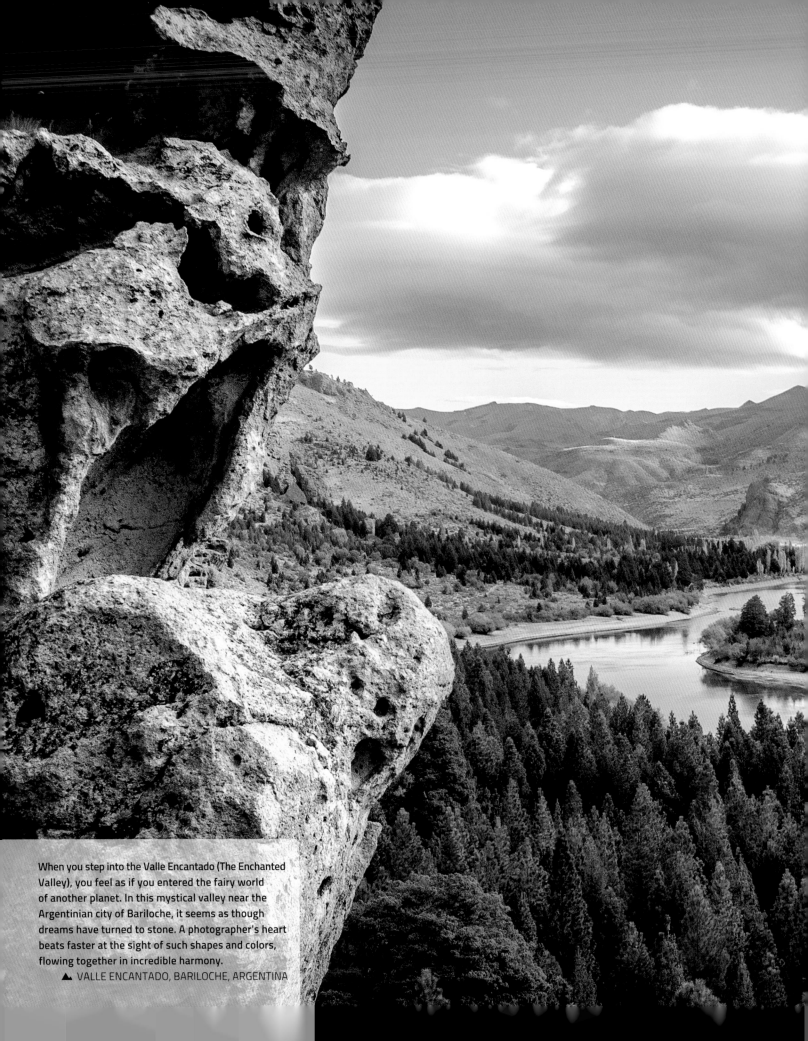

When you step into the Valle Encantado (The Enchanted Valley), you feel as if you entered the fairy world of another planet. In this mystical valley near the Argentinian city of Bariloche, it seems as though dreams have turned to stone. A photographer's heart beats faster at the sight of such shapes and colors, flowing together in incredible harmony.

▲ VALLE ENCANTADO, BARILOCHE, ARGENTINA

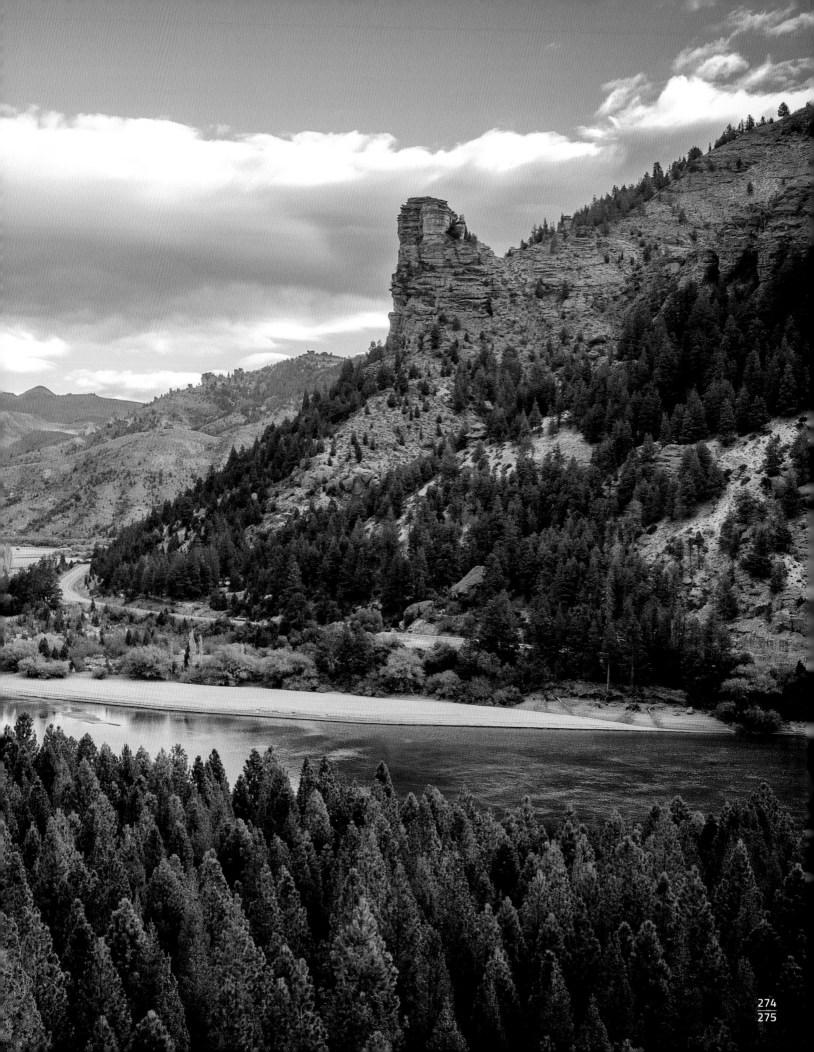

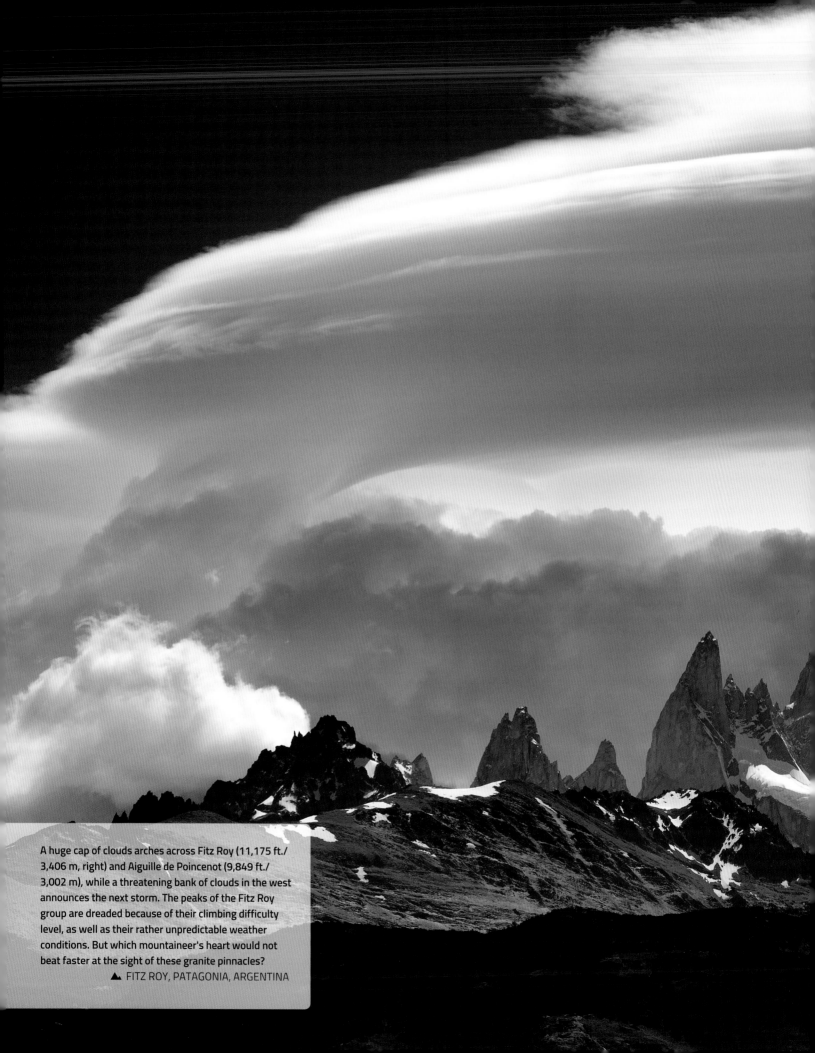

A huge cap of clouds arches across Fitz Roy (11,175 ft./ 3,406 m, right) and Aiguille de Poincenot (9,849 ft./ 3,002 m), while a threatening bank of clouds in the west announces the next storm. The peaks of the Fitz Roy group are dreaded because of their climbing difficulty level, as well as their rather unpredictable weather conditions. But which mountaineer's heart would not beat faster at the sight of these granite pinnacles?

▲ FITZ ROY, PATAGONIA, ARGENTINA

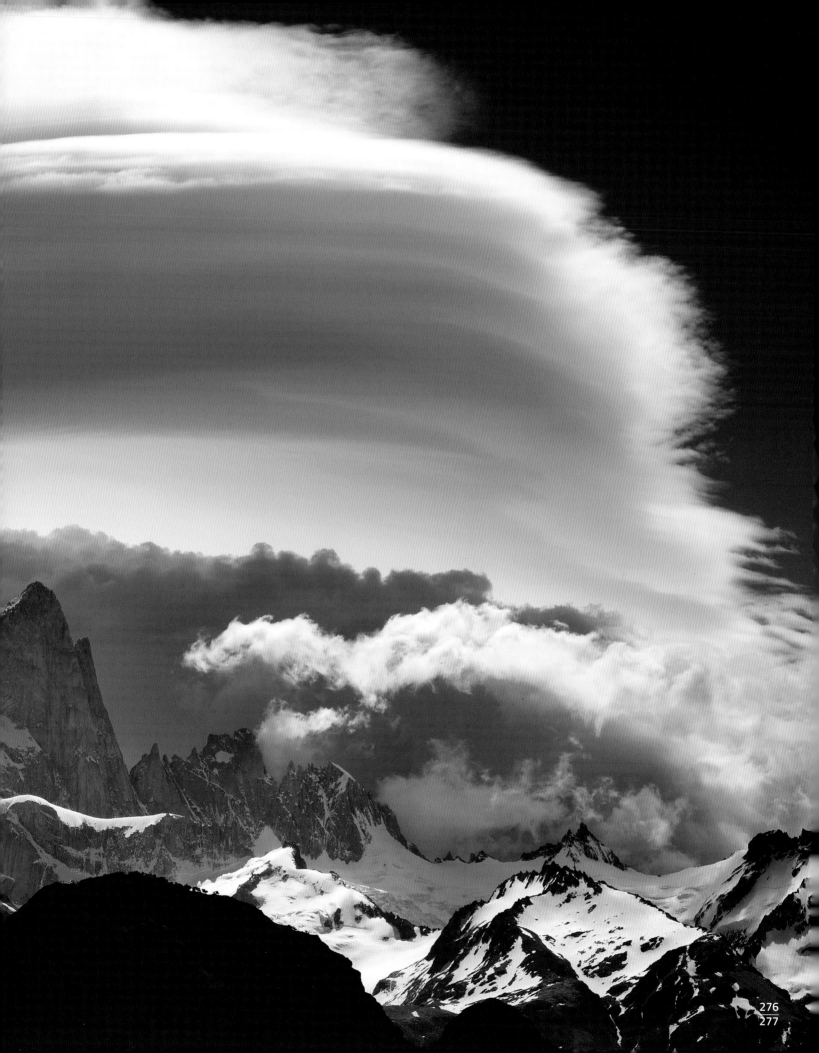

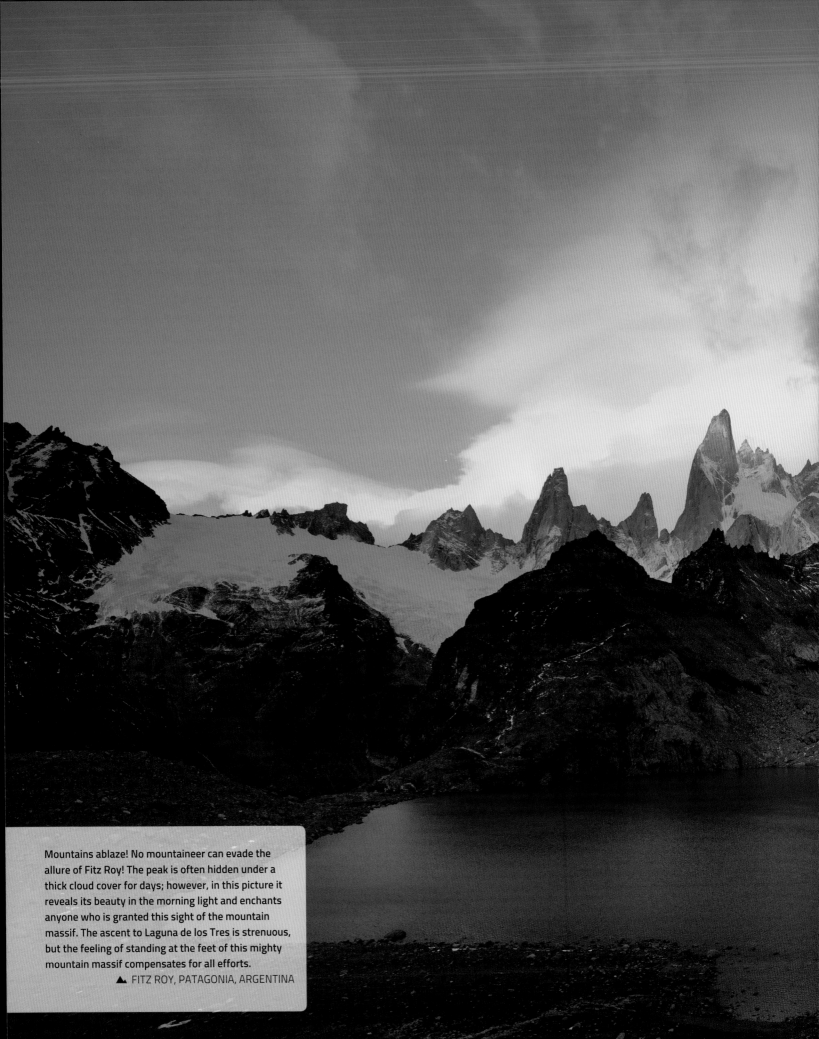

Mountains ablaze! No mountaineer can evade the allure of Fitz Roy! The peak is often hidden under a thick cloud cover for days; however, in this picture it reveals its beauty in the morning light and enchants anyone who is granted this sight of the mountain massif. The ascent to Laguna de los Tres is strenuous, but the feeling of standing at the feet of this mighty mountain massif compensates for all efforts.

▲ FITZ ROY, PATAGONIA, ARGENTINA

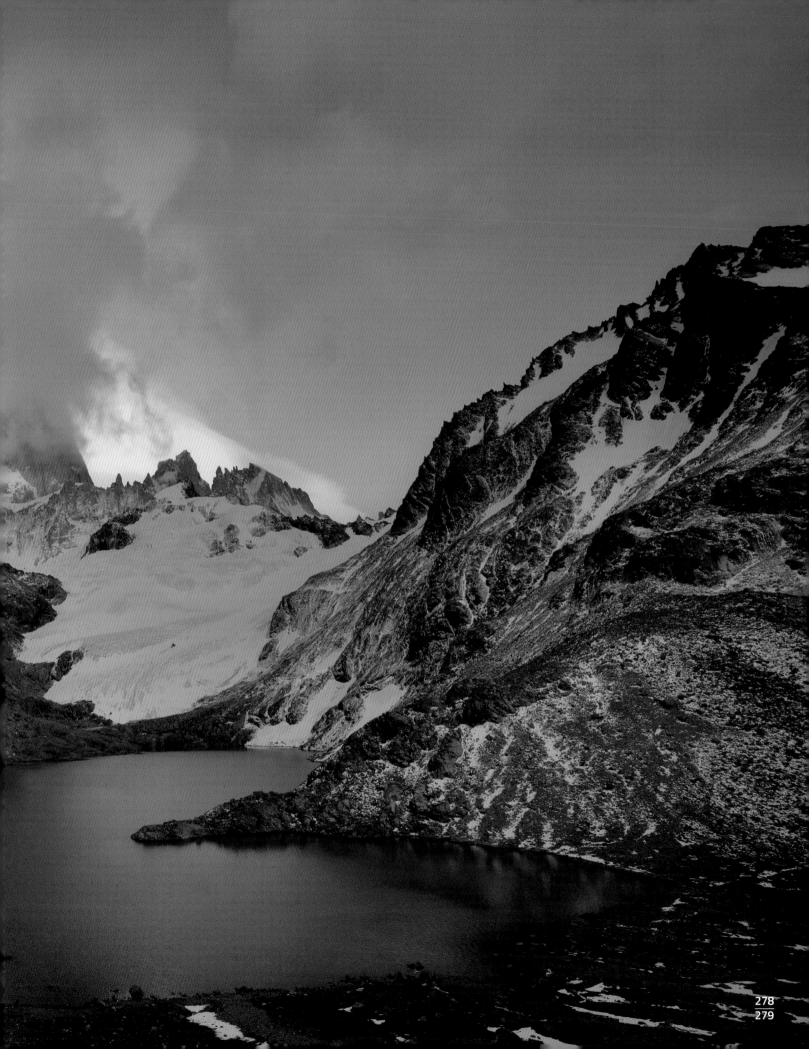

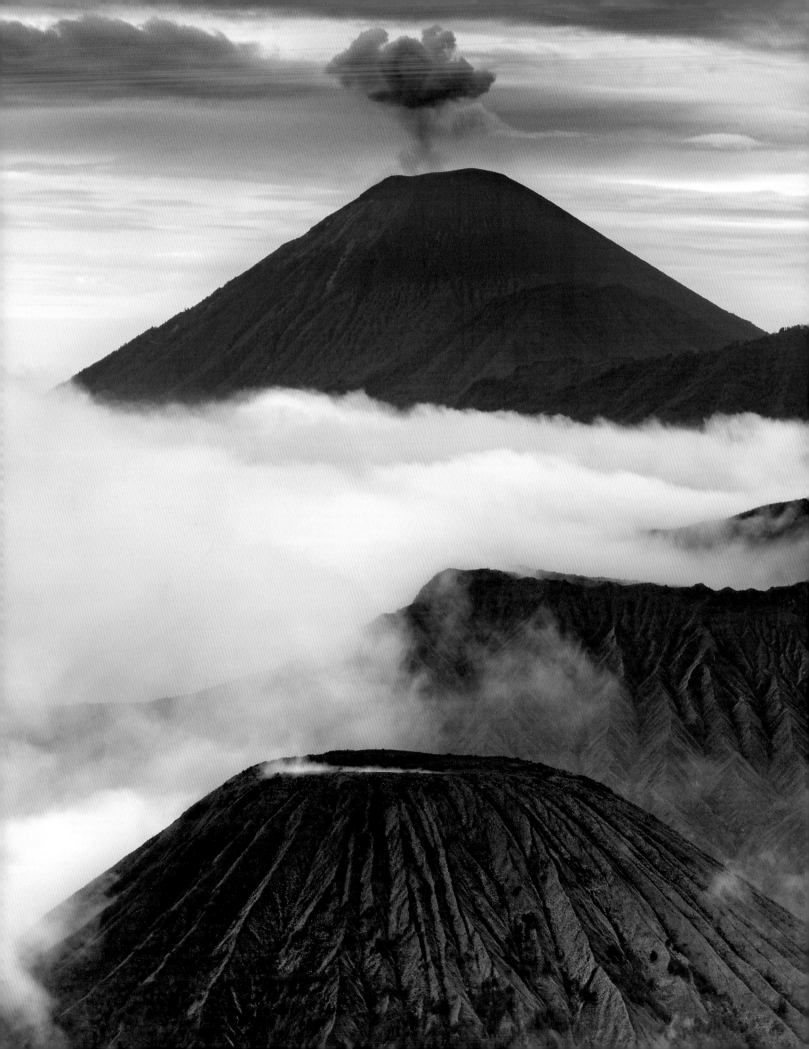

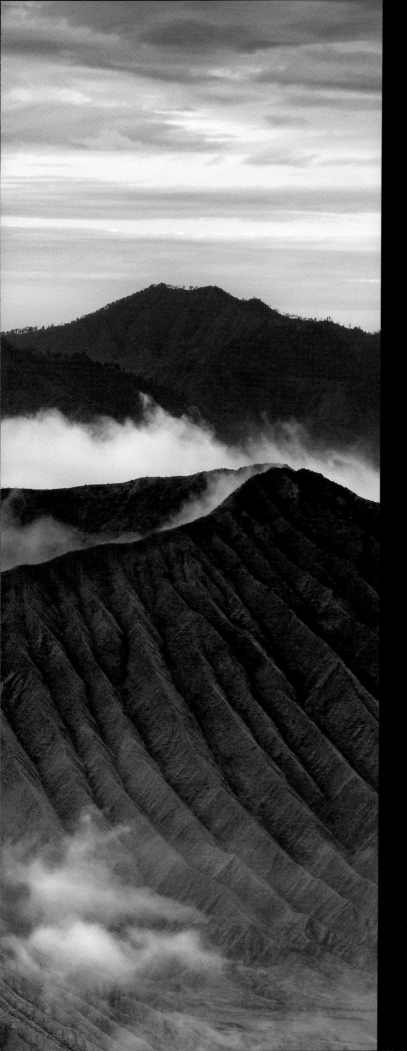

# Artists Behind the Camera

Five peaks characterize the plateau of the Bromo Tengger Semeru National Park, and in particular Mount Semeru, which, at 12,060 feet (3,676 m), is the highest elevation in Java. Four additional volcanoes are located in Tengger-Caldera ("cauldron" in English), Bromo being the best known and easiest to climb. "Tengger" in the name of the national park refers to an indigenous ethnic group, the Tenggerese people, who inhabit the plateau of volcanic origin.

▲▲ SEMERU, JAVA, INDONESIA

### NATALIYA ANDRIANOVA — p. 117

Travel enthusiast and amateur photographer Nataliya Andrianova has won several national and international awards over the past years for her landscape and mountain photography, and her work has previously been shown in exhibitions in Russia, Bulgaria, Italy and Great Britain.

### RAINER AX — pp. 98/99

An amateur mountaineer and photographer, Rainer Ax (born 1948) has been traveling to mountain regions around the world for 36 years.

### MARC BÄCHTOLD — pp. 142/143

Marc Bächtold started taking photographs when he was just 16, and since then has been continuously expanding his portfolio during his travels and expeditions to remote corners of the world. His landscape photography is regularly published in professional journals, outdoor magazines and calendars, as well as on the websites of various German companies. (www.marc-photographie.com)

### BIRENDRA BAJRACHARYA — p. 193

Birendra Bajracharya works as a freelance photographer and artist with a special interest in glaciers and glacial lakes. On his treks through the alpine world over the past 16 years, he has repeatedly witnessed the dire effects of climate change, and strives to make people more aware of this issue through his work. (www.birencollection.com)

### PAVEL BARANOV — p. 180

Product photographer Pavel Baranov has been traveling to Russia, Europe and Asia as a sport climber for 10 years.

### JOAO PAULO BARBOSA — p. 205

Joao Paulo Barbosa was born in 1973 and started working as a photographer after earning a university degree in history. His award-winning photographs have appeared in publications that include *National Geographic*, the *Guardian* and *Smithsonian Magazine*, and have previously been shown in exhibitions in more than 50 countries.

### MANUELO BECECCO — pp. 92/93

Manuelo Bececco was born in 1982 in Perugia, Italy, and became interested in photography as a child. After taking a long creative hiatus, he has been internationally successful for the past few years. He has won several prestigious photography competitions, and can already take pride in his first publications. (www.manuelobececco.com)

### SEBASTIAN BECHER — pp. 96/97

An avid alpinist, Sebastian Becher spends every free minute in the fascinating mountainous landscape of the Alps. Becher, who lives in Saxony, Germany, has been a passionate amateur photographer for several years and has a special fondness for alpine panoramas. His goal is to capture the most extraordinary places as authentically as possible in light and color.

### GABRIEL BELLOC — pp. 274/275

Gabriel Belloc is a professional mountain guide and amateur photographer; on his tours, he is always inspired to get out his camera and capture the breathtaking landscape.

### PETR BENEŠ — pp. 70/71; 74/75

Petr Beneš, born in 1980 in the Czech Republic, works as a civil engineer and discovered photography back in 2005. In addition to photos of his two sons, he mainly concentrates on landscape and architecture photographs. His pictures have previously been published by various photography magazines and the Prague Tourism Association. (www.petrbenes.info)

### LUCA BENINI — pp. 82/83

Luca Benini is a young Italian fine art photographer who finds his subjects in the landscapes of Europe and always tells a story with his dreamy, often melancholy pictures. (www.lucabeniniphotography.com)

### MARKUS BERGER — pp. 32/33

Having retired from his career as a freestyle athlete, Austrian sports photographer Markus Berger now works for international companies and professional journals. He is also the official ambassador of Broncolor.

### ALESSANDRO BERNARDI — pp. 95; 121

Alessandro Bernardi is an avid amateur photographer. He was born in 1974, and ever since he was a child, he has enjoyed spending all of his spare time hiking, running, skiing and climbing on the mountains.

### MARTÍN BORDAGARAY — Back cover of the book

Martín Bordagaray was born in 1978 in Concordia, Argentina. Ever since he discovered his love for photography 11 years ago, he has taken countless pictures of foreign countries and cultures on his journeys through America and Asia. His photos have won acclaim in national and international photography competitions and have been featured in exhibitions in the United States, England, Japan, Mexico, Brazil, China, India, Egypt and other countries.

### STEFAN BRUNNER — pp. 234/235

Stefan Brunner is an alpinist, instructor and photographer. He rarely travels light, because no matter where he goes, he can't leave home without his camera! Whether climbing in the mountains or on high alpine expeditions, he always has his camera equipment at hand to capture spectacular landscapes and moving moments. (www.stefanbrunner.at)

### ADNAN BUBALO — p. 35

Adnan Bubalo is a Bosnian photographer who began his career in 1994 as a war photographer during the Bosnian War. These days, he concentrates mainly on landscape and mountain photography. His works have been published in numerous magazines and calendars as well as on Internet platforms. He organizes his exhibitions himself; the two largest ones were in Rome and Istanbul.

### ALEX BUISSE — p. 266

Alex Buisse lives in Chamonix, France, and is a French extreme mountaineer and photographer. His photo expeditions have taken him all over the world; he sailed around Cape Horn in a yacht, made first ascents in Greenland, attempted to climb K2 and reached the North Pole on skis. Four books, as well as numerous exhibitions and publications, make him one of the most prominent mountain photographers in France. (www.alexbuisse.com)

### GIMENO JAVIER CAMACHO — pp. 116; 197

Javier Camacho has participated in six expeditions to mountains in the range of 26,000 feet (8,000 m) and has climbed, among others, Cho Oyu, Alpamayo, McKinley, Aconcagua, Elbrus, Kilimanjaro, Ama Dablam, Island Peak and more than 50 Alpine summits. An official Olympus ambassador, he has won many photography competitions and his works are exhibited on a regular basis.

### LARA CAMPOSTRINI — p. 94

Lara Campostrini is an amateur photographer from Trentino, Italy, and loves to capture memories with her camera.

### DEBDATTA CHAKRABORTY — p. 8/9; 206/207

Debdatta Chakraborty is from India, and discovered his love for photography on his trekking tours in the Himalayas, where he had the opportunity to become acquainted with indigenous people from the region, including members of the Gaddi and Kirat tribes.

### ROBERTO CILENTI — pp. 52/53

For Roberto Cilenti, photography is more than just a profession — it is his passion. He loves the mountains in all their facets and always has his camera there with him — whether in good or bad weather. His homeland is the mountains of the Aosta Valley, where he lives and works. Monterosa,

Matterhorn, Gran Paradiso and Mont Blanc offer a wealth of photographic opportunities, in every season.

### ANTONINO CIPRIANO — p. 217

When Italian native Antonino Cipriano is not traveling the world with his camera, he lives in Australia. (www.antoninocipriano.com)

### GIANVITO COCO — p. 108

Gianvito Coco was born in Sicily, Italy, on the foot of the Mount Etna volcano, and has been interested in graphic design, photographs, images and media ever since he was young. His style is a mixture of photo journalism and unusual portrait shots. (www.gianvitococo.it)

### MANUEL CONEDERA — p. 18/19

Manuel Conedera was born in a valley in the Dolomites, Italy, and started exploring the mountains as a child. At the age of 21, he began taking landscape photos and became so fascinated with the shapes, power and hidden treasures of the mountains that he started pursuing a degree in geography while continuing to work as a photographer.

### ALFREDO COSTANZO — p. 114/115

Alfredo Costanzo is an Italian photographer living in the Lombardy region. In his work, he seeks to combine his two passions: mountains and photography. In particular, he focuses on landscape photography, a field that requires a lot of time, patience and research.

### JOSHUA CRIPPS — p. 265

Joshua Cripps spends nearly the whole year on a quest to find the most beautiful landscape images around the world. He sports a full beard and has a glorious singing voice. For each photo, he hikes at least 43 miles (70 km) into the heart of the wilderness, and while you are still reading this biography, he has already done 93 push-ups and rescued a few newborn kittens from a burning building. (www.joshuacripps.com)

### MARIANO CUKAR — pp. 268/269

Mariano Cukar has been working in the film industry for 28 years and his job has taken him to the most remote regions of South America. In addition to his work as a location manager and photographer, he also produces TV documentaries about South America. (www.2255.com.ar)

### ANA CAROLINE DE LIMA — pp. 264; 267

As a journalist and documentary photographer, Ana Caroline de Lima specializes in visual anthropology. Her photos depict everyday situations, whether in big cities or remote villages in the Andes, and have prevously been exhibited in more than 40 countries. (www.antropologiavisual.com.br)

### MATTEO DE MARIA — pp. 242/243

Matteo De Maria was born in 1981 in the city of Forlì, Italy. Five years ago, he started taking an interest in photography, and has dedicated his time to all aspects of creating pictures and images, from finding subjects to post-editing photos. His love of nature led him to specialize in landscape photos, which have already won several awards and have been published in professional journals. (www.matteodemaria.it)

### GINO DE MIN — p. 184

As a cartographer commissioned by the University of Trieste (Italy), avid amateur photographer and mountaineer Gino De Min headed seven topographic surveying expeditions as part of the Ev-K2-CNR project, which took him to Mount Everest, K2, Mount Aconcagua in Argentina, and Monte Cervino and Monte Rosa in Italy.

### AKASH DEEP — pp. 194/195

Young travel photographer Akash Deep lives at the foot of the Himalayas, and always takes his camera along when touring the mountains. A photographer for the Himachal Tourism Department, he has already been distinguished with awards and is also an aspiring motographer in the country.

### STÉPHANE DELPEYROUX — pp. 280/281

Stéphane Delpeyroux was born in France in 1985, and had his first experiences behind a camera at a young age. Since 2013, he has been working as a freelance photographer with a focus on nature and landscape photography. After completing a photography trip around the world in 2014, he now regularly exhibits his photographs in galleries and at festivals across France and Europe. (www.stephane-delpeyroux.com)

### DARIO DI BUÒ — pp. 104/105

Dario Di Buò works as a mechanical engineer and has been a passionate amateur photographer since 2012. The avid snowboarder originally comes from a village in Abruzzo, Italy, and enjoys capturing the landscapes of his home country with his camera as he explores the region.

### DENIS DIMITRIEV — pp. 178/179

Denis Dimitriev works as a mountain guide and photographer in Tajikistan. Since 2000, he has been actively climbing, snowboarding and mountain biking, especially in the local mountainous region, and in addition to conventional expeditions, he has also gone on several rescue missions in the Pamirs. His photos deal with the relationship between humans and nature, and have been shown in exhibitions in Tajikistan as well as in Germany, Russia and Azerbaijan.

### JON ERICK DIZON — pp. 214/215

Photographer Jon Erick Dizon lives in the Philippines and specializes in wedding photography. His award-winning landscape photos have been featured in various professional journals and on several websites. To Dizon, a photo is always a journey back in time. (www.diamond-visual.com)

### FABIO ELLI — pp. 106/107

Fabio Elli was born in 1980 and lives with his wife near Como, Italy. The chemical engineer and avid amateur photographer has been climbing since 1994; his favorite destinations include Mont Blanc as well as Alaska and Yosemite National Park.

### GIUSEPPE MARIO FAMIANI — p. 109

Giuseppe Mario Famiani grew up in the northeast of Sicily, Italy, near the Nebrodi mountain range. Even at a young age, he explored the forests and mountains of his homeland, and so it was inevitable that he would develop a passion for landscape photography. He is not a professional photographer, but when he sees breathtaking landscapes, he just has to capture those impressions. His goal is to become a self-employed landscape photographer in the future.

### KLAUS FENGLER — pp. 260/261

Klaus Fengler has been working as a freelance photographer since 2003, with a focus on the outdoors, skiing, climbing, running and travel, among other subjects. His landscape and sports photographs regularly appear in national and international professional journals.

### MICHAEL FERSCH — pp. 160/161; 236/237

A photographer for more than 25 years, Michael Fersch concentrates on sports, portraits and landscapes. In 2006, he discovered his love for Iceland during a hiking tour. Since then, he has visited the island nation in the North Atlantic several times and shows his photographs at exhibitions and presentations. (www.michaelfersch.de)

### TOMMASO FORIN — p. 87

Tommaso Forin, born in 1965 in Padua, Italy, has regularly reported on his travels through the Dolomites on his website. His first book of photographs was published in 2011, followed by joint publications with other landscape photographers, and then a second book of photographs in 2015. In addition to working for various professional journals, he publishes a photo calendar of the Dolomites every year. (www.passeggiando.it)

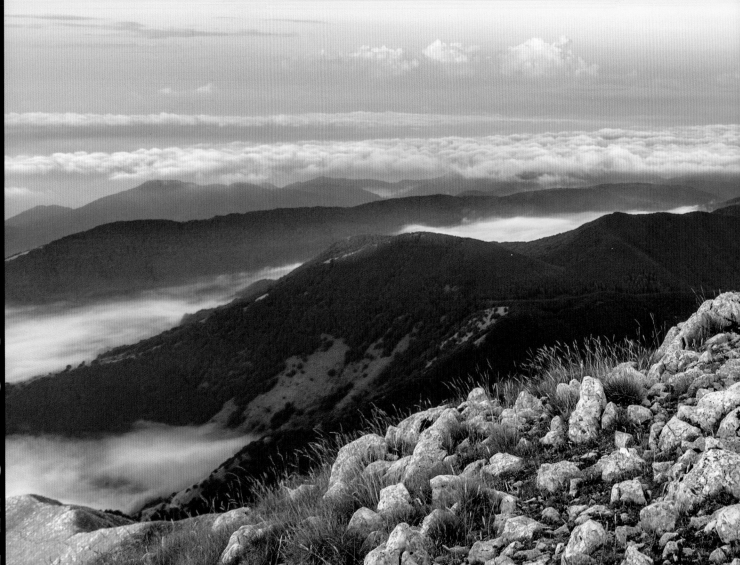

MONTE MILETTO, CAMPAGNIA, ITALY

# THE PHOTOGRAPHERS

"Campania felix," a blessed landscape — that's the name the early Romans gave to the plains of Campagnia, whose largest city is Naples. And the mountain climbers are also blessed — according to an ancient custom, they meet in the summer on Monte Miletto (6,725 ft./ 2,050 m), the highest peak in the region, to bid farewell to the day in the soft transition from light to dark and, after spending the night in a bivouac, to greet the new day the next morning.

▲ MONTE MILETTO, CAMPAGNIA, ITALY

### ENRICO FOSSATI                          pp. 126/127

Photographer Enrico Fossati, based in Northern Italy, likes to draw inspiration for his landscape shots from fantasy movies and surreal artwork. His favorite quotation is by J.R.R. Tolkien: "A single dream is more powerful than one thousand realities." (www.enricofossati.it)

### PAWEL FRANIK                          p. 254

Pawel Franik was born in 1991 and is originally from Silesia, but currently lives in Warsaw, Poland. He is studying film and photography at the Warsaw School of Technology. For Franik, photography is very special, because it lets him feel like he is holding moments right in his hand. He loves minimalistic scenes that have significant hidden meanings behind them.

### PURANJIT GANGOPADHYAY                  p. 204

Puranjit Gangopadhyay started exploring photography as a child, using his father's Zeiss Icon camera. For about 13 years now, the ambitious amateur photographer from India has successfully participated in national and international competitions, and many of his works are also on exhibition.

### RALF GANTZHORN                         pp. 272/273; 276/277

Ralf Gantzhorn has been working as a mountain photographer for more than 30 years and specializes in the most remote regions of the world. He has a special love for Patagonia, and has traveled there more than 22 times.

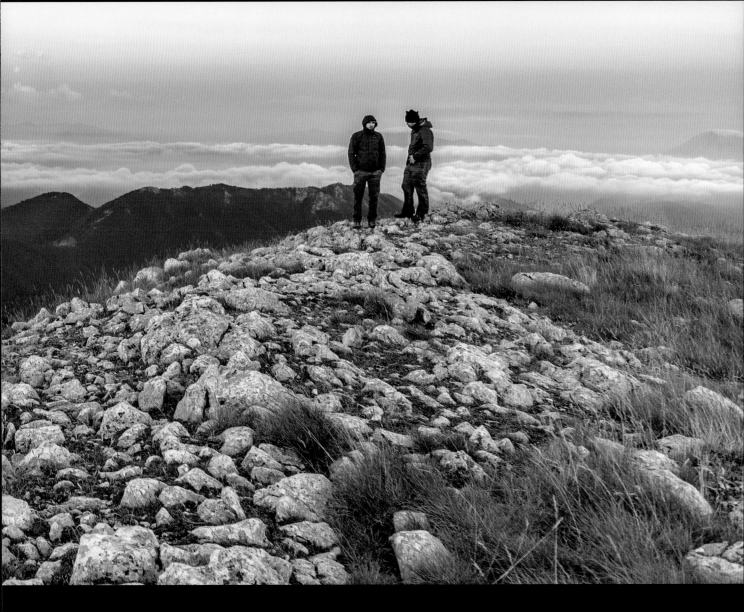

**GÁBOR GARAMVÁRI** pp. 51; 122/123

Even as a teenager, Gábor Garamvári was already a travel and nature enthusiast and dreamed of becoming a photographer. For the past seven years, he has worked throughout the world as a photographer, including for travel magazines, travel agencies and tour operators.

**MORENO GEREMETTA** Photo on front cover of book

Moreno Geremetta was born in the Dolomites, Italy, in 1972, and is a freelance photographer specializing in mountain images — not surprising, since mountains have played a major role in his life from a very early age. He has been a member of the Clickalps team since June 2013, and his photos

**LEONARDO GIANOLA** pp. 38/39

Young amateur photographer Leonardo Gianola comes from Premana, Italy, a small town in the Bergamasque Alps. The avid skier spends most of his spare time in the mountains with his camera.

**ANDREA GRABER** pp. 88/89

"I intensely take in moments, moods and emotions, and become deeply immersed in them. Photography is an opportunity to express a part of what I feel then, and to create images and pictures as they emerge inside of me."

**GABRIEL GRABER** p. 63

Gabriel Graber lives in South Tyrol and often hikes through the mountains, pursuing his photography hobby. He mainly works with a large aperture and also experiments with longer exposure times. He never uses artificial light, because "good photos are not just shot, they are explored and planned."

**PHILIP GUNKEL** pp. 134/135

Philip Gunkel was born in Berlin, Germany, in 1986, where he still lives and works today. Since completing his studies in photo design at Lette Verein in 2012, he has worked around the world as a fine art photographer specializing in architecture, advertising, commercial and landscape

### ERICH HARZENETTER — p. 28

Erich Harzenetter, born in 1935, is an amateur photographer and has been a member of the photographers group at the Naturfreunde Rosenheim (Nature Friends) organization since February 1997. He mainly takes landscape and nature photographs.

### CAROLINE MICAELA HAUGER — p. 43

Caroline Micaela Hauger (born in 1967 in Cologne, Germany) is a journalist, mountain photographer and Olympus ambassador. On steep cliffs and ridges of dizzying heights, she uses her fine intuition to delve into worlds where time seems to stand still. Her summit register boasts 14 mountains in the range of 13,000 feet (4,000 m), including the Matterhorn, the Dom, Mont Blanc and Mount Elbrus. She works and lives in Zurich. Her mountain photographs have previously been shown in several exhibitions. (www.peakart.ch)

### MICHAEL HECK — pp. 240/241

Michael Heck, born in 1976, works as a lawyer at an insurance company. He enjoys spending his spare time outdoors, either on a mountain bike or with his camera. As often as possible, he and his wife travel all across the world, and he is rarely without his camera. Although he had some experience behind the lens in his youth, he only discovered photography as a hobby and passion a few years ago. (http://portfolio.foto community.de/michael2704)

### GERD HEIDORN — p. 34

Gerd Heidorn is originally from Northern Germany, but later moved close to the Alps for his love of mountains. In his photo journalism, he explores the diversity of life, different cultures and nature. For Heidorn, it is especially important that his photos give those who view them a sense of open-mindedness and create an interest in new perspectives.

### ALBAN HENDERYCKX — pp. 10/11

Henderyckx hails from the Atlantic coast of France. He usually travels alone and independently, only taking his backpack and camera along, and enjoys being in nature. His métier is landscape photography. In his opinion, the most fascinating aspect of photography is capturing moments, moods and atmospheres. (www.alban-henderyckx.com)

### DWIGHT HISCANO — pp. 246/247

For more than 30 years, Dwight Hiscano has been one of the most prominent fine art photographers worldwide. His photos have been published in the *New York Times*, *Outdoor Photographer*, *Nature's Best* and *Nature Conservancy Magazine*, as well as in numerous books and calendars and on websites and posters in the United States, Europe and Asia. (www.dwighthiscano.com)

### DAVID HÖLKER — pp. 256/257

David Hölker, born in 1984 in Münster in the German state of Westphalia, has been working as a graphic artist and corporate photographer for almost 10 years. Early on, he discovered his passion for landscape photography and has since used every free minute to paint the beauty and variety of nature with light. He is particularly drawn to the abstract desert landscapes, canyons and national parks in the southwest United States.

### GORAN JOVIC — pp. 226/227

Goran Jovic, from Croatia, has mainly focused on documentary photography since 2008. For example, he took part in a humanitarian mission to Tanzania to photograph a Masai tribe there, and in his travels to South America, Africa and Asia, he is particularly interested in the everyday life of common people and in the culture of indigenous groups, in places like the favelas of Rio de Janeiro or on the Amazon.

### ERKAN KALENDERLI — pp. 164/165

Erkan Kalenderli was born in Istanbul, Turkey, where he still lives today, and after earning degrees in philosophy and economics, he now works as a freelance photographer. His photographs have received awards in 42 different countries, and he holds titles of distinction from the Global Photographic Union and the Federation Internationale de l'Art Photographique.

### GEORG KANTIOLER — pp. 76/77

Georg Kantioler, who lives in South Tyrol (Italy), prefers serene, clean and composed pictures and thus likes to work with a large aperture and/or longer exposure times. He never uses artificial light. In his work, he concentrates almost exclusively on his South Tyrolean homeland, because "there is nowhere else where I can bring place and time into harmony with the ever-changing conditions better than where I live."

### TOBIAS KASER — pp. 84/85

Tobias Kaser grew up in Italy, right in the middle of the Dolomites in South Tyrol, and even as a child, spent all of his free time outdoors. For two years now, he has also been using his camera to capture the magical moments of light on the peaks.

### DAVID KASZLIKOWSKI — pp. 182/183

Award-winning Polish photographer and cameraman David Kaszlikowski specializes in expedition, aerial and underwater photography. His photographs have graced the covers of professional journals such as *Rock + Ice*, *Alpinist*, *Vertical* and *Desnivel*, and have been published in magazines including *National Geographic*, *NG Traveler* and *Outside*. (www.david-kaszlikowski.com)

### NITIN KITUKALE — pp. 186/187

Nitin Kitukale, from India, is a multi-award winner who has worked as a photographer and lecturer for 20 years. His focus is on animals, landscapes and street photography, but he has a special place in his heart for mountains.

### ALEXANDER KODISCH — pp. 4/5

On his trips to exotic, faraway places, Alexander Kodisch uses his camera to capture fascinating landscapes and unique moments so that he can share his experiences with his friends and family back home.

### ANDREAS KÜNK — pp. 26/27

Andreas Künk is an alpinist, freelance photographer, hiking guide and mountain rescuer. Born in 1968, he now lives and works in Schruns (in the Austrian state of Vorarlberg). Since 1985, numerous trips and mountain tours have taken him to the Western Alps, Africa, the Arabian Peninsula, East and Southeast Asia, Nepal, Iran, Russia and North America, where he has climbed more than 70 mountains in the range of 16,400 feet (5,000 m) and 19,700 feet (6,000 m). His photographs have appeared in many professional journals, illustrated and photography books and calendars.

### CHRISTJAN LADURNER — pp. 2/3; 58/59

Christjan Ladurner's photos have previously been published in various professional journals and a total of 22 books. Based in South Tyrol, Italy, he also works as a mountain guide in Canada, specializes in aerial, outdoor and advertising photography, and collaborated with Reinhold Messner on the König Ortler (*King Ortler*) and Die Zukunft der Alpen (*The Future of the Alps*) exhibitions. In his current project with journalist Florian Kornbichler, he is photo-documenting the life of mountain farmers in South Tyrol. (www.christjanladurner.com)

### FEDOR LASHKOV — pp. 172/173

Fedor Lashkov has been a professional photographer for 13 years, and has traveled to the Caucasus Mountains, Lake Baikal and the Leningrad region for his projects.

### ERIC LEW — pp. 232/233

Eric Lew lives in San Francisco, California, and travels the world as a photographer. He has won awards in 16 photography competitions, and his photos have been published on the websites of the BBC, *National Geographic* and DP Review. During an expedition to the west coast of Greenland in 2015, he captured the unique local fauna and the Inuit culture there with his camera.

### ARNE LINK — pp. 44/45

Arne Link (born 1968) is from Koblenz, Germany, and has a degree in geology. In his predominantly black-and-white mountain photos, he puts a special focus on highlighting unusual rock and glacier structures, which he accentuates with extreme light moods. (https://500px.com/arnelink)

## HIMAWAN LISTYA NUGRAHA

pp. 220/221

Himawan Listya Nugraha has been a professional photographer for more than two years, and concentrates on depicting the daily life of the people living in the region surrounding Mount Slamet, an active volcano. His work has been published and exhibited numerous times.

## GUY LONGTIN

p. 42

Canadian Guy Longtin works as a fire department chief. To relax from his demanding day-to-day work, he and his wife take photography trips to the mountains together. His landscape photographs have been published several times.

## TIGRAN LORSABYAN

pp. 166/167

Geologist Tigran Lorsabyan has been an amateur photographer since 2002, and he loves the mountains. He has prèviously presented his landscape and reportage photos at exhibitions and in magazines. (www.lorsabyan.com)

## PAVLO LUTSAN

pp. 198/199

Pavlo Lutsan comes from Lviv in the Ukraine, and has been exploring the mountains ever since he was a child. His love for nature and the fascination of other cultures turned him into an avid traveler and finally led him to take up travel photography, which he has been using to raise his audience's awareness of the fragility of nature for nine years now. (https://lpavlo.wordpress.com)

## DARIO MARELLI

pp. 138/139; 140/141

Passionate mountaineer and landscape photographer Dario Marelli works as a graphic designer in Milan, Italy. In his photographs, he seeks to capture the beauty of our planet and share it with a wide audience. (www.dariomarelli.com)

## DINO MARSANGO

pp. 64/65

Dino Marsango discovered the joy of photography in 1983, when his wife gave him his first camera. However, it is only in recent years that he has devoted more time to his passion on countless mountain tours through the Dolomites. (https://500px.com/dinom)

## JAVIER MARTÍNEZ MORÁN

pp. 128/129

Javier Martínez Morán was born in 1991 in Madrid, Spain, and is currently pursuing a degree in architecture. The avid amateur photographer is continuously honing his technique, and is now working on a photo project in which he strives to capture the night sky and Milky Way over the Sierra de Guadarrama mountain range, near Madrid. (www.flickr.com/photos/jmartinez76/)

## DIETER MENDZIGALL

pp. 152/153

Dieter Mendzigall was born in 1981 in Hildesheim, in the German state of Lower Saxony. (www.mendzigall.de)

## TEJAL MEWAR

p. 196

Tejal Mewar, a government official in India, discovered photography as a hobby more than two years ago. Her favorite topics include street scenes, faces and artwork.

## CAMILLE MICHEL

p. 238

Camille Michel was born in Lille in 1988 and was planning to become a doctor before she discovered her love of photography. Following her photography courses in Paris and Arles as well as trips to the most northern parts of Europe, her multiple-award-winning work has appeared in the *New York Times Magazine*, *Wired*, *Photo Magazine* and *Libération*, among others, and has been on show in France, England, Italy, the United States and Brazil. Her first solo exhibition will be held in Mulhouse in 2017. (www.camillem.net)

## JOYDIP MITRA

p. 209

Joydip Mitra is a freelance photographer in Calcutta. He works for magazines and enjoys using his photos to tell stories — the more unusual the better. (joydipmitraphotography.com/portfolio)

## ROBERTO MOIOLA

pp. 40/41; 56/57; 73; 80/81

Roberto Moiola was born in Morbegno in Veltlin in 1978 and has been working mainly as a landscape photographer for leading specialist journals since 2000. The managing director of the photo agency Clickalps.com, he is responsible for the photos for Le Montagne Divertenti and Meridiani Montagne, regularly publishes calendars and travel reports, and works as an official photographer at various sports events, for the fashion label Rock Experience and for the Veltlin tourist association.

## ABEDIN MOHAMMADI

p. 169

Abedin Mohammadi started out as a caricaturist in his youth and won numerous international competitions. For 11 years now he has been working as a freelance filmmaker and photographer and has gained attention through many exhibitions and competitions.

## HARY MUHAMMAD

p. 1

Hary Muhammad has been working as a travel guide in Indonesia and professional photographer for eight years. He won the Intrepid Travel Photo competition in 2014.

## SANDIPAN MUKHERJEE

p. 181

Sandipan Mukherjee works in India full time as a teacher. The passionate mountain climber and motorcyclist has made a name for himself over the past 16 years both nationally and internationally as an author. His photos have been exhibited numerous times and received multiple awards. He was recently awarded the Travel Photo of the Year Award by the British magazine *Wanderlust*.

## MANUEL MUÑOZ GARCIA

pp. 158/159

Manuel Muñoz García is a Spanish photographer and member of the royal society for photography in Madrid. He was professor of photography at the Comillas University of Madrid and specializes in travel and nature photography.

## JANNA MÜNSTER

pp. 100/101

Janna Münster was born in 1970 and grew up in northern Germany. She has been living with her family in South Tyrol for the past 11 years. She loves being in the mountains and has an eye for bringing out the remarkable in seemingly inconspicuous images.

## CARLO MURENU

pp. 294/295

Carlo Murenu is 30 years old and lives in Sardinia. He took up photography eight years ago and worked as a photographic assistant for advertising and in the studio. His passion is particularly landscapes and travel photography, and he loves immersing himself in local culture around the world. During a 10-month trip to Nepal he improved his travel photography skills and discovered the possibility of using photography for reportage.

## GEORG NIEDERKOFLER

p. 62

Georg Niederkofler has been a keen photographer for more than 11 years. Since he is lucky enough to live near the World Heritage Site of the Dolomites, his favorite leisure pastime is taking photos in the mountains.

## CHRISTOPH OBERSCHNEIDER

pp. 46/47

Christoph Oberschneider was born in Salzburg in 1983. While studying medicine, he began to take an interest in photography and filmmaking, with a focus on sport and landscape themes. He made his first short film in 2012 and took part successfully in various international ski photo competitions the following year. In 2014 he was one of five photographers from all over the world to be invited to the Pro Photographer Showdown in Whistler, British Columbia, in Canada. (www.oberschneider.com)

# THE PHOTOGRAPHERS

### ARKADIUSZ PAŁASIŃSKI · p. 289

Arkadiusz Pałasinski — a Polish photographer — specializes in landscape photography. He travels around the world on the lookout for interesting projects and subjects on his travels. Every little detail — even if it is only the light or the weather — is important to him. (www.palasinski.pl)

### ROKI PANDAPOTAN · p. 213

Roki Pandapotan has been working as a freelance photographer in Indonesia since 2005.

### BISWAJIT PATRA · pp. 202/203

Biswajit Patra started as an artist before his passion for colors was replaced by his passion for photography. Today, he spends most of his free time behind the camera lens and enjoys photographing people the most. He has won multiple international awards for his work.

### SILVANO PEDRETT · p. 244

Silvano Pedrett is a Swiss photographer who also works as an architect and architectural photographer. His greatest passion is nature and the Alps, where he feels at home and is particularly inspired by the rock formations. (www.silvanopedrett.com)

### FABRICE PETRUZZI · pp. 124/125

Nature lover Fabrice Petruzzi was born in Geneva to a French-Swiss mother and Italian father, and fell in love with photography on a trip to Iceland a few years ago.

### UTA PHILIPP · pp. 30/31

Uta Philipp succumbed to the magic of the mountains more than 50 years ago. Following a memorable evening on the Hochkönig, when she was determined to capture the light effects over the summit, the amateur photographer now takes her heavy Nikon D7000 plus lenses wherever she goes on mountain-walking, climbing and ski tours.

### SALLY PILKINGTON · p. 185

Sally Pilkington works as an optometrist in Munich and spends lots of time in the mountains both in summer and winter. Her honeymoon trip — a 12-day trek to Mount Everest Base Camp — was the fulfillment of a long-cherished dream for the passionate amateur photographer.

### ROBERT PIPAŁA · p. 208

The geographer Robert Pipala loves traveling through the European and Asian mountains. He works as a freelance photographer for a major Polish photo agency and as a Google Trusted Photographer. He specializes in sphere photography.

### ELENA PIPENKO · p. 176

Elena Pipenko works as a design engineer and discovered her love of photography more than 40 years ago. The photos she took during trips with her family in the Crimean and Caucasus mountains have appeared in numerous travel guides and coffee-table books about the Crimea region.

### GÜNTHER PITSCHEIDER · pp. 6/7

Günther Pitscheider, born in 1963, lives in Santa Cristina in South Tyrol. Even as a child, he walked the Dolomites, where he learned to appreciate nature's beauty. Since 2007, his great passion has been photography and he aims to capture photographic moments and experiences — no matter the weather.

### DHRUBASIS PRAMANIK · p. 212

The passionate mountain climber Dhrubasis Pramanik has been a keen amateur photographer for 26 years and takes time for his two hobbies on a regular basis, despite his hectic job in a bank in Calcutta.

### HERBERT PRAMSTALLER · pp. 78/79

The landscape photographer and event filmmaker Herbert Pramstaller was born in South Tyrol in 1967 and still particularly enjoys working in the Dolomite region. He uses his countless images for calendars and multivision shows every year. (www.film-foto-herbert.com)

### ABHINAV PRATAP SINGH · p. 211

The engineer Abhinav Pratap Singh is a self-taught photographer and concentrates mainly on landscape images during his travels through Asia and Europe, although he also enjoys experimenting with lifestyle and portrait photography. His photos have previously appeared in various specialist journals in India and on the *National Geographic* website.

### JAN PROCHÁZKA · pp. 118/119

As a passionate amateur photographer Jan Procházka mainly concentrates on landscape photos of unspoiled nature. During mountain tours in the Trentino, the High Tatras and in the Chamonix region, the enthusiastic climber always has his camera with him. (http://janprochazka.name)

### ULRICH RADEK · pp. 22/23

Ulrich Radek is an amateur photographer and nature lover from the Czech Republic who currently lives in Germany. He started his photography career in 2009. His photos try to capture the atmosphere and the spirit of each particular location.

### VALERIO RANERI · pp. 110/111

Valerio Raneri has always been fascinated by the world of photography, but has only drawn nearer to it just recently. Photos are very important to him because they enable him to "freeze moments in time."

### CARLO RESTA · pp. 144/145

Carlo Resta has been an enthusiastic amateur photographer since 2010 and focuses on nighttime images. On his extensive travels, he mainly photographs the starry sky, the northern lights and landscapes at night. He is also interested in light painting.

### TOBIAS RICHTER · pp. 36/37

Tobias Richter was born in 1987 and has been working as a freelance photographer focusing on Europe since 2012. Play on light and the dynamics of the mountains particularly fascinate him. His photos have previously been published in calendars, magazines and books from renowned publishing houses, including Ackermann, Geo, Lonely Planet and teNeues. (www.richterphotographie.de)

### HELMUTH RIER · p. 86

As a cameraman for movies and television, Helmuth Rier has traveled halfway around the world. He has been working as a photographer for national and international companies and publishing houses since the beginning of the 1980s.

### DR. NICHOLAS ROEMMELT · pp. 154/155

Over the past 13 years, dentist Dr. Nicholas Roemmelt has successfully turned his hobby into a sideline. His camera is a permanent companion during his trips to the most beautiful landscapes in the world, which he particularly enjoys capturing under a starry sky or the magic Northern Lights. This passion has already resulted in numerous prizes and publications in national and international media for the "stargazer."

### ANDREW RUTHERFORD · pp. 150/151

Iceland enthusiast Andrew Rutherford combines his enthusiasm for climbing with his passion for photography. His photos have previously been used in various British and American climbing magazines and guides, and he was the official photographer for the Ice Climbing World Cup in 2014 and 2015. (www.andrewrutherfordphotography.co.uk)

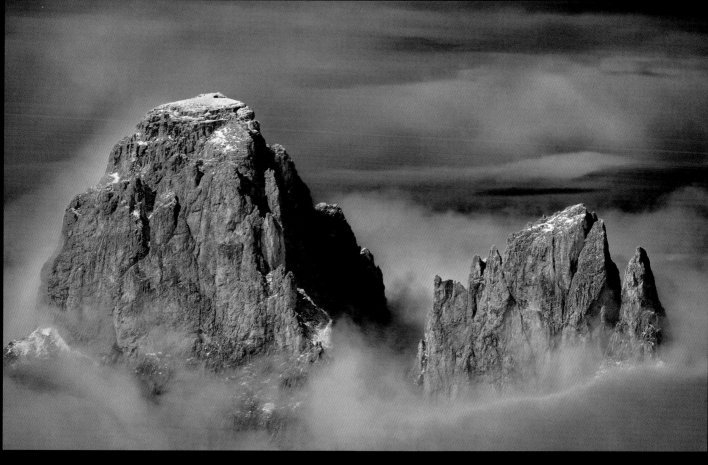

### TOBIAS RYSER

p. 50

In addition to his job as a ranger in a floodplain preservation area, Tobias Ryser (born in 1981) works as a freelance photographer with a focus on nature and landscape photography.

In search of the perfect moment, he attaches great importance to an aesthetic photo composition and unusual light effects. Tobias Ryser is one of the most successful landscape photographers in Switzerland; his photos have received numerous awards in various national and international competitions.

### TOMMASO SACCAROLA

pp. 60/61

Following his degree in communication science, Tommaso Saccarola made his hobby his profession in 2005. As well as working as an industrial photographer, the nature lover mainly works as a landscape photographer; two of his travel reports on behalf of the NGO Cesvitem, on Mozambique and Peru, have also been published in a book entitled *Tra le persone* (*Among People*). (www.tommasosaccarola.com)

### CELESTINA SACCHI

pp. 102/103

Celestina Sacchi was born in Lecco in 1959. She loves photography but only pursues it as a hobby. For several years she has been taking photo trips to the mountains together with her husband, a professional photographer.

### JONA SALCHER

pp. 72; 90/91

Jona Salcher is 20 years old and comes from South Tyrol, Italy. As well as being a mountain climber, he is a passionate filmmaker and photographer. He is currently studying documentary filmmaking at the University of Television and Film in Munich.

### YEVHEN SAMUCHENKO

pp. 162/163

The young photographer Yevhen Samuchenko is mainly known by his pseudonym Q-lieb-in. He always takes his camera with him on his numerous travels. Alongside nature and landscape themes, he has specialized particularly in nighttime photography, because "when you look up at the starry sky, you feel part of the universe." (http://q-l-n.com)

### JAVIER SÁNCHEZ

pp. 148/149

Javier Sánchez works all over the world as a press photographer. He is the author of 13 books and has created more than 50 book projects together with various renowned publishing houses. His prize-winning work has been shown in exhibitions all over the world, including in Washington, Buenos Aires, Madrid and in the gardens of the Alhambra palace in Granada.

Looking like island mountains in an ocean, the peaks of Grohmannspitze (10,256 ft./3126 m, right) and Fünffingerspitze (9,829 ft./2,996 m) rise from the autumn fogs above Sella Pass and Val Gardena. On the right, not captured in the picture, rises Langkofel or Sassolungo (10,436 ft./3,181 m), the highest peak in the Langkofel Group.

▲ SASSOLUNGO (LANGKOFEL), DOLOMITES, ITALY

### STEVEN SANDNER

pp. 228/229

The Australian Steven Sandner has been working as a nature photographer for nine years. He loves the mountains in particular: "At the summit, I am always overcome with a special mixture of amazement, awe and deep respect for nature, which I would like to convey in my pictures."

### KATRIN SCHMIDT

pp. 222/223

Amateur photographer Katrin Schmidt has always been interested in landscape photography. As an enthusiastic walker and globetrotter, she is always on the lookout for moving moments in nature that she can capture on camera. This is her first publication.

# THE PHOTOGRAPHERS

**MARKO SCHOENEBERG** pp. 68/69

Marko Schoeneberg works as a professional commercial photographer. However, it is only his freelance photography projects, for which he often travels to the mountains, that give him the opportunity to tell authentic tales of summit joy and frustration. "It is a great challenge to capture such intensive moments on photos and to document the often critical relationship between mountains and people." (www.markoschoeneberg.com)

**KENNY SCHOLZ** pp. 258/259

Kenny Scholz is a German travel and landscape photographer. His pictures capture the most beautiful aspects of his native country and special moments on his travels. Scholz's main focus is on available light images as well as on sunrises and sunsets. (www.kennyscholz.de)

**FREDERIK SCHULZ** pp. 248/249

On a trip through Australia, Asia and North America, fascinated by the endless expanse, beauty and colors of the wilderness around him, Frederik Schulz discovered how much he enjoyed landscape photography. Ever since then, he has been chasing unique moments of light and nature with his camera. (http://fs-photography.com)

**JAKOB SCHWEIGHOFER** p. 245

The Austrian Jakob Schweighofer lives in Innsbruck, but spends most of the year traveling, when he tries to capture the simple, natural life in the mountains on camera and thus share his passion for the undiscovered, untold beauties of our planet with the public. (www.schweighofer-photographs.com)

**BARBARA SEIBERL-STARK** pp. 278/279

Barbara Seiberl-Stark discovered her love of photography in 2011 and initially taught herself the necessary technical skills. Since then, she has won numerous prizes in national and international competitions and became a member of the Association of Austrian Nature and Animal Photographers (VTNÖ) in 2014. She publishes her photos and travel reports regularly in various specialist journals and as calendars.

**GARNIK SEVOYAN** p. 168

Garnik Sevoyan works as an expert for economic development in Armenia. He is 33 years old, has already climbed the highest mountain in Africa, the Kilimanjaro, and been diving with Jacques Cousteau's grandson through the underwater laboratory "Aquarius." He always has his camera with him on all his adventures.

**MARINA SGAMATO** pp. 284/285

Marina Sgamato was born in Naples in 1986. She discovered her passion for photography at the age of 19 during a trip to Vienna. A history graduate, she is currently deputy director of the multimedia production company BraInHeart and has been a Certified Photographer for Google Maps Business View since December 2013. (www.marinasgamato.it)

**TATIANA SHARAPOVA** p. 192

Tatiana Sharapova began her photography career as a photo editor at the publishing house Condé Nast. Ten years later, she turned her attention to travel photography and now works for various travel magazines. She is particularly fascinated by the still untouched regions of India and Nepal, where time seems to stand still.

**NAKUL SHARMA** pp. 190/191

Nakul Sharma grew up in Delhi, India, and was infected with the travel bug at an early age. He turned his hobby into his profession in 2009, and has been pursuing his passion for foreign countries and cultures as a professional travel photographer ever since. Each of his photos tells a story. (www.nakulphotography.com)

**KERSTIN SILCZAK-THUSS (GEB. HOFMANN)** p. 48

Photography is a fascinating hobby for Kerstin Hofmann and her partner. They are mesmerized again and again by the beauty of the Alps — so much so that they now live in the Bavarian uplands in order to enjoy the magic of the mountains as often as possible.

**DAVIDE SIMIELE** pp. 224/225

Davide Simiele was born in Rome in 1982 and began studying photography there in 2004. Following graduation in 2007, he had several assistant jobs before he went freelance.

**JAIME SINGLADOR** pp. 218/219

The multiple-award-winning amateur photographer Jaime Singlador works in the Philippines as a civil engineer, at the same time doing photo projects for *Expat Travel & Lifestyle* magazine and *Northbound Travel* magazine.

**ALEX SOBOL** pp. 250/251

He received his first camera from his father at 12 years old; since then, the graduate biologist Alex Sobol has been photographing the untouched wilderness in the national parks of Europe, Asia and America, as well as the poetic city landscapes of Istanbul, New York, Kiev, Odessa, Delhi and Lviv.

**SANKAR SRIDHAR** pp. 200/201

Sankar Sridhar is a multiple-prize-winning photographer, widely published travel writer and the author of "Ladakh Himalaja Trance," a visual travel report about traveling with nomads in Ladakh. He spends most of his time traveling in order to document the lifestyle of Indian communities. (www.sankarsridhar.com)

**GARRET SUHRIE** pp. 252/253

Nighttime photographer Garret Suhrie has been exploring the world in the moonlight for almost 16 years. The former artist and enthusiastic traveler turned his hand to photography when he realized "that you can paint with light, too."

**ELISABETH SUMMER** pp. 230/231

Ever since her childhood, Austrian Elisabeth Summer has spent every free minute outdoors. Over the past few years, she has taken to capturing on camera the breathtaking mountains around her during walks and climbing expeditions. (www.elisabethsummer.com)

**RONNY SUTALAKSANA** p. 216

Ronny Sutalaksana works as an engineer for a pharmaceutical company in Indonesia and has been a passionate photographer since the age of nine. He is particularly fascinated by lakes, the sea and mountains, and has recently started experimenting with drone photography.

**STJEPAN TOMISLAV ŠVALJEK** pp. 130/131

Stjepan Tomislav Švaljek has been dedicated to landscape photography for more than 16 years. He enjoys relaxing in the mountains, especially the Alps, so they play a major role in his life and his photos. Many of his photos have been published as calendars, postcards and in various specialist journals. (www.stjepansvaljek.com)

**IGNACZ SZABOLCS** p. 132/133

Ignacz Szabolcs is one of the best-known names in the aerial photography and video scene. His prize-winning photos have been on display in different galleries around the world (San Francisco, Los Angeles, Hong Kong, Romania and more). (www.improduction.ro)

**DON FERDINAND TABBUN** p. 177

Thanks to his mother, Don Ferdinand Tabbun discovered his love of photography at an early age and is now a highly esteemed landscape photographer.

## HANSA TANGMANPOOWADOL
p. 210

Hansa Tangmanpoowadol was born and grew up in Bangkok. He is an artist and photographer, and has been working as a commercial and industrial photographer for around 20 years. He lives in Bangkok and sees himself primarily as an artistic photographer. In 2012 he was voted Thai Artist of the Year in the photography category. His prize-winning photo "Pink Jungle" subsequently received an award in the IMS Photo Contest as well.

## PATRICK TASCHLER
pp. 262/263

Patrick Taschler was art director and managing director at Epica in Paris for many years. He loves riding his motorcycle around the world, exploring new countries, getting to know new people, climbing mountains and volcanoes, and stargazing — and taking photos of all this along the way.

## STEFAN THALER
pp. 24/25

Nature- and mountain-lover Stefan Thaler has been taking photographs for almost 36 years and always has his camera with him on his travels in order "to capture the beauty of things that are otherwise so easily overlooked in our hectic life."

## CHRISTINE THEODOROVICS
p. 49

Born in Austria, Christine Theodorovics now lives in Switzerland as the managing director of an insurance company and has enjoyed more than 30 years of photography. Her travel reports have appeared in books and specialist journals such as Der Bergsteiger (The Mountaineer). Having discovered mountaineering as a hobby more than 20 years ago, she has now climbed several 20,000-foot (6,000 m) and 16,000-foot (5,000 m) peaks and almost all the 13,000-foot (4,000 m) peaks in the Alps. The Himalayas really set her heart racing.

## YULIA TKACHEVA
pp. 174/175

Yulia Tkacheva has been pursuing her hobby of photography for five years now. She has tried various fields, such as weddings and sports events, but her real interest is landscape photography, in particular the beauty of the mountains. She has successfully taken part in various international photo competitions with her photos of snow-covered peaks and blossoming mountain pastures.

## JOHANNES TRIXL
p. 29

Johannes Trixl was born in the mountain world of the Tyrol lowlands in 1983. As a certified mountain guide and army mountain guide, he records the fascinating impressions on his numerous mountain hikes with great passion.

## MATTEO VENTURA
pp. 112/113

Matteo Ventura works as an IT expert for a Japanese company. The mountains are among the preferred subjects of the enthusiastic amateur photographer and nature lover.

## BECCA VERHOEVEN
p. 255

Becca VerHoeven grew up between the Rocky Mountains and Snake River Canyon in the United States, and loved nature and the mountains even as a child. Having taken a course in photography during her studies, the adventurous American has been documenting her trips through North America, Europe and Africa by camera ever since.

## ANDRÉ VIEGAS
pp. 270/271

The enthusiastic amateur photographer André Viegas finds his subjects both during his extensive travels and at home in Lisbon.

## AMANDA VOGELSANG
pp. 136/137

American Amanda Vogelsang (from Michigan, originally) has been interested in photography from an early age, particularly after spending a semester of school in Italy. She has always had her camera with her on trips through North America and Europe.

## ALEXANDER VOLIKOV
pp. 170/171

Alexander Volikov has been a climber for many years, and has spent time in the Caucasus as well as in the Khibiny Mountains and in Tian Shan in Central Asia. The enthusiastic amateur photographer always has his camera at the ready, even on glaciers and rock faces, to make sure he does not miss a breathtaking lake landscape or unique moment.

## MANFRED VOSS
pp. 146/147

At 51 years old, Manfred Voss is a prize-winning photographer, cameraman and light designer for international television, fashion and trade fair productions. With his camera on hand, he has traveled more than 30 countries to capture the beauty of nature. The perfection of light in one single brief moment is what he finds fascinating about his work, which can be summarized by a quotation by Leo Tolstoy: "All the variety, all the charm, all the beauty of life is made up of light and shadow."

## DIRK WAGENER
pp. 54/55

Dirk Wagener is a qualified journalist who has become more and more dedicated to outdoor photography over the past 11 years. Through his WhiteHearts project and the respective community, he sends live story, photo

him not only to the Alps, but also to many exotic winter sports destinations such as Chile, Argentina, Uzbekistan, northern Norway and Bulgaria. He now publishes articles regularly in German winter, mountain and lifestyle magazines such as BACKLINE, SkiMagazin, SNOW, and Powder Magazine, as well as RAUS and TRIP.
(www.whitehearts.de)

## HUI HUA WANG
pp. 188/189

Hui Hua Wang works as a landscape photographer and in image editing. Encounters on his extensive travels, particularly through Asia, inspire him to take photos that all have a story to tell.

## NICO WECKBECKER
p. 120

Nico Weckbecker is an enthusiastic hiker, climber and photographer. Born in the Rhineland, he fell in love with the mountains relatively late, although he has enjoyed photography ever since his youth.

## OLAF WEINMANN
pp. 156/157

The paramedic Olaf Weinmann (39) from Nuremberg, Germany, has enjoyed landscape and architectural photography in his free time for many years. (www.77lights.com)

## HARALD WISTHALER
pp. 66/67

Harald Wisthaler is a young photographer from South Tyrol who specializes in extreme sports. He always manages to capture the passion, tension and concentration of the athletes, whether they are competing in the Sellarondo Hero MTB Marathon, the GORE-TEX® Transalpine-Run or high-lining. He also works for the FIS World Cup, Adidas, Armani EA7 and Dolomiti Superski, and was among the finalists of the Redbull Illume in 2013. (www.wisthaler.com)

## ANNABELLA WOLF
pp. 20/21

Following her final high school leaving exams, the enthusiastic amateur photographer and mountain biker Annabella Wolf traveled to Namibia, where she decided to capture all her adventures from that point forward — whether in South Africa, Namibia or on the Ortler in South Tyrol — on camera.

## ALE ZEA
p. 239

Ale Zea (born in 1977) first came into contact with photography during his studies of painting and photography at the University of Seville in Spain. When he visited Greenland for the first time, he experienced nature in its purest and wildest form. Ever since then, he has tried to record this on camera and feels obliged — as a person and photographer — to marvel at, respect and protect nature. Ale Zea divides his time between Germany and Spain. (www.alezeaphotostudio.com)

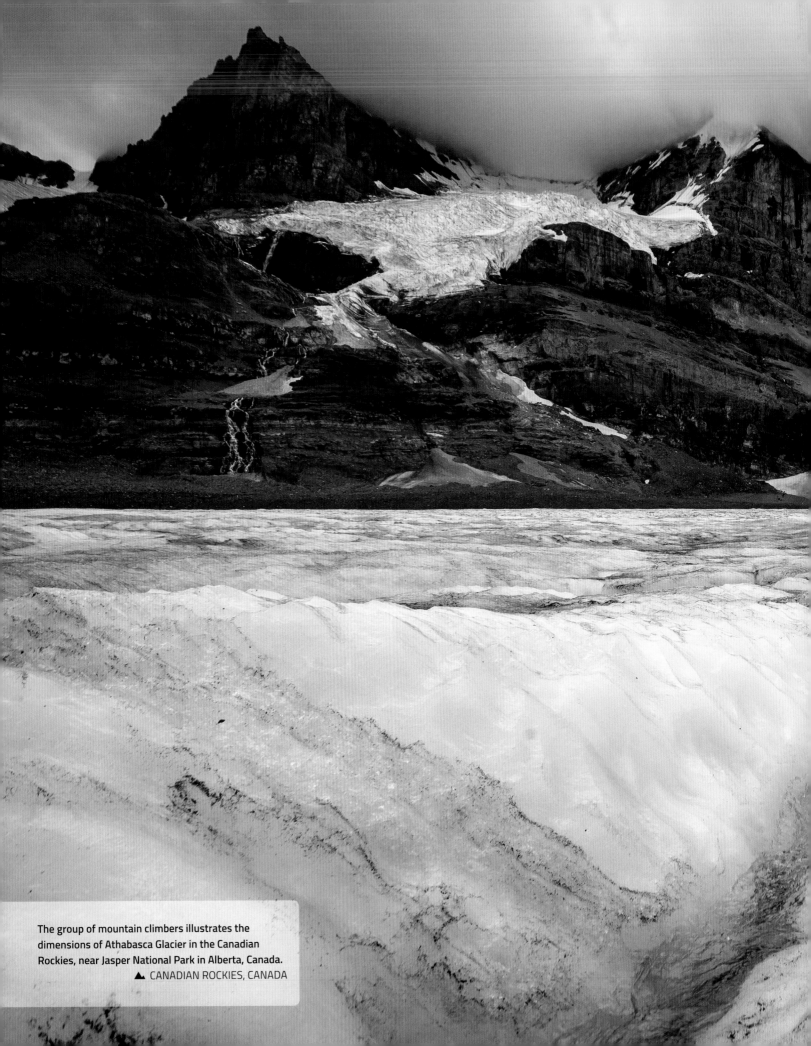

The group of mountain climbers illustrates the
dimensions of Athabasca Glacier in the Canadian
Rockies, near Jasper National Park in Alberta, Canada.

▲ CANADIAN ROCKIES, CANADA

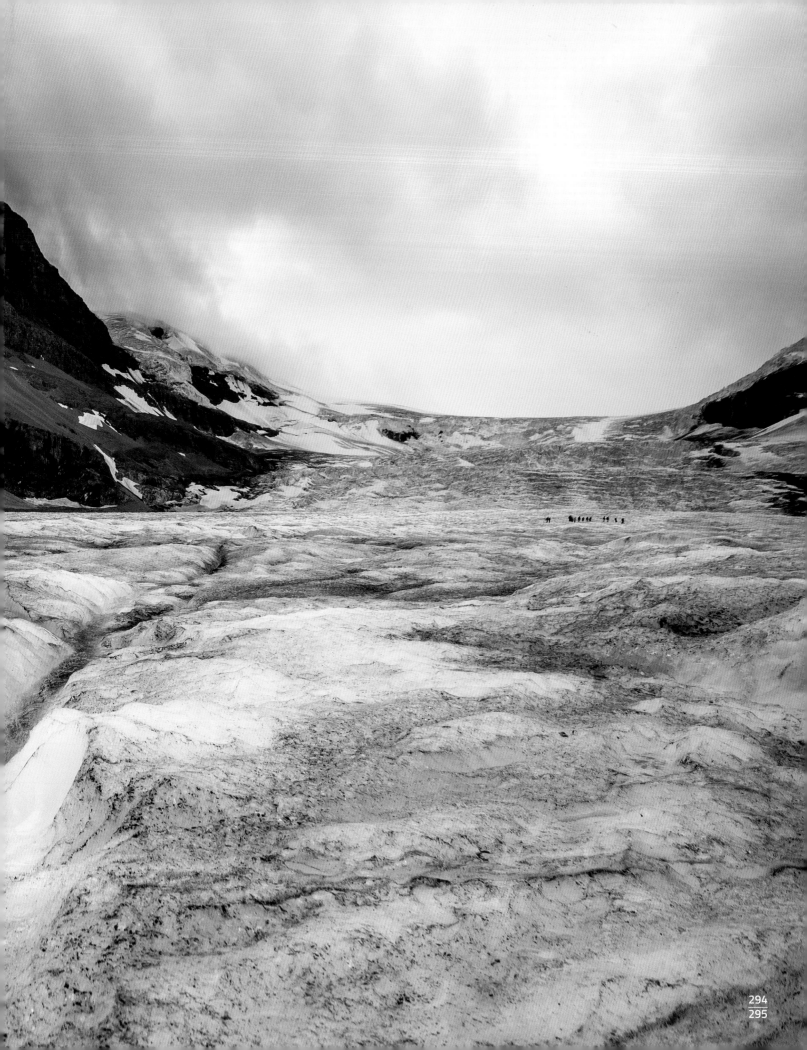

# A FIREFLY BOOK

Published by Firefly Books Ltd. 2017

Original German-language edition copyright © 2015, 2017 Bruckmann Verlag GmbH, Munich
This English-language edition copyright © 2017 Firefly Books Ltd.

First printing

**Publisher Cataloging-in-Publication Data (U.S.)**

Library of Congress Cataloging-in-Publication Data is available

**Library and Archives Canada Cataloguing in Publication**

Atem der Berge. English
        The spirit of the mountains / International Mountain Summit.
Translation of: Der Atem der Berge.
Includes index.
"Best of IMS Photo Contest, 2011-2016, the best mountain photography in the world."
ISBN 978-1-77085-980-7 (hardcover)
        1. Mountains--Pictorial works.  2. Photography of mountains.
I. International Mountain Summit  II. Title.  III. Title: Atem der Berge. English.
GB501.2.A8413 2017          779'.36143          C2017-902186-9

Published in the United States by
Firefly Books (U.S.) Inc.
P.O. Box 1338, Ellicott Station
Buffalo, New York 14205

Published in Canada by
Firefly Books Ltd.
50 Staples Avenue, Unit 1
Richmond Hill, Ontario L4B 0A7

Translator: Beatrix Read

Printed in China

Cover and interior photo credits: page 282-291.
Front cover: The heart of San Lucano, also called "El cor," is a hidden stone arch in the Pala group (Dolomites).
Back cover: The 3406 meter high granite mountain Fitz Roy rises to the south of Patagonia, Argentina.
Page 1: Great view of the Himalayas during the climb to Everest Base Camp.
Page 2/3: A new day starts at the Langkofel, in the heart of the Dolomites.
Page 4/5: This remarkable rock formation called the Kaindl Steward Tower on the Kopftörlgrat (III-IV) begins at the top of the Ellmauer Halt, the highest peak in the Kaiser mountain range.
Page 12 (top), 13: Manuel Ferrigato
Page 12 (bottom): Jürgen Kössler
Page 14, 17: Robert Bösch
Page 15: Heinz Müller

 we acknowledge the financial support of the Government of Canada.